THE BEGINNER'S GUIDE TO ART

THE BEGINNER'S GUIDE TO ART

Brigitte Govignon, *General Editor*

Translated from the French by John Goodman

Harry N. Abrams, Inc., Publishers

LITERARY ADVISOR TO THE FRENCH EDITION: Alain Rey
ART DIRECTOR: Pascale Ogée
EDITOR, ENGLISH-LANGUAGE EDITION: Elaine M. Stainton
DESIGN COORDINATION, ENGLISH-LANGUAGE EDITION: Dirk Luykx and Tina Thompson

Library of Congress Cataloging-in-Publication Data
Petite encyclopédie de l'art. English.
 The beginner's guide to art / Brigitte Govignon, general editor;
 Translated from the French by John Goodman.
 p cm.
 Includes index.
 ISBN 0–8109–4002–7 (hardcover)
 1. Art—History. 2. Art appreciation. I. Govignon, Brigitte.
 II. Goodman, John, 1952 Sept. 19– III. Title.
N5300.P41513 1998
709—dc21 98–2952

ISBN 0–8109–9060–1 (pbk.)

Printed and bound in Italy
10 9 8 7 6 5 4 3 2 1

Harry N. Abrams, Inc.
100 Fifth Avenue
New York, N.Y. 10011
www.abramsbooks.com

PREFACE

Art has been part of human life from the beginning, and every society has produced some form of art. Indeed, the capacity to make and to respond to art is part of what it means to be human. With this guide we hope to introduce a new audience to the world of art and its many pleasures. More than simply recounting the history of art, we hope to raise some of the issues that make an artwork what it is. For example, we shall explore how history and geography shape the painting, sculpture, and architecture that a society produces—how, and why, for example, the art of the Inca civilization differed from that of the Maya. We shall examine techniques, and compare and contrast some of the formal properties that distinguish one style from another. We shall also explore what brought about the birth of modern art in the movements of the late nineteenth and early twentieth centuries, from Impressionism to Futurism to Dadaism to Surrealism. We shall examine the development of cities, and the evolution of architecture, the art form that most profoundly affects our everyday lives, from the pyramids of ancient Egypt to modern skyscrapers.

Above all, our aim is to open the world of art to a new audience, to take the reader on a grand tour through centuries and cultures, presenting clearly expressed ideas, a basic vocabulary, and a selection of representative images to clarify a world of sensation and meaning.

TABLE OF CONTENTS

TIMELINE

PREHISTORY AND ANTIQUITY: From Lascaux

-20,000	-15,000	-10,000	-7,000	-5,000	-3,000	-2,900	-2,800	-2,700	-2,600	-2,500	-2,400	-2,300	-2,200	-2,100	-2,000

SOME HISTORICAL BENCHMARKS

–3,200 Unification of Upper and Lower Egypt

–3,000 Invention of writing in ancient Sumer

EUROPE

–20,000 Female statuette: one of the earliest images of a woman, p. 86

–3,000 to –1,400: CRETAN ART—MINOAN CIVILIZATION

–15,000 Lascaux Caves: rock paintings, pp. 120–21

c. –2,500 Marble statuettes, most of women, from the Cyclades (Greek islands)

–2,000
Stonehenge: a circle of massive upright stones related to a solar cult in the British Isles (pre-Celtic)

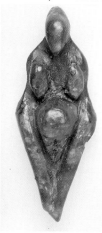

Female statuette, p. 86

THE NEAR EAST AND INDIA

–3,200 to –2,000: SUMERIAN ART

–8,000 Jericho: earliest known fortified city (in present-day Jordan)

–2,900 to –2,400 Statue of Ebih-il, governor of the kingdom of Mari: an early attempt at realistic portraiture

–3,000 to –2,500: VALLEY OF THE INDUS An urban merchant civilization (present-day Pakistan)

–2,500 to –2,000: AKKADIAN ART

–6,000 Chatal Huyuk: painted and carved decoration in sanctuaries in Asia Minor (present-day Turkey)

–2,300 Stele of Naram-Sin, king of Akkad: earliest known portrayal of landscape

AFRICA

EGYPT **–3,000 to –2,200: OLD KINGDOM**

–2,200 to –1,750:

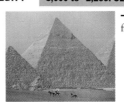

–2,700 Saqqara: Imhotep builds first stone pyramid, p. 42

–2,650 Khufu builds largest of the three great pyramids at Giza, p. 42

–2,200 Valley of the Kings and Valley of the Queens. Great royal tombs in complex underground chambers, p. 43

–4,000 Tassili: rock art of the Sahara, p. 121

FAR EAST

THE AMERICAS

–10,000 Coyote head from Tequixquiac, Mexico

–8,000 Pyramid of Cuicuilco

o the Fall of Rome

-1,800 -1,700 -1,600 -1,500 -1,400 -1,300 -1,200 -1,100 -1,000 -900 -800 -700 -600 -500 -400 -300 -200 -100 0 100 200 300 400 476

-1760 The code of Hammurabi
The earliest known written law code

-1,180 The Fall of Troy **-776** The first Olympic Games
-753 Traditional date of the foundation of Rome
-560 Birth of the Buddha

-331 Death of Alexander the Great

-27 Augustus becomes the first Roman emperor

c. 30 Crucifixion of Christ

312 Victory of Constantine: the first Roman emperor to embrace Christianity

-800 to 500: ARCHAIC GREECE

-500 to -300: CLASSICAL GREECE

-350 to 200: HELLENISTIC PERIOD

425 Mausoleum of Galla Placidia in Ravenna: the earliest Christian mosaics in the western Empire

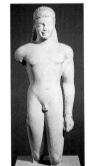

-1,500 Construction of the Palace of Knossos, p. 34

Monumental sculpture erected in Greek cities
The *kouros* (statue of young male athlete) and the *kore* (statue of young woman)
-447 The Parthenon: the height of the Classical architectural style, p. 44
-190 *Winged Victory of Samothrace*, p. 91
-100 *Venus of Milo*, p. 91

-500 to 350: ROMAN ART

-1400 to -1,100: MYCENAE
Construction of the Lion Gate

80 Completion of the Roman Colosseum, p. 78
c. 100–200 *The Apollo Belvedere*, p. 90

-1,200 to the beginning of the Common Era: THE PHOENICIANS
This seafaring people develop maritime commerce in the Mediterranean

-800 to -400: SCYTHIAN ART
Stylized animal figures of gold and bronze

200 to 400: EARLY CHRISTIAN ART, p. 56

-800 to -400: THE ETRUSCANS
-520 Terra-cotta sarcophagus depicting a couple dining together

-800 to -50: MAINLAND CELTS
An art of small, decorated metal and ceramic objects

-1800 to -1,600: THE BABYLONIANS DOMINATE MESOPOTAMIA

-1,700 to -1,200: THE HITTITES DOMINATE ANATOLIA (PRESENT-DAY TURKEY)
-1,400 Sphinx gate and double rampart at the stronghold of Hattushash

3rd century CE: Stupa of Sanchi, p. 48

-1,200 to -600: ASSYRIAN ART
-723 Palace of Sargon II in Khorsabad, p. 96

-550 to -350: ACHAEMENID ART OF PERSIA
-500 Construction of Persepolis, p. 66

300: COPTIC ART (EGYPT)

DDLE KINGDOM -1,600 to -1,000: NEW KINGDOM **-1,000 to -400: LATER DYNASTIES**
-1,480 Deir el-Bahari: funerary temple of Queen Hatshepsut
-1,400 Luxor and Karnak: beginning of temple construction, p. 43
-1,360 Bust of Nefertiti
-1,340 Treasury of the tomb of Tutankhamun
-1,300 Abu Simbel: Ramses II begins construction of his temple
-400 Edfu, temple of Horus

-900 to -200: NOK CIVILIZATION
Terra-cotta heads (West Africa)

-1,066 to -221: CHINA, ZHOU DYNASTY **-206 to 220: HAN DYNASTY**
-1,770 Beginning of Chinese bronze art
-221 Emperor Qin Shi Huangdi and his terra-cotta army, pp. 94–95

-1,000 to the beginning of the Common Era: THE OLMECS
-270 Giant stone heads (Mexico)

-300: THE MAYA
Construction of the earliest pyramids in the Americas (Yucatan peninsula)

THE MIDDLE AGES: From the Fall of Rome to

477 500 600 700 800 900

EUROPE

700 to 850: CAROLINGIAN ART
796–805 Beginning of the construction of Aix-la-Chapelle, p. 57

900 to 1150

600 to 900: IRISH MANUSCRIPTS
Illuminated Gospels that served as models for all of Europe
c.690 Echternach Gospel, p. 134

910
Foundation of the
Abbey of Cluny, p. 58

RAVENNA
530 In the church of San Vitale, mosaics representing
the emperor Justinian and the empress Theodora, p. 54

SOME HISTORICAL BENCHMARKS

527 Beginning of the reign of the emperor Justinian I
622 Muhammad's *hijra* from Mecca to Medina begins the Muslim era
800 Charlemagne crowned emperor of the West in Rome
962 Otto I of Germany establishes the Holy Roman Empire
1066 Norman conquest of England

1096 Beginning of the first Crusade
1215 King John of England signs the Magna Charta
1337 Beginning of the Hundred Years War
1348 The Black Death
1453 The Turks conquer Constantinople

500 to 1450: BYZANTINE ART, pp. 54–5

THE NEAR EAST AND INDIA

532–37 Construction
of the church of
Hagia Sofia in
Constantinople, p. 54

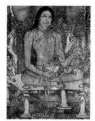

867–1057: MACEDONIAN

670 to 1300: ISLAMIC ART
The mosque, Islam's greatest contribution to architecture, pp. 64–65
c.705 Construction of the Great Mosque in Damascus (Syria), p. 64
717–843 Iconoclastic crisis, p. 131

4th–6th centuries: Frescoes of
Ajanta in India, p. 124

8th century: the rock-cut temple of
Kailasa in Ellora, India, pp. 48–49

c. 850 Mosque of Samarra
(present-day Iraq), p. 65

AFRICA

400 to 700: COPTIC ART FLOURISHES IN EGYPT
Coptic textiles

800 Foundation of Ilfe in Nigeria

FAR EAST

600 to 900: CHINA, TANG DYNASTY
Reunification of China

699–759 Life of the first scholar-painter, the poet Wang Wei, p. 127

710 Japan
Construction of Nara, the first
Japanese capital, pp. 52–53

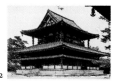

Kondo, p. 52

THE AMERICAS: Mexico and Peru

250–950: APOGEE OF MAYAN ART

8th century: Tikal, pyramid of the Jaguar Temple, p. 46

the Fall of Constantinople

1000	1100	1200	1300	1400	1450

OMANESQUE ART

Use of the rounded arch.
Sculpture an integral part of architecture

1073–83 Bayeux tapestry

1060 Church of San Marco
in Venice: influence of
Byzantine art, p. 55

Chartres Cathedral,
Adoration of the Magi, p. 133

1100 Virgin of Vladimir: one of the earliest Russian icons

1135 to 1450: GOTHIC ART, pp. 60–1

Use of rib vaults, the pointed arch, and taller windows to admit more light

1144 Construction of the abbey church of Saint-Denis (near Paris)

c. 1200 Stained-glass windows of Chartres cathedral, p. 133

1220–36 Amiens cathedral

1296 *The Life of Saint Francis*, a fresco
cycle at Assisi (circle of Giotto), p. 217

1309 The papacy moves to Avignon for 75 years

1280
Cimabue, *Virgin and
Child*, p. 196

1420: BEGINNING OF
THE RENAISSANCE,
p. 136

1432
Jan van Eyck, *Arnolfini
Wedding Portrait*, p. 275

c. 1350 Portrait of John the Good,
king of France: an early example
of realistic portraiture, p. 135

1426
Masaccio, *The Trinity*, an early use
of scientific perspective, p. 136

c. 1411
The Trinity by the Russian icon painter
Andrei Rublev, p. 131

NASTY: APOGEE OF BYZANTINE ART

10th–11th centuries: Construction of the temples of Khajuraho, India, p. 49

. 956 *The Thousand and One Nights*, collection of Arab tales

1th–16th centuries: Golden age of illuminated manuscripts

0th–11th centuries: Foundation of the Mali empire

1275 Apogee of Ilfe art

13th century: The Dogon settle in the Bandiagara cliff, p. 105

Dogon statue, p. 105

960–1279: SUNG DYNASTY

Beginning in 900: landscape painting assumes preeminence

1210 Genghis Khan begins the conquest of China

1280–1368: YUAN DYNASTY 1368–1644: MING DYNASTY

1406
Beginning of construction of the
Forbidden City in Beijing, pp. 68–69

Late 9th century–1431: KHMER ART (CAMBODIA)

1113 Construction of temple complex at Angkor Wat, p. 51

50–1500: THE TOLTECS

50 The rise of the city of Chichén Itzá

c. 1100–1532: INCA EMPIRE (PERU), p. 47

13th century–1519: AZTEC EMPIRE

Foundation of the capital at Tenochtitlán, p. 47

THE RENAISSANCE: From the Fall of Constanti

	1453	1500	1550	1600

EUROPE

1420–1560: THE RENAISSANCE, pp. 136–47

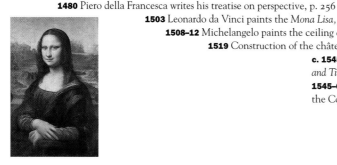

1474 Andrea Mantegna, decorations in the Gonzaga Palace in Mantua, p. 138

1480 Piero della Francesca writes his treatise on perspective, p. 256

1503 Leonardo da Vinci paints the *Mona Lisa*, p. 233

1508–12 Michelangelo paints the ceiling of the Sistine Chapel in Rome, p. 141

1519 Construction of the château of Chambord, p. 70

1527–90: MANNERISM, p. 143

c. 1545 Bronzino, *Allegory with Venus, Cupid, and Time*, p. 143

1545–63 The Council of Trent: Beginning of the Counter-Reformation, p. 148

1568 Palladio builds the Villa Rotunda, p. 253

After 1610–end

1601 Caravaggio paints *The Conversion of Saint Paul*, p. 189

1597–1602 Annibale Carracc paints the ceiling of the Farn Gallery, Rome, p. 149

NEAR EAST AND INDIA

1454 Construction of Topkapi Palace in Istanbul

1538 Sinan, architect of Suleyman the Magnificent

1550–57 Construction of the Suleymaniye mosque, p. 65

16th–19th centuries: RAJPUT SCHOOLS OF RAJASTAN AND THE HIGH PUNJAB

The art of the Indian miniature, p. 125

1526 Foundation of the Mughal Empire in India
Beginning of the Persian-influenced Mughal school, best known of Indian schools of painting

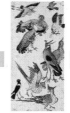

c. 1590 Miskina, *Ten Birds*, p. 125

AFRICA

c. 1500–90 Apogee of the art of Benin: work in ivory and bronze

16th century: Foundation of the Bambara kingdom

FAR EAST (China)

1358–1644: MING DYNASTY

1602–1875: EDO PERIOD

THE AMERICAS

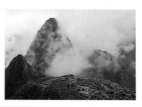

1450 Construction of Inca citadel at Machu Picchu (Peru), p. 47

1519 Spanish soldiers commanded by Cortés conquer the Aztec Empire of Mexico

1531 Pizarro conquers the Inca Empire

ple to the French Revolution

1650 1700 1750 1789

1642 Rembrandt paints
The Night Watch, p. 261

e seventeenth century: CARAVAGGISM

1644–52 Gianlorenzo Bernini, *The Ecstasy of Saint Teresa*, p. 180

1661–1715 Louis XIV rebuilds the château of Versailles

1760–1840: NEOCLASSICISM, p. 152

1770–1840: ROMANTICISM, p. 153

c. 1630 Georges de La Tour,
Cardsharps, p. 228

1703 Founding of
St. Petersburg: Russia
is opened to the West

1774–79 Claude-Nicolas
Ledoux builds the salt works
of Arc-et-Senans, p. 231

1718 Watteau, *Pierrot (Gilles)*, p. 282

1632–43 Construction of the Taj Mahal
in Agra, India, p. 48

Dogon art, now considered the
"classical" art of Africa, pp. 102–7

SOME HISTORICAL BENCHMARKS

c. 1450 Invention of movable type for printing
in Germany (by Johann Gutenberg?)
1492 Christopher Columbus discovers America
1520 Martin Luther initiates the Protestant
Reformation
1527 Emperor Charles V's soldiers sack Rome
1547 Ivan I ("the Terrible"), first czar of Russia
1545–63 Council of Trent; beginning of the
Counter-Reformation
1558–1603 Reign of Elizabeth I of England
1588 The English navy defeats the Spanish armada

1616 Death of Shakespeare
1618–48 Thirty Years' War
1620 English settlers land at Plymouth,
Massachusetts
1643–1715 Reign of Louis XIV of France
1756 Birth of Mozart
1762–96 Reign of Catherine II ("the Great")
of Russia
1776 The United States declares itself
independent of England
1789 The French Revolution

1644–1912: QUING DYNASTY

JAPAN

th-century screens painted by Ogata Korin
panese prints become an autonomous medium, pp. 128–29

ART OF THE NORTH AMERICAN INDIANS

1722 Discovery of Easter Island

1775 John Singleton
Copley

THE EARLY MODERN ERA

1790	1800	1810	1820	1830	1840

EUROPE

1760–1840: NEOCLASSICISM, p. 152

1770–1840: ROMANTICISM, p. 153

1789 David, *War of the Romans and Sabines*, p. 202

1806–08 Antonio Canova, *Perseus with the Head of Medusa*, p. 90

1814 Goya, *The Third of May*, p. 219

1819 Géricault, *Raft of the Medusa*, p. 215

1839 Invention of photography, pp. 172–73

1842 Turner, *Snow Storm*, p. 272

1836–end of the 19th centu

SOME HISTORICAL BENCHMARKS

1793 Louis XVI of France beheaded
1803 United States purchases Louisiana from France
1804 Napoleon Bonaparte crowned Emperor of the French
1814 Napoleon defeated at Waterloo; Congress of Vienna redraws the map of Europe
1830 July Revolution in France; accession of Louis-Philippe
1837 Beginning of the reign of Queen Victoria of England
1848 Revolutions throughout Europe

1852 Second Empire established in France
1860 Abraham Lincoln elected president of the United States
1861–65 American Civil War
1869 Opening of the Suez Canal
1870 Franco-Prussian War; proclamation of French Third Republic
1876 Queen Victoria becomes Empress of India
1894–95 War between China and Japan
1899–1902 Boxer Rebellion in China against western influence; Boer War in Africa

1831 Delacroix, *Liberty Leading the People*, p. 153

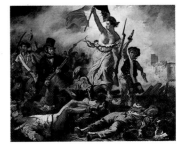

AFRICA

1798 Napoleon's Egyptian campaign

1822 Champollion deciphers Egyptian hieroglyphics

FAR EAST

1602–1875: EDO PERIOD IN JAPAN

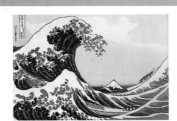

1823 Hokusai, *Below the Waves at Kanagawa*, p. 128

THE AMERICAS

1830–50 The Hudson River School; Thomas Cole, father of American landscape painting

1827–38 John James Audubon publishes *The Birds of America*

1850 1860 1870 1880 1890 1900

1849–50 Courbet's *A Burial in Ornans* provokes controversy at the 1850 Salon, pp. 155, 198

1895
Lumière brothers invent cinematography

1853 Haussmann begins to reconfigure Paris, p. 73

1863 Manet, *Olympia*, p. 155; First Salon des Refusés authorized by Napoleon III

1880 Rodin begins *Gates of Hell*, p. 263

1890–1905: ART NOUVEAU
Revitalization of architecture and the decorative arts

1874–86: IMPRESSIONISM, pp.156–57

839–52 Charles Barry builds e Gothic revival Houses of arliament in London

1861–74 Charles Garnier, Paris Opera House, p. 79

1874 First Impressionist exhibition in Nadar's studio
1876 Renoir, *The Swing*, p. 157

1885 Cézanne, *Mont Sainte-Victoire*, p. 192

EALISM, pp. 154–55

1883 Gaudí begins work on the Sagrada Familia church in Barcelona, p. 213

1889 Gustave Eiffel builds the Eiffel Tower in Paris

1885–1910: NEO-IMPRESSIONISM, pp. 158–59
The theory of optical mixture

1884 Seurat, *Sunday on the Grande Jatte*, pp. 158, 266

1898
Picasso arrives in Paris

1887–1903: THE NABIS, p. 159

1888 Gauguin, *Vision after the Sermon*, pp. 159, 214

1886–1900: SYMBOLISM, p. 159

1893 Munch, *The Scream*, p. 252

Nimba shoulder mask: an evocation of the goddess Nimba, p. 103

1868–1912: MEIJI PERIOD IN JAPAN
Modernization and westernization of Japan

1644–1912: QING DYNASTY IN CHINA

1870–90 Winslow Homer and Thomas Eakins paint scenes of American life

1894–95
Louis Henry Sullivan: Guarantee Trust Building in Buffalo, New York, establishes a new architectural mode

THE TWENTIETH CENTURY: Important Trend.

**FIRST WORLD WAR
[1914–18]**

1900 1902 1904 1906 1908 1910 1912 1914 1916 1918 1920 1922 1924 1926 1928 1930 1932

1900–1905: FAUVISM, p. 159 **1906–15: RAYONISM,** p. 164

1907–14: CUBISM, p. 160

1909: FUTURISM, p. 161

1905–13: DIE BRÜCKE ("THE BRIDGE"); 1911–14: DER BLAUE REITER ("THE BLUE RIDER"); EXPRESSIONISM, pp. 162–63

Various Expressionist movements continue throughout the twentieth century

1930 Max Ernst,
*Loplop Introduces a
Young Girl,* p. 167

1910 Kandinsky embraces abstract art
Abstract art, p. 164
Continues throughout the twentieth century

1925 The International Exhibition of
the Decorative Arts (Art Deco) in Paris:
painting used for mural decorations

Picasso,
Les Demoiselles d'Avignon, p. 254

1913 The "Armory Show": an international exhibition of modern art in New York

1913–18: SUPREMATISM, p. 165

1910 Malevich,
*White Square
on Black Ground,*
p. 165

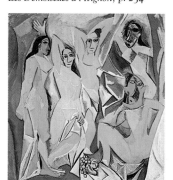

1916–23: DADAISM, p. 166

1924–66: SURREALISM, p. 167

1917–33: DE STIJL ("STYLE")

1919–33: THE BAUHAUS

A revolutionary art school in Germany

1920–23: CONSTRUCTIVISM, pp. 115, 165

EVENTS

1905 Einstein's theory of relativity ($E=mc^2$)

1911 The Emperor of China deposed; Sun Yat-sen establishes a republic

1914–18 First World War

1924–26 Death of Lenin; Joseph Stalin
takes control of the Soviet Union

1917 The Russian Revolution;
first Communist state established
under Vladimir Lenin

1926 Benito Mussolini
comes to power in Italy

1919 Foundation of the League of Nations

1929 "Black Monday"
on Wall Street brings
about worldwide
financial depression

Movements, and Schools

SECOND WORLD
WAR [1939–45]

1934 1936 1938 1940 1942 1944 1946 1948 1950 1952 1954 1956 1958 1960 1962 1964 1966 1968 1970 1972 1974 1976 1978 1980 1982 1984 1986 1988 1990 1992 1995

1942–59: ABSTRACT EXPRESSIONISM, OR "ACTION PAINTING," p. 163

1966 Beuys, *Homogenous Infiltration for Grand Piano*, p. 115

Beginning in 1952: Fluxus, p. 115

1948–51: COBRA, p. 170

1937 Picasso, *Guernica*, pp. 163, 255

1950–70: OP ART AND KINETIC ART, p. 115
Movement introduced into painting and sculpture

1958 Pop Art, p. 168

1960–70: NEW REALISM, p. 168–9

1948 Art Brut
Jean Dubuffet establishes the
Compagnie de l'Art Brut, p. 171

1965 Minimal Art, p. 115

c. 1970 Super Realism
Meticulously accurate depictions of commonplace subjects

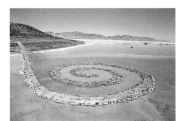

Since 1967: CONCEPTUAL ART

1967–80: ARTE POVERA
Objects made of "poor" materials, p. 114

1967 Earthworks (Land Art)
The earth itself becomes the raw material of art, p. 115

1969–70 Smithson, *Spiral Jetty*, p. 87

1933 Adolf Hitler head of the National Socialist ("Nazi") Party in Germany

1936–39 Spanish Civil War

1939 Germany invades Poland, starting the Second World War

1945 End of the Second World War; first atomic bombs
dropped by the United States on Hiroshima and Nagasaki

1947 Division of Germany into Eastern and Western states

1949 Establishment of the People's Republic of China

1952 Elizabeth II queen of England

1954 American Civil Rights Movement begins

c. 1955 Beginning of the Cold War

1961 East German government builds the Berlin Wall to
separate the two Germanies; Russian Astronaut Yuri Gagarin
the first man in space

1963 Assassination of President John F. Kennedy in the United States

1965–76 Cultural Revolution in China

1967 Jordan and Egypt attack Israel,
losing the west bank of the Jordan to Israel

1968 "Prague Spring": Czechoslovakia tries and
fails to free itself from Russian domination

1969 American Neil Armstrong the first man to walk on the moon

1979 Camp David accord
between Israel and Egypt

1989 Berlin Wall falls;
Germany reunited

1990 Apartheid ends
in South Africa

1994
Nelson Mandela elected
president of South Africa

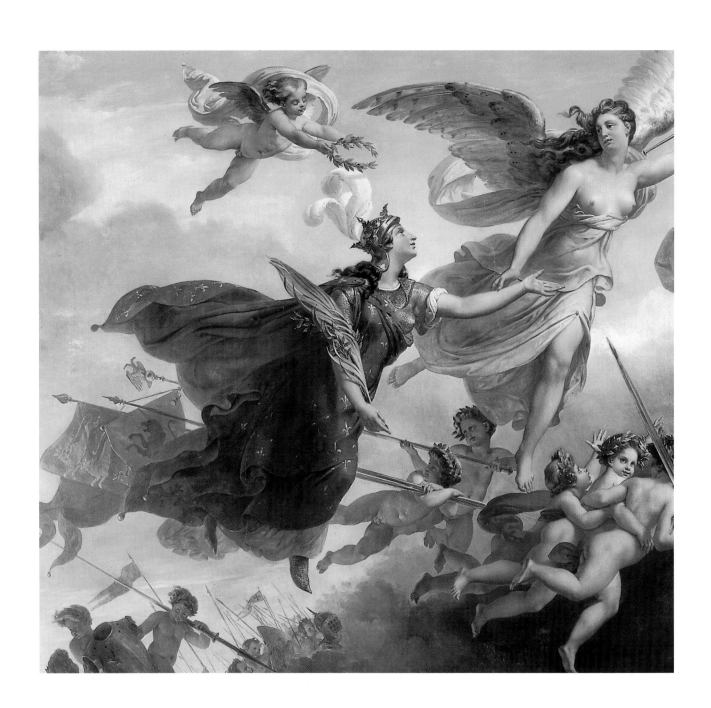

ART AND LIFE
The World of Art

Art is a short word for a very complex reality. When we visit an art museum or leaf through an art book, we may feel that we have entered a world filled with that special kind of beauty achieved by the interaction of color, line, and form. But we do not have to visit a museum to find art, for it is all around us—in objects we see every day around the house, in the street, and in the natural landscape. A world without these objects would be much less interesting than the one we live in.

This book will try to show the reader how to see, understand, and appreciate art. This may seem a strange project at first, for we often think of art as, simply, a source of pleasure. But we are not born knowing how to look at paintings, drawings, and sculptures, just as we are not born knowing how to make them. Artists must learn how to go about their work, and appreciating the things they make requires education, too. In fact, making art and appreciating it are closely related activities. Anyone who knows how to perceive artistic beauty is in some sense an artist.

Books offer us pleasure, distraction, and relaxation. But before we can enjoy these benefits, we must learn to read. The same is true for painting, sculpture, and architecture—and also for music, which is also an art, but which will not be discussed here. This book is a guide to the art of looking, and more importantly, of seeing.

◀ MERRY JOSEPH
BLONDEL (1781–1853).
*France Victorious at
the Battle of Bouvines*
(detail). Oil on
canvas, 1828

▲ SOME MUSEUM
LOGOS:
• Museum of Contemporary Art, Los Angeles
• Georges Pompidou
Center, Paris
• Victoria & Albert
Museum, London

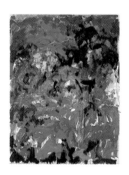

▲ JOAN MITCHELL
(1922–92).
Large Valley IV.
Oil on canvas, 1983

The Art of Showing What Lies Behind Things

Beauty is closely related to art, but the two are certainly not the same. Some artists are concerned with the creation of something beautiful, but some are not. Sometimes they are satisfied with a simple form or line, but often they do much more. They arrange pigments on canvas, carve and polish stone, cast and finish metal, assemble construction materials, always guided by some central idea. Painting, said Leonardo da Vinci (p. 233), is "a mental thing," a thing of the mind, and so it is. But painting may also be charged with emotion. In such a case, it also attempts to show what lies behind things, whether the artist sets out to imitate appearances (as in portraits, landscapes, or narrative scenes), to alter them (as in many twentieth-century paintings; see p. 254), or even to invent new ones (as in geometric designs, building façades, or abstract paintings).

Art transforms everything it touches. An ugly, disagreeable face can be changed by the magic of art into a beautiful portrait. Many people would consider a flayed ox carcass ugly in reality, and would be horrified to watch doctors dissecting a cadaver to teach their students anatomy. But two depictions of these subjects by Rembrandt (p. 261), *The Slaughtered Ox* and *The Anatomy Lesson*, are among the most powerful, and yes, beautiful, pictures ever painted. Their power arises from their ability to show something beyond their subject matter, and also because they are works of art. That is, they admirably display the art of painting itself.

▲ DOMENICO
GHIRLANDAIO (1449–94). *Portrait of an Old Man and a Young Boy.* Tempera on wood panel, c. 1490

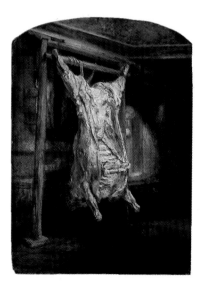

◀ REMBRANDT
VAN RIJN (1606–69).
The Slaughtered Ox.
Oil on canvas, 1655

A Magical Chemistry

A successful work of art shows something beyond the reality that inspired it. What was not beautiful may become so, and things that were beautiful to begin with—a landscape, the sea—may become still more beautiful. This magical transformation requires a veritable chemistry of technique, work, and knowledge. Art is the result of operations that are as carefully controlled as the manufacture of a supersonic jet. Moreover, the jet, assembled from thousands of parts meant to function in unison, is also a sort of art object, as much so as a cathedral. This should remind us that the imitation or evocation of reality—a central preoccupation of draftsmen, painters, and sculptors for centuries, and now the focus of photographers—is only one of the possibilities open to an artist. Many works of art—castles, pieces of jewelry, and geometric designs on vases—resemble nothing but themselves.

▲ MOSAIC PAVEMENT,
Basilica of San Marco,
Venice. Fourteenth and
fifteenth century

Inventing a World of Beauty

Art can resemble things, or it can assemble various components, as in architecture, to become the invention of a new world—a world for which nature can provide a model, almost as if by chance. But we must always remember that art is not "natural." Rather, it is a manipulation of light, form, and emotion in an attempt to convey something.

The artist addresses all of us. Sometimes our response is direct: we look at a painting or a mosaic, we contemplate a statue, or we visit a monument. But sometimes our confrontation with a work of art is indirect, and made possible by technology. We can look at reproductions of paintings, for example, or view a film about a great art collection or a beautiful building. Today, with the help of computer technology, we can even make images that show the original appearance of a building that is now in ruins, or completely destroyed (p. 58).

The Art of Seeing

Modern technology, unfortunately, has also become a threat to the beauty around us. The worst threat is, simply, that ugly, utilitarian objects, or cheap imitations of beautiful ones, will overwhelm our visual environment. When art can be found only in museums or in other rarified places, many people are tempted to flee civilization entirely, and take refuge in nature.

However, art can often be found in the man-made environment of cities and towns, in a harmoniously proportioned house façade, for example, or in the slope of a roof, in the material of a wall, or in the design of a park. Within houses and apartments we find fine paintings hanging on the wall, furniture that is well designed and well made, and objects of wood that have been worn smooth over the years.

Art is not only something made with the skill, thought, and sensibility of painters, sculptors, architects, and decorators; it is also something chosen by the person who enjoys it. The knowledgeable viewer knows what is most likely to give pleasure, and indeed, intelligent looking is an art. It takes practice to know what to focus on—and how to focus on it—in the wealth of things around us.

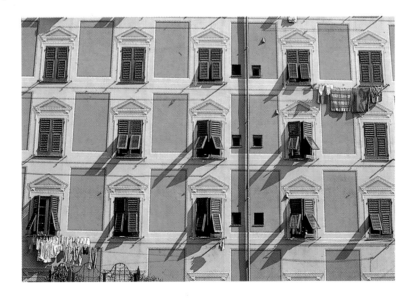

◄ FAÇADE OF AN APARTMENT BUILDING, Nervi, Italy

Learning to See

Since art does not exist in nature, it must be learned, like every other civilized activity and habit of thought. Learning to see is a matter of habit, but learning to understand—and love—what we are looking at requires education. It is a shame to pass by something beautiful without seeing it, whether it is a work of art or not. But if it *is* a work of art, passing it by is an even greater shame, for without an understanding of what it says, we see only meaningless colors and shapes.

Learning to see requires learning to look as well as to touch, and also, sometimes, even to walk. We can actually touch a sculpture, or walk through an architect's creation. And although paintings and drawings are flat, we can also "touch" and "walk through" them in our imaginations. The material reality of a painting is one of colors and lines on a support—paper, canvas, or perhaps a wall. But those colors and lines are also something else entirely: an illusion, sometimes of external reality, almost always of space, and often, of time.

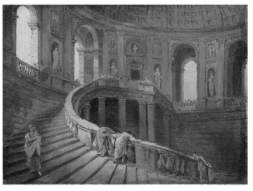

◀ HUBERT ROBERT (1733–1808). *Staircase in the Palazzo Farnese at Caprarola.* Oil on canvas, c. 1756–61

THREE MIRACLES IN WORKS OF ART

The First Miracle

A painting's surface is flat, but it may nonetheless give the impression of enclosing space, of depth, of diffused light, and of having within it objects and figures that have volume and material reality. A great critic once called this miracle—the illusion of the actual presence of objects—a painting's "tactile values" ("tactile" meaning "related to the sense of touch") because it is as though we could touch the objects depicted. With the fingers of the imagination, one can even stroke the cheek of the *Mona Lisa* (p. 234).

The Second Miracle

Some paintings tell a story. The figures shown, although actually motionless, may seem alive, and even to move. This second miracle, the il-

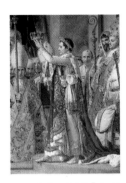

▲ JACQUES-LOUIS DAVID (1748–1825). *The Coronation of Napoleon I* (detail). Oil on canvas, 1806–07

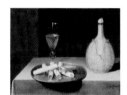

▲ Attributed to LUBIN BAUGIN (c. 1612–63). *The Plate of Wafers.* Oil on wood panel, mid-seventeenth century

lusion of life, can also be conveyed by sculpture and photography. In many paintings animals and people seem alive, clouds seem to fly across the sky, and leaves to tremble in the wind. If you try to narrate such a painting, not only can you describe the things in it, you can also say what the people and animals are doing, what is happening to them, and even, often, what they are feeling and thinking.

With this miracle—the telling of a story by representing people and things in a motionless medium but nevertheless managing to suggest their living reality—artists of the Middle Ages invented a form of unwritten narrative. We can see these narratives in the imagery on the stone relief sculpture, paintings (p. 132), and stained glass windows (p. 133) in Romanesque and Gothic churches. Taken together, they were called in Latin the *Biblia Pauperum,* or "Bible of the Poor," for they provided, in effect, a "book" of stories from the Old Testament and the Gospels for those who had never been to school and could not read.

Art and Images

These two miracles—the first (the illusion of depth) in flat painting and drawing, and the second (the illusion of movement and life) in sculpture, as well—are concerned with the presentation of the image to the viewer's eye. If what is shown actually exists in reality, it will be a portrait, a still life, a landscape, a scene from a person's life, a historical event, or a moment of private or social life. If it does not, it may represent a story from the Bible, Greek mythology, or history.

Art produces images, and the study of what those images represent is called iconography, from the Greek work for image, *eikon.* We speak of the iconography of Romanesque sculpture, which is Christian, and of the iconography of paintings, which, according to the period, can be Christian, pagan (as in mythological paintings), symbolic, or realistic.

Beyond Images

Having been introduced to the first two miracles, we have a better understanding of how we can enter into a work of art using our eyes, imagination, and sensibilities. The use of imagination inherent in looking reveals the ideas and feelings at a work's heart. The miracle of spatial illusion not only transfigures the visible, but it shows invisible realities, as well. The painter's vision is capable of disclosing beauty where we previously saw nothing. For example, the great English landscape painter John Constable (p. 197) is said to have remarked: "I have never seen anything ugly in my life, for, whatever an object's shape, light, shade, and perspective always make something beautiful out of it."

Walking Through a Painting

Fully entering into a painting requires attention, for whatever is depicted in it can have many different meanings. The most obvious meanings can obscure others that enrich the whole. Some paintings are straightforward, and narrate their meaning like scenes from a play. Others are less so, as in the case of a landscape in which figures reveal its meaning. But sometimes the main actor is nature itself—the sky, the sea, or the forest. Sometimes it is light, as in Monet's paintings of grain stacks at different times of day (p. 250). In architecture, light may also play a part;

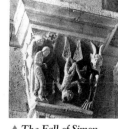

▲ *The Fall of Simon Magus,* a carved stone capital from the nave, Cathedral of Saint-Lazare, Autun, France. c. 1120–32

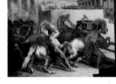

▲ THÉODORE GÉRICAULT (1791–1824). *The Beginning of the Barberi Horse Race, Rome.* Oil on canvas, 1817

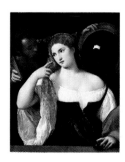

▲ Titian (1488/90–1576). *Young Woman with a Mirror*. Oil on canvas, c. 1512–15

▲ Pablo Picasso (1881–1973). *Still life with Chair Caning*. Mixed media, 1912

the action of light is certainly essential to the beauty and mystery of the great Gothic cathedrals.

When looking at a painting, we should try to imagine that we are walking through it, into its spaces, over its surfaces, and even behind the things depicted in it.

Every painting has life; its immobility is only apparent. It has a "before" and an "after" hidden by its enduring present. When a figure painted by Velázquez (p. 277) or Titian (p. 269) is before us, sometimes it seems actually to be looking out at us, so well has the painter managed to make appearances speak. Sometimes we feel that we can understand the characters of the sitters, that we can almost say what this woman, this man, or this child has just done, or is about to do. Standing in front of such an image we may feel pity, admiration, or fear. When we look carefully at a painted landscape, we can almost feel the air, and its temperature; we seem to see a storm coming, or be inside it.

Such an intense feeling of experienced reality is possible because the person looking at the work is a human being, and the work itself was made by an artist. Artists, as creators, are attentive to human feelings and ideas. So directly does art express the essence of the human condition—the realm of thought, passion, love, hope, or despair—that we often feel that we can understand paintings made five hundred years ago.

To know the lives, emotions, and ideas of artists, and to better understand what they wanted to reveal, is the least we can do to enter into the world of images.

The Third Miracle

Every image has its qualities. Bad paintings, poor drawings, inept copies, and carelessly taken photographs may not be very satisfying works of art, but even they can please or move us.

We have noted that painting has the power to create a world that resembles appearances but is also laden with meaning and emotion, because it expresses the humanity that we share with the artist. From the art of today, however, we know that painting may also accomplish other goals. Some varieties of painting have no need to imitate appearances. They can invent new ones, can simplify and break down forms (as Cubism does; see p. 160), or recombine colors (as do the paintings of Seurat; p. 266), or invent worlds that are simultaneously real and different from reality. All this is part of the domain of the image, and of the world as represented by them. Surrealist painting (p. 167), for example, depicts the artist's dreams, which are the realities of the dreamer's mind.

There is, then, something specific to painting (and, in a different way, to mosaics and stained glass) that constitutes what we shall call the third miracle of art. This miracle is technique—and it gives the artist the capacity to produce images that imitate reality, as well as to make completely new images that resemble nothing in particular. This miracle, like alchemy, transforms mere colors applied to a surface into a "work," into a new world.

Technique

This book will explain some of the mysteries of technique (architecture, p. 41; painting, p. 118; sculpture, p. 88). But these techniques, even

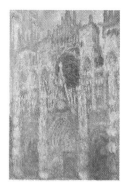

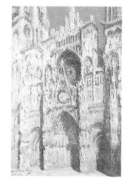

▲ Claude Monet (1840–1926). Two views from the *Rouen Cathedral* series. Oil on canvas, 1894
Above: morning
Below: early afternoon

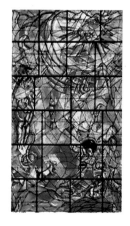

▲ Marc Chagall (1887–1985). *The Creation of the World: The Fifth and Sixth Days*. Stained glass, 1959–62

when mastered, are not all there is to art. Some painters are skilled at creating illusions, at fooling the eye of the viewer. In some cases, the painting appears to be a window opened into a wall, with someone apparently leaning out and looking at us. But it is, in fact, a flat surface on which the painter has worked his magic. Not all of the creators of such illusions are great artists. Sometimes even beautiful images are merely good ones.

In a great painting, however, technique transcends mere description. Although the art of painting produces images, a painter is more than an image-maker, more than an illusionist. A great painter is a *painter,* a master both of lines and shapes—a draftsman—and of color. Such an artist can arrange pigments on a canvas so that they are transformed into light and shadow, into day and night, into space, or into objects, bodies, or movement.

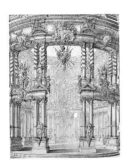

▲ GIUSEPPE BIBIENA (1696–1756). *Perspectival View with a Colonnade.* Ink and wash drawing, eighteenth century

The Artist's Gesture

Forms in space are what we see if we look at a representational painting from a distance. If we gradually move forward, coming close to the canvas, another universe appears. This one has been created by the artist's hand, by his gestures. It is a world of traces left by brushes and palette knives in traditional painting, or by poured or dripped paint in some contemporary works. But in every case these marks were left by the artist's own movements. In such gestures the artist leaves traces that manifest his or her thoughts and emotions. From these the space of the painting is constructed, the image emerges to reveal itself, and the story that the painting has to tell is told.

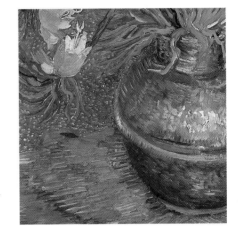

▲ VINCENT VAN GOGH (1853–90). *Fritillarias in a Copper Vase* (detail). Oil on canvas, 1886

The Exchange of Metamorphoses

Painting is an art because all of these elements—image, idea, and feeling—must be related to one another. It is color chemistry on canvas, a mysterious alchemy that conveys feelings and ideas. It is the creation of one human spirit (occasionally of more than one), the artist (or artists), and is addressed to another, the viewer. A great Mexican poet, Octavio Paz, once said: "Every work of art is a permanent possibility of metamorphosis offered to all human beings." But if painting—like sculpture, architecture, music, and literature—can transform us, that change is made possible because painting itself represents a metamorphosis. It has been said that great painters dip their brushes not into pigment, but into light, shadow, and reflections. The magical change of pigment into these essences does not prevent paintings from being material objects that are also transformed by time.

If we look closely at a painting, we see not only traces of the painter's hand, of his technique and way of covering the canvas—that rough or smooth, thick or thin surface known as impasto—but also the traces of time, which erodes everything.

▼ CLAUDE LORRAIN (1600–82). *Seaport, with Setting Sun.* Oil on canvas, 1639

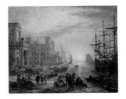

Art Changes over Time, in History

▲ *Book of the Dead of Khonsumes* (detail). Egyptian painted papyrus, c. 1000 BCE

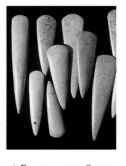

▲ PALEOLITHIC STONE HATCHETS, from the Arzon River Valley, south-central France. Fifth–fourth millennia BCE

Magical Art

Art is both a kind of work, and also a series of techniques placed in the service of ideas. At its beginning, it has been suggested that art was magical and religious. This is sometimes still true of the art of Africa (p. 102) and Oceania (p. 108).

Magic tries to influence nature; religion pays homage to the supernatural. Magical or religious art is thus a kind of formula, prayer, or magic potion. To act on nature, to enlist the help of divine spirits, the artist invents new forms.

Art Both Imitates Nature and Invents New Images

Whatever its aim, art seeks a form of beauty. In some periods, artists have thought that the greatest beauty was to be found in the things around them, in the landscape, in small objects, in animals, and in the human body. At these times, artists tried to imitate nature, to create the illusion of it.

In the prehistoric era, however, artworks tended to be fabricated objects. Flints are naturally beautiful, as are ivory tusks, but flints chipped to make arrowheads and ivory carved into new shapes are beautiful in other ways, because they carry traces of deliberate work and the idea of an object both useful and agreeable. The first clay pots were made to serve practical purposes, but that did not prevent them from having harmonious shapes and carefully applied decoration, or from being made of attractive materials.

Artists and Artisans

The first art was designed to enhance nature, by exploiting the beauty of the materials used: stone, earth, plant fibers, and vegetable or mineral pigments.

Thus, art was not opposed to nature, but developed from it. Those who made artworks first had to be *artisans*, masters of the techniques necessary to produce things that were useful, and occasionally also beautiful. When these artisans produced objects that were not necessarily useful, but existed for their own sake, they became *artists*.

Although weapons, furniture, and utensils have always been made to please, they were at first intended primarily for use. When arms and jewelry were made as ritual objects or as grave gifts to accompany the dead into the afterlife, they often were enriched with engraved designs or stone inlays in response to their new purposes: to protect the dead and to communicate with the gods.

◀ PATEN OF CHARLES THE BALD.
Serpentine, gold, precious stones,
pearls, colored glass, ninth century

Magical art and religious art still exist today; the idea of beauty is less important for these forms of art than their supernatural efficiency. Although Europeans and Americans may have sometimes found the masks of Africa or Oceania strange, or even ugly, these objects are often magnificent works of art.

Art and Beauty

Although the primary purpose of much art has been magical, religious, or decorative, in some societies artists have also sought to express beauty. Sometimes they have tried to invent a new beauty, which is why we may find it difficult to like some of the experimental art being made today, which often seems to challenge our old habits of seeing.

Every society on earth has its own ideas of beauty. Indians of the Amazon basin make works of art of feathers from the brilliantly colored birds in their forests. Westerners generally have no trouble liking these pieces. The body and face paintings of the same peoples, however, may seem strange and frightening to us, simply because we are used to our own clothing and facial paint, which is more discreet than that of the Indians.

Beauty and truth are relative, but whatever an artist makes is intended to represent a form of beauty. Generally, a successful work realizing an exalted intention is beautiful. Ugly works of art may result from poorly realized intentions, from poor execution, or from banal repetition. The religious statues used to decorate churches over the last hundred years, with their repetitious forms and colors, exemplify not so much artistic ugliness as laziness of mind—and perhaps also, the disappearance of art into mass production.

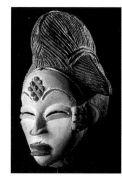

▲ PUNU MASK,
representing a dead
woman. Gabon.
Painted wood

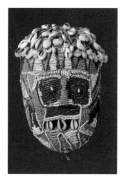

▲ SKULL-FORM.
Fonchatula, Cameroon
Bead and shell
construction

Originals
and Reproductions

Art is the result of creation, and only rarely of repetition. But all images, whether ugly or beautiful, can be reproduced. Repetition increases the number of images of artworks in circulation, and makes them more accessible. If we had to visit all the world's museums to see the work of the great painters and sculptors, or to go to every city (and sometimes deep into the countryside) to admire the most beautiful architecture, the appreciation of art would be the almost exclusive experience of people with money. Artistic tourism is a great pleasure, but it is not an option for everyone. First printing was invented, then came photography and color reproduction, which were followed in turn by videocassettes and CD ROMs. All of these can bring art across great distances to those who want to see it. What is true of great works is also true of small art objects in general. Although buying them is expensive, almost anyone can afford to see them in museums or admire reproductions of them.

Creative Copies

▼ PIERRE PUGET
(1620–94).
Milo of Crotona.
Marble, 1671–82

But there is a contradiction here. Works of art are original and unique. Copies of paintings made by other great painters are never quite identical to their prototypes, or to each other. Their artistic merit resides in their originality. This is certainly true of copies made by Rubens or Delacroix. Similarly, Picasso's variations on *The Women of Algiers* by Delacroix (p. 31) offer the Spanish artist's reflections in paint on a work by a great French artist.

If an artist carefully oversees the printing of a series of three hundred lithographs or engravings, each one will be faithful to his intentions. If their quality is not up to his standards, however, they do not qualify as works of art. In reproductions, altered dimensions (almost always), changed colors (always), and many other details make even the best examples only approximations of the originals they represent. Nevertheless, reproductions can convey what is most essential about those works. Drawings and photographs of sculpture, however, are far removed from the statues themselves, for they capture only a single point of view and single set of lighting conditions. Looking

▶ EUGÈNE DELACROIX
(1798–1863).
Women of Algiers.
Oil on canvas, 1834

▲ PABLO PICASSO
(1881–1973). Study for
*Women of Algiers, after
Delacroix.* Ink drawing,
December 28, 1954

◀ PABLO PICASSO
(1881–1973). Study for
*Women of Algiers, after
Delacroix.* Crayon draw-
ing, January 23, 1955

at these reproduc-
tions is a bit like
trying to get an idea
of a film from look-
ing at a sequence
of still photographs.
But imagination and
an experience of real
art objects can help
us reconstruct the ap-
pearance of the real
object. We derive a
hundred times more
profit from a photograph of a building if we have actually visit-
ed it, or others like it, and from reproductions of paintings if we
have seen real works from the hand of the same artist in museums and
exhibitions.

Forgeries

Reproductions can never replace the originals; everyone can tell the
difference between the two. But productions of another kind are made
with the intention of deceiving. They are forgeries, and those who
make them are forgers. Deliberate forgeries are neither copies nor pas-
tiches. Copies, which can be masterpieces, take other works of art as
their model, just as landscape painters take views of nature as their
model. Pastiches are like caricatures of a style; they imitate a painter's
manner, sometimes to criticize or make fun of it, but their author nei-
ther hides his identity nor tries to make his work pass for one by the
other artist.

Forgers, by contrast, set out to deceive. Like counterfeiters, they
make paintings, drawings, or—more rarely—sculptures with the inten-
tion of fooling people into thinking the works are by a particular artist,
generally one whose works are expensive. Forgers sometimes copy
known works, which they try to convince others are replicas made by

◀ RICHARD REIN
(twentieth century).
Pastiche of the *Mona
Lisa.* Photomontage

◀ ERIC PROVOOST
(twentieth century).
Around Monna.
Mixed media

the original artist. They replicate lost works and claim they are the originals, or they make something in the style of an artist depicting a subject that might have attracted him. In the 1940s a very skillful Dutch forger painted several compositions that he sold as works by Jan Vermeer of Delft (p. 278). The forger used old canvas and pigments, similar to those used by Vermeer, and he painted the sort of subjects Vermeer liked, in his early manner. Even experts were fooled, but today we know the forger's works to be twentieth-century imitations in the style of a seventeenth-century master. The forger, Jan Van Meegeren, was a fine artist, but this does not make him any the less a criminal. Fortunately, there are very few such cases.

Recognizing Authenticity

How, in fact, can we know that a work is "authentic"? Generally we seek the opinion of an expert, someone who knows an artist's work, or the characteristics of a given period or style well. Some paintings have been recognized as the work of a particular artist for a long time, but we do not always know when an old master painting was produced or whether its attribution to a given artist is correct. Sometimes the artist's name is unknown but his style is recognizable. In such a case, we speak of "the Master of" something, be it a city (the Master of Moulins), a subject, or a series of paintings (The Master of the Life of Saint Catherine). Other times, we know a work was made in the workshop of a great painter, but cannot determine precisely what the master painted and what was executed by his assistants. The large painting studios of earlier times were rather like the kitchens in large restaurants: in addition to the "chef," or master painter—for example, Rubens (p. 265)—there were students and assistants, some with specialties and some without, and even (like the cook's boys in kitchens) young apprentices who ground the colors, cleaned the brushes, and sometimes did preliminary painting. Thus, large works were often team efforts. This collaboration did not prevent the artist from conceiving them, directing their execution, and carefully painting the most important portions of the piece.

The production of sculpture is often even more complicated. A large sculptor's studio is like a small factory in which many replicas are made, all of them "authentic." One might add that authenticity, or the secure attribution of a work to an artist, is one thing and a signature is another. It is almost always far easier to imitate a painter's signature than to paint in his or her manner. Thus, experts do not consider the signature of an important artist sufficient to guarantee authenticity.

▲ ANONYMOUS DELFT ARTIST. *Christ Carrying the Cross.* Oil on wood panel, late fifteenth century

▲ MASTER OF THE LEGEND OF SAINT URSULA (late fifteenth century). *The King Sends His Ambassadors to Ask for the Hand of Saint Ursula.* Oil on wood panel, c. 1490–1500

▼ JAN VAN STRAET (1523–1605). *The Studio of Van Eyck.* Engraving, sixteenth century

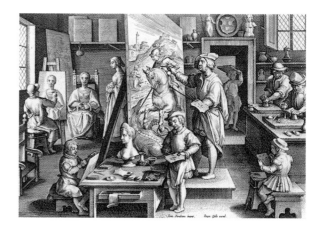

Works of Art Repeatedly Live, Age, and Become Young Again

▼ STELE OF VULTURES from Tello (ancient Lagash), Iraq. Limestone, c. 2450 BCE

▲ A STATUE from the Louvre courtyard during restoration

The Wear and Tear of Time

Like everything in the world, works of art change over time. Paintings crack and darken while statues, especially those placed out-of-doors, become dirty, abraded, and deteriorated in a thousand different ways. Some of the most famous survive only in broken, incomplete form: the *Winged Victory of Samothrace* (p. 91) has no head, and the *Venus de Milo* (p. 91) has no arms. Sometimes such pieces are restored, with unsatisfactory results. Although no one has restored the head of the *Winged Victory of Samothrace*, it remains a masterpiece.

Of all the arts, architecture suffers most from the passage of time. Some ancient buildings, such as the pyramids of Egypt (p. 42) have survived thanks to the desert climate. But most buildings are made of fragile materials. Even stone wears away, or becomes covered with deposits. Pollution has always existed, because the rain and wind have always carried smoke and dust. Stone is also attacked by plants and microscopic animals. It has "illnesses," like human skin. In painting, varnishes darken and dried pigments crack, creating shapes that can mar the look of a work if it is not restored.

Restoration, Transformation

The appearances of ancient monuments and certain other works change not only through wear, but by design. Some are completely rebuilt, transformed in a later period, even centuries after their construction, into entirely different monuments. These new versions are often themselves beautiful, and thus they may never be returned to their original states. Sometimes, however, this is indeed done. In Trani, Italy, the later additions to a church were stripped away to reveal a simple medieval original. In other cases, later alterations have honored the original style, but altered its proportions. The great Romanesque church of Saint-Sernin in Toulouse, France, was recently restored to its original

▶ EUGÈNE-EMMANUEL VIOLLET-LE-DUC (1814–79). Façade design for the Cathedral of Clermont-Ferrand. Wash drawing, 1864

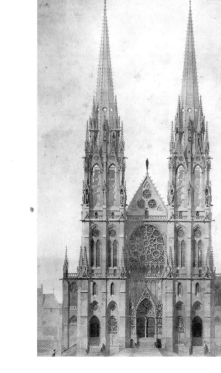

appearance, which had been altered over the centuries.

A hundred and fifty years ago, some architects even tried to give old buildings the appearance they "should" have had but never did, because their prolonged construction passed through changes in style. Sometimes, for example, churches are Romanesque at one end and Gothic at the other, and house chapels that are even later in date. Nineteenth-century theorists like Viollet-le-Duc (p. 280) sought an ideal style, favoring the Gothic. But a building is not an idea, and such restorations, which are really closer to reconstructions, pointlessly change a work's living reality.

The general practice now is to respect what exists, and not to change what has been broken or damaged. Generally, also, people nowadays avoid re-creating what has completely disappeared, for example, the paint that once colored Greek sculpture, or decorated the walls of many ancient buildings.

Replacing Materials

It also happens, when a tradition is still ongoing, that appearances are preserved even as materials are gradually replaced. There is not a single piece of the original wood in ancient Japanese temples, but in every artistic respect—proportions, materials, shapes, colors—they duplicate their original appearance. Thus a work may be simultaneously original, authentic, and remade. Completely restored ancient works can produce the same emotion as works attacked by time—Reims Cathedral, for example, bombed and rebuilt with its own stones—or they can seem false, as copies or pastiches. The final impression reflects the taste and knowledge brought to bear on the project, as well as the skill and the restoration methods used.

Of all the arts, those that have been subject to the most important changes under the pretext of restoration are sculpture, fresco, mosaic, stained glass, and of course, architecture.

▼ THE PALACE OF KNOSSOS, Crete (with extensive restoration in concrete of the wooden pillars). Second millennium BCE

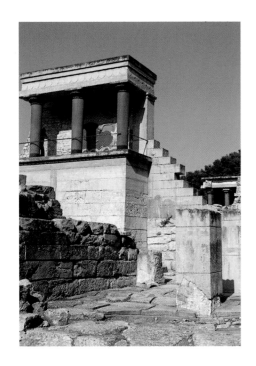

The Beauty of Ruins

Old works of art can exhibit their cracks like beauty marks. We are used to seeing ancient towns and Greek and Roman temples as ruins. People have even fabricated artificial ruins, forgetting that one of the artists of genuine ones is time. But in truth, nearly all the ruins we visit are a little artificial, for archeology, in its quest for an improved understanding of the past, pursues its remains by excavating the earth, exposing buried floors, raising fallen columns, and even reconstructing parts of rooms. The result is indeed architecture, but of a peculiar kind; instead of realizing the idea of a building that never existed in fact, elements of the past are recombined into something resembling their original state without trying to reproduce it.

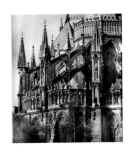

▲ CATHEDRAL OF REIMS, France, in 1850, 1917, and 1983, showing war damage and restoration

Art and Money

Original works of art are forged and copied because they are worth money, sometimes quite a lot.

The Price of Art

The monetary value of a work of art depends on several things. The most important of these is neither beauty, nor emotional content, for people often buy works of art as an investment, in hopes that their value will increase. What primarily determines the price of a painting or sculpture is the fame of the painter or the sculptor who produced it. The work's rarity is also a factor. If a highly esteemed artist's works are few, they will be more valuable than if they were common. And it often happens that when a famous artist dies, the market value of his works increases, for no more of them will be made.

Works of art become increasingly precious with the passage of time as other objects of their period are gradually damaged or destroyed. Today, only national governments, great museums, large corporations, or very rich collectors have the means to buy works of the highest value. But less important objects—minor paintings and sculpture, furniture, or small art objects—are bought and sold by people from all walks of life.

Commissions

In the Middle Ages, most works of art were commissioned either by churches directly, or by private patrons to be given to churches. The artisans who executed these commissions tended to be specialists —painters, sculptors, embroiderers, silversmiths, and the like. In general, their names are unknown today, for they did not sign their work (p. 132); and in fact their names were considered less important than the objects they created. The objects were valuable, of course, but not in commercial terms, as they were not made for sale, but to be given to God.

When princes, or rich merchants and bankers, commissioned secular paintings and sculptures— and this happened increasingly as time went on— the way in which works of art were perceived changed. Gradually, a new category of art buyer appeared: the private collector. Along with collectors, who were often highly cultivated men and women, came a new type of business: art dealing. Among collectors and dealers, art works could be commissioned, bought, owned, exchanged, or sold by anyone able to afford them. With the appearance of this new art-owning class, whose appreci-

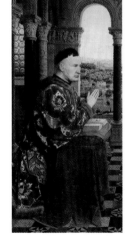

▲ JAN VAN EYCK (c. 1390/1400–1441). *Madonna of Chancellor Rolin* (detail). Oil on wood panel, c. 1435

▼ CHARLES ANGRAND (1824–1926). *Interior View of the Rouen Museum.* Oil on canvas, 1880

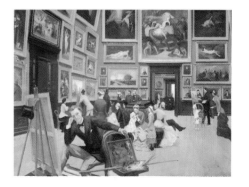

ation of art tended to be primarily for the skill with which the artist had made it, painters and sculptors began to be regarded as more than mere craftsmen.

Art Is Advertised, Exhibited, and Sold

As the political and economic importance of the ancient landed nobility of Europe began to decline, the aristocratic patronage of artists, writers, and musicians also began to wane. With the loss of commissions from bishops and princes, artists began to work for state and municipal governments, and, increasingly, for private collectors and dealers. This new dependence on private patronage was well established in the Netherlands as early as the seventeenth century, and by the end of the eighteenth century had become the normal state of affairs in most of Europe.

Museums

As aristocratic and ecclesiastical patronage declined, a new type of public institution appeared: the museum. The word is derived from the Greek *museion*, a temple dedicated to the Muses, the nine patron goddesses of the arts and sciences. In France, for example, the Palace of the Louvre, with its vast royal collections, was declared a public museum after the Revolution of 1789, in which the ancient nobility was almost totally destroyed.

The French Revolution transformed artistic activity in the country. The old Royal Academy was dissolved, and the formal education of artists was reorganized in a newly created School of Fine Arts. The Salon—the annual state-sponsored exhibition of paintings by living artists begun in the seventeenth century (its name taken from the Salon of Apollo in the Louvre Palace, where it was held)—was opened to all artists, and the public was encouraged to attend.

Although private collections continued to exist, public exhibitions like those in the Louvre Museum and at the Salon were soon the primary venues for viewing art.

In the early nineteenth century, however, the Salon exhibition, which had supposedly been liberalized after the Revolution, became more tradition-bound than ever. A group of judges, usually professors at the School of Fine Arts, decided which paintings and sculptures should be included. These exhibitions naturally reflected the taste of their era. Generally speaking, the art the judges favored was highly conventional both in style and subject, and it was paintings of the most traditional type that won the coveted Rome prize, which awarded the winner a year or more of study at the French Academy in Rome. In the mid-

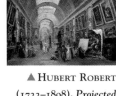

▲ HUBERT ROBERT (1733–1808). *Projected Remodeling of the Grand Gallery of the Louvre*. Oil on canvas, 1796.

▼ HENRI GERVEX (1852–1929). *A Meeting of the Salon's Painting Jury*. Oil on canvas, 1885

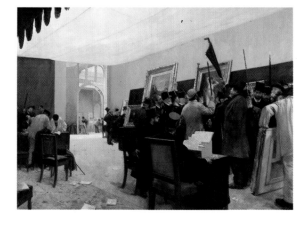

nineteenth century, Realist painters such as Courbet, and later, the Impressionists, were largely ignored and excluded from the Salon. However, many critics—some of whom were important writers (Théophile Gautier, Charles Baudelaire, and Émile Zola)—championed the new styles that signaled the beginnings of modern art.

Collectors and Dealers

A surprising number of collectors and dealers throughout Europe also favored the new styles. While artistic institutions—various national academies, schools of fine arts, the French Salon—tried to preserve traditional taste, some art enthusiasts were passionately committed to more innovative tendencies. At first, painters who favored new ways of seeing found it difficult to make ends meet, for established businessmen and their wives, who bought most paintings, did not like their work. This explains the hard lives of painters like Van Gogh (p. 276) and Modigliani (p. 248). But some dealers, such as the famous Ambroise Vollard, supported these painters by selling their canvases to newly rich industrialists, who were not as tradition-bound as the old guard.

The Art Market

These dealers had galleries of paintings and other works of art, but above all they influenced taste. Beginning about a hundred years ago, art, and especially painting, became the focus of an active commerce, and people began to speak of an "art market" as such. This was not exactly a market like the one where groceries are sold, but it was not completely different, either. As with everything that is bought and sold, there were prices (which could rise or fall), middlemen, tradesmen, and appraisers. There were also auctioneers, who organized sales where anyone could buy a work offered, provided that they were willing to pay more for it than the other bidders at the sale.

Today the art market assigns values both to older works (which are rarer, and hence generally more expensive) and those of living artists. Some of these values can seem incredibly high until we consider how rare the objects are by comparison with any industrial products, and their associative and symbolic values. Great museums compete with one another to buy paintings by important masters, in the hope of assembling collections in which many schools and styles are represented. Similarly people of means also collect paintings and other works of art, sometimes simply for pleasure and sometimes for their value as investments, as well. Some businesspeople buy art with the primary intention of selling it at a profit; this is called speculating. Others assemble collections with the object of organizing museum-like foundations where other people may enjoy their art.

Although financial considerations may seem distant from the ideal of art, the art market supports artistic creation, and the artists themselves. And while the prices of many art works places owning them beyond the reach of most people, the number of museums, exhibitions, reproductions, art books, and other means of experiencing art is always growing.

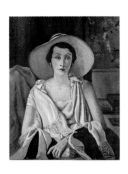

▲ ANDRÉ DERAIN (1880–1954). *Portrait of Madame Paul Guillaume in a Large Hat.* Oil on canvas, 1928–29. *Paul Guillaume was an art collector and critic.*

▲ JEAN DUBUFFET (1901–85). *The Reseda.* Epoxy paint on polyurethane, commissioned by a French government agency in 1988

Art and Nature

▲ COUNT ISIDORE
LEROY DE BARDE
(1772–1828). *Still Life
with Exotic Birds*.
Watercolor, c. 1800

Art is the best way for human beings to create something beautiful. Art requires taste, technique, and skill. Each of us needs beauty, even those of us without the desire or the talent to create it. Nature produces forms that can give us as much pleasure as art. These forms can result from chance (as in the formations of rocks) or from a kind of genetic program, as in the forms of plants and animals. These natural forms can give us as much pleasure as anything produced by a human hand.

Beauty and Ugliness

If things strike us as beautiful, ordinary, or ugly, that is because we do or do not find our own idea of beauty in them. It is our perception that discovers the beauty in a butterfly's wing, in the plumage of birds, in flowers, or in precious stones. We interpret the beauties of the landscape, both that of wild nature and the man-made countryside of cultivated woods and fields, and of ancient towns. Similarly, it is we who have decided that beetles, spiders, and iguanas are frightening. But we can also choose to find these same animals beautiful, for they are just as perfect in their way as butterflies and flowers.

If we sometimes find the products of chance and wild nature as beautiful as works of art, it may be because we ourselves are part of the natural world, and it has surely formed our ideas of beauty and ugliness. Thus our own bodies and faces, which without dress or adornment are as natural as those of any other animal, can represent ideals of beauty.

Many artists draw inspiration from the human body, just as they do from the appearances of animals, plants, rocks, clouds, and waves. But art can invest these objects and beings with feeling and thought. Even purely geometric shapes, which recur in art, the products of mathematical imagination, are distantly inspired by natural forms.

Since we are creatures of the natural world, most of us find nature beautiful, or normal. Ugliness is an accident, more frequent in human creation than in nature. Human beings can both imitate and surpass what they imitate. By producing something new, they both draw upon nature and enhance it, shaping it with a cultural perspective. Culture is a human way of living in nature, sometimes, unfortunately, in ways that destroy it. But much of art enriches nature: literature adds possible stories to real ones, music invents new sounds and new rhythms. Art invents new surroundings for us, correcting the destructive and disfiguring aspects of other human activities.

▼ AN EGYPTIAN
PYRAMID. c. 2600 BCE

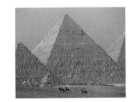

▼ THE LOUVRE
PYRAMID. Designed
by I. M. Pei, 1985–89

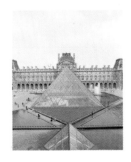

When Nature Imitates Art

Artists imitate or derive inspiration from nature, but in a sense, nature also imitates art. Science, for example, shows us hidden images: those of the electronic microscope, time-lapse film, aerial photographs, and satellite photographs. These images can be quite beautiful, and often resemble abstract painting. This is not a matter of chance: in the one case, new beauty is created intentionally; in the other, beautiful new images related to those devised by the imagination have been discovered in the quest to fathom nature's mysteries. Thus what we call "culture"—art, science, technology, all the activities fueled by our thought, —joins forces with nature in a common project: the enrichment of our experience of the world.

Enriched experience provides some compensation for the destruction done in the name of "progress," under whose reign very different values—utility, profitability, efficiency—and also the more dangerous impulses of contempt, hostility, and hatred—collaborate to degrade both nature and human creativity. Art itself may be compromised by this evolution, which rarely amounts to genuine progress. It often seems as though beauty is beating a retreat. Only the concerted determination of lovers of beauty, those who create and those who love their creations, can limit this pollution of our daily lives.

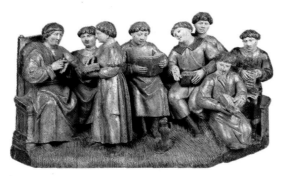

▶ FRENCH SCHOOL,
Sixteenth Century. A
Teacher and his Stu-
dents. Painted and gilt
wood relief sculpture

Knowing how to understand, contemplate, and love a work of art—or a flower, a landscape, or a mountain—is just as important as knowing how to create beauty. It is the aim of this book to encourage and cultivate such appreciation and pleasure.

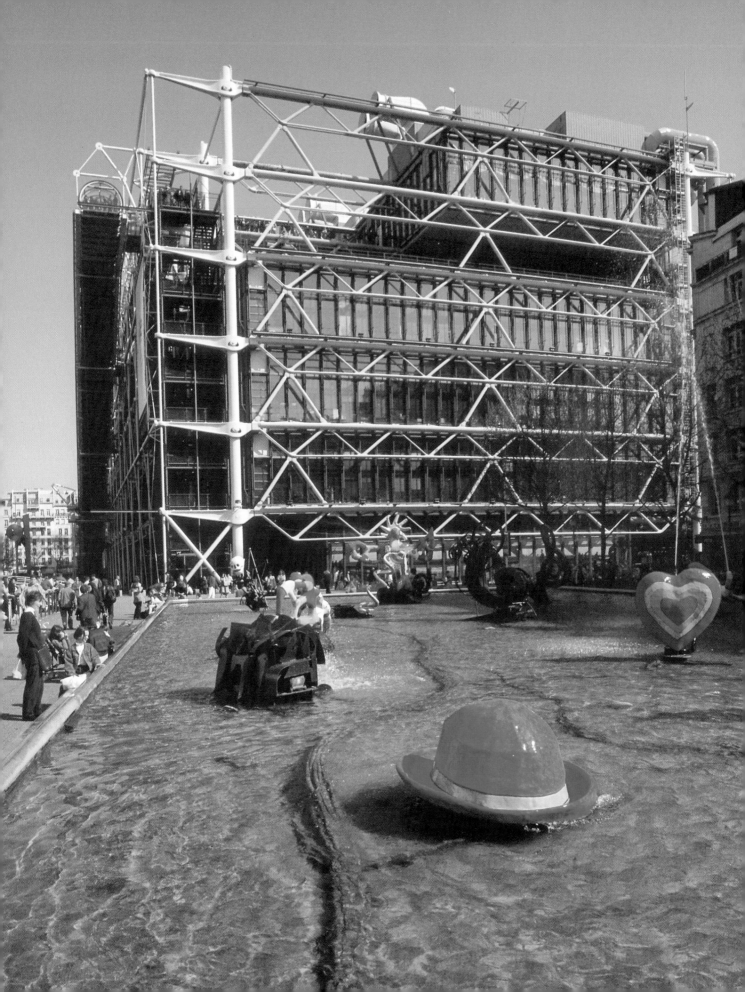

The word "architecture" comes from the Latin *architectura*, itself derived from Greek. Originally, the word simply designated the techniques of building construction, as architects were thought of as craftsmen rather than artists. However, the word's meaning has changed over the centuries. Now it applies to everything that relates to how a building is put together, from the methods of its construction to the balance and proportion of its design. We sometimes say that a building's architecture is simple or straightforward, and we may say it is beautiful. Architecture, then, encompasses both methods of construction and the art of design.

Architecture is judged in terms of its height, width, and length, and also in terms of the space it encloses, all of which play a role in its interior and exterior design. The exterior walls separate inside from outside, and the interior is more or less spacious, and more or less well lit, according to the structure's purpose. A high dome may be intended to suggest spiritual elevation, for example. Some buildings are intentionally dark, either for some practical purpose—as in a movie theater, for example—or for aesthetic effect—to create an atmosphere of mystery. Other buildings are brilliantly illuminated for similar reasons—to meet the practical needs of an artist's studio, perhaps, or to suggest clarity or rationality.

Architecture is indispensable to humanity, whose fundamental needs are the same as those of other animals who build: like beavers, we must protect our families and goods. But architecture also responds to needs that are more specifically human. Unlike other animals, we take delight in formal invention, attractive visual rhythms, and the pleasing arrangement of space and light—in short, in aesthetic effects. The feeling of the presence of structure and rhythm gives architecture something of the character of music. Indeed, a particularly fine building, like any work of art, transcends its functional purposes to satisfy our longing for beauty.

THE ART OF BUILDING

◀ THE GEORGES POMPIDOU CENTER, Paris. Renzo Piano and Richard Rogers, architects. 1971–77

ANCIENT EGYPT

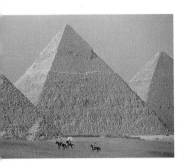

Egyptian civilization developed in northern Africa, along the valley of the Nile River, over a period of four thousand years. Thanks to the work of the nineteenth-century French scholar Jean François Champollion, who deciphered the Egyptian writing that we call hieroglyphics, we know a great deal about the history and society of the ancient Egyptians, and especially, about their complex religion, which was focused on the afterlife.

▲ THE PYRAMID OF
KHUFU, Giza. 2600 BCE
*More than 750 feet wide
at the base, and 692 feet
high, the pyramid of Khufu
is built of limestone blocks
fitted carefully together.
The facing stone has almost
completely disappeared. In-
side, long hallways lead to
the Royal Chamber, where
the pharaoh's sarcophagus
was placed.*

The Pyramids

Historians today divide the history of Egypt before 1000 BC into the periods designated as the Early Dynastic period (3150–2700 BCE), the Old Kingdom (2700–2190 BCE), the Middle Kingdom (2040–1674 BCE), and the New Kingdom (1552–1069 BCE), each of these separated by an interval of political upheaval. The earliest architect in history known to us by name was Imhotep, who worked for the Old Kingdom pharaoh (or king) Djoser (ruled c. 2681–2662 BCE). When Imhotep designed a tomb for Djoser at Saqqara, he took his inspiration from an earlier tomb type, the *mastaba,* a massive squared-off mound faced with brick or stone. Working with stone, Imhotep stacked five of these mastaba forms, one on top of another, to form a stepped pyramid 204 feet high, like a giant stairway leading the king's spirit toward the sky and his meeting with the sun god, Ra.

Djoser's successors were commemorated with similar pyramids, which became the standard form for a royal tomb. Within a century, the profile of the pyramid evolved into the straight-sided shape that we are familiar with today. The most monumental examples of this straight-sided type are the three enormous pyramid tombs of the pharaohs Khufu, Khafre, and Menkaure built from c. 2600–c. 2515 BCE at Giza, near modern Cairo. The one built by Khufu around 2600 BCE is the largest of these, standing some 450 feet high. Greek authors were later to list it among the Seven Wonders of the World.

Each pyramid was accompanied by other funerary buildings, including several temples and other sacred buildings connected by a causeway paved with stone slabs.

Tombs Cut into Mountain Sides

During the Middle Kingdom (2060–1674 BCE), the city of Thebes in central Egypt became the focus of spiritual and religious life. About 2000 BCE, the pharaoh Mentuhotep II (ruled c. 2061–2010 BCE) built his tomb and mortuary, or commemorative, temple, at the foot of a cliff near Thebes, at a site now called Deir el Bahri. The conception of this tomb was revolutionary, for it replaced the pyramid that helped lift the pharaoh's spirit to the sun god Ra with a tomb cut from the side of a mountain like a cave. The new design reflected the ascendency of the worship of the god Osiris, king of the dead, the giver of eternal life.

Book of the Dead of Neferibre. **Egyptian painted papyrus, fourth century BCE. Chapter 125: The Weighing of the Heart of the Deceased before Osiris.**

As the descendants of the sun god, Ra, the Pharaohs were entitled to magnificent tombs, where their eternal afterlives began. The Egyptians believed that if the dead were to live forever in the afterlife, their bodies had to be preserved, and their priests perfected the art of mummification to prevent the body's decay. After the body was embalmed, it was wrapped in many feet of cloth and enclosed in several sarcophaguses. Throughout the funeral ceremony priests recited prayers and magical texts from the Book of the Pyramids *and, later, from the* Book of the Dead. *These books, in the form of papyrus rolls, were buried with the deceased to help him gain entry to eternal life. After the funeral ceremonies, it was believed that the dead took a final journey across the Nile by boat, which brought him to the afterlife. There, according to the* Book of the Pyramids, *". . . he will sit on the right hand of Ra, among the imperishable stars."*

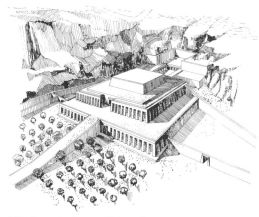

▶ Reconstruction
of the Funerary
Temple of Mentu-
hotep II, Deir el
Bahari, Egypt. 2040 BCE
*A gallery 730 feet long
was cut deep into the
mountain to the sarcopha-
gus hall. The temple was
built on terraces linked by
ramps. The central building
resembles a stack of three
mastabas, or flat-topped
tombs, piled on top of one
another.*

Thebes, A City of Temples

During the New Kingdom (1552–1069 BCE), Thebes became the capital of all Egypt. On the eastern bank of the Nile stood the city itself, with its many palaces and temples. Across the Nile, on the western bank, was a necropolis, or "city of the dead," dedicated to tombs and mortuary temples. This area included the Valley of the Kings and the Valley of the Queens, where most of the pharaohs and their wives were buried, and the tombs of many nobles, as well. In the necropolis of Thebes most of the kings and queens followed the example of Mentuhotep in having their tombs cut into the valley walls. Nearby were temples devoted to the cult of the dead, which was celebrated at great annual ceremonies in which an effigy of Osiris was rowed across the Nile from Thebes to be received at the necropolis.

In the New Kingdom, the god Amun, the lord of creation, was considered the most powerful deity, and the king of the gods. Every pharaoh participated in his cult by building, or at least embellishing, temples to him. From the Nile, processional routes lined with stone figures of sphinxes (mythological creatures, half human and half lion or ram) led to these temples, which were entire complexes surrounded by high walls. Their gates were flanked by massive, truncated pyramidal towers or pylons, before which obelisks or colossal statues were often erected. Upon entering, a visitor passed through several colonnaded courts to reach a vast room filled with columns. Art historians call a room of this kind a hypostyle hall (from Greek *hypo*, "below," and *stylos*, "column"). The hypostyle hall could only be entered by priests or kings, for beyond it lay the most sacred part of the temple, the sanctuary. Here stood the cult image of the

god, which incarnated his presence on earth, and here the rites of the cult were performed by a priest, or the pharaoh himself, every day.

The Forest of Columns at Karnak

The hypostyle hall of the temple of Amun at Karnak, near Thebes, is among the most grandiose projects built by two great pharaohs of the New Kingdom, Sety I (ruled 1294–79 BCE) and his son Ramesses II (ruled 1279–12 BCE). Its 134 enormous columns reproduce the reeds and papyrus plants of the Nile in stone; they terminate with capitals resembling lotus buds or open flowers, and like the walls, they are covered with reliefs recounting the martial exploits of the pharaohs.

▼ Hypostyle Hall of the Temple of
the God Amun, Karnak, near Luxor, Egypt.
Measuring 334 x 170 feet, the Hypostyle Hall, or columned hall, at Karnak is colossal in scale. The central aisle rises to a height of seventy-eight feet; the side aisles are approximately sixty-five feet high.

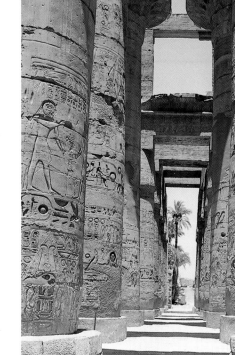

THE GREEK TEMPLE

A view of classical columns in a landscape evokes for us the world of the gods, goddesses, and heroes celebrated by Homer in his epic poems, the *Iliad* and the *Odyssey*.

"Riches must be used for works that, once completed, achieve immortal glory," the Athenian statesman Pericles is reported to have said. And indeed, the beauty of the temples that he built, especially the Parthenon, has proved to be immortal.

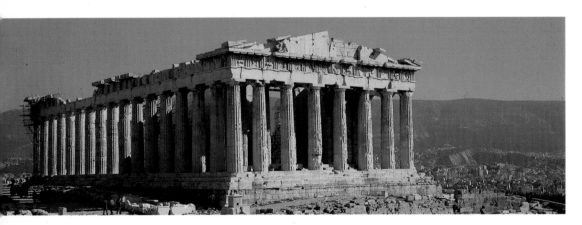

◀ THE PARTHENON,
Athens. 447–432 BCE
Combining elements of both the Doric and the Ionic styles, the great temple of Athena is surrounded by forty-six fluted columns. Although its design seems a simple arrangement of verticals and horizontals, its elegant effect is the result of subtle geometric calculations.

The House of a God

Each Greek temple was built as a "house" for a god or goddess. Only priests could enter the principal room, or *naos*, where the cult image of the divinity stood. This room was preceded by a vestibule, or *pronaos*, and was often complemented by a room called the *opisthodomos*, where offerings were left. Sacrifices were made at altars outside the temple, where most of religious life took place. A temple might also have a columned portico or porticos, and sometimes a colonnade around its entire perimeter.

Early Greek temples were made of wood or brick, but, beginning in the seventh century BCE, these materials were replaced by stone, particularly by marble when possible. Although marble was heavy and difficult to move, it was plentiful in Greece, and architects prized it for the beauty of its color and its fine grain.

The Architectural Orders

Greek architects rapidly developed an exceptional sense of balance and proportion. Temples were built according to specific "orders," which established a series of ratios between a building's overall dimensions and those of its different parts, specifying, for example, the height and diameter of the columns, the height of the entablature—the horizontal elements above the columns—and the sizes of various other parts of the building, as well.

By the sixth century BCE there were two principal architectural orders in use in Greece: the Doric and the Ionic. The Doric order evolved on the Peloponnesus, a broad peninsula extending southward from the mainland of Greece, and from there spread to the Greek settlements in southern Italy and Sicily. Doric columns rest directly on the temple floor, or stylobate; their shafts are carved with broad grooves, or flutes, whose number per column was fixed, in the fifth century, at twenty. The entablature consisted of an architrave—a flat strip extending around the building—and above it, a frieze made up of alternating triglyphs—units of three vertical rods separated by two vertical grooves—and metopes—rectangular areas that could be decorated with painted or carved figures or other forms. Temples built in the Doric order are thought to have a severe, or even solemn, character.

The Ionic order, lighter and more ornate,

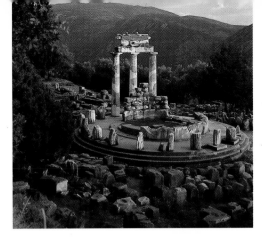

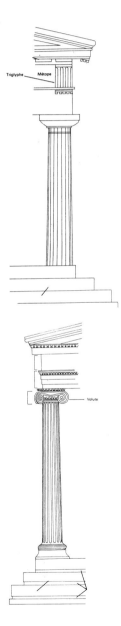

▶ TEMPLE OF ATHENA
PRONAIA, Delphi.
390–380 BCE
*All that remains of this
exquisite rotunda are a few
Doric columns, originally
doubled on the interior by
Ionic columns set against
the wall.*

▲ DORIC ORDER *(top)*.
IONIC ORDER *(bottom)*.
(Drawing by Pierre Hamon)

developed in Asia Minor (roughly modern Turkey) and the Greek islands. Its columns are thinner than Doric columns, and they rest on molded bases. Its capitals are decorated with volutes, scroll-like forms that recall the tendrils of plants. Ionic friezes, often decorated with narrative paintings or reliefs, run around the entire perimeter of the building. The general effect of an Ionic building is one of lightness and elegance.

At the end of the fifth century BCE, a third order, the Corinthian, began to appear. This was essentially a more elaborate version of the Ionic order, in which the columns were proportionately taller and slimmer, and their capitals were embellished with stylized acanthus leaves and, often, rosettes. Originally used only in interior spaces, the Corinthian order was soon used for exterior colonnades as well. It was later much used in Roman architecture.

The triangular area marked out by a temple's pitched roof, called the pediment, was often decorated with brightly painted, monumental sculpture. The figures represented in pediments recounted stories from mythology, generally events associated with the deity to whom the temple was dedicated. The oldest pedimental compositions depicted combats, such as those of monsters, giants, or wild animals. Later pediments often featured scenes of the gods majestically bringing order to human life.

The Delphic Oracle

The grounds of the sanctuary of Apollo at Delphi, on the rocky slopes of Mount Parnassus in central Greece, are covered with temples and monuments. For centuries this remarkable site attracted large crowds of people who came to consult the Pythian oracle, a priestess of Apollo charged with transmitting the word of the god. It became customary for Greek cities that had enriched themselves by military victories to build treasuries—small temple-like buildings intended to house the most valuable offerings. After their military victory over the Persians in 490 BCE, the Athenians decorated their Doric treasury with a frieze of metopes depicting the exploits of the heroes Theseus and Heracles.

The Century of Pericles

After the Persians were driven back, Athens was at the peak of her military and economic power.

Her elected chief of state, Pericles, decided to rebuild the Athenian Acropolis (from Greek *acro*, "high"; and *polis*, "city"), the walled sanctuary of the city's patron goddess Athena that stood on a high hill in the center of the city, which the Persians had sacked. Pericles commissioned the architect Iktinos and the sculptor Phidias to build a magnificent new temple, the Parthenon, to be dedicated to the goddess. Phidias was also to sculpt an immense new image of Athena for this temple, to be made of gold and ivory. This beautiful combination of precious materials is known as *chryselephantine* work (from Greek *chrysos*, "gold" and *elephas*, "ivory").

The Parthenon was remarkable for including both Doric and Ionic elements. The outside colonnade was Doric, as was the frieze above it. The surviving metopes illustrate a battle between centaurs (mythological creatures, half man and half horse), and Lapiths, a legendary Greek people. They are carved in high relief, and the composition of each is remarkable for its balanced, yet dynamic, interplay of diagonals and horizontals.

Running along the top of the wall behind the colonnade was an Ionic frieze 525 feet long, carved in low relief. It represents the Great Panathenaia, the Athenian national festival held every four years, for which the citizens of Athens walked in procession from the city below up to the Acropolis to deliver a newly woven tunic for the cult image of Athena. The frieze shows the horsemen who accompanied the procession to the foot of the Acropolis, as well as musicians, offering-bearers, and other participants, advancing to stand in the presence of the twelve Olympians—the most powerful Greek gods and goddesses—who were shown as appearing on this festival day to be greeted by the people. This extraordinary frieze is both a celebration of Athena, and of the city of Athens as a triumphant force in the world.

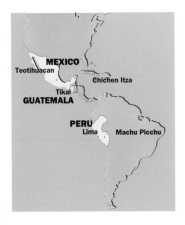

THE MAYA, THE AZTECS, AND THE INCA

The discovery and conquest of the Americas by the Spanish and the Portuguese at the dawn of the sixteenth century introduced Europeans to civilizations previously unknown to them. Those of the Maya, the Aztecs, and the Inca are the best known today. They left a monumental religious art evidenced by the remains of numerous temples and many works of sculpture. We call this art Precolumbian, which means that it predates the discovery of the Americas by Christopher Columbus.

The Maya

At the heart of Central America, the Mayan civilization emerged in the fourth century CE, reached its zenith during the eighth and ninth centuries, and declined over the following century for reasons that remain unclear. In the eleventh century, the Mayan world enjoyed a new period of splendor on the Yucatan peninsula, with the brilliant civilization of the Toltecs.

The Maya were astronomers and mathematicians. They devised a solar calendar of considerable precision that determined the rhythms of religious life. Their picture-writing (sometimes called hieroglyphs) has been partly deciphered.

In their cities, the Maya built pyramidal temples of precisely cut stone to honor their gods. These are the most characteristic buildings of the Maya, who placed several such temples as well as palaces and ceremonial platforms around squares designed for religious rituals. Other buildings were connected to one another by avenues that formed a communications network.

These steep pyramids are strikingly tall. They are built up of superimposed platforms, cut though by a long, railingless sweep of stairs that leads to the summit, on which is a temple. The temple is often surmounted by *cresteria*, or carved crests, which add to the sense of lightness and height, and harmonize with the tropical forest landscape.

Along the streets of a Mayan city, which intersect at right angles, there are courts for playing *pelote*, a game linked to the Mayan conception of the world. The combat of its two teams symbolized the struggle between night and day.

The public squares are decorated with many stelae—carved stone slabs—bearing reliefs of figures and hieroglyphs commemorating important events.

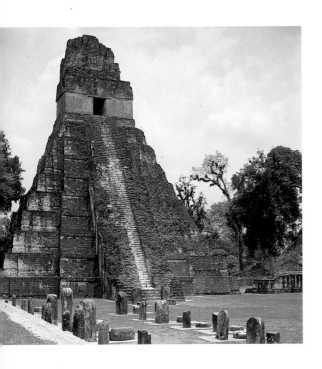

◀ TEMPLE I, OR JAGUAR TEMPLE, Tikal, Guatemala. Eighth century

Tikal is the most important ancient site of the Mayan period. Temple I, which has three rooms, stands on the upper platform of a nine-stepped pyramid, rising 147 feet above the square. A steep stairway leads to its only door. Temple II faces Temple I across the square. It is surmounted by a complex carved frieze.

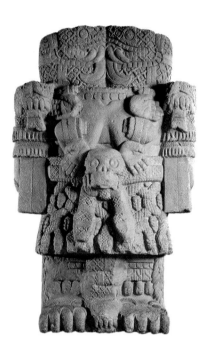

The Aztecs

In the thirteenth century the Aztec people settled in Tenochtitlán, an island in Lake Texcoco, on the present site of Mexico City. There they built a splendid civilization, reaching a very high level of artistic, cultural, and economic achievement. The Aztec city was destroyed by the army of the Spanish conqueror, Hernando Cortés, in 1519. All that remains is a pyramid surmounted by a double sanctuary. On its ceremonial platform was a sacrificial stone where victims—usually prisoners of war—were sacrificed to the gods. The Aztecs believed that offerings of blood and human hearts were required to smooth the course of the sun and to guarantee its reappearance each day. To achieve this, priests ripped the hearts from still-living victims and placed them on the belly of a statue of a recumbent god, the Chac Mool.

The Aztec Gods

Aztec society was dominated by a religion of numerous powerful divinities. Especially noteworthy are Huitzilopochtli, god of the sun and of war; Tlaloc, god of rain; and Quetzalcoatl, the feathered serpent, an ancient creator god associated with the calendar and civilization. The gods were often depicted in monumental sculpture. One remarkable surviving example is a figure of Coatlicue, goddess of the earth, shown on this page.

The Inca Empire

The third great Precolumbian civilization is that of the Inca, whose empire evolved in Peru in the twelfth century. The Inca, or emperor, was the absolute ruler over his people, which is also referred to as the Inca. The forces of the Spanish soldier-adventurer Pizarro annihilated this society in 1532.

The Inca were tireless builders. Throughout the Andes they built causeways, bridges, dams, and canals that furrowed the region's high plateaus, and they covered its slopes with terraces for farming.

The foundation of their religion was sun worship. After being proclaimed emperor, Pachacutec (1438–71) led his empire to its height of military and economic power, establishing an authoritarian government, a state religion, and an official language. The city of Cuzco, at an altitude of 11,800 feet, was declared the capital and rebuilt in monumental form. The temple of the Sun, or Coricancha, with its trapezoidal base, dates from this period; its outer walls are made of large, perfectly cut and smoothed stones, which are characteristic of Inca construction. The most beautiful Inca site is the city of Machu Picchu, which sits at an altitude of 6,700 feet on an outcropping of rock surrounded by terraces and overlooking a deep channel through which the Urabamba River flows.

◀ COATLICUE, AZTEC GODDESS OF THE EARTH. Fifteenth century. Basalt, height 8 feet 6 inches. Mexico City, Museo Nacional de Antropología

A masterpiece of Aztec art, this terrifying figure of Coatlicue wears a skirt of twisted snakes, an allusion to her name, which means "she of the serpent skirt." Two snakes, representing gushing blood, rise from her neck to form her head. On her chest, human hearts and severed hands form a necklace with a skull pendant.

▼ VIEW OF MACHU PICCHU, Peru. c. 1450

Three temples dominate this vast site, which attests to the great skill of the Inca as builders.

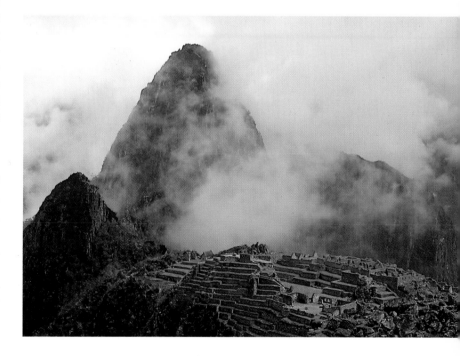

THE ARCHITECTURE OF ANCIENT INDIA

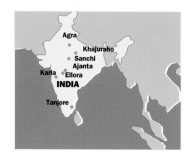

Indian architecture began to flourish about the third century BCE, with the development of two great Indian religions, Hinduism and Buddhism. The adherents of Hinduism revere a complex system of gods, the three most important of whom, Brahma, Vishnu, and Shiva, are believed to periodically create, preserve, and destroy the world. Buddhism, whose founder, Siddhartha Gautama, known as the Buddha ("the enlightened one"), lived in the sixth–fifth centuries BCE, teaches a way of life respectful of all creatures, and seeks to achieve transcendent enlightenment by the negation of all desire.

All that survives of early Indian architecture are religious buildings, which were built of brick and stone. Domestic buildings, even palaces, were made of wood and mud, and thus have not survived in the humid climate of India. It was only in the twelfth century, when Islam was established in the country, that Indians began to build secular structures with more durable materials.

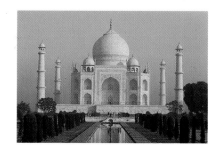

▲ THE TAJ MAHAL, Agra, India. 1632–43
The white marble Taj Mahal was built as a tomb for Mumtaz Mahal, the favorite wife of the Mughal emperor Shah Jahan.

The *Stupa*, an Early Form of Buddhist Architecture

The *stupa* is one of the oldest types of religious monument found in India. It symbolizes the goal sought by the Buddhist faithful, *nirvana*, the extinction of desire and the soul. Indians believe that every creature that dies is reincarnated, or reborn in another form. As life is often a source of pain, Buddhists hold that suffering only ends when we escape from the cycle of reincarnation. After acquiring sufficient merit in accordance with the Buddha's teachings, the soul no longer needs to be reborn; it then knows neither suffering nor joy.

Stupas, which are monumentalized mounds, originally contained relics of the Buddha; they later became commemorative monuments, and they are now found throughout the Buddhist world.

In India, stupas take the form of domes on cylindrical bases of varying height, surmounted by parasols, emblems of sanctity.

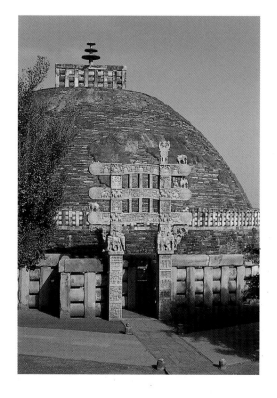

◄ STUPA I, Sanchi, Madhya Pradesh, India.
This stupa, or Buddhist reliquary mound, was built in the third century BCE and enlarged in the second century. It is the largest and one of the best preserved of these shrines. The monumental gateways date from the beginning of the Christian era.

They are surrounded by richly decorated stone barriers that define a sacred area in which the faithful express their faith by walking around the monument. Stupas are built of piled brick or stone; inside, a small space, inaccessible after construction is finished, houses the relics.

Sculptural Architecture: Rock-Cut Monuments

Around the second century BCE, in the period of the first great Indian empire unified by the Maurya dynasty, Buddhist monks created a new kind of architecture by hewing cavelike spaces from the stone plateaus of western India.

This rock-cut architecture, which could almost be called sculpture, is made by carving entire buildings out of the living rock, imitating all of the structural and decorative features of freestanding buildings, including windows and ceiling beams.

Until the fourth century, most rock-cut halls were Buddhist sites. They either took the form of a sanctuary (*chaitya*) or a monastery (*vihara*), used by the monks as living quarters.

Chaityas have a central nave and low side-aisles separated by pillars. They terminate in a semicircular apse that houses a small stupa (as at the second-century hall at Karla); such stupas were later embellished with representations of the Buddha (as at Ajanta, carved in the fifth or sixth centuries).

Viharas are square or rectangular rooms lined on three sides by small cells in which the monks lived; the fourth side is occupied by a veranda and large arched windows.

Many Hindu sites were cut into rock between the fourth and eighth centuries. The most extraordinary example is the Kailasa Temple of Ellora; dedicated to Shiva, it is probably the largest carving in the world.

The Hindu Temple

The earliest surviving freestanding stone or brick temples in India date from the fourth and fifth centuries. Originally composed of small quadrangular rooms with flat roofs preceded by pillared porches, they evolved into the Hindu temple, whose most beautiful examples date from between the tenth and fourteenth centuries.

These temples, like those of Greece, were designed as the earthly home of a god. They were conceived as microcosms, images of the universe on a human scale. Profusely decorated with sculpture, especially depictions of the minor divinities in the god's entourage, they were the most important places in the daily lives of Hindus.

Often protected by walls, the temples consist of a windowless inner chamber, the *garbhagriha*, which houses the temple's main image. This is sometimes surrounded by an ambulatory, but always preceded by at least one, but generally several, halls known as *mandapas*. In the south, temples have elevated roofs of stepped pyramidal shape; in the north, they have faceted towers known as *shikharas*, crowned by circular ribbed stones. Regardless of the deity to which the temple is dedicated, only priests can enter the *garbhagriha*. The *mandapas*, by contrast, are open to the public, serving the faithful as sites of assembly and prayer.

The Rajarajeshvara Temple in Tanjore is the most representative example of southern Indian architecture. Built in the early eleventh century, it aligns with the four points of the compass, like all Indian temples. It features a very large rectangular *mandapa* and an immense tower-sanctuary, the *vimana*, in which is placed a columnlike *linga*, a phallic cult image, the symbol of the god Shiva, to whom the temple is dedicated.

In the north, the spectacular temples in Khajuraho were built between the tenth and twelfth centuries. They are famous for their profusion of beautiful, carved figures, arranged in elaborate (sometimes erotic) positions, and their high roofs, which seem to rise toward the heavens.

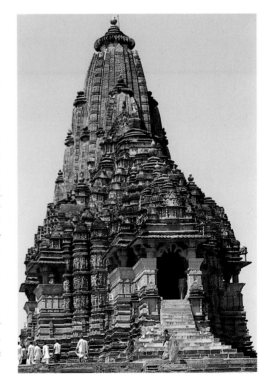

▼ KANDARIYA MAHADEO TEMPLE, Khajuraho, Madhya Pradesh, India. First half of the eleventh century
The towerlike structures, or shikharas, that crown this temple and others like it are characteristic of the architecture of northern India.

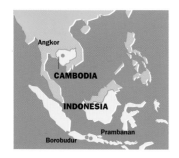

THE INDIAN-INFLUENCED COUN

From the first centuries of our era, India played a major cultural role in many countries of Southeast Asia, to which it exported its religions and its art. Rather than simply copying the architectural forms developed on the Indian subcontinent, however, these countries reinterpreted them in accordance with their own traditions.

The Island of Java and Borobudur

In Indonesia, the island of Java has the largest and most beautiful monuments created by adherents of the Indian religions. These buildings, called *candi*, are square or rectangular in plan and their roofs consist of superimposed false floors. The tower-sanctuaries of Candi Loro Jongrang in Prambanan (ninth century) are typical of classic Javanese architecture.

Borobudur, the great Buddhist monument in the center of the island, is the most famous Javanese building. It was built around a natural hill during the Chailendra dynasty, in the eighth and ninth centuries.

Borobudur consists of five square terraces, decorated with sumptuous narrative reliefs, and three circular terraces, on which seventy-two small stupas shaped like pierced bells surround a large central stupa. Ascending the various levels, the faithful gradually become aware of the path to liberation, in the evolved form of Buddhism known as the *Mahayana*, or "great vehicle," then practiced in Java along with Hinduism. The symbolism of this monument is so complex, however, that it is still not fully understood.

Some of the reliefs decorating the square terraces illustrate the *Jataka*, or previous lives of the Buddha. The most famous series is that of the *Lalitavistara*, which tells the life of the Blessed One, from his birth to his first sermon in the gazelle park of Sarnath.

These extremely beautiful reliefs were devised as teaching tools rather than as decoration. The various scenes are surrounded by frames of geometric shapes or vegetal motifs, and their compositions are always balanced. Nature, trees, and animals are rendered with verisimilitude and an exceptional luxuriance of detail. The figures, whose bodies and faces are idealized, strike elegant attitudes.

Finally, the decorative scheme at Borobudur is completed by 432 freestanding sculptures representing *jina*, a representation of the Buddha specific to *mahayana* Buddhism.

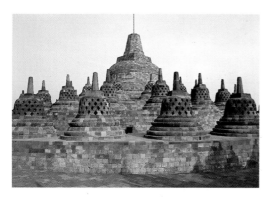

▲ BOROBUDUR, central Java. Eighth–ninth centuries
The upper terraces of this complex are covered with stupas pierced with small windows, each stupa containing a statue of the Buddha.

▶ BOROBUDUR. STONE RELIEF IN THE FIRST GALLERY
The upper register depicts a scene from the life of the Buddha; below it is a scene from one of his earlier lives.

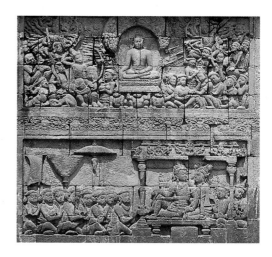

...RIES OF SOUTHEAST ASIA

The great historical and religious capitals of the Southeast Asian countries are now archeological sites as famous as the pyramids of Egypt and the temples of Greece. Of all these magnificent complexes (including Pagan in Burma, and Sukhothai and Ayuthaya in Thailand), the most fascinating is Angkor, in Cambodia.

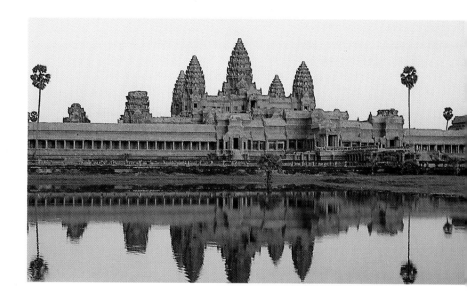

Angkor, Capital of the Khmers

Angkor was the capital of the Khmer empire from the late ninth century to 1431, when it was apparently abandoned. There kings and other dignitaries built hundreds of monuments, such as the tenth-century temple of Banteay Srei, which is situated apart from the main site.

Every important ruler built a splendid temple at Angkor to Shiva, the empire's patron god. These sanctuaries, erected on stepped pyramidal platforms, were called, because of their shape, temple-mountains. A superb example of this type—although it is not dedicated to Shiva—is Bayon, built by King Jayavarman VII in the early thirteenth century and consecrated to the Buddha. It is famous for its towers decorated with gigantic faces.

Simpler sanctuaries were erected to honor various divinities or the ancestors of the king who had ordered their construction.

The center of a great empire, Angkor is notable for its gigantic water reservoirs, or *barays*, which served the city's religious needs by supplying the moats of its great temples, as well as its economic needs, by providing irrigation for its rice fields.

Khmer monuments were typically rigorous in plan. Aligned with the four points of the compass, they were surrounded by square or rectangular walled precincts.

Angkor Wat, built in the first half of the twelfth century, is perhaps the most beautiful of the temple-mountains. Surrounded by a wide moat, it sits within a large walled enclosure. Its principal feature is a three-stepped pyramid on which its most sacred buildings were erected. Skillfully organized horizontal galleries and vertical tower-sanctuaries lead the eye to the central building, which rises 197 feet above the plain. Almost perfect in its conception, Angkor Wat also boasts a wealth of refined reliefs, including a profusion of decorative motifs, as well as figures of female divinities wearing extravagant hairstyles and clothing. The most remarkable feature of the complex is a series of reliefs carved in the one wall representing a number of mythological events, including episodes from the Hindu epics, the *Mahabharata* and the *Ramayana*.

Although Khmer monuments are religious in character, they are also expressions of the power and wealth of the kings who built them.

▲ VIEW OF THE
MOUNTAIN-TEMPLE
OF SURYAVARMAN II,
Angkor Wat, Cambodia.
First half of the twelfth
century
*This temple is dedicated to
the god Vishnu.*

▼ FACE-TOWER.
Southern gate of the
city of Angkor Thom,
Cambodia. Early
thirteenth century

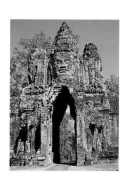

NARA, THE FIRST CITY OF JAPANESE HISTORY

In 710, the Empress Gemmei built a new Japanese capital, Heijo-kyo, now known as Nara. We do not know the names of its builders, or even their nationalities for certain, but it is plain that part of their intention was to glorify the imperial family. Moreover, in this period, Buddhism was on the rise in Japan (the religion was officially introduced in 592 CE), and so there was a demand for temples for this new form of worship.

Two centuries earlier, Japan had opened its doors to foreign influences. Ambassadors and monks departed on missions to the powerful Chinese empire of the Tang dynasty. Greatly impressed by Chang'an, then the Chinese capital, they returned with the idea of building a Japanese city in its image. The architects imitated Chang'an's symmetrical gridiron plan. On each side of the wide, central avenue of the Red Sparrow, which ran along a north-south axis, sixty-eight neighborhoods were built, each with markets, temples, and sumptuous residences. At the end of this avenue was the imperial palace, surrounded by gates, courts, and pavilions.

▼ THE KONDO OF HORYU-JI, Nara, Japan. Late seventh–early eighth century
The Horyuji monastery is the oldest surviving wooden building on earth. Within its walls, the imposing mass of the kondo, *or sanctuary, houses a bronze statue of the Buddha flanked by two saints.*

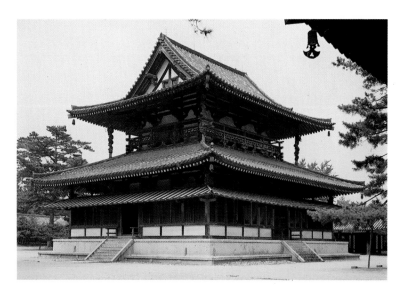

Nara, Buddhist Capital

The palaces and Buddhist temples erected in the new capital reflected the power and wealth of the Emperor and the new governing class. Previously, religious architecture had been devoted to the native Japanese Shinto religion, whose nature divinities, the *kamis*, were venerated in simple sanctuaries built in natural surroundings. With the arrival of Buddhism, a religion whose worship centered around temples, the art of building in Japan underwent a revolutionary transformation.

The new temples at Nara were built in the heart of the city, and their principle purpose was to house the images of the Buddhist pantheon, and to accommodate the rituals of the new religion. These images themselves were intended to portray the Buddha and Buddhist saints as majestic, living beings worthy of veneration. The monasteries that were attached to the most important temples were large, walled complexes with monumental gates and courtyards surrounded by covered galleries. The two most important of the new temple complexes in Nara each had their own walled precincts; their large southern gates, known as *chumons*, faced south. Each also had a main sanctuary, or *kondo*, which housed the image of the Buddha or of the saint to whom the temple was dedicated, and a multi-storied tower, or pagoda, containing relics of the Buddha. Crowned by a bronze shaft decorated with nine metal rings, the pagoda, a Chinese adaptation of a watchtower, served a function similar to that of the stupa, the characteristic reliquary monument of Buddhist India (see p. 48). Japanese monastery-temple complexes also included dormitories for the monks, a bell tower, storage rooms, a repository for Buddhist texts, and a *kodo*, or lecture hall.

Previously unknown building materials and techniques gave Nara a spectacular appearance. As in Chang'an, the columns of the temples were painted a brilliant red, and the roofs were covered with glazed-tiles. The porches were filled with gilded bronze, clay, and wood

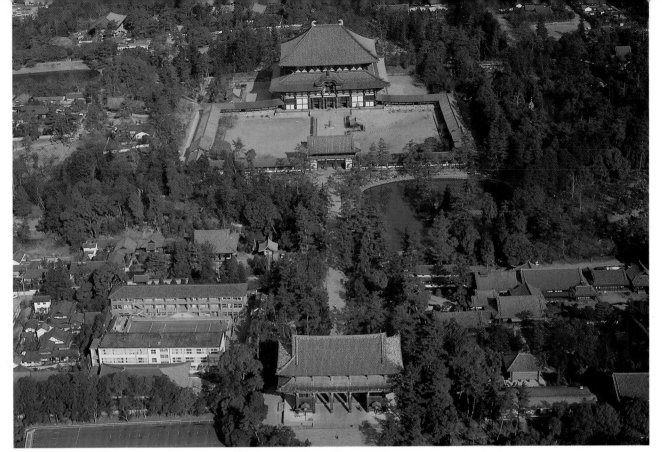

statues, and the porch roofs were heavily ornamented. The roofs, which extend considerably beyond the building walls, and turn elegantly upward at the corners, require extensive brackets for support. The interlocking wood pieces of the construction system made it possible to dismantle the buildings and reconstruct them elsewhere. Some early Buddhist temples that were built before the establishment of Nara were apparently transferred to the new capital in 714. Mobility of this sort was to remain characteristic of Japanese architecture.

Nara, a Museum City

Nara's many temples make it seem like a museum today. The Horyu-ji temple, built in 714, is distinguished by an asymmetrical plan, very different from the Chinese examples upon which the Nara temples were often modeled. Inside the kondo of the Horyu-ji stands the Shaka Triad, a remarkable group of three gilt bronze statues (c. 623) by the sculptor Tori Busshi, which represents the Buddha and two saints. The decorative character of the drapery folds, and the subtle, understated smiles of the faces, are typical of early Japanese Buddhist sculpture.

The largest temple in Nara is the Todai-ji, founded in 743 by Emperor Shomu. It was built to house an imposing bronze statue of the Buddha, some fifty-six feet high. Unlike the Horyu-ji, the Todai-ji is faithful to Chinese models in having a symmetrical ground plan and two pagodas to the east and west of the central axis, on which the kondo is sited. A famous pilgrimage site, the Todai-ji seems to have served as a model for all of the temples ordered built throughout Japan by Emperor Shomu. Treasures presented by Shomu —metalwork, masks, lacquer objects inset with precious stones—were kept in a monumental wooden safe known as the *shosoin*. Brought from all parts of Asia along the silk route to China, and from there to Japan, these splendid objects give evidence of the refined taste of the imperial court.

The reflections of the art of India, China, and Korea that can be seen in the art and architecture of Nara show something of the creativity of Japanese artists. At the very edge of the Far East, Nara Japan was receptive to influences from the Asian continent, and held them in esteem. In 794 Nara was replaced by the new capital, the present Kyoto, but its splendor was never forgotten. The Japanese continued to draw inspiration from the heritage of this city. By selectively absorbing and reformulating the international influences received in the period of Nara's flowering, Japan developed its own traditions.

▲ Aerial view of the Todai-ji Temple, Nara, Japan

This temple was founded in 743 by the Emperor Shomu. The architect organized his design in accordance with symmetrical Chinese models rather than adhering to the asymmetricality typical of earlier Japanese complexes, such as the Horyu-ji monastery.

BYZANTINE ART

In 330, the Emperor Constantine I, known as The Great (ruled 306–337 CE), chose as his new capital the seaport of Byzantium, on the Bosporus, the strait between the Black Sea and the Sea of Marmara. Byzantium, which the emperor renamed Constantinople after himself, stood at a confluence of routes between the East and the Greco-Roman world, and it was thus ideally situated for the defense of the Empire. As the new capital became a thriving center of trade, art, and culture, and Italy grew weaker under the onslaught of barbarian invasions from across the Alps, the old capital of Rome became a backwater.

With the adoption of Christianity as the state religion later in the fourth century, Constantinople also became an ecclesiastical center as well. The art of Byzantium aimed not only to reveal the presence of God but to glorify the church and the emperor as God's representatives on earth. Byzantine art was to flourish, with two major interruptions, from the reign of Constantine until 1453, when Constantinople was captured by the Ottoman Turks.

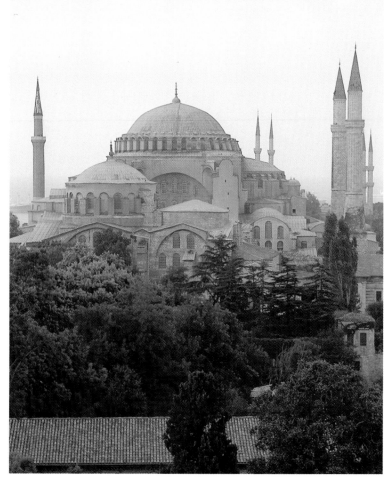

▲ Exterior view of Hagia Sophia, Istanbul.
The masterpiece of Byzantine architecture
Dedicated to divine wisdom (the meaning of its name in Greek), the original church of Hagia Sophia was destroyed during riots in 532 CE. The Emperor Justinian immediately commissioned a new church, which was completed in 537. The architects, Anthemius of Tralles and Isidorus of Miletus, combined an oblong basilican plan with a central domed one. The originality of this conception and the high quality of its execution are unsurpassed anywhere. Later the Turks converted the church to a mosque. Today it is a museum.

Constantinople, Center of Byzantine Art

The golden age of Byzantine art began in the sixth century, in the reign of the Emperor Justinian I (ruled 527–565 CE), an able soldier and a great administrator, who oversaw the drafting of the Justinian Code, a compilation of Roman law that was to become the foundation of most of the legal systems of modern Europe. Justinian tried, without success, to reestablish the Roman Empire as it had existed at its height, and thus he was to spend much of his reign on military campaigns. During his lifetime the first great monuments of Byzantine architecture were built. In Ravenna, Justinian's capital in northern Italy, the mosaics at the church of San Vitale, for example, are of an incomparable beauty. They also provide us with the majestic images of Justinian and his empress, Theodora, who are shown with their retinues.

On Justinian's death in 565 the empire went into temporary decline, and the two following centuries were marked by Arab invasions of the eastern Empire as the Muslim armies conquered territory for the new religion of Islam. The production of most Byzantine art was brought to a halt in the eighth and ninth centuries by the iconoclasts (p. 131), who, by prohibiting the making of religious images, put an end to all but secular artistic creation for more than a century.

The Byzantine Empire began to regain some of its power from the ninth to the twelfth centuries. Despite wars against the Arabs and the Bulgars, a new period of prosperity restored

Opposite page, top to bottom:
• Dome on pendentives
• Central basilican plan
• Greek cross plan

▶ Interior view of
Hagia Sophia

*The dimensions of the great
church are exceptional. The
central dome, supported
by pendentives, is carried
by four enormous piers.
Buttressed by two half-
domes, it measures 101 feet
across and 180 feet high.
The light from the windows
accentuates the elegance of
the arches and the beauty
of the marbles and mosaics.
The dome, which collapsed
in 558, was rebuilt in 562.*

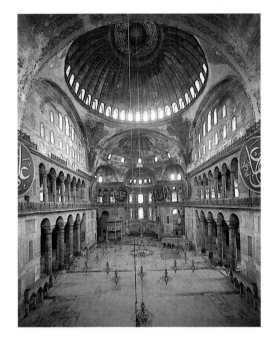

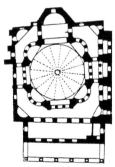

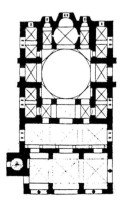

much of the former glory of Byzantine art. Emperors again sponsored the construction of churches and monasteries decorated with rich mosaics. This high point of achievement was abruptly interrupted in 1204 by Crusaders from Western Europe, who captured Constantinople, pillaged its treasures, and established their own rule for approximately sixty years.

In 1261 the Byzantine noble Michael Paleologus drove out the last of the Western invaders and founded the Paleologan dynasty, the last to rule the Byzantine empire. The reestablishment of the rule of a native Greek emperor initiated a rebirth of artistic production and building. Unfortunately, the empire was now so weakened that it could not withstand the force of a new invader: the Ottoman Turks of Central Asia. Over the course of a century, the armies of the Turks gradually took one Byzantine stronghold after another, until Constantinople was completely surrounded by Turkish territory. On May 29, 1453, the city was taken by the troops of Sultan Mahomet II.

Whatever the empire's military fortunes, the artistic prestige of Byzantium was so powerful that its influence extended throughout the Christian world. In Italy, the eleventh-century rulers of Venice built the great church of San Marco, its floor plan, domes, and mosaic decoration clearly inspired by Byzantine models. Similarly, the mosaics of the churches of the Norman kingdom of Sicily show the influence of Byzantium. Many works of Byzan-

tine art were carried north across the Alps into France and Germany, where they continued to inspire artists for centuries. And further east, the forms of Byzantine art and architecture spread throughout the Balkans and into Russia.

Builders of Churches

By blending elements from various sources, Byzantine architects created a new style of sacred building. From the East, they inherited a taste for color and magnificence; from ancient Rome, a love of grandeur, as well as a number of engineering techniques, particularly the use of domes; and from Greece, an instinct for harmonious proportion.

Byzantine Materials

The most widely used material was brick. Light and easy to work with, in some regions it was combined with stone and marble. On the exteriors of buildings, these materials made it possible to use a variety of colors and decors, while the walls of the interiors were covered with rich marble facing, mosaics, and frescoes.

Vaulted Ceilings

Vaulted ceilings and domes are typical of Byzantine architecture. One of the architects' innovations was the placing of domes on pendentives, which allowed a round vault—a dome—to be placed over a rectangular building, as shown in the drawing at left. Pendentives also allowed for lighter and more elegant construction.

Plans

Some Byzantine churches were basilicas, like those of the early Christians (see p. 56), that is, long halls with three or five aisles separated by columns running most of the length of the interior. Others were arranged around a central point, with either a round or polygonal floor plan. Many were surmounted by a dome, which symbolized the hemispherical vault of Heaven.

In the fourth century architects began to build churches in the form that would become the most typical Byzantine plan. In these buildings, the floor was laid out in the form of a Greek cross—that is, a cross with arms of equal length, short enough to fit within a square—with a dome over the intersection of the arms. After the eleventh century almost all Byzantine churches were built in this form.

THE FIRST CHRISTIAN CHURCHES

In 313, the Emperor Constantine's Edict of Milan granted all people in the Roman Empire freedom to worship as they wished. Thus, after two centuries of persecution, the practice of Christianity was legal. Although it was not yet the state religion, as it would later become, the emperor's own allegiance to Christianity was well known. As a result, the Church benefited enormously from the emperor's patronage and that of the imperial court. Most of the great Roman nobles became converts, and they and the emperor sponsored the construction of great churches throughout the empire. Thus, beginning in the fifth century, large and sumptuously decorated sanctuaries were erected from Rome to Constantinople to the holy sites of Bethlehem and Jerusalem. Many of these still number among the most important monuments of Christianity.

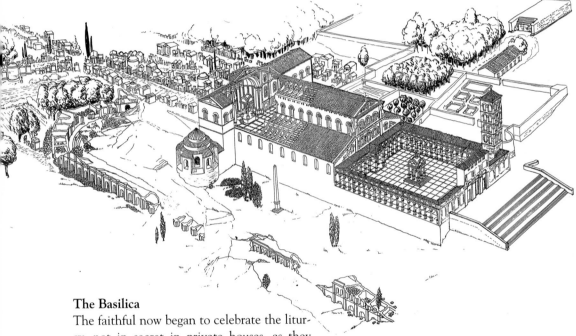

◀ **THE FIRST BASILICA OF ST. PETER, the Vatican, Rome. Early fourth century**
The first basilica of St. Peter, built by the Emperor Constantine, was 393 feet long and 210 feet wide. Its five parallel aisles culminated in a transverse aisle, or transept, which gave the whole the form of a cross. The atrium, or outer court, whose imposing street façade included a tower, was surrounded by an arcade. In its center was a monumental fountain for ablutions. The crypt of the apse, built on the site of St. Peter's tomb, housed his relics. St. Peter, the founder of the Christian community of Rome, is revered as the first pope. The basilica was ordered pulled down in the early sixteenth century by Pope Julius II, so that it could be replaced by the present basilica.

The Basilica

The faithful now began to celebrate the liturgy, not in secret in private houses, as they had during the first two centuries of Christian history, but in public. Since classical temples were not designed to accommodate the crowds that now attended Christian services, new ecclesiastical buildings were needed. The large hall known in antiquity as the basilica was soon adopted for the purpose. Initially used for covered markets and law courts, basilicas were rectangular structures whose interiors were divided by rows of columns into a broad central aisle, or nave, and two or more narrower side-aisles. A large semicircular niche, or apse, at one end provided a place for the altar. The main entrance was generally preceded by a forecourt, or atrium, which had been a standard feature of a middle-class Roman house. Surrounded by porticos, the atrium often had a fountain at its center, where a worshiper could purify himself or herself before entering the house of God. Although few churches of this period retain their original form, one surviving example of the early Christian basilica (although heavily restored) is the church of Saint Paul's Outside the Walls in Rome.

The interior decorative programs of the early Christian churches were often quite elaborate. They narrated the events of the life of Christ, or the legends of the early martyrs of the faith, or the stories of the prophets and heroes of the Old Testament, who were thought of as precursors of Christ. Such narratives were designed to remind the faithful of the power of God and the Christian promise of eternal life.

CAROLINGIAN ART

During the fifth, sixth, and seventh centuries, the Roman Empire went through considerable unrest, which included the invasion of its borders by various Germanic and Asiatic peoples. Eventually the western half of the Empire was broken up into smaller states, several of them ruled by the kings of the Franks, one of the Germanic groups. In the eighth century, the Frankish king Charles (ruled 768–814), whom we know as Charlemagne (French for "Charles the Great"), restored the political unity of what had been the western Roman Empire. On Christmas Day in the year 800, he was crowned emperor by Pope Leo III.

Charlemagne spent much of his time at war, but he also sponsored the reform of intellectual, artistic, and religious life in his empire. He organized the state's administration, and founded schools and studios where books were copied. He also fought tirelessly to support the primacy of the pope as the spiritual leader of Western Christianity. This allegiance of emperor and pope was a defining feature of his empire and that of his successors.

Charlemagne and his heirs are known as Carolingians, from Carolus, the Latin form of his name, and the territory that he ruled is known as the Carolingian Empire.

The Palace Chapel at Aachen

Architecture flourished in the Carolingian Empire, along with the economic revival that marked Charlemagne's reign.

Like his predecessors, Charlemagne rarely stayed in any one of his residences for long, but instead traveled almost constantly. Inspired by the great palaces of Rome and Byzantium, around 790 he decided to build a new capital and a principal

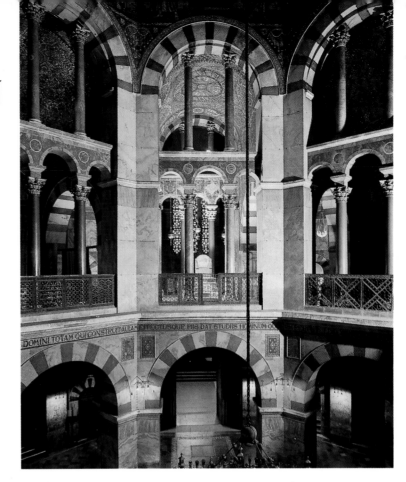

residence for himself at Aachen, now in northwestern Germany. His secretary and biographer, the Frankish nobleman Einhard (c. 770–840), explained the choice of this city, known since the Roman era for its springs: "He also liked thermal waters, where he often enjoyed swimming; he so excelled at it that no one could surpass him. That is why he built a palace in Aachen and remained there through his last years, until his death."

Work began on the new palace around 790, and its chapel was consecrated in 805. The chapel was the heart of the palace, which in addition to the private apartments of Charlemagne and his family, also contained the administrative offices of his government. From the Royal Audience Hall, the emperor could walk directly to the second story of the chapel, from which he could watch the service while seated on a throne.

The architect of the Palace Chapel was inspired by Justinian's church of San Vitale in Ravenna (p. 54). Like that building, Charlemagne's chapel had a polygonal central plan, a second-story gallery, and a tall, central clerestory—that is, an upper story filled with windows to admit light. Despite these similarities, the chapel's strong, simple forms and powerful vertical emphasis are innovations, new symbols of the emperor's majesty.

▲ INTERIOR VIEW OF THE PALATINE CHAPEL, Aachen, Germany, from the gallery. Late eighth–early ninth century
This round church, crowned by a dome and surrounded by a gallery, is decorated with ancient columns and other marbles brought from the Byzantine churches of Ravenna, Italy. The dome, completely remodeled in the nineteenth century, was originally decorated with a mosaic depicting Christ. The bronze grilles of the gallery and the monumental chapel doors attest to the high quality of Carolingian metalwork.

See: The Medieval Arts of Color, p. 134.

ROMANESQUE CHURCHES

▶ THE ABBEY
CHURCH OF CLUNY,
France. Begun 1088
*A computer-generated
image of the abbey shows
its appearance in the late
eighteenth century, before
its masonry was pillaged
during and after the French
Revolution. The abbey
at Cluny was one of the
largest churches in medieval
Europe. Only its southern
transept remains today.*

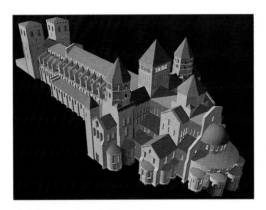

A Blossoming of Churches

After the death of Charlemagne, his territories were shaken by new invasions of Vikings from the north, and Hungarian tribes from the east. By the end of the tenth century, however, after these peoples had either been driven back or peacefully assimilated into the empire, Western Europe recovered its prosperity. Feudal society began to flourish and the art of building reawakened, bringing about a two-century period (approximately 1000–1200 CE) that we now call the Romanesque. This term was coined by architectural historians of the early nineteenth century, who found the heavy construction, round-arched arcades, and barrel vaults of the buildings of the eleventh and twelfth centuries reminiscent of ancient Roman architecture. Thus, they said the buildings were "Romanlike," or "Romanesque."

In his *Chronicle,* written about 1040, Raoul Glaber, a monk at the great monastery of Cluny, expressed wonder at Europe's determination to "cloak itself in a white robe of churches." He was probably thinking chiefly of the vast religious complexes that were built at this time, especially in the French provinces of Normandy and Burgundy, the north Italian province of Lombardy, the Rhineland, and northern Spain. These included cathedrals (the home churches of bishops), pilgrimage churches, and also abbey churches intended principally to serve their resident religious communities.

The eleventh and twelfth centuries were violent; war was such a constant threat that most social institutions seemed precarious and vulnerable. The Church, however, stood for order and cohesion, and nearly everyone felt some reassurance as members of the Christian community. Striking testimony to this is found in the monastic "empires" of Cluny and Cîteaux, two abbeys in Burgundy. Since its establishment in 910, the expansion of the community of Cluny was felt throughout Europe; in the year 1108, 1,200 religious houses were under its authority. Cluny's great rival, the abbey of Cîteaux, founded in 1098, was the mother church of some 343 Cistercian ("of Cîteaux") monasteries.

In this period, architectural activity was intense, as great abbey churches and cathedrals rose in enormous construction programs shaped by new liturgical needs, and a resolve to build magnificent churches of stone.

Larger Churches

It was a time of intense religious feeling. Fervent reverence for the saints and martyrs was accompanied by a desire to see and touch their relics, which were jealously guarded in the crypts and choirs of churches throughout the Christian world. The holiest pilgrimage destinations were considered to be Rome, Santiago de Compostela in northern Spain, and Jerusalem. The faithful thronged to the churches in these cites, often traveling great distances and encountering considerable danger to reach them.

The new aspirations and religious practices that came with an upsurge in religious fervor resulted in a need for larger churches. Naves were enlarged, and horizontal wings crossing the nave near the altar, called transepts, were added to accommodate larger crowds of the faithful. The sanctuary where the altar stood, now called the choir, was enlarged and extended to accommodate elaborate liturgies for a growing number of clergy. Often, to facilitate circulation and permit pilgrims to visit the saints' relics without disturbing the liturgy, walking galleries, or ambulatories (from Latin *ambulare,* "to walk") were built around the choir. Opening from the ambulatories were small chapels for private devotion, and small apses were often added to the transepts, as well;

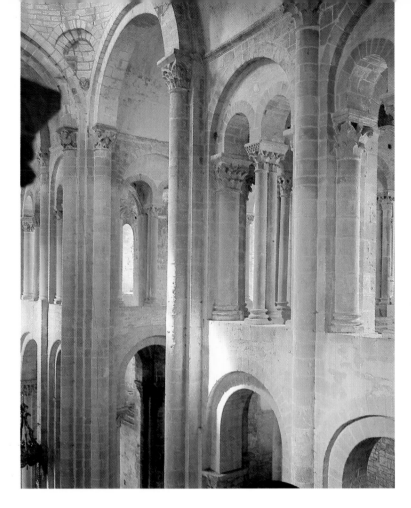

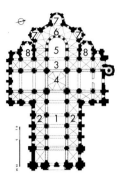

◄ **INTERIOR VIEW OF SAINTE-FOI, Conques, France. Late eleventh century**

This church was on one of the pilgrimage routes to the tomb of St. James the Greater in Santiago de Compostela, Spain. Note the tunnel vaulting with transverse arches, the gallery above the side aisles, and the transept crossing, which is surmounted by a tower pierced with windows to light the interior.

▲ **PLAN OF SAINTE-FOI, Conques, France**
1 nave; 2 side aisles; 3 transept; 4 transept crossing; 5 choir; 6 ambulatory; 7 radial chapels; 8 subsidiary apses

both of these features increased the number of sites for altars.

Toward the end of the eleventh century, these innovations gave birth to a church type that was to become common throughout Europe, notably along the pilgrimage routes. The most ambitious of these was the immense abbey church of Cluny, erected between 1081 and 1130. A grandiose building 613 feet long that rivaled Saint Peter's in Rome, it was large and elaborate, boasting two transepts, an ample choir, multiple chapels, and six towers, and its decoration was sumptuous. Somewhat later, the Cistercians imposed a simpler, more austere building style, which was ardently promoted by a member of that order, St. Bernard of Clairvaux (1091–1153). A particularly fine example of the Cistercian architectural style is Fontenay Abbey, whose church was built between 1139 and 1147.

A Fascination for Stone Vaults

Architects of this period had a consuming ambition: the replacement of wooden roofs, which were vulnerable to destruction by fire, with stone vaults. They already knew how to cover small spaces with stone, but vaulting a large building was another matter. A large stone roof not only requires thick walls to support it, its weight also tends to force the walls underneath it to buckle outward. Architects call these lateral forces "outward thrust." In order to contain the outward thrust exerted by the weight of the vault, architects of the Romanesque period reinforced the walls with large piles of stone, or buttresses, set along the walls at intervals.

As architects strove to build stone vaults over the course of the eleventh and twelfth centuries, they experimented with a number of solutions to the problems posed by building such roofs, and their experiments often failed. The vaulting at Cluny, for example, collapsed in 1120. But as builders persisted, they gradually discovered how to build the vaults that they wanted.

In case buttresses alone did not suffice to support the walls, second-story galleries were built above the side aisles, or the aisles were built taller, so that they were almost as high as the nave.

The simple harmony of the proportions and the beauty of the carved decoration of the best Romanesque churches place them among the finest works of Western architecture.

▲ **ARCHES AND VAULTS** *(top to bottom):*
• *ribbed vault*
• *pointed arch*
• *round arch*

GOTHIC CATHEDRALS

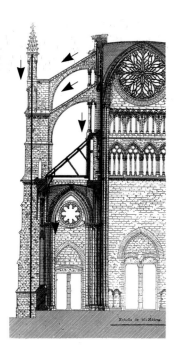

▲ CROSS-SECTION
OF THE CATHEDRAL
OF AMIENS, France.
Thirteenth century
*This partial section of the
church shows the forces
exerted by the weight of the
vault, as well as the basic
components of Gothic
construction. The weight-
bearing elements are
marked in black; the point-
ed arch of the nave vault is
shown in red; vertical and
lateral thrusts are indicated
by arrows.*

The Birth of the Gothic Style

In 1144, Abbot Suger, the superior of the abbey of Saint-Denis, where the French kings were traditionally buried, consecrated his church's new choir. Although Suger supervised its construction, the actual architect is unknown. His work, however, was immediately acclaimed as a marvel.

The new choir at Saint-Denis was surrounded by a two-aisled ambulatory with seven chapels radiating out from it. Its great novelty lay in the construction of its vault, which offered a new solution to the problem of keeping the walls from buckling outward under the tremendous pressures that the weight of the vault exerted on them. The Romanesque solution to the problem of containing the outward thrust, as the tendency to fall outward is called, was to line the walls with heavy piles of stone, called buttresses. The architect at Saint-Denis, however, devised a skeletal system of stone ribs, in the form of a sequence of crossed pointed arches, which were interlocked to form rectangular units, or bays. The physical forces within a pointed arch tend to be directed more downward than outward; thus, the arches concentrated the weight of the vault at the four corners of each bay. The outward pressures from a pointed-arch vault were so much less than those exerted by a Romanesque barrel vault that the walls could now be relatively thin. They still needed reinforcement at the corners of the bays, where the outward pressures were concentrated. If the buttresses were set at exactly those points along the wall where the corners of the bays met it, they could be less massive than previously. They could even be set back from the wall and linked to it with elegant arches, or flying buttresses (see diagram at left).

The original vault at Saint-Denis may have been overly audacious; we know that it had to be rebuilt in 1250. But it is nevertheless one of the most ingenious structural systems ever devised, and variants of it were used throughout medieval Europe, beginning in the late twelfth century. Thus was born, as if by a single stroke, what was later to be called Gothic architecture. The techniques of this architecture have

nothing to do with the Germanic people known as the Goths. The eighteenth-century critics who coined the term, however, thought these medieval buildings "barbaric" compared to classical temples.

New Effects of Light

One of the great advantages of the new construction system was that the vault, ribs, pillars, and buttresses were almost structurally independent of the walls. Thus the walls were now largely freed from having to support the roof. One result of this was that the windows, which in Romanesque architecture had of necessity been kept small so as not to weaken the walls, could now be considerably larger and admit much more light.

Abbot Suger, who wrote an account of the construction of Saint-Denis, saw great spiritual significance in the light that flooded his new choir, maintaining that its contemplation would help the believer discover the "true light of God." We should note here that the light that streamed through the windows at Saint-Denis was not white daylight, but light colored by passing through small panes of stained glass.

Taking advantage of the structural possibilities offered by the new building system, architects gradually introduced larger and larger windows in their churches, transforming the walls into delicate networks of stone filled with brilliant fields of multicolored glass. A superb example of this style is the Sainte-Chapelle, the palace chapel built by Louis IX of France (St. Louis; ruled 1226–70) between 1246 and 1248 (illustrated opposite). Here the walls seem almost to have dissolved into a curtain of colored glass.

Higher and Higher

As the innovations at Saint-Denis were gradually understood, other builders emulated them. Within a century of the consecration of the choir at Saint-Denis, great churches with ribbed vaults and vast stained-glass windows were begun in towns all over northern France, and in England and Germany, as well.

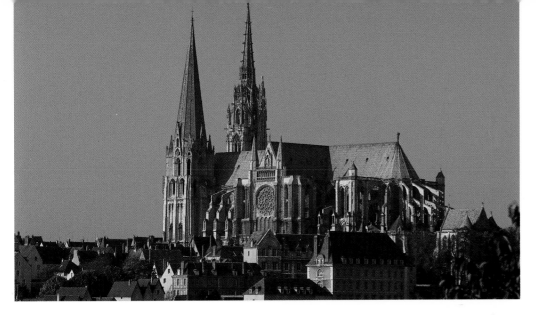

◀ CHARTRES CATHEDRAL. Early thirteenth century
The majestic silhouette of this famous church, with its two great steeples, attests to the originality of its builders.

Although every Gothic church had a character of its own, most followed the general plan developed in the Romanesque period, which featured a central nave flanked by side aisles, a transept, and a choir surrounded by an ambulatory with radiating chapels. The elevation, or vertical plan, of the nave was generally three-part, with an arcade, on which rested a triforium (a smaller arcade), and a clerestory to admit light. The more important churches had majestic façades, and high towers that could be seen at a great distance.

In northern France, a competition developed to see who could build the highest vault. The nave of Notre-Dame in Paris is 115 feet high (c. 1163); that of Reims Cathedral, 108 feet (1211). The tallest naves are those of the cathedrals of Amiens (1220–69), at 139 feet, and Beauvais (1235), at 148 feet. But in 1284 the vaulting of Beauvais collapsed, signaling that the outer limit of tall ribbed construction had been reached.

Dissemination

For more than three centuries, almost all of European religious architecture was built along the lines established in the hundred years from 1140–1240. Once the basic technical problems were solved, architects stressed structural virtuosity and decorative refinement.

Every European country adopted the Gothic style, some, such as England and Germany, at a very early date. Architects everywhere sought to integrate ribbed construction with local traditions, and the results varied considerably. The English, for example, preferred flat apses and highly complex, decorative ribbing in the

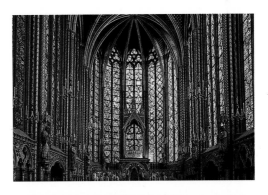

◀ INTERIOR VIEW OF THE SAINTE-CHAPELLE, Paris, the royal chapel of King Louis IX (St. Louis). 1246–48
The chapel is a single, aisleless chamber. Its tall windows, with their brilliantly colored stained glass create a continuous curtain of light.

◀ ST. ANNE, Annaberg, Germany
Built between 1499 and 1520, this is a fine example of a hall church, a characteristically German style of church with three aisles of the same height.

vault. The Germans favored the hall church, a type in which the side aisles rose as high as the nave; the Spanish and Italians preferred single-aisle structures.

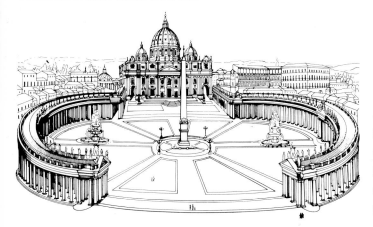

BAROQUE ART

Art historians use the term Baroque to refer to the art and architecture of the seventeenth and early eighteenth centuries in Europe. The word is derived from *barroco*, a Portuguese word for an irregular pearl, and by extension it has come to signify dramatic contrast, emotionality, eccentricity, and dynamism.

▲ SAINT PETER'S SQUARE, the Vatican, Rome. 1656–65

The colonnade, designed by Gianlorenzo Bernini, seems to reach out to embrace the world. The elliptical square formed by it can accommodate enormous crowds of pilgrims.

Baroque Architecture

After the Protestant Reformation in the early sixteenth century split Western Christianity in two, Pope Paul III summoned a convention of bishops at the north Italian town of Trent to discuss the restoration of the Catholic Church. The Council of Trent, as this gathering was called, was first convened in 1545, and continued to meet until 1563. The bishops and other influential clergy at the council clarified some essential points of Catholic dogma, and also established an agenda for church reform. One of the chief points of discussion was the veneration of images, which the council reaffirmed, and the importance of the visual arts as a support of faith. The Baroque style of architecture, which flourished in Europe from the late sixteenth century until the early eighteenth century, expressed this spirit of renewal well. Its grand and often dramatic treatment of church façades and interiors was intended to move believers emotionally, and to encourage them to participate more fully in worship. Similar tendencies of design appeared in civil architecture, too, for the new vocabulary of organic forms and magnificent proportions could easily be adapted by rulers to express their power. Much of the Baroque vocabulary had already been introduced by later Italian Renaissance architects such as Michelangelo and Vignola. Indeed, the emotionally charged effects and grandiose scale of their late sixteenth-century buildings prepared the way for the flowering of the Baroque style.

Religious Architecture

The Baroque movement in architecture began in Rome, the capital of the Catholic world. One of the most important projects was the completion of the rebuilding of St. Peter's Basilica, which had been begun a century earlier. In 1615 the façade was finally finished by the papal architect, Carlo Maderno (1556–1629). As successive popes built or remodeled churches and the Baroque style continued to develop, Rome became virtually a Baroque city. Roman architects were summoned to work all over Catholic Europe, and carried the new style abroad with them.

The architect and sculptor Gianlorenzo Bernini (1598–1680) was appointed papal architect at Maderno's death in 1629. Bernini's work for St. Peter's Basilica was to exemplify the new Baroque style. The great square that he designed as the entrance to the church was intended to express the basilica's position at the center of the Catholic world. This vast irregular space, enclosed by a magnificent colonnade, became the theater of papal authority, and an exterior extension of the great basilica itself. For the interior, Bernini designed a number of imaginative marble and gilt bronze monuments. Particularly noteworthy are the Baldacchino, an enormous bronze canopy supported by four massive twisted columns that stood over the high altar (p. 179), and the Throne of St. Peter, an allegorical sculpture of an elaborate gilt bronze throne carried by four over-life-size bronze figures of Early Christian theologians.

Francesco Borromini (1599–1667), Bernini's great rival, invented a highly original architectural and decorative vocabulary. Borromini was particularly fond of sinuous lines, complex volumes, and sumptuous materials. The façades and interiors of his churches feature a subtle play of curves and counter-curves, which introduced a

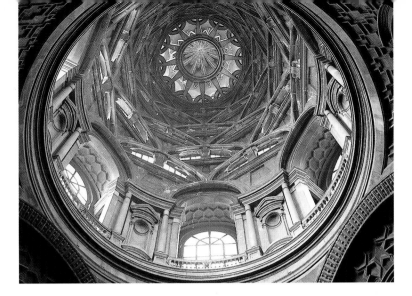

▲ **Dome of the Chapel of the Holy Shroud, Turin, Italy. 1667**
The architect Guarino Guarini devised this highly original variation on the dome, using a sequence of superimposed arches that maximize the light and seem to lead the viewer's gaze toward infinity.

▶ **Pilgrimage Church, Wies, Germany. 1746–56**
On June 14, 1738, a Bavarian shepherd, praying before a small devotional sculpture of the flagellated Christ, saw the statue weep. This miracle attracted so many pilgrims that a church was built to accommodate them, with the sculpture on its high altar. Built by Dominikus Zimmermann, with lavish painted and sculpted decoration by his brother Johann, the church is one of the masterpieces of European Baroque architecture.

new feeling of movement into architecture. This sensation of movement was to become one of the distinguishing features of the Baroque style. Immensely influential abroad, Borromini's work helped to spread the style far beyond Rome. Two churches in the north Italian city of Turin by the architect Guarino Guarini (1624–83) are particularly fine examples of Borromini's style, which was carried beyond the Alps by other architects to Germany, Austria, and Bohemia.

Secular Architecture
Kings and princes shared the Church's love of theatrical effects, and they saw to it that their capital cities were redesigned as settings to glorify their rule.

First in Italy and France, then throughout Europe, a new palace type was developed, a grand residence with a formal garden combining elements of both city and country houses. The Palazzo Barberini in Rome, begun by Maderno and Borromini and completed by Bernini is a superb early example of this type. The palace of Versailles, the favorite residence of King Louis XIV near Paris, begun by Louis Le Vau (1612–70) in 1668 and later enlarged by Hardouin-Mansart from 1672–85, was the culmination of this development. Versailles also exemplifies a distinctly French form of Baroque architecture that shares the grandeur and opulence of the Roman Baroque style but is more emotionally restrained and uses a strictly classical vocabulary.

The Baroque Elsewhere in Europe
Several European countries responded to the inspiration of Roman examples by developing their own version of the Baroque. The Por-

tuguese Manuelin style of the early seventeenth century was one highly ornate variant, as was the even more exuberant Spanish Baroque idiom of the late seventeenth century. Both of these styles were carried to Latin America by Catholic missionaries. In Central Europe—Bohemia, Austria, Germany, and Switzerland—architects produced an astonishing number of opulent churches and palaces in their elegant regional version of the Baroque. In the eighteenth century, this style developed into the lighter, more graceful Rococo, whose luxurious and refined forms harmonized well with the highly cultivated life at the princely courts of the period.

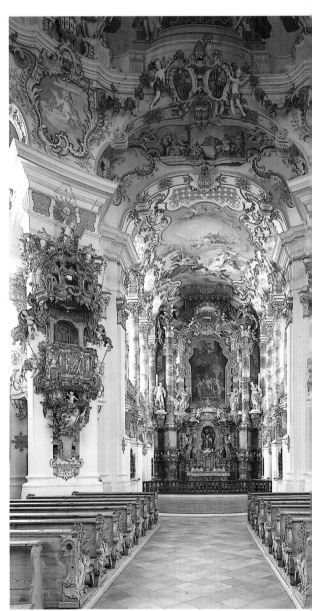

MOSQUES

In 610 in the city of Mecca on the Arabian peninsula, Muhammad, then aged forty, began to preach to his people that he had received revelations from God. These included a reaffirmation of God as the single, all-pervading, immaterial deity, and of Muhammad himself as the last of a great succession of messengers from God, starting with Adam and progressing through the prophets mentioned in the Jewish scriptures to Jesus of Nazareth. Muhammad's preaching in 610 was the beginning of the religion of Islam, whose faithful are known as Muslims. After Muhammad's death in 632, the revelations that he had received throughout his life were assembled in 114 chapters, or *surahs*, organized from the longest to the shortest, and divided into verses. This compilation forms the sacred scripture of Islam, called the Koran ("recitation").

Muhammad's successors assumed control of the religious state that he had founded and began to conquer the territories around them for the faith. Soon his followers had occupied Syria and Palestine, then Egypt, Persia, North Africa, and Spain. Continuing north into what is now France, their advance was stopped in 732 by the army of the Frankish king Charles Martel ("Charles the Hammer") at Tours. A century after the prophet's death, the Muslim empire extended from the shores of the Atlantic across the southern Mediterranean basin to the borders of India. The caliphs, the rulers of this empire, built mosques, Muslim places for congregational worship, throughout this vast area. The stylistic variety of Islamic architecture reflects the differing skills of the craftsmen in the countries where the buildings rose: some were built of brick, others of stone; some had vaulted roofs, others domes; some had stucco ornament, others featured mosaic or ceramic tile decoration.

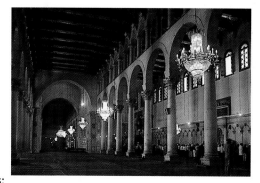

▲ INTERIOR VIEW OF THE UMAYYAD MOSQUE, Damascus, Syria. 705–715

The prayer hall is divided by columned arcades into three aisles parallel to the qibla wall, which the faithful face during prayer.

According to tradition, the House of Muhammad in Medina is the first place where believers gathered, kneeling to pray in its inner courtyard, where palms protected them from the sun. Growing ever larger, mosques became political centers as well as places where the Koran was read and taught.

One essential for a mosque building is that the *qibla*—the direction of Mecca, toward which the faithful face to pray—be clearly indicated. Prayer halls are rectangular and roofed. Worshipers enter through doors on one of the long sides, opposite the wall of the qibla. These rooms generally open onto a courtyard, which can have doors on its three other sides. This is the case at the great mosque of Koufa, Iraq, rebuilt in 670, which established a model that was followed for centuries.

The *mihrab*, a concave niche framed by an arch, was set into the qibla wall to indicate the direction of Mecca. Very early in the history of Muslim architecture, mosques were built with minarets, towers from which believers were summoned to prayer. These towers also stood as material emblems of the triumph of Islam.

The oldest surviving mosque is the Umayyad Mosque in Damascus, Syria. Built between 705 and 715, on a site previously occupied by a basilica dedicated to St. John the Baptist, it consists of a courtyard with entrances on three sides and a prayer hall. On its interior, the lower walls are decorated with marble tablets, above which are rich mosaics. Apparently the work of Byzantine artists, they depict landscapes and rich vegetal motifs. There are no representations of either human beings or animals, since such images are forbidden by the Koran.

Erected in mid-ninth century, the Great Mosque of Samarra in Iraq was the largest ever built. It was enclosed with a wall, the *ziyada*, intended to isolate the mosque from city life. All that remains of the building are its outer walls, made of baked brick and reinforced by towers decorated with stucco reliefs, and the conical minaret known as al-Malouiya ("the

◄ THE AL-MALOUIYA
MINARET OF THE
GREAT MOSQUE OF
SAMARRA, Iraq. 847
*Built on a square base
108 feet wide, this 164-
foot-high minaret features
an exterior spiral ramp. It
was probably inspired by
the ziggurat, a temple
type built by the ancient
Babylonians, examples of
which the architect could
easily have seen.*

ration of brilliantly colored ceramic tiles.

After the decline of the Seljuqs, the Ottoman dynasty assumed power. At the end of the fourteenth century, Ottoman architects began to focus their attention on domes. These attained monumental proportions, becoming the most characteristic feature of Turkish mosques of the period. In Istanbul, Turkey, the enormous dome of the Suleymaniye Mosque, built between 1550 and 1556 by the architect Sinan, dominates the city. Nearby, the Mosque of Sultan Ahmed (ruled 1609–17), known as the Blue Mosque, famous for its splendid ceramic tiles, has many domes crowning large spaces for prayer.

► COURT OF THE
FRIDAY MOSQUE,
Isfahan, Iran.
Eleventh century
*The majestic arch of the
iwan of this mosque is
flanked by two minarets.
Discernable within the
main arch is the geometric
network of smaller inter-
connecting arches. The
courtyard, with its central
pool, is surrounded by a
two-level arcade.*

spiral"), for which the mosque is famous. The Great Mosque served as a model throughout the Islamic empire. For example, the mosque of al-Qatai in Cairo, Egypt, built not long after the Samarra mosque between 876 and 879, also has a ziyada, a spiral minaret, and a very long prayer hall, another feature of mosque architecture in ninth-century Iraq.

When the Great Mosque of Kairouan, Tunisia, was rebuilt in 836, the architects introduced a feature that was much imitated, especially in North Africa: the prayer hall was divided into seventeen "naves" by arcades built at right angles to the qibla wall.

In the eleventh century, with the Seljuq sultans, the first Turks to rule in Asia Minor, a new type of mosque inspired by Persian architecture appeared in the eastern part of Moslem territory. The Turks and Persians now built mosques with four *iwans*, or arcs, opening off of each side of a central courtyard. The domed hall containing the qibla and the mihrab is thus preceded by an iwan. The courtyard now became the true center of the Persian mosque, a place where beauty and calm reigned. Beyond each iwan, which serves as a passage or threshold, is a rectangular prayer hall. This plan was adopted for the Friday Mosque, built in the eleventh century, and later for the Shah Mosque (1610), both in Isfahan, Iran, and both featuring rich interior and exterior deco-

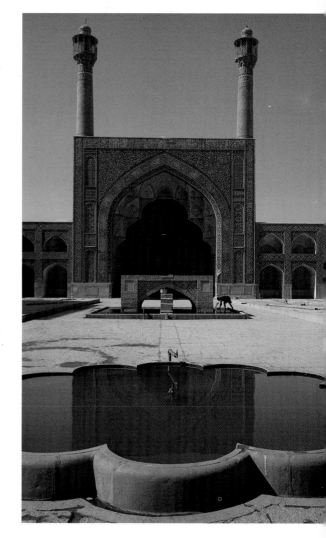

PERSEPOLIS

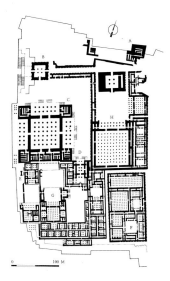

▲ PLAN OF PERSEPOLIS.
B Gate of All Nations; C Apadana;
E Palace of Darius; F Treasury;
G Palace of Xerxes; H Hall of the
Hundred Columns

In 518 BCE, Darius I (ruled 521–486 BCE), the greatest king of the Achaemenid dynasty of ancient Persia (now Iran), began to build a capital at Parsa, or Persepolis, as the Greeks called it. Darius commanded an immense empire encompassing the entire Middle East as far as Egypt. As we know from inscriptions and accounting records engraved on clay tablets found at Persepolis, construction there continued for more than two hundred years. In 330 BCE, the armies of Alexander the Great defeated the Persian army and burned Persepolis, although according to Greek historians, the destruction of the city was accidental. Archeological excavations begun in 1930 have now recovered something of the past grandeur of the site.

▲ VIEW OF THE EASTERN STAIRWAY OF THE APADANA TERRACE. 518 BCE
The basement levels of this building were richly decorated with reliefs. Those shown here represent the many foreign delegations who came to pay homage to the Great King and present him with gifts. Marching in solemn procession, they entered the Gate of All Nations, passed by the huge Apadana, and entered the Throne Hall, where they presented their offerings. All twenty-three of the participating peoples—including Ethiopians, Egyptians, Arabs, and Greeks—are recognizable, their arms laden with gifts.

The Palace

Persepolis was situated on a vast terrace dominating the plain and backed by mountains. A visitor entered the complex by a grand double staircase, whose steps were low enough to accommodate horses and livestock. The Gate of All Countries, decorated with bulls and bearded sphinxes, led to vast courtyards bordered by buildings. To the west was an enormous audience hall called the Apadana. Built on a high platform, it was entered by two stairways decorated with carved reliefs. Its roof, which was destroyed in the fire set by Alexander's soldiers, was supported by seventy-two stone columns more than sixty feet high, some of which are still standing. Extremely elegant, their fluted shafts were crowned by palmette and scroll-form capitals surmounted by figures of kneeling oxen.

To the east was the throne room, called the Hall of the Hundred Columns, whose wooden pillars were also destroyed in the fire.

To the south was a splendid palace built by Darius, and another built by his son Xerxes, which was even larger. Both of these were reserved for banquets. Finally, there was a Treasury to store gifts that were given the king.

Persepolis was built and maintained solely for the celebration of the great feast of the Spring equinox. During this feast, the king held court there and received homages and offerings from the high Persian nobility, as well as from the various peoples of his empire. A magnificent banquet was offered to the king's guests in the palace of Darius or Xerxes, and the best generals were rewarded for their victories during the year. At the close of the festival, the court returned to the empire's primary capital at Susa, and Persepolis was deserted until the next spring.

THE POMPEIAN HOUSE

On August 24 in the year 79 CE, an eruption of the volcano Mount Vesuvius (near modern Naples) destroyed the Roman town of Pompeii, burying it under many cubic feet of ash and stone. Archeological excavations have uncovered the city's remains, which are remarkably well preserved. Rediscovered by chance in 1748, they offer a unique glimpse of the daily life of the ancient Romans.

Settled by the Greeks in the seventh century BCE and declared a Roman colony in about 80 BCE, Pompeii was a favorite holiday resort of prosperous Romans, and the houses that they built there were both intimate and comfortable.

Many houses had an *atrium* (plural, *atria*)—a large rectangular entry hall open to the sky—which was set off from the street by a vestibule. The atrium had a central pool surrounded by a columned gallery, and a pitched roof that allowed rain water to fall into the pool, where it was stored. In the early days of Roman society families gathered in these rooms to be near the hearth, and this is where they maintained a shrine to their household gods. Opening onto the atrium, the *tablinum* was originally both a dining room and a bedroom. Later it evolved into the public area of the house, where the father of the family might receive visitors or conduct his business. Beyond this was a portico and garden.

The private rooms of the house were located around the *peristyle*, an interior courtyard with a garden for pleasure and relaxation. Some of these might be bedrooms, with alcoves for beds, although these might also be on the second floor. The *triclinium*, or dining room, was furnished with couches, for the Romans, like the Greeks, ate their formal meals while reclining. Beyond the peristyle was a rectangular or circular *exedra*, which contained a formal reception room. The kitchen, with its fixed hearth, latrines, and storage rooms, was set apart from the rest of the

house. A fine house might have a bath, consisting of a warm room (*tepidarium*), a hot room (*calidarium*), and a pool for cold baths (*frigidarium*).

Pompeian houses were richly decorated, both with wall paintings and with elaborate floor mosaics that were often made to resemble paintings. The wall paintings that survive are remarkable. Beginning in about 80 BCE they evolved from geometric designs imitating marble veneers into full-scale figural scenes in the first century CE. These may depict landscapes, still lifes, or scenes of everyday Roman life, or they may narrate stories from Mythology. Art historians have divided these paintings into four categories, referred to as First, Second, Third, and Fourth Pompeian Style.

◀ PERSPECTIVAL VIEW OF A POMPEIAN HOUSE

▼ *Cult Scene*, from Pompeii. Fresco, c. 62 BCE. Paris, Musée du Louvre

The two seated women to the left wear long tunics that leave one of their shoulders bare. Their faces are delicately and precisely modeled, their gazes distant. One of the women holds out a green bough to a fawn, who nibbles at its leaves. Standing in the center is a woman who seems to be reading something. The solemnity of the scene suggests that it may depict the celebration of a religious ritual whose meaning is now lost.

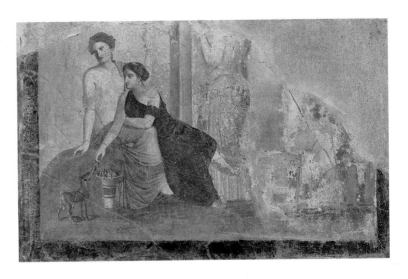

THE FORBIDDEN CITY

The Emperor as the Center of the Universe

The emperor who reigned over the immense territory of China did not govern from a palace, as in the West, but from within a self-contained city at the heart of his capital. The only surviving example of this form of palace complex is the Forbidden City in Beijing. Begun in 1406 at the order of Yongle, second emperor of the Ming dynasty, it has since been rebuilt several times. The oldest buildings date from the eighteenth century, when China was ruled by the Qing dynasty of Manchuria.

The Forbidden City was the symbolic heart of the Chinese world. It was protected by moats and walls entered by several gates, and by high watchtowers that rose at each of its corners. Within, the buildings were placed one after another along a central axis that ran from north to south through the entire complex. The visitor made his way in a manner that was prescribed by a regular and symmetrical sequence of gates, courts, and halls. Since the emperor was considered the center of the universe, each of the ceremonial halls in the Forbidden City bore a name symbolizing the universal harmony of which he was the pivot. Moreover, each building was associated with specific events of the year. The emperor could not circulate freely outside of his private quarters. His movements were strictly regulated by the complex protocols of court life and the imperial calendar.

Ceremonial Buildings

The first and most important of all the buildings in the Forbidden City is called the Hall of Supreme Harmony. The principal ceremonies of the year—the Lunar New Year, the Winter Solstice, and the Emperor's Birthday—were

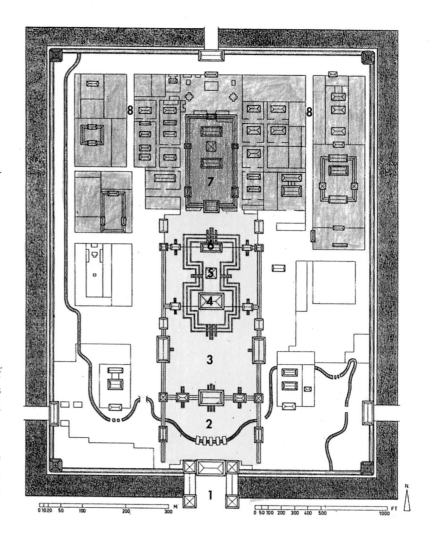

▲ PLAN OF THE FORBIDDEN CITY, BEIJING

The complex lies within a rectangular plan measuring 1,093 x 831 yards.
Entry is through the monumental Meridian Gate (1), a fortified entry structure
pierced by three vaulted passages. Beyond is a vast courtyard traversed by a small canal,
the River of the Golden Waters, which is crossed by five bridges (2),
the central one being reserved for the emperor. After passing through a second gate,
the visitor enters another vast courtyard (3) dominated by a three-stepped platform
from which rise the three buildings used for official ceremonies (4, 5, 6).
Beyond these are the emperor's private quarters (7) and garden, on either side
of which were the residences of members of the imperial family (8).

celebrated here. This is also where new imperial decrees were announced to courtiers and dignitaries.

The second ceremonial building is situated at the center of a terrace. Square in form, its three rows of four columns support a pyramidal roof. The emperor rested here before great ceremonies, and, once a year, here he blessed the new seeds in hopes of ensuring a rich harvest.

After this small pavilion the visitor encounters the third ceremonial building, the Hall of Preserving Harmony. This is where the emperor held banquets for foreign ambassadors and dignitaries. It was also here that he presided over competitions of the imperial academy, in which it was decided which students of the school of government would be awarded the governorships of the eighteen Chinese provinces under the authority of the emperor.

Private Buildings

A large gate flanked by two bronze lions separates the ceremonial buildings from the most secret rooms of the palace, the private quarters of the imperial family. While these were open during the day to certain governmental officials and dignitaries, in the evening the doors closed to exclude all but the emperor, his family, concubines, and eunuchs. Three pavilions of private quarters are aligned along the main north-south axis of the Forbidden City. Initially, the first building was the emperor's personal residence, the second housed the empress's throne, and the third served as her residence.

These were followed by the magnificent imperial garden, dominated by two kiosks from which the emperor could contemplate his beautifully laid-out plantings. On either side were labyrinths of galleries and pavilions housing the imperial wives and concubines; these also housed quiet retreats for the emperor, and rooms where the imperial collections of paintings and works of art were kept.

The houses of noble or wealthy Chinese families have many of the same features as the Forbidden City: interlocking spaces, sequences of courts and galleries, walled gardens. They are smaller variants of the imperial complex, reflecting the same social and familial hierarchy and values that are expressed there.

▶ PORTRAIT OF THE EMPEROR QUIANLONG. Ink drawing on paper (detail), 1748. Paris, Musée de l'Homme

▼ THE HALL OF SUPREME HARMONY

A triple stair of white marble rises to the temple platform. The central stair, carved with dragons, was reserved for the emperor's palanquin. The building itself is rectangular in plan, measuring 197 feet long. Its high red-lacquered columns support a double roof of amber lead-glazed tiles rising to a height of almost ninety-eight feet. The immense hall within, divided by four rows of columns and covered by a richly decorated ceiling, housed the imperial throne, which was flanked by six gilded columns and decorated with dragons.

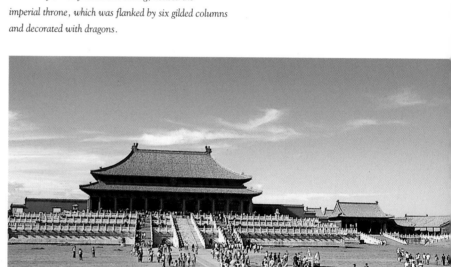

More About Chinese Architecture

Chinese wooden buildings are generally erected on terraces made of tightly compressed earthen blocks; extremely solid, in the imperial residences they are covered with white marble. Chinese walls are not weight-bearing; the roof and upper floors of a building are borne by wooden columns, which also establish strong visual rhythms. Chinese architects perfected an ingenious method of wood-frame construction in which large and small beams are stacked one atop another, supporting the superimposed tile roofs. Usually these roofs are gently curved and rise slightly at each corner, as though drawn toward the sky. They rest almost directly on wooden columns, which have no capitals, as in the West, but rather a system of brackets to support the roof beams.

THE CASTLES OF KINGS AND PRINCES

The English word "castle" is derived from the Latin *castellum*, which means "fortress." The idea of a castle has changed a great deal since the Middle Ages. Initially, it meant a walled feudal residence defended by moats and towers. In the sixteenth century, however, the word began to be applied to the large and beautiful country houses of kings and the nobility.

Fortified Castles

Originally, castles were built on elevated ground to improve their defenses. When this was not feasible, a castle might be built on an artificial mound, surrounded both by a fence made of large wooden stakes, and a moat. Whether on flat or elevated ground, every castle had a central building, or keep, strongly fortified against attack, from which the castle could be defended in an emergency. Soldiers' barracks, storerooms, a chapel, and an assembly room were built against the keep's outer walls. Early castles were made of wood, but in the eleventh and twelfth centuries, the nobility began to build fortresses of stone, whose walls grew progressively thicker and whose towers thrust ever higher.

Pierrefonds: A Classic Example of Castle Architecture

A superb example of medieval castle architecture is the château (French for castle) of Pierrefonds northeast of Paris (see p. 280). According to the architectural historian Eugène-Emmanuel Viollet-le-Duc, who restored this castle in the nineteenth century, it is perhaps the best example of a castle built just at that moment when siege machinery was at its highest degree of development, but before there were canons powerful enough to break through fortress walls. The defensive walls that Viollet-le-Duc restored at Pierrefonds were originally built between 1392 and 1407 by Louis, the duke of Orléans, and dismantled in 1617. The logic of the castle's system of circulation is especially remarkable. The walls were circumscribed by two sentry paths, an upper one protected by battlements—notched walls—and a lower one with a projecting parapet protected by straight walls. The entry gate was heavily fortified and set behind a drawbridge. Observation platforms atop the walls provided a commanding view of the surrounding terrain. Eight towers projected from the outer wall, one of which housed the chapel, and another the dungeons, which could easily be reached from the assembly room where the lord held his court of justice. The barracks communicated directly with the sentry paths. The solidity and efficiency of this plan made it possible for three hundred soldiers to resist assaults by forces ten times as large.

Modern Castles

At the end of the fifteenth century, the feudal system that had been the organizing principle of medieval society was on the decline. Moreover, as gun founders made larger and larger canons, few castles could withstand bombardment. As a result, the old fortresses began to be used as country retreats for the king and the nobility, and architects built, remodeled, and decorated them accordingly. But even as castles lost their military function, they were often built with features reminiscent of their former use. Thus, towers, keeps, and moats were constructed as ornamental elements for houses whose defensive walls had been replaced by courtyards and gardens, and whose interiors were richly decorated. This pattern was retained in most of the châteaus in the Loire Valley in France, which was famous for its beautiful castles. One splendid example from the region is the château of Chambord,

▶ THE CHÂTEAU OF CHAMBORD, Loire Valley, France. Dominique Cortone, architect. 1519–50
Built during the reign of Francis I, Chambord is the earliest French château whose architect is known to us by name. With its keep flanked by four towers and its wall of lower buildings with towers and moats, the castle retains many of the forms of a feudal fortress. The forms of its chimneys, windows, and other decorative elements, as well as the great double-spiral staircase in its great hall, reveal a strong Italian influence.

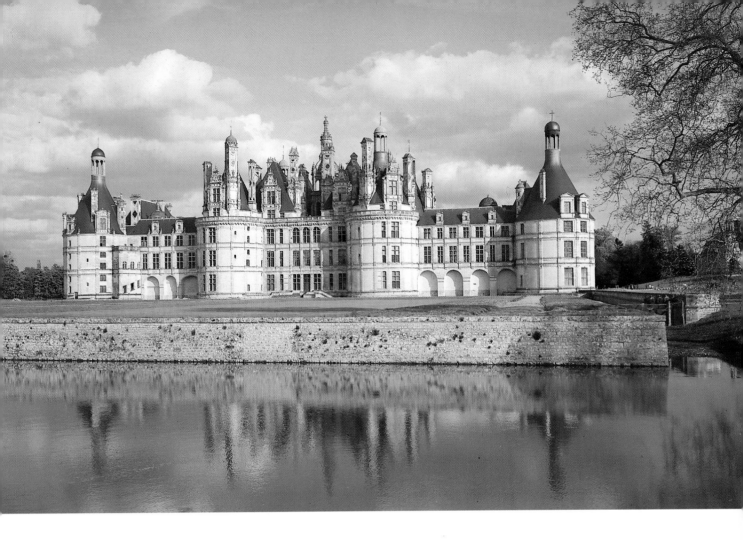

built for Francis I of France between 1519 and 1550, whose general layout and handsome towers recall those of a feudal castle. The château of Fontainebleau, built for the same king between 1528 and 1540, incorporated a medieval keep in its center as a symbol of royal power, but the rest of the building reflected new priorities. For example, there was a long gallery, elaborately decorated with paintings and stucco figures, with large windows to admit light and to provide views of the countryside. Grand galleries like the one at Fontainebleau were to become a characteristic feature of French château architecture.

Castles completely lost their military character in the second half of the sixteenth century, and in the seventeenth century there was a proliferation of new-style castles—country residences with beautiful gardens. Two of the most notable examples are the château of Maisons by Mansart (p. 238), and the enormous château of Versailles, the country palace built outside Paris for Louis XIV of France, which was enlarged and remodeled countless times.

Dream Castles

In the nineteenth century, castles in every conceivable style sprang up in Europe and the United States. In France, the emperor Napoleon III, indulging his nostalgia for the vanished world of chivalry, commissioned Viollet-le-Duc to transform the château of Pierrefonds into a private residence for himself. In 1889 George Vanderbilt, the bookish grandson of the American railroad magnate Cornelius Vanderbilt, commissioned Biltmore, a lavish house near Asheville, North Carolina, that incorporated many features of the Loire châteaus. But perhaps the most fanciful nineteenth-century castle is Neuschwanstein, in the foothills of the Alps near Munich, which King Ludwig II of Bavaria built as a poetic evocation of medieval legends. With such creations a king —or an industrialist—could realize his dreams.

THE CITY

The Medieval City

Cities proliferated in the Middle Ages. When they were independent of the authority of a nobleman or bishop, they often bore names like Villefranche ("free city") and Villeneuve ("new city"). Some were built on the remains of Roman towns and therefore adhered to the standard Roman plan, which consisted of a rectangular grid of streets divided by two large main thoroughfares, one running north and south, the other east and west. Other cities grew up around monasteries and castles, where the inhabitants sought refuge during invasions. Many cities built their own defense systems, surrounding themselves with walls within which residential development was often dense and irregular. Market squares, often with covered halls for buying and selling, were generally the only open spaces.

The Ideal City of the Renaissance

During the Italian Renaissance, the rediscovery of Roman town planning helped create a new idea of what a city should be. After studying the architectural treatise written by the Roman architect Marcus Vitruvius Pollio in the first century BCE, the Florentine architect and antiquarian, Leon Battista Alberti (1404–72), wrote his own treatise explaining how cities could best be made both convenient and beautiful. Alberti's ideal city had its streets laid out to offer perspectival vistas of squares, each with a monument at its center, and each enclosed by buildings with identical or harmonious façades.

Seventeenth- and Eighteenth-Century Realizations

Since most of their buildings were wood, the old cities of Europe were extremely vulnerable to destruction by fire. One of the most devastating of these was the Great Fire of London, in 1666. After this disaster, wooden houses were outlawed in London, as they were in many cities damaged by fire, and the old wooden structures were replaced by new ones of stone

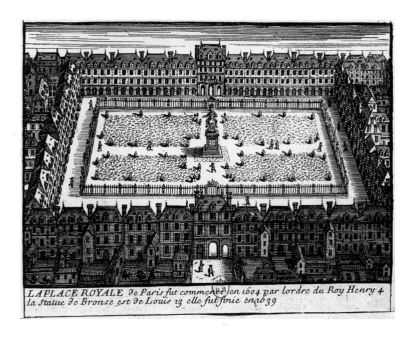

LA PLACE ROYALE de Paris fut commencée en 1604 par lordre du Roy Henry 4
la Statue de Bronze est de Louis 13 elle fut finie en 1639

and brick. Façade design was carefully controlled, and often buildings were made to form continuous street frontages, both for aesthetic effect and to facilitate traffic. The monumental squares built in Italy during the Renaissance and Baroque period inspired architects north of the Alps to build such squares of their own. In France, these often took the form of royal squares, with façades arranged in regular formation around a statue of the king. In Brussels, after the central market square was destroyed by the bombardment ordered by Louis XIV of France in 1695, the houses on the square were rebuilt in a consistent style, with their façades as a harmonious whole.

As city populations grew denser and fresh air was harder to find, houses were built to allow their owners to enjoy as much of the natural world as possible. Often buildings were constructed on embankments, facing the rivers that flowed through the cities—as in London and Paris—or along canals, as in Amsterdam. Similarly, houses in English eighteenth-century cities were placed around garden squares, while French town houses were built with courtyards facing the street, and gardens behind.

▲ PLACE DES VOSGES, Paris. 1605–12

The Place des Vosges in Paris was designed for a building project initiated by Henry IV. Pavilions for the king and queen were built on the square to encourage nobles and members of the middle class to follow the royal example. The façades were to be identical, as were the materials: brick, stone trim, and slate roofs. Originally called the Place Royale, the square was renamed the Place des Vosges in 1799, in honor of the region of France that had been the first to deliver the full amount of its taxes to the government.

Urban Growth in the Modern Era

In the nineteenth-century, train stations, department stores, and other glass-and-iron structures were built in the centers of most large European cities, giving them a modern character. In Paris, an enormous urban renewal project, in which large portions of the old city were demolished and rebuilt, was carried out in the 1860s and 1870s under the direction of Baron Georges Haussmann (1809–1891). Wide avenues were built and planted with trees—to allow the circulation of fresh air as well as for their handsome appearance—which eased the flow of traffic, and incidentally, made the erection of revolutionary barricades virtually impossible. The avenues converged on traffic circles, linking various neighborhoods. Inspired by English models, Haussmann also laid out vast public parks and gardens, which offered places for walking and taking the air.

In many capitals, the now-useless city fortification walls were demolished, making it possible to build new neighborhoods outside the old city centers. In Vienna the walls were replaced by the Ringstrasse, a broad avenue planted with trees and lined with public buildings. In Barcelona, the architect and urbanist Cerdá established a grid for a new quarter, erected outside the old fortifications, consisting of extremely long streets, some extending for thirty miles. Cerdá coined a term to designate the organization of the city and its adaptation to its inhabitants: *urbanism*.

The City of Le Corbusier

The cities we know today are much indebted to the theories of the Franco-Swiss architect Le Corbusier (Charles Edouard Jeanneret; 1887–1965). He believed that old cities should be demolished to provide "clean slates" for the construction of new ones, an idea that he presented at various international congresses on modern architecture. At the congress held in Athens in 1933, he proposed a model that influenced the design of many new cities, especially after World War II. Activities were allocated among four zones dedicated, respectively, to housing, work, relaxation, and traffic circulation. Streets were replaced by highways and small apartment buildings by towers, all surrounded by parks and green belts.

For a Human City

In the 1960s, the growing size and impersonality of many modern cities drew considerable criticism. Some architects, hoping to recover the qualities of life that made older cities so pleasant and interesting, focused their energies on city centers. Between 1984 and 1987, several famous architects, each working in his own style, remodeled one of Berlin's old neighborhoods for an international architecture exhibition. The idea was to demonstrate that old neighborhoods could be revitalized without demolishing them, and that there were many possibilities for urban renewal other than the massive and impersonal developments that had disfigured so many cities after World War II. The fact that metropolitan centers so often attract more people than they can house remains a constant problem, and solutions to it remain elusive.

◄ LE CORBUSIER. *Design for a contemporary city of three million inhabitants.* Gouache on paper, 1922. Paris, Fondation Le Corbusier *Exhibited at the Salon d'Automne in Paris in 1922, this is one of Le Corbusier's earliest depictions of the modern city he hoped would replace traditional ones. In his conception, housing would be concentrated in immense skyscrapers surrounded by parks, and residents could contemplate this new urban landscape from terraces awash in sunlight.*

HOUSES IN NATURE

In Europe, the dream of living in a quiet house in the country, far from the noise and pollution of the industrial city, flourished in the second half of the nineteenth century.

▲ SCHRÖDER HOUSE, Utrecht, The Netherlands. Gerrit Thomas Rietveld, architect. 1924 *Like the painters and sculptors of the De Stijl movement, Rietveld used only rectangles, verticals, and horizontals, and restricted his palette to primary colors (red, yellow, blue) and black and white. The result resembles a painting by Mondrian.*

In England, where industrialization had proceeded at a feverish pace, the notion of returning to nature had special appeal. Houses began to be viewed as refuges from modern life. Wood, brick, and stone "cottages" with white walls and broad protective roofs became very popular.

The color of brick gave its name to the Red House, which the artist William Morris (1834–96) had built for himself in 1859 to designs by his friend Philip Webb. Morris, who wanted no conventional industrial artifacts in his home, designed the furniture himself, had craftsmen build it, and then had it painted by his artist friends. This experience gave him the idea of establishing a workshop in which artists and craftsmen would design wallpaper, fabrics, and ceramics for interior decoration.

In 1895–96, the Belgian painter Henry Van de Velde (1863–1957), inspired by Morris's example, had Bloemenwerf House ("House of Flowers") built to his own specifications. He designed every detail of his life there, from the interior decoration to gowns for his wife. After becoming an architect, he founded a workshop for the production of elegant but simple furniture. As a result of such experiments as these, houses began to be conceived as integrated ensembles. Architects started to design furniture and establish workshops for the production of beautiful objects for daily use. Around 1900, the shop Art Nouveau in Paris sold furniture and decorative objects produced in the workshops of William Morris in London, Van de Velde in Brussels, Joseph Hoffmann in Vienna, and Charles Rennie Mackintosh in Edinburgh. Thus the name "Art Nouveau" became associated with the style shared by these artists, which was based on geometric and floral motifs, and which was characterized by the use of common materials and new techniques.

The House Open to Nature

English cottages became very popular in the United States in the late nineteenth century. They were perfectly appropriate to the great American spaces; the wood with which they were built recalled the simple life of the pioneers, and their porches eased the transition between inside and outside.

In the early twentieth century, the houses of Frank Lloyd Wright (1867–1959) achieved even greater integration with nature. Emphatically horizontal, they nestled below the surrounding trees and seemed to hug the ground (p. 283). With their cantilevered terraces and large windows, these houses welcomed nature inside.

In 1949, Philip Johnson (b. 1906) built a house in New Canaan, Connecticut, that took this tendency to its logical conclusion. A pristine glass rectangle, it offers unobstructed

views of the surrounding landscape. Only the bathrooms are enclosed within a brick column, although moveable interior walls make it possible to create isolated private areas.

Distinct from Nature

After World War I, the residential house became a focus of experimentation. The Schröder House, built in Utrecht by the Dutch designer Gerrit Thomas Rietveld (1888–1964) in 1924, applied the ideas of the strictly geometrical Dutch modernist movement known as *De Stijl*. Here the house is a work of art within, although quite distinct from, nature.

The Villa Savoye, built by Le Corbusier in Poissy, France, in 1929, is also essentially a beautiful object set down in nature. Le Corbusier here applied the ideas of the modern house he had proposed in his treatise *Five*

Architectural Points: houses should be raised on piles to lift them above ground; they should have roof terraces; they should have a long strip of horizontal; their different floors need not adhere to the same plan, for the interior walls are no longer load-bearing; their façades, being merely envelopes, could be pierced by large windows. These principles could be applied anywhere, regardless of where a house was situated.

The houses built by the Swiss-Italian architect Mario Botta (b. 1943) in the 1970s are strangers in their environment. Their large walls are barriers meant to fend off the outside, while their interiors are protected shelters. Featuring overhead lighting, they are almost windowless except for a few dormer windows that frame the landscape like paintings. Here the house is set apart from nature.

▼ FALLINGWATER. **Frank Lloyd Wright, architect. 1936** *Built over a waterfall in rural Pennsylvania, Fallingwater is a superb example of a house made to blend into its natural surroundings. Its cantilevered terraces and balconies extend outward from a central core, displaying Wright's remarkable mastery of reinforced concrete construction.*

COLLECTIVE HOUSING

Rapid industrial development in the nineteenth century created a need for workers. Drawn by the prospect of employment, country people emigrated to the cities. Poorly paid, they were also badly housed, crowding into cramped and unhealthy neighborhoods on the outskirts of cities. The construction of affordable housing for these workers quickly became a matter of concern.

Cities in the Country

The cause of the workers was first championed by the early nineteenth-century "utopians," who envisioned communities with day-care centers and schools in which people would share their work, lodgings, and leisure time. They saw no reason why cities could not be extended infinitely, maintaining that when one reached its limits another could begin.

In the second half of the nineteenth century, industrialists built housing complexes for workers near the factories where they were employed. Long streets lined by modest houses with private gardens led to squares lined by a town hall, schools, and shops. In the north of France, such housing complexes for miners were known as *corons*.

In England, the social reformer Ebenezer Howard (1850–1928) championed the development of "garden cities." In their center were a train station, shops gathered in glass-covered buildings, and a theater. This core was surrounded by a green belt, which was in turn surrounded by house-lined boulevards. A final ring of industrial facilities and cultivated land provided work and nourishment for the inhabitants.

The English model proved very successful in northern Europe in the early twentieth century. The German architect Bruno Taut (1880–1938) built one of the first garden cities in Berlin, an experiment that prompted the building of many more in Germany, where such "green cities" were welcomed as an alternative to the "gray" industrial ones. In France, the influence of the garden city movement can be seen in the design of the city of Suresnes in the suburbs of Paris, built by Henri Sellier beginning in 1921.

In 1901 the Lyon-born architect Tony Garnier (1869–1948) drew up plans for an industrial city that revolutionized urbanism. It featured different road systems for pedestrians and vehicles, many green spaces, and distinct areas for a number of activities such as public services, housing, and leisure activities.

The use of identical house designs made it

▶ THE INDUSTRIAL CITY, Tony Garnier, architect. Residential quarter, plates 73 and 75
Tony Garnier worked on this scheme for a new city from 1899 to 1917. It was the first urbanist manifesto of the twentieth century. Houses were set within a grid of streets designed to facilitate traffic, and ample space was set aside for parks and greenery.

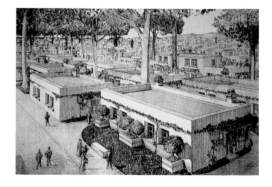

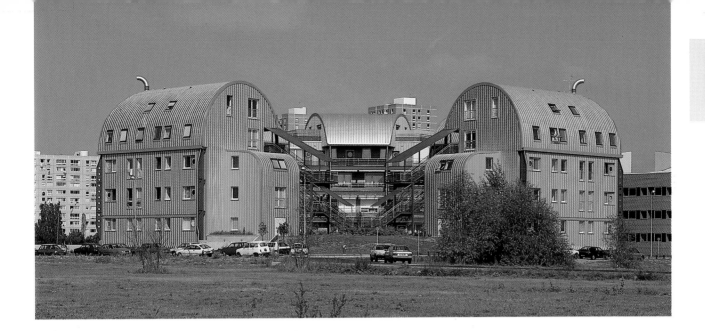

possible to mass-produce many of their components, including doors, windows, fireplaces, and kitchen and bathroom facilities. Such mass production considerably reduced construction costs, placing "standardized" housing within the reach of many workers.

Le Corbusier's "Machines for Living"

After World War I, the question of housing acquired special urgency in many European countries. The governments of Belgium and France encouraged the development of affordable housing, known as HBMs from the French words *habitations à bon marché*, that is, "inexpensive housing." The simple volumes of these designs, with their flat roofs and terraces, bring Cubism to mind. Between 1925 and 1935, the fortifications built around Paris in 1845 were replaced by a belt of HBMs made of inexpensive materials, primarily brick and concrete.

Le Corbusier was convinced that the housing shortage could be solved by mass production. He envisioned standardized "machines for living" that could easily be manufactured in large numbers. To maximize the use of space, he advocated the use of apartment towers containing spacious housing units with ample light and views of nature. At his urging, the International Congress of Modern Architecture, or CIAM, sought to establish guidelines for such maximum-efficiency housing in the 1930s.

From Reconstruction to New Cities

Massive destruction during World War II left much of Europe in ruins. Many people lost their homes and were forced to live in temporary lodgings. Thus, large-scale communal housing became a necessity. In 1950, HBMs were replaced by HLMs (for *habitations à loyer modéré*, or "housing with moderate rents"). The experiments of the 1930s were resumed as still more apartment towers sprang up in green belts. Between 1947 and 1952, Le Corbusier erected the first of his Radiant City designs in Marseille, an immense concrete slab of functional duplex apartments of various sizes. But most of these "modern cities" were more like characterless barracks dependent on nearby urban centers. Many such complexes were built in the 1960s, but their rapid degradation, hastened by the dissatisfaction of their residents, who found them far too impersonal, led to the abandonment of such designs.

In Paris, another approach was attempted. Five new cities were built within commuting distance of the city. Currently, architects working in collaboration with sociologists are trying to determine the needs of their future inhabitants, who sometimes participate in the design process. Aware of the need to make such housing attractive to them, the Catalan architect Ricardo Bofill has declared that his aim is to build "châteaus of Versailles for the poor."

▲ KRONOS, SUBSIDIZED HOUSING ON BEAULIEU ISLAND, Nantes, France. Dubose and Landowski, architects. 1991
This apartment project was named Kronos, the Greek name for the god Saturn, because the arrangement of the buildings was meant to suggest one of the rings of the planet Saturn. The corrugated steel used here has been treated with a weather-resistant resin and painted gold. The result is an inexpensive, but attractive, building material. Covered stairways provide access to a central garden flooded with light and planted with magnolias, where residents can meet and socialize.

ARCHITECTURE AND SPECTACLE

Theaters are designed to make it possible for an audience to see and hear performances in the best possible conditions. Viewers are arranged side by side on steps or in individual boxes.

Step Theaters

Theaters arranged with seating that rose in steps up from the stage first appeared in ancient Greece. Since the climate was warm, performances were given in the open air. The audience was seated on simple stone seats rising in a semicircle and set into the side of a hill. Below them was the stage, consisting of a round area for the chorus (which sang during part of the performance) and an elevated platform for the actors. Behind them was a wall that improved the acoustics and provided a framework for sets.

The Romans retained the Greek model but used it in places where there were no hillsides in which to set the rows of seats, which thus had to be supported by structural elements in the theater building. The stage, now semicircular, was set against a wall resembling a palace façade that functioned as a permanent set.

In the Renaissance, the Italian architect Palladio built step theaters inspired by ancient models for the performance of ancient plays. In his magnificent Teatro Olimpico, in the north Italian town of Vicenza, the public sits on semicircular steps like those of a Roman theater, and the wall backing the stage creates a perspectival illusion of three city streets receding into the distance.

It has been suggested that spectators seated on steps feel close to the performance, almost as though they were participating in it. The German composer Richard Wagner, who valued a sense of communion with his public, used a version of the stepped arrangement in the theater he created in Bayreuth in the late nineteenth century. Thanks to electric lighting, the audience could now be plunged into darkness while the stage was lit. Here the music seems to come from nowhere, for the

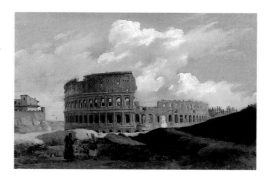

musicians are invisible, occupying a deep, hooded pit just in front of the stage.

Arena Theaters

These are theaters in which the stage, called an arena, is completely surrounded by stepped seating. They are modeled after ancient Roman amphitheaters, which were called arenas (Latin for "sand") after the sand scattered on the ground to absorb the large quantities of blood spilt during gladiatorial combats and wild animal hunts that were staged in them. Roman arenas are the ancestors of modern sports stadiums, and a number of Roman ones are still used today for bullfights and circus performances.

Theaters with Boxes

Theater boxes make it possible for parts of the audience to be separated from one another according to their social class. English theaters of the Elizabethan period, built of wood, were erected outside the city walls. Performances took place in the open, with the audience standing in the "pit" and seated on benches in covered galleries. This arrangement, used in Shakespeare's Globe Theater, was inspired by inn courtyards, which had often served as impromptu theaters.

Italian opera houses of the seventeenth cen-

◀ ACHILLE-ETNA MICHALLON. *View of the Colosseum.* Oil on canvas, nineteenth century. Paris, Musée du Louvre

The Colosseum, or Flavian Amphitheater, completed in 80 CE, took its name from a colossus—a 115-foot-high statue of the emperor Nero—that originally stood nearby. The building was huge. Its perimeter measured 1,720 feet; it contained eighty stepped levels; and it could hold 50,000 spectators. Here the Roman emperors provided the city's inhabitants with extravagant spectacles, which were attended by people of every social class. The emperor and his family were accorded the privilege of seating in a special box of comfortable benches with an excellent view of the events.

 See: Palladio, p. 253.

tury also featured galleries of seats. Balconies ringing the hall at several levels were divided into boxes which could be rented by wealthy families. The best seat in the house was reserved for the local ruler, whose box was directly opposite the stage. The worst seats were in the orchestra, where the audience had to stand packed together, their view often blocked by the musicians in front of the stage and by the chairs of nobility, who were often allowed to sit on the stage until the eighteenth century.

These U-shaped "Italian" theaters gradually became more common than other theater arrangements, replacing the rectangular "French" theaters, which were derived from enclosed tennis courts.

In nineteenth-century theaters and opera houses, the public spent as much time looking at other audience members in their boxes as at the performance. Smoking rooms and restaurants made it possible to relax during intermissions. In general, more space was devoted to imposing entry halls, majestic staircases, and huge backstage areas for sets and machinery than to the theaters themselves.

New Experiments

In the twentieth century, some theatrical performances have become experimental events in which the spectator participates. The architect Andreas Weininger, a member of the Ger-

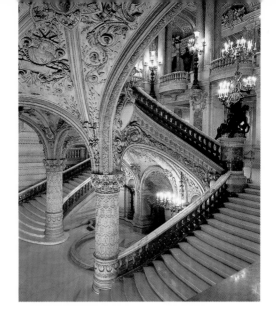

◀ STAIRCASE OF THE PARIS OPERA HOUSE. Charles Garnier, architect. 1862–74
The Paris Opera House is characteristic of the opulent Second Empire style associated with the reign of Napoleon III. The staircase is a setting for spectacle; its rich decoration in marble, bronze, and gold was intended to provide a sumptuous setting for the elegant ladies and gentlemen who attended the performances.

man avant-garde school known as the Bauhaus, envisioned a "spherical theater" whose auditorium, shaped like a deep funnel, would plunge onto the stage; Walter Gropius (1838–1969), another Bauhaus architect, designed a "total theater" with three stages that could be used simultaneously. These projects were never realized, but they anticipated adaptable theaters whose shapes could be altered to stage performances of different kinds.

To accommodate the growing public for the arts, many complexes are now being built with opera houses, concert halls, dance theaters, and movie houses. They use both balconies and stepped seating, sometimes combining the two in novel ways.

▶ SYDNEY OPERA HOUSE, Sydney, Australia. Jorn Utzon, architect. 1956–73
Jorn Utzon won a competition for his innovative design for the Sidney Opera House, which also includes a theater and a concert hall. The billowing forms of the roof, which are covered in ceramic tiles, were intended to suggest the sails of schooners coming into the harbor.

SKYSCRAPERS AND TOWERS

Twentieth-Century Skyscrapers

The skyscraper is an American invention. In 1871, Chicago was destroyed by fire. Reconstruction was a necessity, but land was expensive and the great city was attracting more people than it could comfortably house. To create more space, buildings were built taller than ever before. Already in 1851, the American inventor Elisha Graves Otis (1811–61) had developed the steam-driven elevator, which had made it possible to carry people and freight to upper floors with little effort. At that time, however, it was impossible to build higher than six stories, since the weight of the stone or brick of the upper stories would crush the foundations.

During a period of study in France, the American architect William Le Baron Jenney (1831–1907) was introduced to the structural potential of iron. After his return to America, he was among the first to use steel, a light but resilient industrially-produced variant of iron, in office buildings. He began by reinforcing brick walls with steel columns, but in the early 1880s he discovered the advantages of steel-frame construction, which made it possible for a metal skeleton to carry a building's full weight. In such a skeletal support system, the

Skyscrapers, an especially spectacular form of architecture, are the symbol of the modern city. Thanks to new techniques and materials, they continue to rise ever higher. The skyscrapers of Manhattan, Hong Kong, Tokyo, La Défense in Paris, and the "City" in London are urban emblems of ambition and success and the world of business and finance.

walls were no more than curtains, which meant that the façade could be made of light, thin materials like ceramic, which was cheap and easy to maintain, or even glass, which made it possible to multiply the number of windows. The architect Louis Sullivan (1856–1924) was partial to industrially molded terra cotta, whose pliability and naturally warm color allowed him to create idiosyncratic effects over large areas.

In the last decade of the nineteenth century and early years of the twentieth, skyscrapers of twelve, fourteen, or twenty floors and equipped with elevators were built. In these structures vertical accents emphasizing the building's height tended to replace such traditional horizontal forms as moldings, running friezes, balconies, and cornices.

Skyscrapers are divided into three parts of unequal size: a base, which ties the building to the street and contains the entrances; the superimposed floors; and a summit, in which ventilators, elevator machinery, and other service facilities are hidden.

In the period preceding World War I, skyscrapers in New York grew higher and higher. Some of them abandoned the modern forms developed specifically for office build-

ings in favor of others inspired by Gothic cathedrals.

Skyscrapers During the Interwar Period

Architecture profited from the technical advances made during World War I. In the 1920s, thirty-story buildings became increasingly common, and in 1931 the Empire State Building in New York rose to 102 stories. It became the symbol of the preceding decade of enterprise and prosperity. More and more towers sprang up, often resembling gigantic art deco sculptures surmounted by slender steeples. But the stock market crash of 1929 brought an end to this building boom.

In the 1930s, Austrian and German architects fleeing the Nazis sought refuge in the United States. They invented the so-called "international style" skyscraper, which was

◀ "THE CITY" OF LONDON

Although it dates from the last century, recently the part of London known as "the City" has taken on a resolutely modern character, its site by the Thames dominated by towering skyscrapers designed by architects of the late twentieth century.

◀ The architect WILLIAM VAN ALEN wearing a "Chrysler Building" costume for the ballet *Skyline*, New York, 1931

▶ THE CHRYSLER BUILDING, New York. William van Alen, architect. 1930

This skyscraper, 1,050 feet high, designed by William van Alen as a headquarters for the Chrysler Corporation, is a classic example of Art Deco architecture. Its metal-sheathed geometric summit is intended to suggest the radiator grilles and hubcaps of Chrysler automobiles.

composed of pristine geometric shapes. After World War II, their designs became a model for similar buildings throughout the world. Skyscrapers by Ludwig Mies van der Rohe (1886–1969), a German architect who began his work in Berlin but emigrated to the United States in 1938, are shaped like simple blocks. Their glass façades seem to be mirrors reflecting the city.

Concrete Skyscrapers

Less expensive than steel, reinforced concrete was widely used for construction in the 1960s and 1970s. The structural skeletons of these buildings are made not of steel but of reinforced concrete. Concrete, which is made from a mixture of sand, gravel, and water, can be molded into any number of forms. In reinforced concrete, it is strengthened by the insertion of metal armatures before it hardens.

The components of such buildings could be prefabricated, making great height easier to attain. Apartment buildings were now built as towers, and office buildings were erected with as many as a hundred floors.

Skyscrapers in the 1980s

Skyscrapers rose in all the great cities. Some architects, specialists in the "high-tech" look, stressed their use of modern industrial materials. Norman Foster and Richard Rogers designed skyscrapers resembling glass-and-steel machines. Their buildings often display the elevators and ventilation systems on the exteriors, liberating the interior space; light could penetrate their glass walls to create spectacular light wells at their cores.

Other architects rejected the modernist aesthetic of structural simplicity, incorporating the columns and pediments of classical architecture into their skyscrapers. The result was the "post-modern" skyscraper.

It is now rare for skyscrapers to have more then fifty floors, but the aspiration to build ever higher persists. In 1991, Jean Nouvel won the competition for a building to be constructed in La Défense, a quarter of Paris built in the 1970s, with a design for an "endless tower." If it is ever built, it will be some 1,380 feet high and its summit will disappear into the heavens.

FACTORY ARCHITECTURE

In the Middle Ages, craftsmen worked in workshops in their own homes. Later, when they began to work for kings, they did so in separate communal workshops. Eventually a new type of architecture appeared: industrial architecture.

Palaces for the Royal Manufactories

In the seventeenth century, Jean-Baptiste Colbert (1619–83), the chief minister of Louis XIV, established the royal manufactories, which continued to operate through the eighteenth century. They alone were authorized to produce certain art objects, the secrets of whose fabrication were carefully guarded. The Gobelins factory made tapestries, Sèvres made porcelain, and Saint-Gobain made mirrors for such grand interiors as the Gallery of Mirrors at the palace of Versailles. The façades of these manufactories resembled palaces, to evoke the power of the king. At the royal salt refinery in Arc-et-Senans, the only French facility allowed to produce this seasoning, the architect Claude-Nicolas Ledoux (1736–1806) designed a complex reflecting the organization of monarchical society. The director's house, symbolizing the king, stood in the center, with the other buildings symmetrically arrayed around it.

An Architecture of Work

English textile factories of the late eighteenth and early nineteenth centuries were the first to reflect the new working conditions. Energy was provided first by watermills and then, beginning in the mid-nineteenth century, by steam. The buildings were long rectangles several stories high. The mechanical looms that now replaced the old manual ones were

massive, requiring vast interior spaces as well as vibration-resistant floors capable of supporting their weight. New building techniques and industrially produced materials were tried: cast iron columns supported iron beams on which wooden floors were laid to absorb the vibrations. The looms were placed along the windows to assure ample light and allow for a central corridor through which raw materials could be delivered and woven cloth removed.

In the late nineteenth century, the French architect Jules Saulnier (1828–1900) hit upon an important innovation in his design for the new Menier chocolate factory in Noisel. Inspired by metal bridges, he used an exposed metal skeleton of crisscrossing beams whose gaps were filled by bricks. Many architects, including Gustave Eiffel (1832–1923), the architect of the famous Eiffel tower in Paris, were influenced by this building.

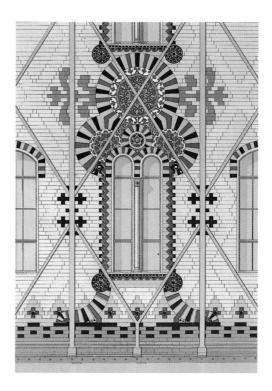

◄ MENIER CHOCOLATE FACTORY (detail of the façade). From the *Encyclopédie d'architecture,* 1877
Built at Noisel, near Paris, by the architect Jules Saulnier in 1871–72, this factory was the first building to be supported by an exposed metal skeleton. The glazed-brick designs on the façades were inspired by the Menier family monogram and the flower of the cocoa plant.

▶ *Bottom:*
THOMSON FACTORY. Guyancourt, Saint-Quentin-en-Yvelines, France. Renzo Piano, architect. 1989–91
Here the Italian architect Renzo Piano has achieved a distinctive harmony of architecture and landscape. The factory seems rooted in the soil, standing firm against the winds that buffet the plain. From a distance, its arched roofs seem to redefine the horizon. The complex is unified by a consistent color scheme of blue, grayish white, and red.

Castles of Industry

In the beginning, industrial architecture was strictly utilitarian, forgoing any hint of decoration except for severe neoclassical window frames. But the phenomenal industrial development of the second half of the nineteenth century made factories symbols of economic prosperity. Architects were now expected to express this new power within limited budgets. Industrially produced brick fit the bill perfectly, for it was cheap and could be used to make colorful decorative patterns. Stair towers and smokestacks were ornamented and, sometimes, the tops of the buildings were crenelated like battlements, making factories resemble medieval fortresses, Renaissance palaces, and even oriental palaces.

▼ BRAUN FACTORY, Melsungen, Germany. James Stirling, architect. 1992
The English architect James Stirling, inspired by Le Corbusier, experimented with new techniques and with audacious contrasts of materials and colors.

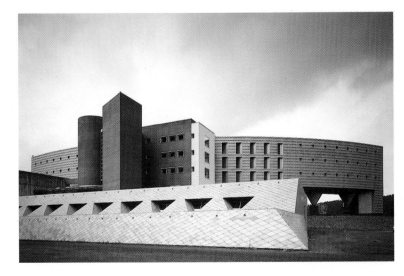

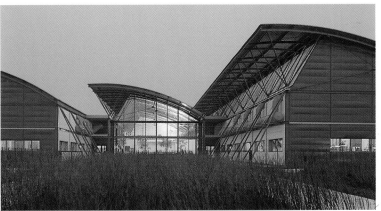

Concrete, Glass, and Steel

Industrialists lived in fear of fires that would put a stop to production. At the end of the nineteenth century, the architect François Hennebique (1842–1921) devised a kind of reinforced concrete that was more resistant to fire than metal structures.

In the early twentieth century, the German architect Peter Behrens (1868–1940) built concrete factories for the AEG firm that inaugurated a new approach to industrial architecture. His designs, which were functional but had a machine-like beauty, became a point of pride for the company.

On the eve of World War I, Walter Gropius (1883–1969), who had studied with Behrens, and was later to teach at the Bauhaus school, built the Fagus factory—a shoe-last manufactory—in Alfeld-an-der-Leine, Germany, in which he replaced concrete walls with large windows supported by brick and metal armatures.

Industrial Zones

Industrial booms followed each of the two world wars, prompting the construction of many factories. In the 1930s, thousands of prefabricated ones sprang up on the outskirts of cities throughout the world, many of them built by the French firms of Hennebique and Eiffel and the American firm of Albert Kahn, Inc. After World War II, factories were consigned to industrial zones and tended to take the form of readily adaptable but anonymous boxes.

Industrial Architecture as a Form of Publicity

In the 1980s, large manufacturers began to commission spectacular factories from prestigious architects. These buildings function as a kind of publicity, attracting the attention of passers-by and even the occasional visitor. They also foster a sense of community among the workers. Such designs revive something of the original mandate of industrial architecture, which was to provide efficient working environments at minimal expense in buildings that also function as trademarks.

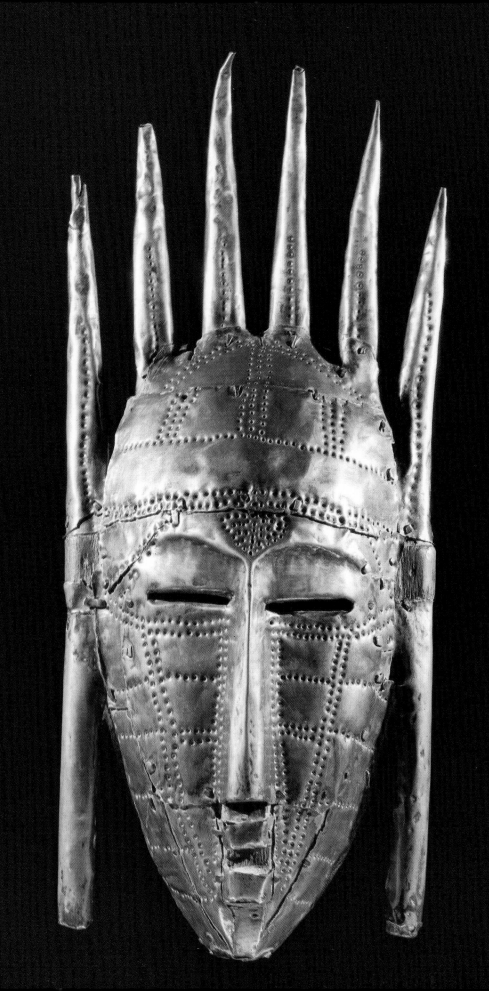

To sculpt is to make solids and voids work together. By modeling clay, carving stone, or assembling pieces of wood, metal, and glass, and sometimes even whole objects, sculptors create forms that no longer remain flat like a painting on the wall but occupy space in three dimensions. Viewers can often walk around them; when they do, the forms change beneath their eyes as new spatial relationships reveal themselves.

A sculptor's choice of material and technique is very important, for it has a crucial effect on the impression a sculpture will make. To cite one example, a bust made of terra cotta will appear vivacious while the same bust carved in marble will seem more majestic.

The art of sculpture is extremely various, encompassing a range of objects from carved devotional images with almost magical powers ascribed to them to twentieth-century "ready-mades," from prehistoric amulets to the Great Sphinx of Giza in Egypt, from Greek marbles to the dustbin accumulations of the New Realists.

THE ART OF SCULPTURE

Bamana or Marka mask; see p. 103.

WHAT IS A SCULPTURE?

In the Book of Genesis, God created first the heavens and the earth, then the plants and animals. Finally, he took clay, modeled a human being in his own image, and breathed life into it. This story is told not only at the beginning of the Judeo-Christian Bible, but in the traditions of Greek and Roman mythology.

In ancient Greece, for example, Prometheus, one of the Titans—primeval divinities who fought with the gods for control of the world—modeled a man from clay and made him animate with a spark of divine fire. In this myth, fire was the source of life.

According to another Greek legend, Pygmalion, a famous sculptor from Cyprus, had almost completed a magnificent statue of a woman. Proud of his work, which was nearly perfect, he named it Galatea. While his hands were touching the sculpture, he felt it move beneath his fingers. His creation was transformed into a real young woman, with whom he fell in love, and eventually married. In this legend, beauty was the source of life.

Like the gods, sculptors seem to be capable of infusing matter with life. The great Italian Renaissance sculptor Michelangelo is said to have once turned to one of his sculptures and said, "Speak!" as though it were a living being.

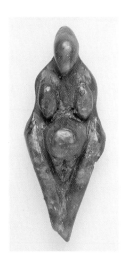

▲ **FEMALE FIGURE.**
c. 20,000 BCE. Soap-
stone, height 2⁷⁄₁₆ inches.
Saint-Germain-en-Laye,
France, Musée des
Antiquités Nationales
This statuette is from the
Grimaldi Cave in Italy. Its
imposing forms suggest the
presence of divine powers.

The Spirit of Matter

From prehistory, people have worked stone, clay, and wood. The first weapons and tools were made of stone, and ancient peoples are believed to have thought that every material embodied a spirit that could be liberated from it by some act of magic. Working with their hands and simple tools, ancient people fashioned human and animal figures, which may have represented protective spirits or divinities.

The earliest statuettes known, which are probably more than thirty thousand years old, depict women with large breasts and projecting bellies, attributes that suggest fertility. These figures may have had some magical function to guarantee fruitfulness, of the earth, and of the makers themselves. In less remote antiquity, the Greeks and Romans made sculptures first of their gods, and later of famous men. In the Middle Ages, statues of saints and kings, who were thought of as God's representatives on earth, were carved to decorate the great cathedrals. Similar stone likenesses were also carved for tombs.

Solids and Voids

A sculpture is an artful combination of three-dimensional solids, hollows, and voids. Its appearance changes with the viewer's point of view and the lighting.

Sculpture can be either free-standing or in re-

▼ **AUGUSTE RODIN (1840–1917).** *The Hand of God.*
c. 1897. Marble, height 16 inches. Paris, Musée Rodin
Rodin here draws a parallel between his own work as a
sculptor with God's modeling of Adam and Eve in the Bible,
suggesting that they both sought to make their ideas
take shape in matter. The marks left by Rodin's tools
attest to his struggle with the stone.

 See: Romanesque Churches, pp. 58–59; Michelangelo, p. 244; Rodin, p. 263; Daumier, p. 201.

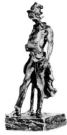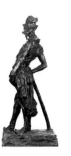

lief. A free-standing sculpture is a completely independent form; the viewer can—theoretically, at least—move around it. In contrast, relief sculpture is attached to its background. When the forms project only slightly above the surrounding plane, the work is said to be in low relief. When they project strongly—sometimes they are almost completely detached—the sculpture is said to be in high relief. Lines engraved on a stone or other surface may also be called relief sculpture.

The Art of Balance
The word statue is often used to designate a free-standing sculpture. Derived from the Latin verb *stare,* "to stand upright," it suggests the importance of balance in sculpture. Naturally, sculptors must take into account the weight and density of their chosen material when designing a work. If a figure's arms are too thin, they will break; if the center of gravity is too high, or the work is not firmly grounded, it will fall over. In the Middle Ages, statues on cathedral façades were carved from single blocks of stone. The arms of these monolithic figures often remain at their sides; such figures are sometimes called "column statues" because of their columnar form.

The Play of Light and Shadow
The role of light is essential to the effect of sculpture. Light throws projections into relief, accentuating both the forms and the modeling. Materials with matte surfaces, like plaster and clay, seem to absorb light, while those with shiny surfaces, like bronze and copper, reflect it. White marble, especially the marble from the quarries at Carrara, Italy, is preferred by many artists, who consider it the noblest material for carving. Light falling on its smooth surfaces is caught by its rough ones with special subtlety, revealing its grain, which can resemble the texture of skin.

A Change of Course
In the twentieth century the imitation of nature has ceased to be a central preoccupation in sculpture, as it has in painting. Sculptors have experimented with new forms, materials, and modes of presentation; they have developed new ways to make sculpture, by assembling, joining, or even smashing materials of all kinds, and exhibiting them in unexpected ways. They have also made use of manufactured materials such as plastic, rubber, resin, and concrete. Some artists have even assembled sculpture of food products, studying their transformation over time.

Bases are less common. Instead of isolating sculpture on a raised block that prevents us from approaching the work, sculptures are often set directly on the ground. Sometimes they move, produce sounds, or toss balloons or water into the air. Occasionally, a work is a large construction that viewers may enter to explore the space within.

Some sculptors no longer work with their own hands, instead having their ideas executed by others, often in industrial workshops.

Still others have made their mark on the earth itself, transforming the landscape by carving, bulldozing, mound-building, or by introducing such man-made additions as walls, pillars, fountains, or even ephemeral structures such as curtains, umbrellas, or banners.

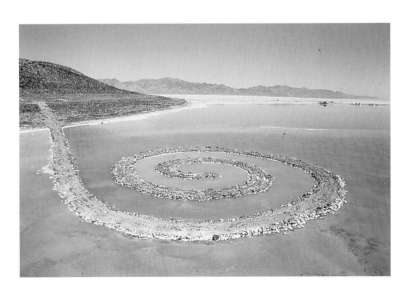

HOW IS A SCULPTURE MADE?

Essentially, sculpture can be made in any of three ways: carving, modeling, and casting. Each of these methods calls for different materials.

Clay and wax are used for modeling. Wood, marble, stone, and a few other hard materials like ivory or bone are carved with sculptor's tools. Bronze, iron, silver, gold, and other metals are used for casting.

Large sculptures of wood or marble are often composed of several different pieces, with the joins of heads, hands, feet, and the like hidden by drapery folds. In much of the ancient world the skin, lips, and clothing of statues were painted in bright colors to give them vibrancy, and, in the case of outdoor sculpture, to make them more visible in bright sunlight.

Adding and Removing: Modeling

When an artist uses a pliable material like clay or wax, he begins by building an armature of wire or wood to assure its stability.

Clay is the material most often used, for it can be found everywhere. It is also extremely soft, which makes it easy to add or remove material to refine the forms. There are two ways to preserve a form made in clay: by firing it in a kiln; or by making a plaster model of it. In the second case, the clay is first covered with plaster and then, after the plaster has dried, it is removed. This produces a plaster mold of the clay form. Liquid plaster is then poured into the mold. After the new plaster has dried, the mold is broken to reveal a plaster version of the original work in clay.

Carving

Carving is the process of cutting or chiseling a block of stone or a piece of wood in order to gradually remove material from it.

There are several successive phases in the process of carving. First the block is cut and trimmed roughly in the general shape finally intended for the work. Then the fine carving begins. During this stage, the shapes and relief effects of the work are cut with a good deal of precision. Then the piece is finished, that is, the more subtle details of modeling and cutting are completed. Stone sculptors use

▼ Stages in the casting of *Small Female Faun* by Auguste Rodin at the Coubertin foundry, using the lost wax method

1. The sculptor creates a model—usually plaster—to send to the foundry.

2. Using elastic material in a solid container, the founder makes a mold of the model.

3. The mold is used to make a model of fireproof cement that will serve as the core of the bronze during casting. Iron shafts are inserted to make sure it remains stationary within the mold.

4. The surface of the core is worn down, creating a narrow space between it and the mold.

5. Melted wax is poured into the mold, filling the space between it and the cement core. The mold is then removed, revealing the core shape covered with a layer of wax. The artist's signature, the casting number, and the foundry stamp are imprinted in the wax.

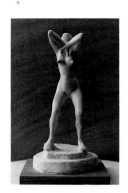

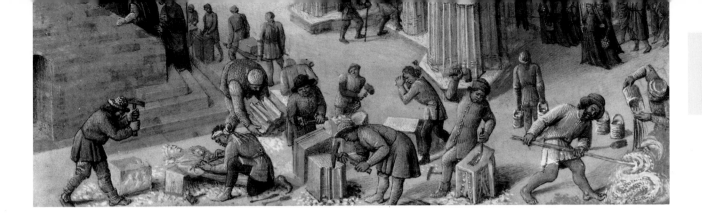

punches and chisels of various kinds—flat, broad-bladed, or clawed—to remove material from the block and to shape what remains. If the material is particularly hard, these tools may be struck with mallets to penetrate the surface. Finally, the surface may be refined by polishing with abrasives, to create a smooth surface, if this is desired, and to erase marks left by the chisels.

By the end of the eighteenth century, some artists had begun to have the actual carving of their works done by artisans, who faithfully copied a clay or plaster model provided by the artist. The resulting piece could be larger or smaller than the model produced by the artist. Such shifts of scale were facilitated by a procedure known as pointing, in which a network of points was marked on the model, and then transferred in enlarged or reduced dimensions

to the new block of stone or wood. An artisan could then block out the basic shapes, or even bring the final work to completion. Often, however, the artist himself would take over after the preliminary work had been done.

In the nineteenth century, the invention of a mechanical pointing device made the production of such copies much easier.

Casting

Techniques of bronze casting have been in use since the third millennium BCE. In fact, contrary to what is commonly thought, the ancient Greek sculptors were primarily bronze casters. The production of a bronze statue is a team effort and can only be carried out in a foundry. It amounts to making the most faithful possible reproduction in bronze of a model in another material (see below).

▲ JEAN FOUQUET
(1415/20–1480).
*Stone Carvers at Work
on Solomon's Temple
in Jerusalem.*
Manuscript illumination,
mid-fifteenth century.
Paris, Bibliothèque
Nationale de France
*Fouquet has conceived
Solomon's artisans as
fifteenth-century sculptors,
carving a variety of figures,
moldings, and ornamental
details that might be seen on
the façade or in the interior
of a late medieval church.*

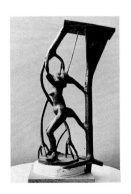
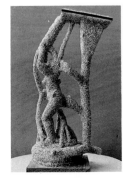

6. A network of conduits is created to allow the melted wax to run out of the mold when it is heated (step 7). Later these conduits will also be used to pour in the molten metal.

7. A second mold is created of fireproof clay. When it is sufficiently thick, and thoroughly dry, it is heated, both to melt the wax and to harden the clay.

8. The fireproof mold is then covered by an exterior mantle of fireproof cement.

9. The mold is fired at high temperature. Molten bronze (1,140° centigrade) is poured into the space formerly occupied by the wax. After the bronze cools, the mold is broken to reveal a bronze replica of the model.

10. The conduits and other protuberances are removed from the bronze figure, which is then finished with chisels, polished, and treated with chemical solutions to give its surface the desired patina.

THE EXAMPLE OF ANTIQUITY

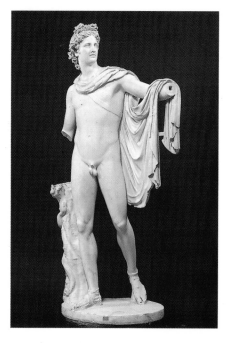

From the Renaissance to the end of the nineteenth century, most people in the West agreed that the sculptors of ancient Greece and Rome had achieved ideal beauty, and that the small group of statues surviving from antiquity embodied the summit of artistic creation. Visitors from all over Europe and the Americas made pilgrimages to Italy to admire these works, and those who remained at home became familiar with them through copies, prints, and casts. Young artists who wished to be taken seriously copied these pieces, an experience that exerted a strong influence on their own work.

▲ *Apollo Belvedere.*
Greek, early second century CE. Marble, height 7 feet 4¼ inches. Rome, Vatican Museums
Discovered at the beginning of the sixteenth century, the Apollo Belvedere immediately became one of the most famous works of ancient sculpture; it was considered to represent the ideal of male beauty well into the nineteenth century. It inspired many artists, including the Neoclassical sculptor Antonio Canova, whose Perseus was hailed as its worthy successor.

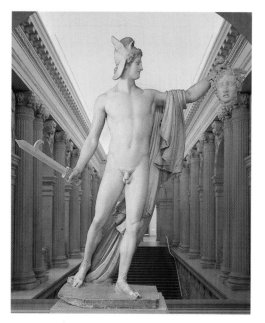

▲ ANTONIO CANOVA (1757–1822).
Perseus with the Head of Medusa. 1806–08.
Marble, height 6 feet 7⅜ inches.
New York, The Metropolitan Museum of Art

The Birth and Development of Archeology

During the Renaissance in Italy, the first excavations of ancient Roman temples, baths, and other buildings were carried out. A small group of well preserved statues discovered in these explorations induced wonder in Renaissance artists, including Raphael and Michelangelo, who studied them closely. In Florence, the ruling Medici princes, who were great art lovers, sponsored the first classes in archeology, a word derived from the Greek words for "study" (*logos*) and "old" (*archos*).

In the following centuries, a passion for discovering ancient objects became widespread. Scholars and amateurs known as "antiquarians" excavated, studied, and collected statues and coins, and deciphered inscriptions on newly uncovered monuments. In the eighteenth century, scholars began to develop methods for classifying such artifacts, and in the nineteenth century, archeology became more scientific. New and important sites were excavated, and public museums, many of which were established at about the same time, become repositories for many objects

See: The Renaissance, pp. 136–147; Mannerism, p. 143; Michelangelo, p. 244; Raphael, p. 259; Le Brun, p. 229.

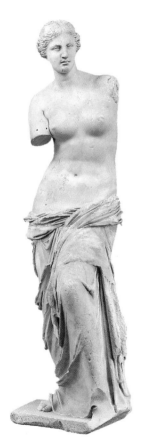

▼ *Venus de Milo.*
Greek, late second
century BCE. Marble,
height 6 feet 8¼ inches.
Paris, Musée du Louvre
The French explorer Du-
mont d'Urville recognized
the importance of this work
shortly after it was discov-
ered by a Greek farmer on
the island of Melos in 1820.
The French king Louis
XVIII gave it to the Louvre
Museum, where it is still
much admired. In 1846, it
inspired the French poet
Leconte de Lisle to write:
"Pure as lightning
A thing of harmony
Oh Venus, oh beauty
White mother of divinities!"

found. The passion for archeology has contin-
ued in the twentieth century, but now there
are sophisticated technologies that can help
archeologists assess ancient objects, in particu-
lar making more precise dating possible.

Collectors of Ancient Sculpture

From the moment of the earliest archeolog-
ical discoveries, popes and Italian noblemen
began to assemble collections of the most
beautiful pieces unearthed, and later people
of means from all over Europe also formed col-
lections of antiquities. Pope Julius II (reigned
1503–13) built the Belvedere Courtyard in the
Vatican Palace to display some of the finest
examples of ancient sculpture in the papal
collection. Here, surrounded by orange trees
and fountains, statues were placed in niches
especially designed for them, where most can
still be seen today, after having served as
models for young sculptors for nearly five hun-
dred years.

Copies of the masterpieces in the papal col-
lection were avidly sought by art lovers. Fran-
cis I of France, for example, sent the Italian
painter Primaticcio, who was one of the artists
decorating the royal château at Fontainebleau,
back to Italy to buy ancient works for the royal
collection. Primaticcio had casts made of the
most famous pieces and sent them to France,
where he then had full-scale bronze copies
of them cast in a specially built foundry at
Fontainebleau. This collection, which was
placed in the château's gardens, became a
model for all of Europe.

Copying the Great Ancient Models

In the Middle Ages and most of the Renais-
sance there was essentially one way to become
an artist: through apprenticeship with a mas-
ter. In the middle of the sixteenth century,
however, art academies were established in
Florence and Rome, where an aspiring young
artist could attend classes in drawing, paint-
ing, and art theory. A century later, the gov-
ernment of Louis XIV of France established an
Academy of Fine Arts in Paris; like its Italian
prototypes, its mission was to teach drawing
and painting, and its pedagogical methods
remained virtually unchanged until the late
nineteenth century. The heart of the curricu-

lum was daily drawing class, where students
could draw the nude, either from live models
or from ancient statues.

In addition to models for artists of the
Renaissance and later, Greek and Roman an-
tiquity also provided an inexhaustible reser-
voir of mythological and historical subjects.

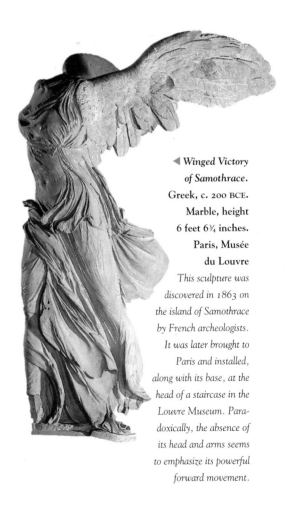

◀ *Winged Victory*
of Samothrace.
Greek, c. 200 BCE.
Marble, height
6 feet 6¾ inches.
Paris, Musée
du Louvre
This sculpture was
discovered in 1863 on
the island of Samothrace
by French archeologists.
It was later brought to
Paris and installed,
along with its base, at the
head of a staircase in the
Louvre Museum. Para-
doxically, the absence of
its head and arms seems
to emphasize its powerful
forward movement.

THE NUDE

The nude, male or female, has been a preoccupation of the arts of the Mediterranean from prehistory to the present day. It is fundamental to the aesthetic sensibility of Western civilizations. Much more than a subject category, it has also provided an outlet for the expression of feelings and ideals.

Each period and culture recasts the nude in its own way. Sometimes the favored vision of the nude is as an ideal, representing the human body as a divine creation. At other times artists emphasize the fragility and imperfection of the body, sometimes even representing it as a source of shame.

◀ KOUROS
Greek, c. 540 BCE. Parian marble, height 40½ inches. Paris, Musée du Louvre
Whether made of marble, like this kouros (Greek for "young man"), or of bronze, ancient Greek nudes reflect a striving for balanced proportion, formal perfection, and serenity of mind.

▶ *Christ on the Cross.* c. 1200. Polychromed wood. Paris, Musée National du Moyen Âge (Cluny Museum)
Throughout Christian history, figures of the crucified Christ have remained a favored devotional image for devout Christians.

Gods of Greece and Rome

The Greeks often represented their gods as completely nude. All idea of suffering, illness, and decay is absent from these eternally young and triumphant bodies. Sculptors emphasized the dominant quality of the deity they were depicting: Hercules was possessed of exceptional strength, Zeus of unrivaled power, and Apollo of great beauty.

The Medieval Treatment of the Nude

For almost a thousand years after the Roman Empire collapsed, the old pagan gods were destroyed, buried, or abandoned, for they were seen as the idols of a lost civilization. Christianity taught that modesty was a virtue, and that the body should be covered. One notable exception, beginning in the fifth century, was that the figure of the crucified Christ, an object of veneration and prayer, was often depicted virtually nude.

The suffering body of Christ on the cross was meant to divert the believer's thoughts from earthly to spiritual matters. This body, covered only by a loincloth, signified the human form of the Redeemer, not the glorified body of the Resurrection. Thus the body of Jesus was depicted in all its suffering, the

marks left by his tormentors—the wound in his side, the nail holes in his hands and feet, the cuts in his forehead left by the crown of thorns—fully visible. In some images Christ seems impervious to pain, while in others he seems to be suffering greatly.

Between the Human and the Ideal: Renaissance Nudes

Italian Renaissance sculptors strove both to imitate antiquity and to attain an ideal of bal-

 See: The Great Models of Antiquity, pp. 90–91; Giacometti, p. 215; Maillol, p. 236; Michelangelo, p. 244; Rodin, p. 263.

ance and harmony, and the nude was one of their favorite subjects. Renaissance sculptors also sought to express the principles of humanism, the new current of thought that placed humanity, rather than God, at the center of all philosophical reflection. They studied the human body closely, gaining familiarity with its every detail through the study of anatomy and the dissection of cadavers. In the sixteenth century, the Florentine sculptor Michelangelo Buonarroti (1475–1564) was fascinated by the nude. His *David* celebrates the eternal power of victorious heroes, but his figures of *Slaves* (p. 244), originally intended for the tomb of Pope Julius II, express both torment and vulnerability. Despite their superb proportions, these athletic figures seem to speak of the reality of pain and even the imminence of death.

The Decorative Nude

The nude figures on palace façades and garden fountains, like the smaller ones on elaborately carved mantels and tables, are purely decorative in character. Moreover, many of the nudes produced in the eighteenth and nineteenth centuries, most of which represent women and children, were meant to please, rather than to prompt reflection. Their sculptors used figures from mythology—often Venus, Diana, or nymphs—to charm the viewer. These figures were made to delight, and their forms were conceived primarily to please male viewers.

The Expressive and Symbolic Power of the Body

Toward the end of the nineteenth century, the greatest of French sculptors, Auguste Rodin, reacted against this gracious but somewhat affected approach to the nude. Seeking to make the body a vehicle for expressing life's most basic emotions, he produced figures that embrace passionately (*The Kiss*, p. 263), undergo torments (*The Gates of Hell*), and withdraw reflectively into themselves (*The Thinker*). Rodin often made audacious use of fragmentation to intensify the body's expressive potential.

The nude retained much of its symbolic power in the twentieth century, when striking distortions were introduced. Aristide Maillol's opulent female nudes were supplanted by the needle-thin figures of Alberto Giacometti, which seem about to disappear altogether. But the work of many contemporary artists suggests that the expressive potential of the nude is far from exhausted.

▼ AUGUSTE RODIN (1840–1917). *Walking Man.* 1905. Bronze, 83⅞ x 63⅜ x 28⅜ inches. Paris, Musée d'Orsay

This monumental figure's lack of head and arms compels the viewer to concentrate on his legs, which are powerfully rooted in the ground. It prompts reflection about the forces that drive all of us forward to meet our destinies.

SCULPTURE AND DEATH

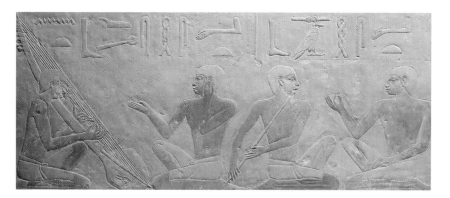

▲ *Musicians.*

Painted relief from the wall of the mastaba of Akhetep (detail).

c. 2500–2350 BCE.

Painted limestone.

Paris, Musée du Louvre

The fine reliefs in Akhetep's mastaba show him engaged in both work and leisure activities. These include marsh fishing, hippopotamus hunting (a favorite of the Egyptian nobility), farming, and scenes of music and dance.

The Funerary Art of Ancient Egypt

The Egyptians believed that earthly existence was followed by another, but similar, life in the beyond. In order for the deceased to enjoy the afterlife, the body, or at least an effigy of it, had to be preserved. Thus, the Egyptians mummified the bodies of the dead, and also made statues of them for their tombs. In these tombs there were chapels decorated with paintings or low reliefs. The body was laid in a large, carved and painted coffin or sarcophagus, and the internal organs were preserved in special containers known as canopic jars. Tombs were supplied with all the material necessities of life: servants (in the form of small painted figures), furniture, models of the boats that the deceased would need to ferry himself and his belongings to the realm of the dead, offerings (in the form of small sculptures of fruit, vegetables, meat, and drinks), miniature storehouses and granaries, and tools. Also in the tomb were statues and reliefs showing the deceased, some of which identified him with Osiris, god of the dead. The walls, lintels, and many articles in the tomb were also decorated with pictures and texts relating to the gods of death, particularly Anubis, Osiris, and the sisters Isis and Nephtys.

Many of the distinctions that we commonly make between painting, architecture, and the decorative arts do not apply to Egyptian tomb art, where all of these media are combined to create a systematic whole.

Warriors of the First Emperor

From the earliest times the Chinese emperors built tombs modeled after their palaces. Qin Shi Huangdi, the first ruler of a unified China, honored this tradition. In 221 BCE, the beginning of his reign, he ordered the construction of a grandiose mausoleum on the site of Lintong, close to Xianyang, which was then the capital.

Roughly 1,600 yards from the tomb, which has not yet been excavated, three large pits were discovered containing an "army" of more than 7,000 life-sized terra-cotta warriors. Infantrymen, cavalrymen, chariots, and horses with bronze harnesses reproduce the conquering army that made it possible for the emperor to reign over all of China. The torsos are all identical, but idiosyncratic postures and painted details make these sculptures resemble portraits. The erect cavalrymen defy the enemy; the archers kneel, intent upon their targets. The faces are impassive, but they are personalized by mustaches, beards, high plaited chignons contained by helmets, and eyes that narrow toward their temples. All wear trousers covered by long tunics; their average heights, roughly 5 feet 11 inches, vary according to rank.

These terra-cotta figures, which replace the human sacrifices made at earlier royal burial sites, suggest that the emperor was buried with elaborate funeral rites. The figures were provided to guard the ruler's repose for eternity.

Recumbent Effigies

In the Middle Ages in the West, generally priests, bishops, and monks were allowed burial in the churches, but occasionally noblemen and other important laymen were also granted this privilege.

Tombs marked with carved slabs were set into the floor close to the altar, or later, in the nave; the fact that visitors to the church would walk on them was a sign of humility. Just large enough to cover an adult human body, the rectangular tomb slabs were often

 See: Egypt, Land of the Pharaohs, pp. 42–43; Chinese and Japanese Sculpture, pp. 100–101.

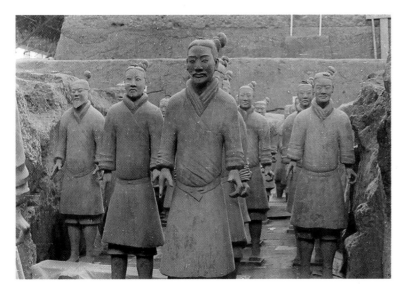

◄ THE ARMY OF
EMPEROR QIN SHI
HUANGDI. c. 221 BCE.
Lintong, Shaaxi
Province, China
*Pit No. 1 (755 x 203 feet)
at this archeological excava-
tion contained an army of
6,000 terra-cotta soldiers in
battle formation. Most of
the figures were infantry-
men, who occupied the cen-
ter of the grouping. Archers
and chariots were positioned
in front, with cavalrymen at
the sides and back.*

▼ ANTOINE
LE MOITURIER.
Tomb of Philippe Pot.
Late fifteenth century.
Painted stone, height
5 feet 10⅞ inches;
length 8 feet 8⅜ inches.
Paris, Musée du Louvre
*Philippe, lord high steward
of Burgundy, is memorial-
ized in this moving image
of eight mourners in black
capes and hoods carrying
the slab that will cover his
sarcophagus. The mourn-
ers, who can be identified
only by the coats of arms
affixed to their cloaks,
communicate their sorrow
through posture alone.*

engraved, usually with a monogram, an hour glass, a death's head, or a skeleton. Sometimes they bore linear depictions of the deceased, in which case the presence of a crown, a cross, or a sword identified him as a king, a bishop, or a knight.

Made of stone such as white marble, these slab tombs were originally painted bright colors. Occasionally they were made of bronze, gold, or silver and inset with colored materials to enrich the effect, but few such sumptuous examples survive.

Beginning in the thirteenth century, re-cumbent effigies were carved in relief. Known as *gisant* figures (from the French verb *gésir*, to lie), they usually depict the deceased in ideal-ized youth, his eyes open, his head resting on a cushion and his hands joined or crossed over his chest, as if he were sleeping on his bed. His feet often rest against a lion or a dog, emblems respectively of victory over evil and of fidelity, while angels prepare to transport his soul to paradise.

Around the beginning of the fourteenth cen-tury sculptors began to represent gisant figures with their eyes closed, as if the deceased were at the moment of death. There are even a few de-pictions of desiccated or decomposing bodies, although these disturbing images are rare.

Monuments to Great Men
In the thirteenth century, important people began to commission monumental tombs for

themselves with funeral processions depicted on their bases. These often featured angels or apostles set into arcades or hooded mourning monks—known as *pleurant* (weeping) figures —carrying the casket. In some cases, the earthly life of the deceased was represented on a lower level and his spiritual life on an upper level.

Some fifteenth-century tombs incorpo-rate figures of the family of the deceased in prayer before an altar. Often their faces are true portraits.

SCULPTURE AND ARCHITECTURE

Sculpture has often been incorporated into architecture, sometimes on a monumental scale and sometimes in smaller forms. Sculptural ornament enriches a building, complicating the play of light and shadow over its surfaces, and often introducing color, for architectural sculpture has generally been painted in vivid colors. In some cases it is purely decorative, but in others it is closely integrated with the building's function and meaning, commemorating an event, recalling an historical period, or honoring a god or saint.

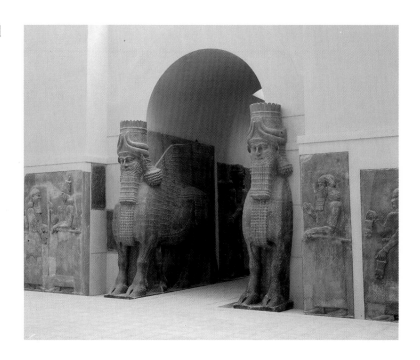

▲ GATE OF THE PALACE OF SARGON II (reigned 721–705 BCE), Dur Sharrukin (modern Khorsabad, Iraq). Assyrian, c. 720 BCE. Stone, height 14 feet 5¼ inches. Paris, Musée du Louvre

Stone Colossi

The pyramid tombs of the pharaohs at Giza, near Cairo, were guarded by an enormous recumbent lion with a human head: the Sphinx. Carved from the living rock, this sculpture is gigantic, measuring 187 feet long x 66 feet high. It is also architecture of a kind, for a small temple for offerings stood between its two giant paws.

Beginning in 713 BCE, King Sargon II of Assyria ordered a new capital city built at Dur Sharrukin, near modern Khorsabad, Iraq. The new city was incomplete at the time of Sargon's death in 705 BCE. Within its citadel was a gigantic palace boasting almost 200 courtyards and rooms whose walls were covered with relief sculpture. The exterior was decorated with more reliefs depicting the life of the court, especially its majestic processions. Many of the interior compositions recount the life of the king, notably his hunting victories and military campaigns. Traces of color can still be seen on the faces and clothing of many figures, a reminder that portions of all these reliefs were painted.

Sargon's palace was entered through a monumental gate guarded by two fantastic animals: large winged bulls with human heads sporting finely chiseled beards and hair, as well as tiaras, emblems of their divinity. The figures have five legs, since they are meant to be seen both frontally and in profile. From the front they appear motionless and serene, but from the side they seem to be moving slowly forward. Between their legs are cuneiform inscriptions describing the construction of the palace, and laying a curse on anyone daring to destroy the king's work.

The wall reliefs at Khorsabad are both decorative and narrative, recounting the king's exploits for the benefit of visitors to the palace. The sculpture plays another role here, strengthening the building's structure and serving as supports for its gates.

See: Egypt, Land of the Pharaohs, pp. 42–43; The Greek Temple, pp. 44–45; Romanesque Churches, pp. 58–59.

Marble Decoration

Ancient Greek temples were decorated with brightly painted reliefs, first made of terra cotta, and later of stone. Greek sculptors represented stories from mythology as well as the great religious festivals that set the rhythms of Greek communal life. Sculpture soon decorated many places on Greek temples: the pediment (the triangular area formed by the eaves of the roof), the column shafts (which were sometimes replaced by female figures known as caryatids), and especially the friezes above the colonnades. As noted above (p. 44), the friezes of Doric temples consisted of triglyphs (units of three vertical rods separated by two vertical grooves) alternating with rectangular metopes, which were often sculpted, but could accommodate only two or three figures. Ionic friezes, however, offered uninterrupted bands that could be carved from one end to the other; they were ideal for depicting religious processions or complex battle scenes.

Bible Stories in Stone

In the late Romanesque period—at the beginning of the twelfth century—sculpture was widely used both inside and outside cathedrals, monasteries, and even modest churches. It complemented and enriched the architectural forms, but it also served as a pictorial "Bible" for people who could not read.

Architectural sculpture narrated stories from the Old and New Testaments, recounting the life of Christ and the legends of the saints. The sculptors, most of whom are unknown to us, sometimes added scenes from daily life as well as animals, plants, devils, or fantastic monsters. Such work can be found on column capitals, around windows, and above all, on the jambs, lintels, and other areas surrounding the doorways.

▶ *Hercules Carrying the Kerkopes*, a metope from Temple C at Selinunte. c. 530 BCE. Limestone, height 4 feet 9⅞ inches. Sicily, Museo Nazionale di Palermo

Hercules caught these two bandits trying to rob him during his sleep and took them prisoner. He strides forward, carrying them suspended upside down from a pole on his back. According to the legend, their good-humored mockery of the hero's abundant hair made him burst out laughing, and he freed them. Despite the narrowness of the metope, this representation of the story is both original and amusing.

▼ TYMPANUM OF THE CATHEDRAL OF SAINT-LAZARE, Autun, France. 1120–32. Stone, width 21 feet 3⅞ inches.

Worshipers entering the church at Autun were greeted by a large stone composition depicting the Last Judgment, dominated by a majestic figure of Christ as the judge separating the souls of the good from those of the wicked.

The Elect—those being saved—are being admitted to Heaven (left), as the Damned are consigned to Hell (right), here populated by open-mouthed demons eagerly awaiting the arrival of these unfortunates.

▶ *Archivolts*

▶ *Tympanum*

▶ *Lintel*

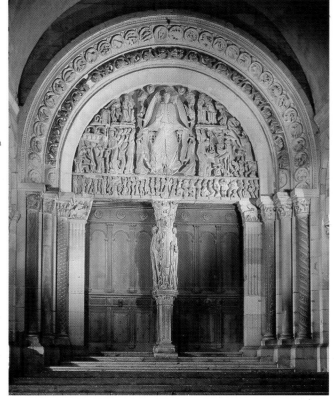

SCULPTURE AND RELIGION: THE INDIAN WORLD

As with architecture and painting, the sculpture of India and the countries that embraced its culture was dominated by the dictates of religious patronage. Appreciation of this sculpture requires familiarity with some of its key images, without a knowledge of which the sculpture is difficult to understand.

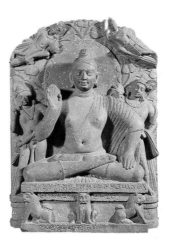 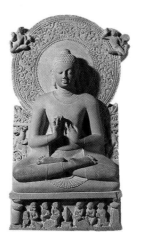 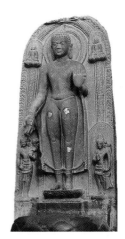

Indian sculptors worked in every conceivable material: stone, wood, bronze, ivory, terra cotta, stucco, and even papier mâché.

The images of Indian deities are stylized, for it was thought that realistic human forms were inappropriate to portray divinity. The superior powers of Indian gods are sometimes indicated by their having multiple arms and heads, a practice that sets Indian sculpture apart from the traditions of the West. The Greeks and Romans represented their gods as having exalted, but humanlike bodies. Indian sculptors preferred to show their deities as distant and impersonal.

Buddhist Sculpture

The most important figure in Buddhist sculpture is that of the religion's founder, the Buddha himself. Several features distinguish images of the Buddha from other religious representations, the most important being a calm and meditative expression, expressing the serenity of Enlightenment.

Texts describing the Buddha speak of thirty-six major signs and eighty minor ones specific to "great men," beings chosen to become either great rulers or *buddhas* ("enlightened ones"). Only a few of these could be incorporated into sculpture, since many of them would have been impossible to render pictorially. The most important of the "signs" that can be seen in sculpture are *usnisa* (cranial protuberance), the *urna* (a patch of hair represented by a small knob set between the eyebrows or in the middle of the forehead), wheels stamped into the palms of the hands or the soles of the feet, and webbed fingers. The Buddha's earlobes are also distended from the weight of the jewelry that he wore during his youth as a prince.

Dressed in the simple clothing of a monk, the Buddha expresses himself with *mudras*, or codified hand gestures. An extended palm with vertical fingers signifies the reliability of his Law; an extended palm pointing downward indicates the bestowal of a favor; finally, hands held close to his chest with the fingers intertwined indicate that he is turning the wheel of the Law, a gesture symbolic of his teaching.

▲ *Left to right:*
Buddha Making the Gesture of Reassurance. Mathura style, second century. Uttar Pradesh, India, Mathura Museum

Buddha Making the Gesture of Enlightenment. Gupta style of Sarnath, fifth century. Uttar Pradesh, India, Sarnath Museum

Buddha Making the Gesture of the Gift. Pala style, eighth–ninth century. Bodhgaya, Biohar, India

The *bodhisattvas*, or Buddhist saints, are intercessors who possess the qualities needed to become buddhas but refuse to do so, preferring to help others traverse the ocean of existences. They are often shown richly dressed and bejeweled. As with the Buddha, distinctive attributes make them readily identifiable. Avalokiteshvara, the most venerated of the bodhisattvas, is shown carrying a lotus in one hand and wearing a miniature figure of the meditating Buddha on his headdress.

Hindu Sculpture

Shiva, a very important Hindu god, is often represented as a *linga*. This stylized depiction of an erect phallus, an emblem of Shiva's generative power, appears in all temples dedicated to him, whether in India or elsewhere. When he is represented anthropomorphically, the god wears a chignon associated with ascetics and very simple clothing. On his forehead is a vertical third eye, which signifies knowledge; the attributes of the trident, the water jug, and the hatchet are also associated with him. Like all Hindu deities, Shiva may also appear in a terrifying aspect. In this guise he is attired in snakes and skulls. In southern India Shiva is particularly venerated as Shiva Nataraja, king of the dance, who periodically destroys and re-creates the world.

Vishnu, the preserving god, is generally benevolent. Dressed like a prince and richly adorned with jewelry, his usual attributes are the disk, the club, the conch shell, and a lotus seed or lotus flower. He sometimes assumes various forms known as *avataras* (from the Sanskrit word for "descent," the source of the English word "avatar"). These can be common animals such as tortoises or fish, fantastic beasts that are half animal and half human, such as Narasimha, a lion-man, or heros such as Rama or Krishna.

Hindu mythology is immensely rich, boasting thousands of deities. Brahma, creator of the world, is recognizable by his four heads. Ganesha, remover of obstacles, has an elephant's head; his aid is sought to surmount difficulties, even for examinations at school. Lakshmi, the wife of Vishnu, is the goddess of Fortune and Beauty. Nandin, the white bull, is the mount of Shiva. Durga, Shiva's wife, saves the universe from a wicked buffalo demon. According to Indian thought, all of these deities participate in the creation, survival, or destruction of the world. At each of life's new dawns, they return to play their role in our world as well as in the upper and lower realms unknown to human beings.

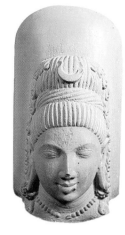

▲ *Linga with a Face.* Gupta period, fifth century. India, Allahabad Museum

The linga, *or phallus, represents the power of the god Shiva.*

▼ *Vishnu Reclining on the Serpent of Eternity Between Two Cosmic Eras.* Early sixth century. Temple of Deogarh, Uttar Pradesh, India

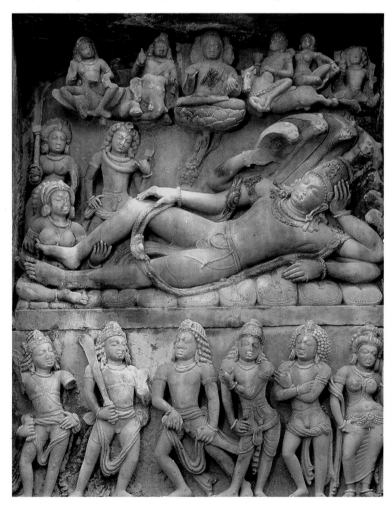

CHINESE AND JAPANESE SCULPTURE: THE TRIUMPH OF

How Buddhism Arrived in China

In the second century BCE, Buddhist monks carrying statuettes and sacred texts traveled the silk route from central Asia to China, spreading their religion. In the fourth century, Dunhuang, a crossroads where central Asia and China met, became the site of one of the earliest Chinese Buddhist sanctuaries. Its large grottos, carved into a cliff and sheltering colossal statues, became a model for many other similar sanctuaries.

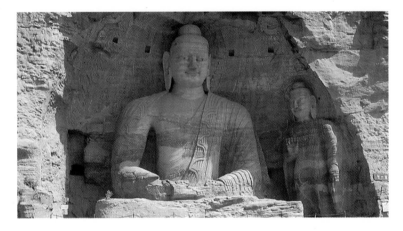

▲ *Colossal Carved Buddha*. Cave 20, Yungang, Shanxi Province, China. c. 466. Height 45 feet. *Still under Indian influence, the style of these sculptures is powerfully hieratic. The large, fine-featured faces of the figures smile impersonally. The wall behind the central figure is carved with an aureole of small Buddhas in relief, a distinctive Chinese innovation in Buddhist imagery.*

The Zenith of Buddhism

In 398, the Wei dynasty of northern China assured Buddhism's triumph there by declaring it the national religion. Exhausted by continuous wars, the Chinese under the Wei emperors embraced the new religion and its promise of a better life in the beyond with enthusiasm. The emperors ordered the construction of Buddhist grottos in China itself, at Yungang and Longmen, sites where Buddhist stone sculpture reached its zenith.

The spectacular Yungang caves in Shanxi province, which date from the 460s, punctuate a cliff face a thousand feet long. In the center of each grotto is a monumental statue of the Buddha, the largest of which is fifty-five feet high. Five other statues of the Buddha seem to bear the features of the five Wei emperors, a political statement intended to identify them as his living embodiments.

Near their capital at Loyang, the Wei emperors had a sanctuary carved at Longmen, a narrow passage between two cliffs separated by the Yi River. Work began in 494 and continued until 536.

In the center of each of its 1,352 grottos is a statue of the Buddha, often shown accompanied by disciples and bodhisattvas. The surrounding walls are carved with small niches containing statuettes.

The soft, broad faces of Yungang here gave way to an angular, more mystical style. The elongated bodies and emaciated faces, with Chinese rather than Indian features, express a profound spirituality. The bodhisattvas wear high crowns and the silky folds of their clothing create ample cascades of drapery.

Tang Realism at Dunhuang

Famous for their paintings, the Dunhuang grottos also house a vast array of sculpture, most of it made of clay. Examples made during the Tang dynasty (618–907) are especially fine. After the Northern Wei period the style of Chinese sculpture evolved in a warmer and more naturalistic direction, with the result that the Tang Buddhas at Dunhuang seem gentle and benevolent. The bodhisattvas now seem almost feminine, smiling graciously and wearing richly decorated clothing. Their bodies are carefully modeled and rather sensuous.

BUDDHISM IN THE FAR EAST

The Appearance of Buddhism in Japan

Converted to Buddhism by missionaries from China in the fourth century, Korea played an important role in the transmission of the new religion to Japan. Increasingly, however, Japanese Buddhism distanced itself from Chinese and Korean models, spreading in the form of various sects that were embraced by both aristocracy and common people.

From the Beginnings to the Golden Age of the Nara Period

In the seventh century, images imported from the Asian mainland were replaced by statues in wood and gilt bronze. One of the most famous is the gilt bronze Shaka Triad, representing the Buddha and two saints, made by the sculptor Tori Busshi around 623 for a temple at Nara (p. 53). This work retains the gravity and serenity of Chinese Buddhas. Rapidly, however, a naturalistic tendency emerged. The style of faces became more individualized, and the draperies grew lighter.

Japanese sculpture reached its golden age in the eighth century, during the Nara period. In the intense Buddhist fervor of this period, monumental sculpture groups were erected in Japanese temples. A new feeling for movement is in evidence in these figures, with their gracious movements and poses.

Japanese sculptors excelled in the depiction of Guardian Kings, protectors of the Buddhist world, whose grimacing faces and gleaming cuirasses drive away evil. The sophisticated naturalism of these figures, like so many others of the period, bear witness to Nara Japan's close ties to Tang China.

Using the Chinese technique of dry lacquer on clay statuary, Japanese sculptors produced some remarkable portraits of monks, for example, the statue of the monk Ganjin shown at right.

The Ninth Century in Kyoto

Japanese sculptors gradually became masters of the art of wood sculpture, creating an imposing Buddha type characterized by massive forms and stylized drapery. After the imperial court moved to Kyoto in the ninth century, a style of great refinement emerged there, epitomized by delicately colored wooden figures influenced by contemporary fashion. For the new temples at Kyoto sculptors created elegant images of the Amida Buddha—a particularly comforting aspect of the Buddha popular at this time in Japan—seated beneath ornately carved canopies and flanked by angel-musicians meant to evoke paradise.

A Martial Realism

In the thirteenth century, the samurai, or Japanese warrior class, seized power. In response, sculptors adopted a harsher style more in accord with the manners of their new rulers. Figures of the Buddha of this period seem more forceful than previously, concentrating their spirituality in their eyes. The sculptor Jokei produced severe and vigorously naturalistic guardian figures, with knotty muscles and inlaid crystal eyes.

After the fourteenth century, Japanese sculpture lost much of its creative impetus, and painting became the more important mode of artistic expression.

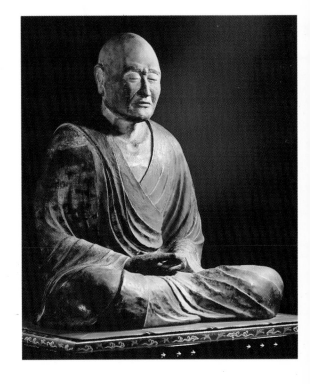

▼ *Portrait of the Priest Ganjin.* **Mid-eighth century. Dry lacquer, height 31⅞ inches. Toshoda-ji, Nara**
This life-size figure captures the meditative serenity of a monk at the end of his life. It seems to have been the model for a sculptural type that became quite widespread in the Japanese archipelago.

See: Nara, The First City of Japanese History, p. 52

THE ARTS OF BLACK AFRICA

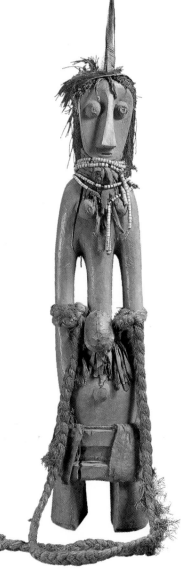

1. Magical object
2. Holo panel
3. Nimba mask
4. Bamana mask
5. Byeri sculpture
6. Igbo couple
7. Mother and child
8. Dogon statue
9. Lobi statue
10. Zulu spoon
11. Songye shield
12. Ioniake mask

In any discussion of African sculpture, it is important to understand how what Westerners call "art" is viewed in African societies. We need to be aware that the history and cultures of these societies are vastly different from our own, and that their people apprehend the world differently than we do.

▶ 1 HANGING MAGICAL OBJECT, Zaire. Wood, shells, horn, textiles, fibers, and pearls, height 40¼ inches. Iowa City, The University of Iowa Museum of Art

In Africa, as in many places in the world, objects thought to have magical powers are used in rituals intended to bring rain, heal the sick, punish an enemy, or promote fertility, and the like. First the object is made; then a magician or holy man transforms it into a magic object, sometimes called a fetish*, adding other materials in the process. Sometimes the original object disappears completely beneath these additions, as in so-called nail fetishes, which are covered with pounded-in nails. The example at right is remarkable for its strong presence as well as for its emphatically vertical form. The lower extremities are truncated, as though emerging from the earth; the long arms are without hands, the torso is very thin, and the face, schematic but expressive, is surmounted by a protruding horn. The whole is draped with symbolic objects chosen to increase its power. The simple harmony of the resulting figure is accentuated by its color scheme of browns and ochers.*

Some Historical Background

The part of the Africa continent whose art we are examining here is sub-Saharan Africa, that is, the vast area south of the Sahara Desert. Its peoples are black, their civilizations are ancient, and their traditions are transmitted orally instead of in writing. For millennia this part of the world was left to itself. Over the last thousand years, the sub-Sahara has had to confront a number of imperialist incursions, first by Arabs, and then by various Europeans, which, taken together, have caused great human suffering and wreaked considerable cultural and ecological damage. Beginning in the sixteenth century black Africa was colonized by Portugal, England, France, Belgium, Germany, and Italy, all countries that imposed their own values on the native population by killing and enslaving people and destroying property, and also by economic and cultural pressure. Although most African states have been independent since the 1960s, they still bear the scars of the colonial period, and they remain at the mercy of the international marketplace, whose dynamics place them at a disadvantage.

The Meaning of "Art"

In Africa, art performs a social role, fostering societal cohesion and retaining close ties to religious life. Artists perpetuate the traditions of the people to which they belong. In African societies, many of which are governed by seasonal rhythms, sculpture usually represents human and animal forms.

The Principle of Style

To preserve tradition, griots (bards), musicians, and sculptors repeat stories, rhythms, and forms inspired by those of previous generations. In the case of sculpture, new works must be approved by the elders of the social group to which the sculptor belongs. If found to bear a sufficient resemblance to older, previously approved objects, they are judged "good." As a result, each group has its own identifying style: a Nimba mask (3) will not resemble a Bamana mask (4). The style of a work marks it as belonging to a particular group. If sculptors fail to respect this stylistic identity, they risk having their work rejected by their people.

▲ 2 HOLO PANEL, South Kwango, Kongo (formerly Zaire). Wood, height 13⅛ inches. Tervuren, Royal Museum of Central Africa

The Holo people formerly used these small wooden frames in rituals of protection and healing. The frames were kept in small cases, from which they were removed for ceremonial use. This example is notable for its harmonious design. The figure, probably an ancestor, is seated on the threshold of a gatelike opening. He blocks the entrance with his outspread arms and large hands, which are characteristic of the art of this region.

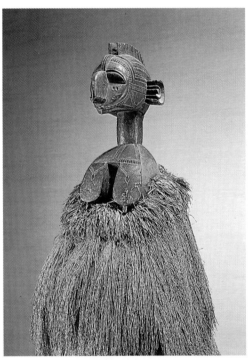

◀ 3 NIMBA SHOULDER MASK, Baga, Guinea. Wood, copper, and fibers, height 40⅛ inches. Paris, Musée National des Arts d'Afrique et d'Océanie

The goddess Nimba of the Baga people, who cultivate rice, is associated with fertility, and especially with the harvest. In this shoulder mask she is represented in the guise of a woman with an enormous head and dangling breasts. There are small viewing holes between the breasts for the dancer who wore the mask, whose body would have been completely covered by its large skirt. Nimba's appearances were both awaited with eagerness and feared.

Objects of this kind, simultaneously masks and sculpture, are exceptional in African art, in terms of both their size and their construction. The exaggerated facial features and idiosyncratic geometry—the chin and neck, for example, are off-center—make this mask a good example of African spatial treatment.

◀ 4 BAMANA OR MARKA MASK, Mali. Wood and brass (or copper), height 16½ inches. Marseilles, Musée d'Arts Africains, Océaniens, Amérindiens (MAAOA)

This mask was worn by young men during the domo, a male initiation ritual directed and orchestrated by elders. The mask represents and is intended to instill vitality and harmony. Covered in metal, it was fashioned in part by master blacksmiths, who took part in the ceremony. The face, a perfect oval with half-closed eyes, is framed by pointed rods. The brilliance of the metal must have contributed to the effect of the ritual, reflecting sunlight by day and firelight by night.

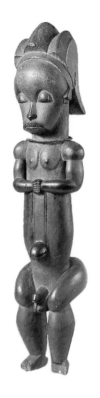

The Principle of Efficacity

Almost all objects had religious functions associated with specific cults and rituals; and each played but a single role. To take one example, they might represent an ancestor whom the priests wished to invoke in certain contexts. At such moments the figure was an intermediary, summoning a desired spirit to manifest its presence among the living through the object. The group always made sure that such sculptures "worked," that the ancestor in question agreed to inhabit them. If so, the sculpture was judged good; if not, it was rejected, and the sculptor had to make another.

The Principle of Symbolism

For a sculpture to function properly, it had to satisfy other obligations. It had to incorporate symbols that distinguished the sculptor's group from others, signifying its ethnicity and the village in which it resided.

▲ 5 BYERI FIGURE.
Fang, northern Gabon.
Wood with clear patina,
height 23¼ inches.
New York, The Brooklyn
Museum

Ancestor figures like this one were used in important ceremonies. Installed atop a reliquary box, usually of bark, containing the bones of one of the important historical personalities of the Fang people, the figures served as both portraits and guardians. Because of the importance of these objects to the Fang, the mastery of their design, and the virtuosity of their carving, they are widely regarded as classic examples of Fang art.

▶ 6 IGBO ANCESTOR COUPLE, Nigeria. Wood,
height 63⅜ inches (man) and 65⅜ inches (woman).
Private collection

The Igbo, one of the largest African peoples, live along the Niger River. They are governed by councils of elders and secret associations.

The Igbo made masks and statues of deified ancestors, often paired in couples, whose realism is exceptional in African art. Almost life-size, these two statues signaled their owner's lineage and prestige. The ritual scarring on their faces and torsos, as well as their bracelets and ankle rings, indicate their high social status and their membership in a secret association. These figures are remarkably dynamic, and their faces manage to convey serenity, wisdom, strength, and alertness to danger all at once.

Time and Space

Another factor that has shaped the production of African art is the distinctive approach to space and time that informs it. Western civilizations have their own ideas of space and time, but millions of men and women elsewhere understand these concepts differently, and they are often expressed, formally and symbolically, in works of art. African art reflects an approach to perspective, volume, and proportion that differs from our own and may initially seem unfamiliar.

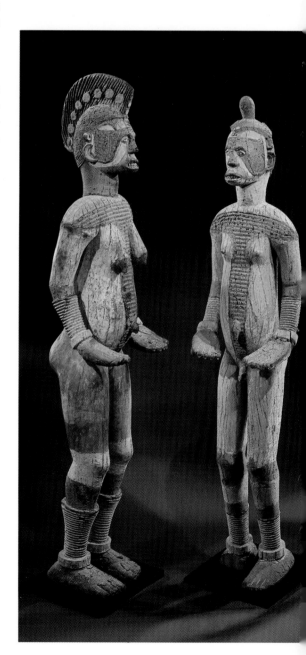

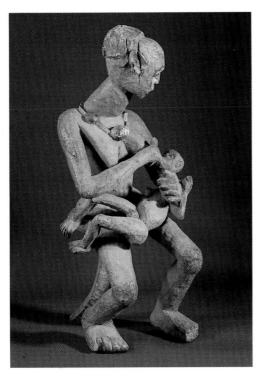

▲ 7 MOTHER AND CHILD, Bamileke,
Bangangte region, Cameroon. Stained wood,
height 24⅜ inches. Paris, Musée de l'Homme

*The maternity theme is frequently represented in African art,
especially by the Bamileke. It evokes human fertility, as well
as venerability and prestige, for the nursing mother is a queen.
This example is notable for the artist's virtuosity in his han-
dling of solids, voids, and interacting curves, and for his natu-
ralistic evocation of bodily postures, which are both complex
and schematic. The mother's intense gaze and her protective
gesture are remarkably sensitive evocations of maternal feel-
ing. The unusual off-balance position of the figure is accentu-
ated by the serpentine form of the infant, who seems to writhe
in delight at his mother's attention.*

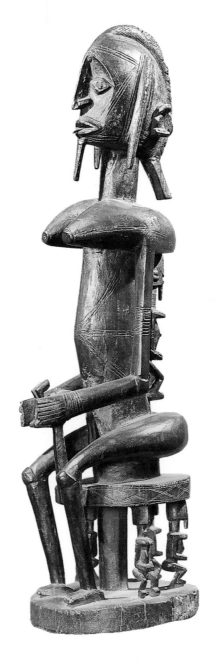

◄ 8 DOGON STATUE,
Mali. Eighteenth
century. Wood,
height 30⅜ inches.
Private collection

*The Dogon live along the
great Bandiagara cliff, in a
region where water is in
short supply. Their black-
smiths and sculptors are a
special caste, usually trans-
mitting their knowledge of
their crafts from father to
son. The art of the Dogon
is considered by many
Westerners to be one of
Africa's finest, for its for-
mal perfection is compara-
ble to that of Greek art.
This statue is probably an
ancestor figure. Character-
ized by elongated, vertical
forms, Dogon sculpture is
notable for its elegance and
refinement.*

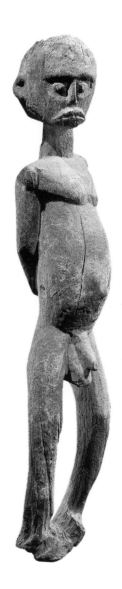

9 LOBI FIGURE, Burkina Faso (formerly Upper Volta). Wood, height 30¾ inches. Private collection

The Lobi, who are thought to have once been a warrior people, are now farmers and shepherds. They produce much sculpture for agrarian cults, funerals, and initiations as well as for magical and divinatory rituals. Only rarely are their sculptors professional craftsmen. Lobi sculpture is characterized by an idiosyncratic treatment of the facial features, especially the eyes, which have prominent, half-lowered lids. This example represents a prisoner with his hands tied behind his back. Its extraordinary presence is due to the contemptuous expression of the mouth, the fixity of the gaze, and the handling of the volumes, which perfectly convey the idea of a captive man.

Artists

Artists occupy a special place in African society. Some assume other roles as well, for example that of farmer, but as artists they are commissioned to make statues, masks, and other ritual objects. This is an important responsibility, and their social status is commensurately high. Sometimes artists constitute a separate caste within their village. Other artists are professional sculptors who work for a single patron—for example, the village chief—or for a ruler and his court. Since professional artists must first undergo long apprenticeships, they, too, are respected and enjoy certain privileges.

African artists have traditionally worked in wood, metal (bronze, brass, iron, copper, and gold), ivory, bone, and textiles, and in the past they used natural pigments. Presently, they also use other material introduced by Westerners, such as plastic, paint, and cement.

The African artists of today combine traditional with more modern approaches to their material and are universally recognized in many fields, including music, dance, film, and fashion, which they influence in the West as well as elsewhere.

African Sculpture

Traditional African society has often expressed itself in sculpture, with masks, statues, everyday implements, and musical instruments. We must bear in mind, however, that the meanings of these artifacts almost always will escape us at first, and that the only way to gain some understanding of them is to acknowledge the differences between our own culture and those for which they were made.

From the thousands of traditional African ethnicities, which have produced almost as many styles, we have chosen twelve sculptures. While significant, they of course cannot provide a comprehensive survey of African creativity, just as no such selection could possibly do justice to the richness of the Western tradition.

A choice of twelve works out of millions can only suggest a few approaches to the immense treasury of African art.

10 ZULU SPOON, South Africa. Wood, height 22 inches. Paris, Musée de l'Homme

The Zulu, who live in South Africa, were originally farmers and cattle-breeders. Little known in the West, their art is extremely refined, especially in its handling of everyday implements. This spoon, for example, displays an exceptional formal mastery that infuses it with symbolic meaning. The sculptor has attenuated the human figure, reducing it to its essential forms, and producing a visual poem to feminine beauty.

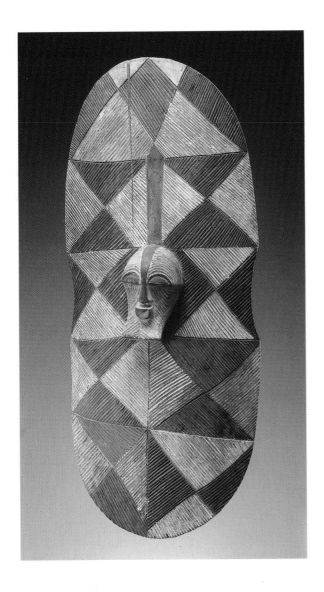

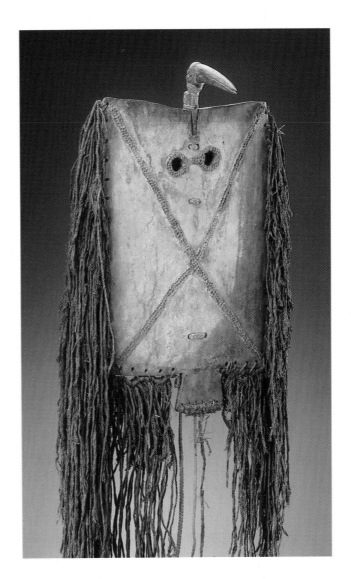

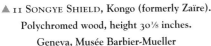

▲ 11 SONGYE SHIELD, Kongo (formerly Zaïre).
Polychromed wood, height 30⅛ inches.
Geneva, Musée Barbier-Mueller

*Songye art is largely a servant of power. As is often the case in Africa,
this power is buttressed—and opposed—by secret associations.
The Songye specialize in anthropomorphic sculpture and masks, the
most famous of which is the kifwebe mask, characterized by a face
with narrow eyes and falling eyelids, a flat triangular nose, and a
mouth shaped like a horizontal figure eight, the whole usually covered
with deep striations. Songye shields, placed in huts with kifwebe masks,
were intended to ward off invaders. This oval shield with a central
kifwebe mask affixed to it is decorated with triangular striations in
green and white. The simplicity of the design enhances the overall
effect of harmony and balance.*

▲ 12 IONIAKE MASK, Tusyan, Burkina Faso
(formerly Upper Volta). Wood, vegetal fibers, and seeds;
height 26⅜ inches. Geneva, Musée Barbier-Mueller

*The Tusyan are a small population living in the southwest of Burkina Faso.
Masks like this one, made by blacksmiths, were carried by young men during
initiation ceremonies, after which they could keep them. The animal head at the
top symbolizes the totem of the young man's clan. Objects like this are halfway
between painting and sculpture. They are abstract, but a face is suggested by
round or square holes outlined with red seeds for eyes and short horizontal lines
composed of the same seeds at intervals below to form the nose and mouth.
Vegetal fibers frame the face, transforming the flat mask into a sculpture. In
addition to concealing the wearer—the mask's primary function—it generates
a powerful aura of mystery, largely through its surprising juxtaposition of mate-
rials. Not surprisingly, masks of this type fascinated the painter Max Ernst.*

1. Sulka Mask
2. Moai Kavakava
3. "Matua" Mask
4. Ithyphallic Figure
5. Zoomorphic Carving
6. Saibai Mask
7. Akua Ka'ai Figure
8. Female Figure

THE ARTS OF OCEANIA

Oceania spreads across much of the Pacific, encompassing one island continent (Australia), a few large islands (Papua New Guinea, New Zealand), and a great many small islands. It is divided into three areas known as Melanesia, Polynesia, and Micronesia.

The history of the settlement of Oceania is still poorly understood, but there is evidence of a human presence in Australia and Melanesia as early as 40,000 years ago. The dark-skinned peoples that populate Oceania must have come from southeast China, perhaps in

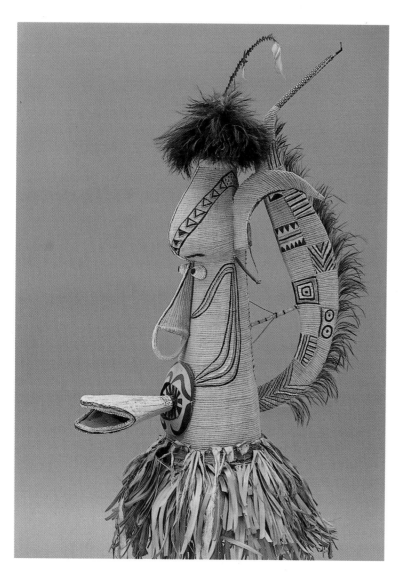

◀ 1 SULKA MASK, Island of New Britain, Papua New Guinea. Wood, fibers, feathers, and paint; height 47¼ inches. Bremen, Germany, Bremen Museum

The Sulka people of New Britain work with tinted vegetal fibers and are especially renowned for the rose color of their large masks. Made for use in funeral ceremonies and public dances, they are worn atop robes made of leaves that obscure the wearer's body. Some are monumental, attaining a height of many feet, and they can take several months to produce. This example is composed of conical and curved forms which culminate in a plume of casoar, itself topped by a small white feather. Its painted geometric designs beautifully complement its basic volumes. The wooden projecting element is especially interesting. It might represent the head of an animal—a snake? a shark?—in the mask's mouth, or it might be the artist's idiosyncratic way of rendering the figure's own mouth.

several waves. In all likelihood, the present populations settled in Oceania about 8,000 years ago, displacing and even eliminating those already living there. Polynesia is the most recently settled zone; some of its islands appear to have been inhabited for only a few centuries. The European discovery of Oceania dates from the seventeenth century.

As in Africa, art objects in Oceania have traditionally been used in religious rituals closely tied to the cycles of nature. As a result of Western colonization, whose effects have often been as brutal here as in Africa, most of these cults are disappearing. Their originality stems from the small size and isolation of most of the islands, which fostered the development of unique social structures with their own laws.

The beings depicted in Oceanic art—people, animals, and abstract forms—represent the supernatural world. The fact that many of these figurations do not conform to Western rules, notably those governing perspective, can sometimes make them seem alien to us.

Not all local traditions have disappeared,

◀ 2 MOAI KAVAKAVA, Easter Island, Chile.
Wood, height 11¹³⁄₁₆ inches. London, British Museum
Westerners first visited Easter Island in the late eighteenth century. The results proved disastrous for the Pascuans, the island's inhabitants. The bulk of their religious artifacts were destroyed and many of the people were deported to perform forced labor. The great stone heads for which the island is famous, however, survived. The culture of this people has long fascinated Western archeologists and anthropologists, but even now it remains mysterious. The function of small wooden sculptures like this one, for example, which the Pascuans produced in large numbers, continues to elude us. They may have been ancestor figures, but this is not certain. In any event, this male figure has great dignity but seems exhausted and close to death; his skeletal body may indicate starvation as a result of famine.

and in some countries the inhabitants have revived old forms and practices for tourist consumption. This rebirth is making it easier to study the history of these populations as well as to appreciate the richness and inventiveness of the objects produced by its artists.

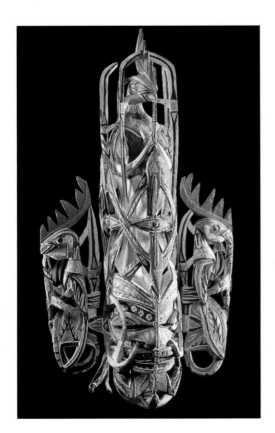

◀ 3 "MATUA" MASK, northern New Ireland.
Painted wood, height 32¼ inches. Geneva, Musée Barbier-Mueller
Almost all of the religious ceremonies of the small island of New Ireland are designated by the generic term malanggan. *Some required several months of preparation for which entire villages were mobilized. Malanggan sculptures were assembled and publicly exhibited in special house-theaters, where they were arranged in tableaux suggestive of stories recounting the interaction of men and animals—fish, birds, snakes, or pigs—central to the local mythology. The sculptor of this piece has displayed great technical virtuosity, undercutting the white wood to produce a complex network of interlocking curved bands. His formal mastery is equally impressive, for the manipulation of volume, line, and color is remarkably assured. The result is striking: despite a multiplicity of elements, it is perceived as a satisfying whole. Malanggan artifacts might be described as "baroque" in contrast with the more "classical" approach typical of Sepik art (8).*

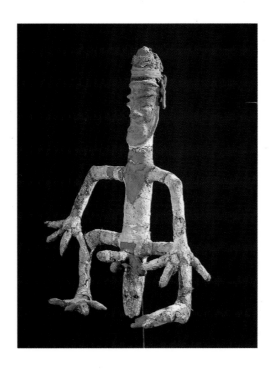

▶ 5 ZOOMORPHIC CARVING, Yambu,
Enga Province, New Guinea. Prehistoric era.
Stone, height 7¹³⁄₁₆ inches. Canberra, National
Gallery of Australia

*We know very little about this small but magnificent stone
sculpture, which was found in a mountain cave in New
Guinea. "Zoomorphic" means "with an animal-like
shape"; the creature represented here could be either a
natural animal or one with a man's head. It is seated
and holds a spherical object against its belly. No other
object resembling this figure has yet come to light, and its
uniqueness intensifies its fascination. Carved from very
hard rock, its formal mastery and powerful presence are
remarkable. Seen in profile, the oval shape of the stone
from which it was made is readily apparent. Viewed from the front, the figure's eyes, mouth,
and hands appear in perfect alignment. Thus it is a fully sculptural conception, designed to be
seen from several points of view as it was turned in the hand.*

▲ 4 ITHYPHALLIC FIGURE, Vanuatu,
Malakula Island. Wood, vegetal paste,
textile, paint; height: 15 inches.
Marseilles, Musée d'Arts Africains,
Océaniens, Amérindiens (MAAOA)

*The erect penis of this small figure—"ithyphallic"
means "erect phallus"—indicates it was intended
for use in a fertility rite. It was probably attached
to a head-mask worn by men during the nalawan
ceremony in the southern part of the island at
the end of the nineteenth century. It may repre-
sent one of a group of divinities known as the
Small Nambas, or perhaps Rambat, another
divinity believed to have established the practice
of circumcision.*

*This figure was originally part of a larger piece
whose volumes it would have complemented.
Despite its small size, it projects considerable
strength and presence. The threads of fabric cir-
cling its forehead are of western origin.*

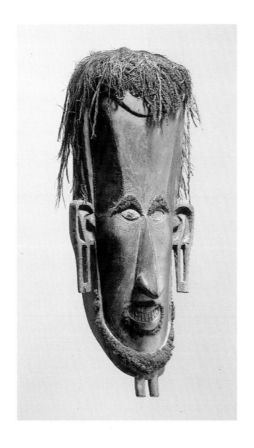

◀ 6 MASK, Saibai
Island, Torres Strait,
Australia. Wood, fibers,
human hair; height
31½ inches. Geneva,
Musée Barbier-Mueller

*Masks of this type were
worn during the mawa cer-
emony, performed during
the harvest of a prune-like
fruit. Hidden by the mask
and a vegetal costume, men
could enter homes in the
night and confiscate food.*

*These masks are found
only on the tiny island of
Saibai. Their beauty derives
from the subtle interplay
of their profiles and the
curving shapes of their eyes,
mouths, and noses.*

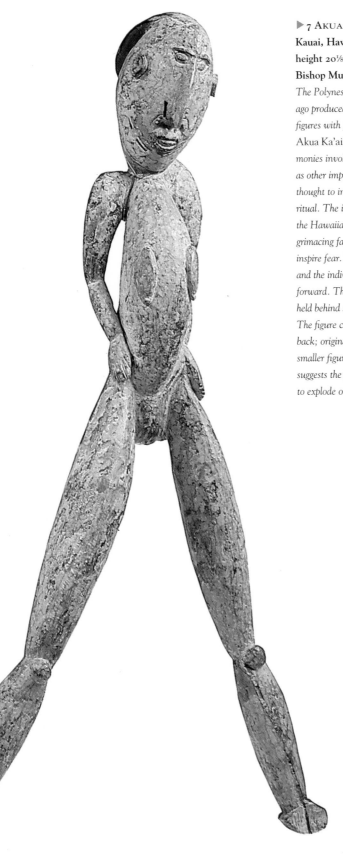

▶ 7 AKUA KA'AI FIGURE,
Kauai, Hawaii. Wood and hair,
height 20⅛ inches. Honolulu,
Bishop Museum

The Polynesians of the Hawaiian archipel-
ago produced a lively art of male and female
figures with pronounced musculature.
Akua Ka'ai figures were used during cere-
monies invoking the chief's ancestors as well
as other important divinities, who were
thought to inhabit the sculptures during the
ritual. The illustrated piece exemplifies
the Hawaiian conception of beauty. The
grimacing facial expression was meant to
inspire fear. The musculature is massive
and the individualized volumes tend to point
forward. The crouching posture with arms
held behind suggests defiant readiness.
The figure carries another small one on his
back; originally there were two of these
smaller figures. Hawaiian art frequently
suggests the presence of inner tension about
to explode outward.

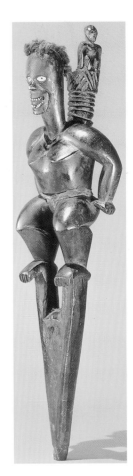

◀ 8 FEMALE FIGURE, Abelam, Papua New Guinea.
Wood, height 42½ inches. New York,
The Metropolitan Museum of Art

The Abelam people live along the great Sepik River. This
statue of a woman with legs spread and hands on her hips
seems determined to prevail over the viewer. The sculptor has
displayed a remarkable mastery of the formal conventions
prevailing in his social group. The relation of the proportions
of the head, torso, and legs is superbly controlled, and the tilt
of the head and the shape and placement of the arms are pow-
erfully evocative. The attenuated legs, crucial to the upside-
down Y form, give the figure a certain majesty, and the oval
breasts echo the profile of the torso.

URBAN SCULPTURE IN NINETEENTH-CENTURY FRANCE

▶ PIERRE-JEAN DAVID
D'ANGERS (1788–
1856). *The Grand
Condé.* 1817. Plaster
model, height 6 feet
1¹⁄₁₆ inches. Angers,
France, Musée des
Beaux-Arts

*This work, the first official
commission awarded the
young David d'Angers,
made his reputation. The
great French general is
shown at the head of his
army in the field, about to
toss his baton of command
into the enemy ranks.
Proud and energetic, he is
the embodiment of martial
determination.*

Commemorative Monuments

Before the French Revolution, the only figures to merit public monuments were rulers and members of the nobility, the army, and the clergy. At the beginning of the nineteenth century such depictions still retained something of a sacred aura. When Louis XVIII became king of France in 1815, one of his first acts was to replace the statues of Henry IV, Louis XIII, and Louis XIV destroyed during the Revolution, and in 1816 he prohibited anyone from erecting a monument without his authorization.

Political tensions persisted, and the French nation was to undergo three revolutions, three republics, two monarchies, and two empires in the nineteenth century. It was, nevertheless, a century of increased historical awareness, and efforts were made to rally community spirit by honoring historical military heros like the ancient Celtic chieftain Vercingetorix, the mediaeval knight Bayard, and the fifteenth-century warrior-saint Joan of Arc. Thus the national pantheon was beginning to include popular figures as well as monarchs.

Gradually, monuments were raised to French military heros such as the seventeenth-century Prince of Condé, who was depicted by the sculptor Pierre-Jean David d'Angers (1788–1856), as well as to legendary figures. Many forms of presentation were used, from simple busts to full-scale equestrian statues. By the end of the century professional groups such as farmers, inventors, and doctors, were seeking to honor their "ancestors." Popular leaders, soldiers, and even industrialists began to be memorialized, although not without controversy. The erection of a monument to Xavier Jouvin, the inventor of a process for sizing gloves, was prohibited three times before finally being approved; it was inaugurated in Grenoble in 1889.

Urban Evolution and the Cult of Progress

Cities were changing, and their rapidly growing populations demanded the construction

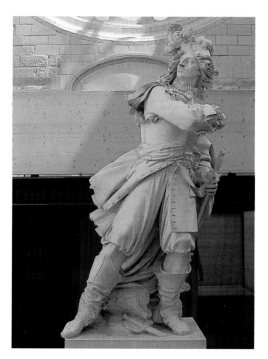

of new neighborhoods. Old ramparts were demolished and replaced by broad tree-lined boulevards. New modes of transportation, proliferating vehicles, and the need to improve water distribution all entailed the paving of new streets and the widening of old ones. At the same time, new sculpture appeared in parks and gardens as well as on the façades of buildings.

Scientific discoveries were being made at a feverish pace, in chemistry, mechanics, and medicine, and also in ethnography, history, and archeology. Art was mobilized to educate the public. It was thought that honoring men renowned for their discoveries or for their virtue, courage, and patriotism would encourage others to emulate them, with beneficent effects for the nation. Monuments of this kind prompted the poet and critic Charles Baudelaire (1821–67) to speak of sculpture's "divine role," with pedestals functioning as altars, inscriptions serving as articles of faith, and reliefs recounting a new set of sacred stories. Solemn dedication ceremonies with processions and orations reinforced this idea, and

legitimized the role of such works as safeguards of the national memory.

Allegorical Sculpture

Statues were also used to proclaim convictions and defend ideas, especially after Emperor Napoleon III was deposed and the Third Republic was established in 1871. Allegory was often used to express abstract concepts. Just as in earlier periods the monarchy was represented by the king, the Republic was now represented as a female personification known as Marianne. As an example, the ideals of liberty and justice were represented allegorically as individual personifications, as in *The Triumph of the Republic* (at right) by Aimé-Jules Dalou (1838–1902).

Public embodiments of political ideals are inevitably linked to the regimes that erected them, which explains why revolutions often lead to the destruction of such monuments. The Vendôme column in Paris, which was originally surmounted by a statue of Napoleon, was demolished twice, first after the fall of the First Empire and then after the collapse of the Second Empire of Napoleon III (reigned 1852–71).

Garden sculpture tends to be less political, generally featuring mythological figures or allegories of the seasons. One of the most monumental examples of such sculpture is the Fountain of the Four Parts of the Globe by Jean-Baptiste Carpeaux (1827–75) and Emmanuel Frémiet (1824–1910), erected in Paris in 1873.

Realism and Symbolism

When a statue represents a king, a statesman, or a doctor, the sculptor usually executes a faithful portrait whose posture helps the viewer identify him. In such works, orators may gesture rhetorically, writers hold their pens, and chemists examine test tubes.

Around the turn of the twentieth century, sculptors began to challenge such conventions. The *Burghers of Calais* (1884–86) by Auguste Rodin (1840–1917) is a monument to brave and virtuous men: six citizens of the town of Calais in northern France, who, after a defeat in a war with the English in 1387 offered their own lives so that the rest of the town might be spared. The sculpture's inten-

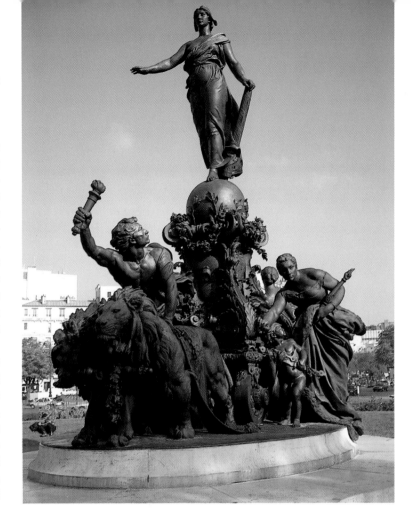

▲ Jules Dalou (1838–1902). *The Triumph of the Republic.* 1879–99. Bronze, height approximately 40 feet. Paris, Place de la Nation

The triumphant Republic, wearing a phrygian cap, enters Paris on a chariot pulled by two lions and driven by Liberty, whose torch lights the way. Female personifications of Abundance, Justice, and Peace, accompanied by Work, represented as a blacksmith wearing wooden clogs, escort the chariot.

tion is consistent with nineteenth-century ideals—but its unidealized mode of expression is not. Rodin intended the figures of the burghers to be placed at ground level so that the viewer would be surrounded by them, and he used expressionist modeling, twisted poses, and tortured faces to communicate the despair of these men about to die to save their fellow citizens. The work's powerful emotional expressionism pioneers an utterly new approach to the public monument.

▼ François Rude (1784–1855). *Marshall Cavaignac.* 1847. Bronze, life-size. Paris, Montmartre Cemetery

It is said that when Cavaignac's brother saw this figure in Rude's studio, he touched it and then suddenly withdrew his hand, surprised by the chill of the metal. For an instant he had mistaken it for his brother's actual body.

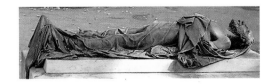

SCULPTURE IN THE TWENTIETH CENTURY

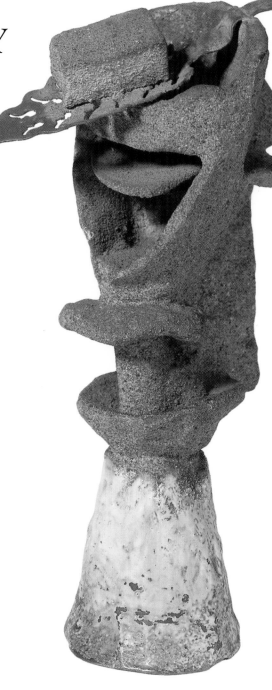

After Rodin

At the beginning of the twentieth century, the human figure remained the preferred subject of many sculptors. Early in the century, some of Rodin's students began to move away from their teacher's naturalism and emotional expressionism in favor of a more formalist treatment of the figure. For example, Emile Bourdelle (1861–1929) favored blocky rhythmic poses, while Aristide Maillol (1861–1944) and others shaped full, smooth volumes into undulating, arabesque-like forms. Gradually, figural sculpture gave way entirely to purely formal statements of increasing simplicity. This tendency reached its zenith in the smooth surfaces and organic forms of Jean Arp (1887–1966) and Henry Moore (1898–1986).

Ready-mades and Assemblages

The Cubist painters (see p. 160) and their sculptor friends, who focused on the relation between three-dimensional space and the flat plane, set out to fragment volume. In 1914, the Spanish Cubist Pablo Picasso (1881–1973) incorporated an actual spoon in his sculpture *Absinthe Glass*, producing what is now known as an assemblage. In the same spirit of desanctifying art, Marcel Duchamp (1887–1968), also in 1914, exhibited an industrially produced bottle rack as a sculpture, dubbing it a "ready-made" (p. 166).

The Dada movement opened the way for many developments in sculpture. Scepticism about scientific progress led its members to mock machine imagery. The American artist Man Ray (Emmanuel Radnitsky, 1890–1970) produced absurd objects, such as an iron with nails protruding from its bottom (*Gift*, 1921).

Assemblages and ready-mades contain the germ of all of modern sculpture. French "Dustbin art" uses waste materials, and the Italian *Arte Povera* movement also makes a virtue out of cheap material. Art continues to be influenced by this approach. Since the 1960s, the

▶ PABLO PICASSO (1881–1973). *Absinthe Glass.* 1914. Painted bronze with absinthe spoon, 4¹⁵/₁₆ x 6½ x 2⁹/₁₆ inches. Paris, Musée National d'Art Moderne, Centre Georges Pompidou
This piece represents the first instance that an object not made by the artist was presented as a work of art.

French sculptor Bertrand Lavier has exhibited industrial objects covered in thick coats of paint; arranged to take full advantage of a specific space, the result is called an "installation."

A number of twentieth-century artists have tried in other ways to erase the bound-

See: Cubism, p. 160; Dadaism, p. 166; Abstract Art, pp. 164–165; Pop Art and New Realism, pp. 168–169; Brancusi, p. 184; Calder, p. 188; Maillol, p. 236;

aries between art and ordinary life. In pursuit of this principle, the American artist George Maciunas (1931–78) launched the Fluxus movement in West Germany in 1952.

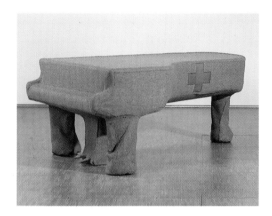

The movement spread to other countries, and soon included the Frenchman Ben (Benjamin Vautier, b. 1935), and the German Joseph Beuys (1921–86). Beuys's works reflect events in his own past; in some cases his pieces continue to evolve through physical or chemical changes in their materials. Pushing the theory of the unity of art and life to extreme lengths, Beuys's work suggests that each of us is a sculptor who shapes his own life and thought.

From Constructivism to Minimalism
The Constructivists, a group of Russian artists who expressed volume through assemblages of lines and planes in the early twentieth century, carried the exploration of three-dimensional space to the limit. In 1915, Vladimir Tatlin (1885–1953) crafted his *Counter-Reliefs* to fit into corners, thereby uniting sculpture and architecture; in these works, the primary material is, simply, a void.

Some artists, like Max Bill, produce sculptures without a subject by materializing mathematical laws. The American Minimalists arranged repetitive elements—blocks or solid forms, planes, neon tubes—according to precise geometric schemas. The viewer, moving toward, through, and around their works, functions as a part of them. Carl Andre, for example, has placed small metal plates on the floor, while Richard Serra has made precariously balanced compositions of colossal steel

slabs. Land Art, which is, in effect, sculpting the earth, evokes certain prehistoric forms. Michael Heizer has had his compositions excavated from vast tracts of deserted land.

New Themes and Materials
Duchamp-Villon, with his *Horse* (1914), tried to capture movement by using industrial material, combining shapes evocative of rods and gears into a composition vaguely resembling an animal. Later real movement was introduced in the kinetic sculpture of Naum Gabo, who in 1920 produced an optical illusion of form with vibrating rods, and in the mobiles of Alexander Calder. László Moholy-Nagy added light and sound to the mix in his *Space-Light Modulator,* a poetic machine that continuously transforms its environment. Constructivists and members of the Bauhaus carried out many experiments with glass, metal, and plexiglass, while other artists worked with concrete and resinous materials.

In the 1960s, however, American Pop Art and the French New Realist movement introduced new approaches to figuration. The giant soft sculptures of Claes Oldenburg explore the nature of consumer culture. George Segal arranges plaster casts of living models in tableaus suggestive of everyday situations. Similarly the world of the machine has been imbued with an absurd poetry in the constructions of Jean Tinguely. Arman encased entire cars in blocks of concrete, creating fossils of our own time. More recently, artists as different as Edward Kienholz and Rebecca Horn have continued to work in the figurative sculptural tradition.

◀ JOSEPH BEUYS (1921–86). *Homogeneous Infiltration for Grand Piano.* 1966. Piano covered with felt, 39⅜ x 59⅞ x 94½ inches. Paris, Musée National d'Art Moderne, Centre Georges Pompidou
This piece was produced during one of the artist's "happenings."

▼ MAX BILL (1908–94). *Endless Ribbon, Version IV.* 1935. Saint-Gothard granite, 51⅛ x 68⅞ x 35⅜ inches. Paris, Musée National d'Art Moderne, Centre Georges Pompidou
With this piece, the sculptor transformed a Möbius strip into a stone arabesque.

Today, sculpture can no longer be defined as a discrete three-dimensional artifact. It has descended from its pedestal to reestablish, somewhat as in the Middle Ages, a direct relationship to its environment in architecture, in the landscape, or in the world of everyday life.

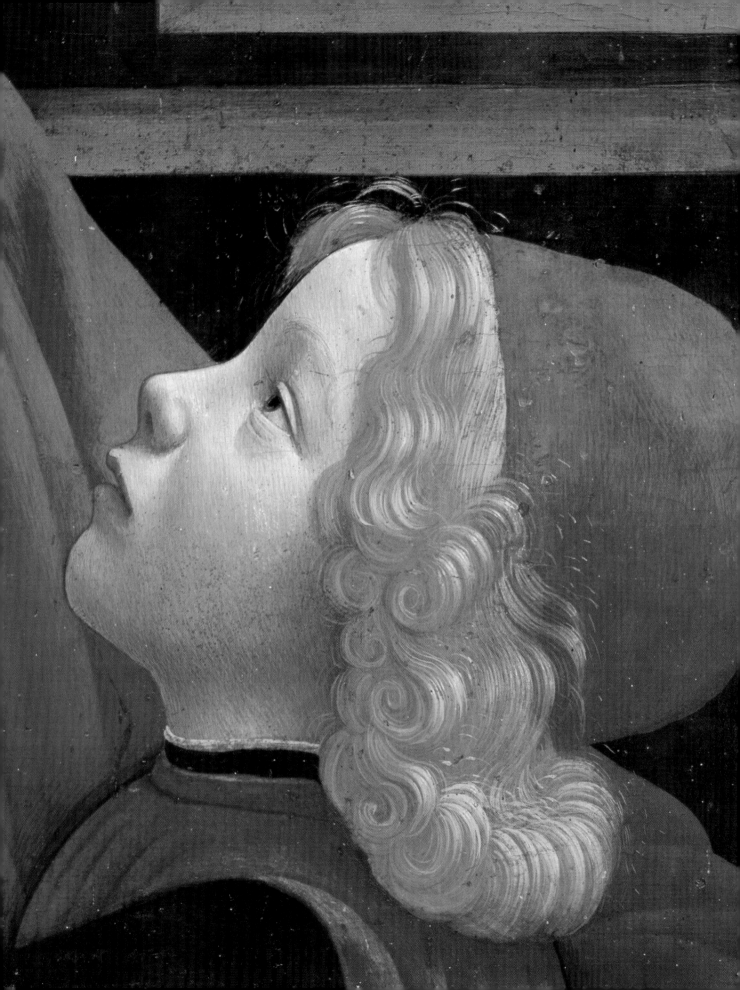

Well before the invention of writing, people left records of their presence by marking on rocks and on the walls of caves. In these arrangements of line and color are the origin of painting. Some of these images are made up of only a few lines; others are complex drawings or paintings, quite the equal of anything produced since. In any case they bear witness, affirm, narrate, suggest, and activate the imagination. Painting and drawing can indeed do all of these things, and much more.

There are many techniques of painting, but, simply put, they all require the artist to select colored pigments and to work with them on a supporting surface. Virtually anything can be painted on—stone, wood, plaster, canvas, paper, metal, or even plastic. The first pigments were produced from the soil, from rocks, and from plants. Now, of course, there are new, industrially produced colors, and even the most ancient pigments are mass produced in factories.

Paintings are more than mere documents of their time and place. They have lives of their own. The artist has infused them with life and meaning, in religious, social, moral, or aesthetic terms—and sometimes all of these at once. The viewer, recognizing at least some of these intentions, responds to the image, and thereby engages in a dialogue with what the artist has painted, accepting at least some of it and perhaps rejecting the rest.

Today painting shares many of its traditional functions with reproductive media such as prints, photographs, television, or video. Nevertheless, the give and take between work and viewer, fascinating and unique, remains the principle goal and motivating force of art.

PAINTING AND ITS TECHNIQUES

Painting arose from the desire of people to leave behind traces of their existence in the form of marks—attempts to represent the world—made on a variety of natural surfaces. Its three basic ingredients were pigments—derived from soil, rocks, plants, crushed bone, or soot—a supporting surface, such as a cave wall or other rock face, and something with which to apply the pigment—bare hands, sticks, or other tools that could be used to define contour and form. Every technique later used in drawing, painting, and printmaking can be traced back to these simple beginnings.

 LEONARDO DA VINCI (1452–1519). *Study of Drapery.* Brush drawing on linen canvas with white highlights, 7⅛ x 9¹⁄₁₆ inches. Paris, Cabinet des Dessins, Musée du Louvre

According to Giorgio Vasari, Leonardo's sixteenth-century biographer, the artist ". . . applied himself seriously to drawing after nature, and he made clay figurines, draping them with light cloth dipped in plaster; then he patiently drew on fine pieces of canvas, in black and white, with the point of a brush. He did this admirably, as can be seen in examples in my drawing collection."

Drawing

Drawings can be executed on various supports, such as walls (as in the case of preparatory sketches for frescoes), parchment or vellum, or paper, which can be made from the fibers of shredded cloth or wood pulp. The actual drawing can be produced in a number of media, including charcoal and ink (both of which have been in use since antiquity), various metal points (in use since the Middle Ages), and chalk (used since the fifteenth century). Ink line drawings with additions in washes of the same ink or in other colors were a special favorite of artists of the seventeenth and eighteenth centuries, and in the nineteenth century, graphite, a soft variation of the traditional metalpoint, was introduced, a medium that lives on as the common lead pencil.

Painting

Painting requires colored pigment mixed with a binder or other medium such as water, gum arabic, turpentine, or oil. It can be diluted with water or another solvent, depending on its makeup.

From antiquity, artists painted walls in tempera or in the fresco technique. Tempera paint can either be water-based or mixed with egg yolk to form an emulsion. In its water-based form it can be applied to dry, fine-grained plaster, a manner of painting used in the West for large-scale decoration since the thirteenth century. Water-based tempera colors are matte and rather fragile. When tempera is mixed with egg yolk (in which case it is sometimes called egg tempera), it produces colors that are brighter, more brilliant, and less fragile than the purely water-based variety. In the fresco technique (sometimes called "true fresco" to distinguish it from tempera, or "dry fresco"—*fresco secco* in Italian), the water-based paint is applied to plaster that is still wet (*fresco* is the Italian word for "fresh"). The colors penetrate the wet plaster, and when it dries, bond with it so that they are firmly attached to the wall. Not only is fresco much more stable than tempera wall painting, but the colors retain more of their brilliance.

Watercolor is another water-based medium, used primarily on paper. Its transparency and fluidity require unusual awareness of the support. Gouache, another water-based paint, is thicker and more opaque, but it is also sensitive to humidity, and less stable than watercolor.

Chemical advances have made it possible to make vinyl and acrylic paints with a synthetic resin base. Water soluble and easily manipulable, their colors are vibrant and more

Silk screen + Serigraph is same technique

tion to the advantage of easy reproducibility.

Prints are made in two stages. First, a surface is carved, incised, or engraved to create a plate or block for printing; then, prints are made from it.

Prints are made either by "relief processes" or "intaglio processes." In relief processes, such as woodcut or linoleum cuts, the white areas of the design are cut out of the block, leaving the lines that form the desired composition in relief. The block is then coated with ink and pressed against paper, leaving an impression of the image cut from the block. In intaglio processes, such as engraving, etching, drypoint, and mezzotint, the image is cut or incised directly into the plate, which is usually of metal. The plate is first inked and then wiped clean, leaving ink only within the incised lines; it is then printed under pressure, which forces the ink from the recesses onto the paper.

Lithography, another reproductive technique, exploits the incompatibility of oil and water. The design is traced onto a stone with an oil pencil, and the stone is then inked. The ink, being water-based, adheres only to the areas not covered by the oily pencil, and prints only from them. In silk-screen printing, color is pressed through a screen prepared with a stencil, transferring its shape onto the support, usually paper or cloth.

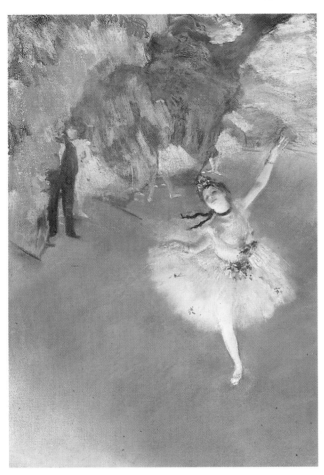

▲ EDGAR DEGAS (1834–1917). *L'Étoile.* 1876–77. Monotype with pastel additions, 22⅞ x 16½ inches. Paris, Musée d'Orsay
Pastel can be applied in strokes in several successive layers and smudged to produce tonal effects. Its best support is paper, preferably with a coarse grain, to which the medium's powdery particles easily adhere.

or less matte. Easily applied to a wide array of supports, they are also stable and dry rapidly.

The discovery of oil painting as a pictorial medium is attributed to the Van Eyck brothers of fifteenth-century Flanders. Within a century, it became the most common medium in Western painting. Oil paint, suspended in linseed oil and thinned with turpentine, can be applied in fine strokes that leave little trace of the painter's touch, or in robust strokes, which leave a thick layer of paint, or impasto. Oil painting is time-consuming. The support must first be covered with priming to prevent direct contact between the canvas and the pigment, to avoid undesirable chemical reactions. In addition, oil paints take a long time to dry, sometimes several months.

Printmaking

Prints were first used in the fifteenth century to reproduce and disseminate copies of an image, but artists soon realized that the various print media had desirable aesthetic qualities, in addi-

▼ REMBRANDT VAN RIJN (1606–69). *Christ Healing the Sick ("The Hundred Guilder Print").* 1649. Etching, drypoint, and burin, 11 1/16 x 15⅛ inches. Paris, Musée du Louvre
Rembrandt used different printing techniques to obtain the effects that make this print a masterpiece of chiaroscuro, the depiction of light and shadow. It received its popular nickname in Rembrandt's lifetime, when it was sold for one hundred guilders, an astonishingly high price in the seventeenth century.

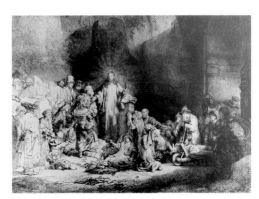

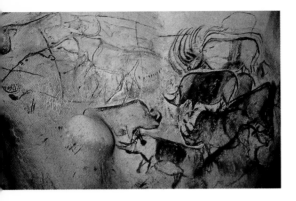

PREHISTORIC PAINTING

The earliest surviving examples of prehistoric art were made about 32,000 years ago. They predate human history, which began with the invention of writing in Sumeria, Mesopotamia, around 3,000 BCE.

▲ RHINOCEROS AND OTHER ANIMALS, from the cave at La Combe, Ardèche (south-central France). c. 15,000–18,000 BCE

A unique bestiary unfolds on the walls of the vast network of underground chambers at La Combe. Rendered in black or white depending on their placement, rhinoceroses confront one another, while bears and large felines appear alongside deer, mammoths, and horses. In all, there are more than three hundred animals. A panther, a hyena, and an owl are especially remarkable, for no other paleolithic representations of these animals are known. A consistent sense of relief, use of color, and technical mastery suggest that these paintings are the work of a single artist. They are certainly among the great masterpieces of prehistoric art.

The World of Cave Art

The first images painted on cave walls were discovered in the late nineteenth century. The most remarkable examples are in the Pyrenees mountains, at Altamira in northern Spain, and in Gargas and the Cave of the Three Brothers in southern France. Other examples are to be found in the French provinces of Lot and Périgord, which boast some twenty painted caves, notably those at Pech-Merle, Rouffignac, Combarelles, and, best known of all, the cave at Lascaux. Some of the figures in the Cosquer cave, discovered in 1991 in the south of France, are 27,000 years old.

On December 25, 1994, another cave containing remarkable markings and paintings roughly 20,000 years old was discovered in Combe d'Arc, in the French province of Ardèche.

These caves, which consist of successive chambers linked by passages, contain images of animals, silhouettes of hands, abstract signs, and networks of points that seem to be deliberately arranged. In an effort to determine their meaning, archeologists are examining everything they have found there, including handprints and footprints, tools, sticks, bones, and the ashes of ancient fires.

Prehistoric men and women did not live in these caves, but in shelters built just inside them, which afforded protection from bad weather and from danger. To paint on the walls of the caves' inner reaches, they used lamps fueled by a mixture of plant material and animal fat, whose illumination resembled candlelight.

Images of Beasts and Men

By and large, parietal art consists of depictions of animals. Images of horses and bisons predominate, but ibexes, deer, reindeer, and wooly mammoths are also common. There are also occasional representations of bears and large cats. Always in profile, most of these animal depictions are small. An exception are the bulls painted on the walls at Lascaux, which are quite large.

Human figures are more unusual, but on the Ajjer plateau in the Sahara there are paintings of female figures with birds' heads. Other caves are painted with "ghost" silhouettes. One of these, the "sorcerer" from the Cave of the Three Brothers, appears to be part animal and part human, with a head with owl eyes and reindeer horns on a man's body. At Lascaux, a very rare scene represents a wounded man falling in front of charging bison.

Hands and Enigmatic Signs

The hand imprints found in most caves are especially abundant at Gargas, where many of them lack one or more fingers. Some scholars interpret them as a hunter's code while others think they refer to a religious ritual in which the hand was mutilated.

Abstract signs often figure in these compositions, in the form of grouped or aligned dots, arrows, bars, featherlike hooks, and filled-in squares and circles.

Color in Cave Art

The basic colors of cave painting are red and black, sometimes enriched with yellow,

The earliest period is characterized by crudity, consisting of unformed animals with awkward profiles. Beginning in the second period, animals are recognizable by their sinuous backs and rounded bellies. Horns, muzzles, and eyes are perfectly captured but legs are often blunted. The Lascaux caves belong to the third period, dating from some 17,000 years ago when art was more developed. The bodies remain disproportionate, but each species is readily identifiable. Artists had begun to translate animal movement. By the final generation they had begun to study living models more closely, aiming for realism, but the results are rather stiff.

Artists or Magicians?

The frequency of animal depictions suggests their importance in the life of prehistoric man. But why paint them?

Many of these images clearly relate to the hunt. Perhaps they were intended to bring good luck and conquer fear.

Or perhaps these caves were sanctuaries reserved for the celebration of a myth, a fertility ritual, or magical rites.

The meaning of these signs continues to elude us. Evidence of early man, they predate the discovery of writing and thus the beginning of human history.

▲ RUNNING ARCHERS, a detail of a rock painting from the Tassili plateau, Sefar (central Sahara), Algeria
These remarkably lifelike paintings convey a vivid impression of the movement and rhythms of running. Their age has not been determined with any certainty.

▼ ROTUNDA OR HALL OF THE BULLS, caves at Lascaux, France. c. 15,000 BCE
This room contains the largest known prehistoric painting, a frieze depicting a cavalcade of bulls and horses placed some ten feet above floor level.

maroon, and violet. All of these were made by combining ground minerals with fat. Red was made from iron oxide, yellow and brown—used for lights and shadows—from ocher. Chalk was sometimes added to lighten the color. Black was derived from manganese. Painters generally mixed these colors in stone cups or on flat stones.

Sculptors, Engravers, and Painters

In addition to painting, prehistoric people sculpted and engraved. Silhouettes and such prominent details as eyes and muzzles were often incised in the wall before the pigment was applied.

Sometimes artists exploited irregularities in the rock to suggest an animal's body or a bison's hump, accentuating its effect by cutting into the wall with stone implements. Often they used their fingers to trace thick lines, but pigment might also be applied with sticks, reeds, brushes made of hair, or pieces of animal skin. Painters were able to vary line thickness, exploit color contrast, and evoke shadows with hatched lines, thereby furthering the illusion of volume.

To depict hands, the artists traced outlines of their own hands, or used them as stencils by blowing colored powder over a hand as it was held against a wall, thereby producing a negative image.

Generations of Artists

While the themes of parietal art remained the same, specialists have observed a stylistic evolution over time.

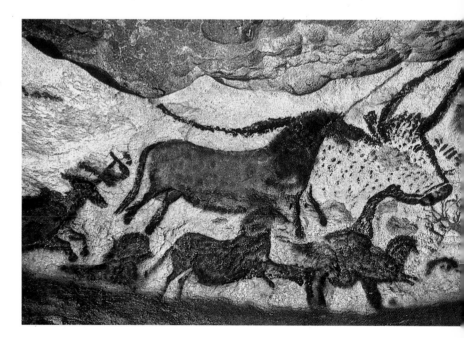

ANTIQUE DECORATION: GRECO-ROMAN MOSAICS

An Ancient Art

Long neglected by art historians, who considered it simply as a derivative of painting, mosaic is in fact one of the oldest arts. The earliest floor mosaics known are eighth-century-BCE examples discovered in the city of Gordion in Asia Minor. Mosaics appeared in Greece around the sixth century BCE, and flourished in the Greek world and later in the Roman empire until the fifth century CE.

▲ GEOMETRIC MOSAIC from Daphne, near Athens, Greece. Fourth century BCE
This tessellated mosaic represents interlocking white and yellow shields set against a background of red and black.

▶ DEER HUNT (detail). Fourth–third centuries BCE. Pebble mosaic from Pella, Macedonia, Greece
This work from a private house is among the finest surviving Greek pebble mosaics. It is signed by an artist named Sophilos, which makes it one of the very few signed examples.

Mosaics are made by arranging pieces of stone or glass to form patterns, or even pictures, in a bed of cement. Originally they were set into the floor as decorative pavements featuring geometric and figural motifs.

Two successive techniques were used:

Pebble mosaics, as the name suggests, are composed of small stones, about one quarter to three quarters of an inch across. Usually, they present geometric or figural compositions in two colors, light against dark. The best and most highly developed examples of this type were produced at Pella, the capital of Macedonia, in the fourth century BCE.

Tessellated mosaics are made of *tesserae* (singular, *tessera*), small terra-cotta, stone, or glass paste squares, about one-quarter to three-quarters of an inch across. These pieces, like the stones in pebble mosaics, are arranged in compositions and set in a bed of cement, which consisted of three layers, the uppermost of which consisted of crushed brick and lime. These in-terlocking layers assured the mosaic's stability.

Thanks to the many colors of the tesserae, mosaics of particularly high quality often seem like paintings in stone. Floor mosaics were designed like carpets, featuring a central composition—called the *emblema* in Latin—surrounded by decorative borders, usually of floral or geometric designs.

Mosaics as Architectural Ornament

Greek and Roman mosaics were carefully integrated with their architectural surroundings, and mosaic pavements abounded in public buildings, palaces, and private residences. The earliest known Greek pebble mosaics were assemblages of geometric designs, but later examples, such as the *Deer Hunt* mosaic at Pella, Macedonia (see illustration below), present figural scenes. In the third century BCE, tessellated mosaics with more motifs and a wider color range appeared, as at the House of the Masks on the Greek island of Delos. When the Romans began to decorate their buildings with mosaics, they found it readily adaptable to any architectural form. Roman mosaicists often coordinated their work with the furniture in a room; a rectangular composition, for example, might correspond to the placement of a bed. The function of the room was also taken into account. For example, geometric, floral, figural,

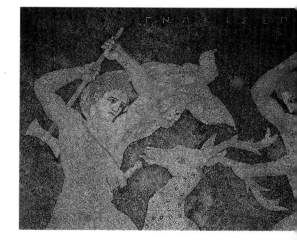

 See: The First Christian Churches, p. 56; The Pompeian House, p. 67; Byzantine Art, pp. 54–55.

mythological, and historical motifs often decorated the floors of private villas, while theatrical scenes, marine views, and gladiatorial combats often appeared in theaters, amphitheaters, and public baths. A particularly fine example in a public bath is the famous black and white mosaic of the god Neptune driving his sea-horse chariot in the Baths of Neptune at the Roman port at Ostia, dating from the second century CE.

Mosaics in the Roman World

The armies of the immensely powerful Roman state conquered many countries, and archeologists have discovered mosaics throughout the Roman world. There are fine examples from Italy, Spain, Portugal, France, and parts of northern Africa, all of which became Roman territories between the late first and the third centuries CE. With their original compositions and vibrant colors, these far-flung mosaics are the equal of any produced in Rome itself.

A variety of pictorial themes appear in the luxurious villas of the Romans: plants, animals —including both wild and domestic species— birds, and fish, as well as scenes of hunting, fishing, and grape gathering. The seasons, which were frequently represented in the Roman world, were symbolized by young

women, fruit, or flower garlands. The god Dionysus was often depicted in private residences, either as a youth surrounded by boys his own age or as the god of pleasure, in which case he is depicted as drunk. Dionysus was also represented as a triumphant or amorous deity.

Demand for mosaics was so great that workshops to produce them sprang up in many North African cities, for example, at El Djem, Acholla, and Carthage in Tunisia and Constantine, Djemila, and Cherchell in Algeria.

The Romans became masters of the mosaic art, exploiting all of its artistic possibilities to perfection. The production of Roman mosaics ceased around the fifth century, however, after the fall of the empire. The art of mosaic continued to develop under the patronage of early Christians, who commissioned religious images in mosaic for their churches. Later, mosaics were to be a major pictorial medium in Byzantine art.

Some Technical Terms

Opus tesselatum: mosaic composed of small, regular squares; the most widely used technique.

Opus vermiculatum: mosaic of smaller squares than in *opus tesselatum* (between a quarter and half an inch across); used for fine details, for example, in facial features.

Emblema: a composition in *opus vermiculatum* set within a frame of *opus tesselatum*.

▲ CUPIDS AND DOLPHINS. Third century BCE. Tessellated mosaic for the semicircular floor of a pool, diameter 7 feet 5¾ inches. From ancient Utica (near Tunis). Paris, Musée du Louvre
The rich palette of this mosaic includes red, blue, yellow, orange, and brown. The cupids and dolphins are well proportioned, moving through a sea cleverly evoked by a series of jagged irregular lines. At left, two cupids astride dolphins tussle like two children.

PAINTING IN INDIA

The oldest paintings in India date from the prehistoric era. Like most prehistoric examples found in Europe, they are painted on rocks and on cave walls, and represent large animals, such as elephants, and hunting scenes. Some caves and a great many sheltered spaces under overhanging rocks, notably in Bhimbetka in central India, preserve these earliest Indian paintings. They are difficult to date with much precision, for they were executed in different periods beginning in the paleolithic era (the Stone Age), in styles that changed little over what may be thousands of years.

The Art of Mural Painting

We know from literary sources that mural painting played a very large role in the religious art of ancient India. Unfortunately, many of these works have been destroyed by the country's humid climate.

The caves at Ajanta are now badly damaged, but the site still boasts a beautiful assemblage of paintings from the fifth and sixth centuries. Like the sculpture decorating the sanctuaries and monasteries in this Buddhist holy place, the paintings were intended to instruct the faithful. They also offer a vibrant portrait of Indian high society of their period, with court scenes, portraits of important figures, and depictions of buildings.

The mural paintings of Ajanta were executed in tempera. First the rough cave walls were primed with several coats of coarse mortar mixed with straw or horse hair to give it solidity. Then a finer, smoother surface was applied, on which the artists traced the broad lines of their compositions. After this layer had dried, the artist began to paint, highlighting the contours of certain details with a fine brush. The palette used in Ajanta is rich and varied, with ocher, red, brown, white, and yellow, as well as greens made from ground malachite and deep blues made similarly from lapis lazuli.

Manuscript Painting

Manuscript illumination has historically been an important field of Indian painting, but, as with murals, only a few examples have come down to us. Like murals, manuscript illuminations were religious in character, illustrating the sacred texts they accompanied. The oldest extant manuscripts were copied on palm leaves, and cannot predate the eleventh century. Interestingly, manuscript painting actually reached its highest degree of originality in Nepal, on India's northern frontier.

▲ MURAL PAINTING AT AJANTA.
Fifth–sixth century CE. Cave I, Maharashtra, India
This scene of anointment from a jataka, or previous life of the Buddha, unfolds in a palace of great opulence. The painted columns recall the lost wooden structures of early Indian architecture. Although based on a religious text, the result is a refined depiction of courtly life at its most luxurious.

 See: The Architecture of India, pp. 48–49; Sculpture and Religion: The Indian World, pp. 98–99.

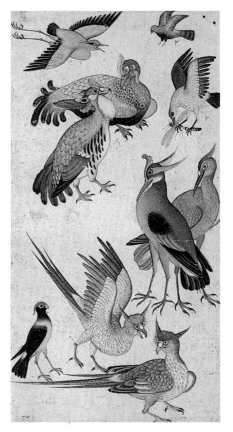

▲ MISKINA
(Mughal School,
sixteenth century CE).
Ten Birds. c. 1590.
Gouache on paper,
10¹⁵⁄₁₆ x 5¹³⁄₁₆ inches.
Paris, Musée des Arts
Asiatiques-Guimet
*Beginning in the sixteenth
century, Indian rajas, great
lovers of painting, main-
tained sumptuous courts
and encouraged an art of
great refinement, exempli-
fied by this decorative
composition of birds.*

The Art of Miniature Painting

The introduction of paper into India around the fourteenth century transformed painting in the subcontinent. Although mural and palm leaf painting did not disappear entirely, paper fostered the development of miniature painting, whose forms exhibited unprecedented refinement and expressivity.

A number of schools of miniature painting flourished on Indian soil, each with its own characteristics, usually connected to local traditions. Notable in the period between the sixteenth and the nineteenth centuries were the Rajput schools of Rajastan and the high Punjab in northwest India, and the schools of the sultans of Deccan in central India. The episodes most frequently represented in these schools were incidents from the life of the demigod Krishna, scenes of everyday life, and portraits. These miniatures, intended for an audience of princes and their courtiers, were meant to induce *rasa,* or "relish," in the viewer. *Rasa* could take many forms, including a feeling of peace, fright, physical pleasure, or amusement.

The richest and most famous of Indian schools is the Mughal school, which flourished from the late sixteenth century into the eighteenth century. Artists of great renown, some of them from Islamic Persia, worked for the glory of such Mughal emperors as Akbar (ruled 1556–1605) and Jahangir (ruled 1605–27). Unlike Indian sculptors and architects, the names of these admired and respected painters are known. They included Bichtir, a brilliant portraitist under Jahangir and Shah Jahan, and Mansur, the unrivaled master of Indian flower and animal painting. Mughal miniature painting, influenced initially by Persian painting and then by Western works brought to the country by Jesuit missionaries, produced images of great brilliance and refinement in sixteenth- and seventeenth-century India. After portraits and depictions of animals and plants, the most common subjects were compositions illustrating the memoirs of various emperors, and other historical texts. Exalting the grandeur and magnificence of powerful rulers, Mughal painting represents a high point of Indian art. It also has provided a basis for much of the imagery of later periods of Indian art.

▲ Pahari School, second half of the eighteenth century CE. *Krishna and Radha.* Gouache on paper, 7¹⁄₁₆ x 5⁵⁄₁₆ inches. Bharat Kala Bhavan, Bénarès, India
Inventing a thousand pretexts, Radha resists the amorous advances of her husband Krishna.

CHINESE PAINTING

Painting and Calligraphy

Many people consider Chinese painting, whose history encompasses more than twenty centuries, the truest expression of the Chinese artistic imagination. It is not well understood in the West, however, for its technique and spirit are foreign to Western conceptions of painting. The great religions and philosophies of Chinese civilization—Confucianism, Daoism, and Buddhism—have been its main sources of inspiration.

Confucianism, a doctrine of wisdom elaborated by the philosopher Confucius (551–479 BCE), is dominated by principles of respect, benevolence, and piety toward elders. Daoism is a Chinese mystical doctrine founded by the sage Laozi (sixth–fifth centuries BCE), emphasizes a life in harmony with nature. Buddhism, a religion founded in India in the sixth century BCE by Buddha, the Enlightened One, advocates a renunciation of earthly life, compassion for all living things, and forgetfulness of self.

Unlike Western pictorialism, Chinese painting does not attempt to depict forms as they actually appear to the eye, or to convey volumes or perspectival space. Like calligraphy, the art of Chinese writing, painting in China is a linear form of expression that exploits the potential of ink to create a rich array of tones.

Painters and calligraphers in China use the same tools. They both begin by diluting part of an ink stick, made of lampblack and gum, on an ink stone with the aid of a few drops of water. Then, with a calligrapher's brush, a bamboo stick with a few animal hairs attached, they apply the ink to paper or silk, absorbent materials that did not allow correction. Seated in front of their work tables, arm and hand held high, Chinese artists paint with broad gestures that use the elbow and sometimes the entire body.

Religious and Didactic Painting

The oldest Chinese paintings that survive are from funeral decorations of the Zhou dynasty (1100–221 BCE). These silk banners and sarcophagi evoke a magical and religious world, often depicting the deceased astride a mythical animal such as a dragon or a phoenix, who carries him or her to the paradise of the Immortals. In the Han dynasty (206 BCE–220 CE), painting began to play a didactic role that it retained throughout the rest of Chinese history. In their depictions of historical figures and events, painters tried to encourage emperors and their subjects to lead ethical lives. In the fourth century, painting was elevated to a major art, and painters began to emerge from anonymity. The famous scroll by Gu Kaizhi, *The Advice of the Prefect to Ladies of the Court*, exemplifies the beauty of the art of this period.

Between the sixth and tenth centuries, Buddhism, which had made its way from India to China through Central Asia, inspired Chinese artists to works of great creative genius. The frescoes and paintings on silk of this period gave life to a new Buddhist iconography, in which Buddha himself and his followers have a distinctively Chinese character.

▲ GU KAIZHI
(fourth century CE).
The Advice of the Prefect to Ladies of the Court (detail of horizontal scroll). Ink and pigment on silk, height 9¹³⁄₁₆ inches. London, British Museum
Chinese horizontal scrolls were unrolled slowly, scene by scene, for small gatherings, and then closed until the next viewing. This scroll offered practical advice to ladies of the court. The elegance of the figures, and the variety of episodes, expressions, and postures animates the bare space of these pictures, which are separated from one another by columns of calligraphic text.

Landscape and Scholarly Painting

Landscape, the preeminent subject of Chinese painting, owes its status to Daoist philosophy, which fostered a profound harmony between man and nature. The eighth-century poet Wang Wei is believed to have been the first artist to paint free and spontaneous monochrome landscapes in ink. Thus was born the tradition of "scholarly painting," practiced as a pastime by erudite men who used painting to express emotions they could not translate into words. Large landscapes, considered by the Chinese themselves to be the most important genre in their painting, first achieved prominence during the Song dynasty (960–1279 CE), and became a uniquely privileged mode of visual expression beginning with the Yuan dynasty (1279–1368 CE).

Artists like Ni Zan found in landscape painting a refuge from the vicissitudes of social life. Seeking to distill the mystical vision of life's power they found inherent in nature, these painters mastered the possibilities of ink and brush to create lyrical or austere renditions of towering mountains, undulating valleys, and mysterious lakes. Scarcely visible, human figures appear in these vast spaces as but one natural element among many. Their tiny figures are shown climbing precipitous mountain paths, rowing on placid lakes, or relaxing in solitary pavilions, reading or conversing with a companion.

Professional and Academic Painting

The professional painters of the Chinese imperial court rejected calligraphic spontaneity and scholarly landscape in favor of delicate colors and realistic, highly detailed renderings, specializing in plants and flowers, birds, insects, figure compositions, and portraits. Emperor Huizong of the Song dynasty, himself a painter, consolidated this art full of poetry and emotion by establishing the Imperial Academy of Painting, which remained the institutional embodiment of this refined tradition until the end of the nineteenth century.

◀ NI ZAN (fourteenth century CE). *Trees in the River Valley at Yushan.* 1371. Vertical scroll, ink on paper, 37⅛ x 14⅛ inches. New York, The Metropolitan Museum of Art *This work is a characteristic example of Chinese scholarly painting, with a landscape of studied simplicity, a restrained brush technique inspired by the art of calligraphy, and a poetic gloss at the upper right. The red marks are collectors' seals; their large number reflects the great esteem accorded the art of Ni Zan.*

JAPANESE PRINTS

The art of woodcut originated not in Japan, but in the Chinese empire in the eighth century, during the Tang dynasty (618–907 CE). In 1875, at the end of the Edo period, the art of Japanese woodcut was entering a period of decline. But it was at this time that Westerners discovered these images and were enthralled by their expressive lines, uniform blocks of color, decorative compositions, and everyday subject matter. The vogue for Japanese prints in late nineteenth-century Europe was intense, and this medium, considered minor in Japan, influenced and inspired many European artists, including the Impressionists Degas and Monet, members of the younger *Nabis* group such as Gauguin and Van Gogh, and the creators of the Art Nouveau style.

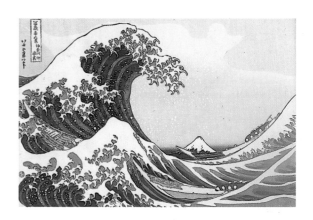

The Chinese Model

The Chinese invented a type of woodblock printing six centuries before anything of its kind was in use in the West.

The Chinese had recorded their history with prints and seals since antiquity. During the Tang dynasty (618–907 CE), Buddhist pilgrims returned from India bringing *sutras*—sacred texts—and holy images that they wanted to disseminate throughout the vast empire. Thanks to printing, the new faith quickly spread throughout Chinese society. The *Diamond Sutra,* which was printed during this period of intense religious fervor, in 868, is the world's oldest extant printed document. As Buddhism continued to spread across the Far East in the sixth century, the new religion fostered the development of printing in Korea and Japan, as well.

The installation of the Japanese government at Edo (now Tokyo) in 1602 signaled the end of what had been a period of incessant struggles between competing warlords, and initiated a long period of peace. Soon, a growing population began to settle in flourishing cities, and a new social class of artisans and

merchants emerged to challenge the rule of the samurai, the rich and powerful military caste. Although only the samurai could afford to commission the splendid gold-ground folding screens and decorated wooden panels made in this period, the new middle class could buy woodblock prints, which were cheaper, because they were produced in multiple editions. These colorful images thus became a popular art form. Woodblock prints were initially used to illustrate books, but they became an autonomous medium when around 1660 the painter Moronobu began to publish independent signed images without accompanying texts.

Print Production

Printing techniques continued to develop in Japan after their introduction from China. The original process involved four different artisans. First, a publisher selected the subject; then a painter produced a design, which he executed in India ink on mulberry paper. The drawing was then glued to a block of cherry wood, and an engraver went to work, cutting the block so as to leave the composition in

▲ **KATSUSHIKA HOKUSAI (1760–1849).** *Below the Waves at Kanagawa.* 1823. **Woodblock print, 9⅞ x 14⅝ inches. Paris, Musée National des Arts Asiatiques-Guimet**

Whether dominating the composition or dwarfed by an enormous wave, as here, Fuji, the sacred mountain of Japan, is rendered with superb imagination in Thirty-six Views of Mount Fuji. The artist of this series, Hokusai, is considered by many to be the greatest of Japanese woodblock landscapists.

 See: After Impressionism, pp. 158–159; Degas, p. 203; Gauguin, p. 214; Monet, p. 249; Van Gogh, p. 276.

relief. After inking the block, the printer placed a sheet of paper against it, and pressed it into the sheet from behind using a pad made of hemp. This resulted in a black and white impression. The painter then colored the print by hand.

Around 1760, the master Harunobu introduced the color print. This required the production of as many blocks as there were colors, each of which was printed in turn on the same sheet using a precise alignment mechanism. Elaborate prints could require more than ten such blocks. The effects thus obtained might resemble a sumptuous silk brocade in which gold and silver threads enrich the design.

Painting "the Floating World"

The Japanese merchant class lived in a refined environment rich in pleasurable diversions, which they called *ukiyo-e*, or "the floating world." Beginning in the seventeenth century, artists depicted this milieu in a considerable number of prints and paintings. They especially favored the world of the theater, geisha houses, and scenes of travel.

Actors of the popular theater, the kabuki, were favored subjects, and artists represented them with particular frequency. Rendering them with vigorous strokes and vibrant colors, they portrayed these actors both waiting in the wings and on the stage, resplendent in their costumes, and intensely involved in projecting the characters that they played. In 1794, the printmaker Sharaku produced a remarkable series of portraits of actors with grimacing, caricature-like faces set against dark backgrounds.

Geishas, the highly cultivated courtesans of the Edo period, were also a favored subject, whether depicted in erotic images or compositions emphasizing their magnificent attire. These beautiful women changed their elaborate hairdos and clothing in accordance with the hour and season. Shown at their toilette, playing music, or reading poetry, their appearance varies from artist to artist. The majestic silhouettes that characterize the early geisha images were succeeded by Harunobu's portrayals of them as frail beauties, and then by the geisha portraits of Utamaro, which are among the most beautiful depictions of feminine beauty in Japanese prints.

A Sensitivity to Nature

To paint the "floating world" was also to convey the passage of time and the profound Japanese sensitivity to nature. New Year's prints depict delicate still lifes; walks beneath red maple trees were favored in autumn, while flowering cherries were a favorite subject in spring.

Two devoted landscapists, Hokusai and Hiroshige, reinvigorated the Japanese woodcut. In 1823, Hokusai published what he considered his masterpiece, *Thirty-six Views of Mount Fuji*, the sacred mountain of Japan. These prints are remarkable for their compositional audacity. In contrast to Hokusai's genius for the dramatic and picturesque, Hiroshige cultivated a delicate style attentive to the luminosity of the Japanese landscape, exemplified by his *Fifty-three Stations on the Tokaido Road*, in which travelers are shown at all times of day and in all types of weather.

▼ **Kitagawa Utamaro (1753–1806).** *The Courtesan Hanaogi d'Oga.* Late eighteenth century. Woodblock print, 15⅛ x 10 inches. Paris, Musée National des Arts Asiatiques-Guimet
Utamaro devoted his life to portraying the women of Yoshiwara, the courtesan quarter of Edo. Using every nuance of which color woodblock printing was capable, he introduced large-scale portraiture to the medium, conveying a sense of personality and emotion with unrivaled subtlety.

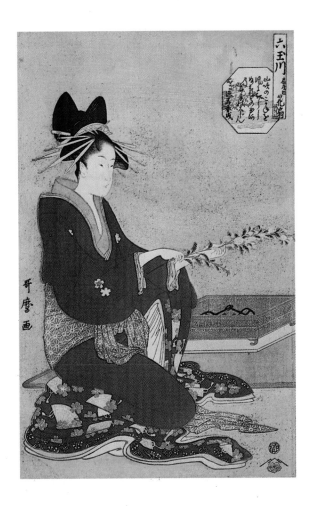

ICONS: IMAGES FOR PRAYER

Strictly speaking, any object bearing a representation can be called an icon, for the word derives from the Greek *eikon*, which means, simply, "image." But the term is most often used to denote the sacred images of Eastern Orthodoxy that were pervasive in the Byzantine empire and are still revered by orthodox believers today. The early Christians did not represent God, or even Christ, out of respect for the majesty and perfection of the creator. Moreover, they preferred to set their religion apart from the cults of the pagan gods, with their many images. Gradually, however, the human desire to have images to venerate won out over these scruples. Christian images proliferated, and the theologians became reconciled to the almost universal human need to contemplate representations of the things they revere.

▲ **Russian School, nineteenth century.** *Pieta.* **Tempera on wood panel, 10⅝ x 7⅞ inches. Rouen, Musée des Beaux-Arts**
This Virgin, hands crossed over her breast, contemplates the body of the dead Christ.

Icons Are Sacred Objects

Orthodox icons are representations of Christ and the saints made expressly to be venerated by Christian believers. They are in no sense decorative, or even merely instructive. Their primary function is to represent the prototype —Christ, a saint, the Trinity—and to receive veneration. The believers who pray in front of icons are offended when these images are exhibited in museums or sold as if they were mere works of art, for in their view, icons are not art objects or paintings like any other. They are sacred objects made in a particular way to serve their very special function.

The Production of Icons

Icons have been made in accordance with strict and unvarying rules for sixteen centuries. Icon painters must adhere scrupulously to them, for each stage has a religious meaning. The painter, usually a monk, selects an unframed piece of hardwood, which he coats with gesso until it is white and smooth, "pure and stainless," like the body of the Virgin when she conceived the body of Christ. On this immaculate surface, the painter draws or incises the contours of the figures. These marks, like those used in writing, are designated by the Greek word *graphe* (the root of "graphic," our word for anything relating to writing or drawing), for drawing of this type is regarded as an equivalent to writing. Eastern Christians believe that the inscription of form

at this stage is identical to the writing of scripture, effectively obliterating the distinction between word and image.

When the underdrawing is complete, the process of applying the paints, which are made from crushed pure pigment, begins. Colors have specific spiritual meanings, and cannot be applied in random order. The painter must begin with the darkest colors and proceed toward the lighter ones, concluding with a transparent glaze. After the dark browns and reds come green, yellow, and light red; the background ground is always gold. Finally, whites are applied to heighten the modeling of the faces and to suggest the fall of God's gaze on creation. Thus the production process enacts a progression from darkness into divine light. The painter's final act is the application of a coat of wax, which makes the image brilliant and transparent. Such concerns as a perspectival space or optical realism are of no concern to the icon-painter.

Icons Are Prayers

With its formulaic construction, an icon functions almost as a form of prayer for the faithful. Each face is circled by an inscription. Called an *epigraphe*, it names the figure represented. This inscription is an obligatory feature, signifying that the holy person, his or her name, and the image are mystically one and the same. Icons of Christ, for example, bear his name, thereby indicating this co-identity. An

epigraphe, then, is not a title of the sort that an ordinary painting might have; it is regarded as proof of the actual presence of the holy person represented.

But as God cannot be fully present in any material object, this presence is relative, perhaps even symbolic. Orthodox Christians believe that symbols bring something from the immaterial world into the material one. Thus, they are guides that lead us toward the invisible presence of the spirit.

The Rules of Representation

Persons and scenes must be rendered in accordance with canonical models, that is to say, they observe certain rules. These models are unchanging types. A Virgin of Tenderness, for example, must press the Christ child tenderly against her face; a Virgin of the Hodegetria type must gesture toward the child with one hand; an Orant Virgin must raise her hands heavenward to receive divine grace. One famous type, *The Trinity*, also known as *The Hospitality of Abraham* because it represents the Christian Trinity as the three angels entertained by Abraham in the book of Genesis, was originated by the great fifteenth-century Russian icon-painter Andrei Rublev (right).

The Iconoclastic Crisis

In 726 the Byzantine emperor Leo III launched a campaign of iconoclasm (image-breaking). He decreed that the veneration of icons was a form of idol worship and that all of the icons in the territories he ruled should be destroyed. This act set the emperor against the Church, and divided Christians throughout the empire into two opposing factions, a conflict now known as the Iconoclastic Crisis.

Why would a Christian emperor implement such a divisive policy? The Church had long understood the power of icons to move their viewers. As inducements to conversion, these beautiful images had often been more convincing than the most eloquent verbal persuasion. Perhaps the emperors grew wary of this very power, which may have seemed to exceed their own. By destroying the icons—while retaining and even propagating images of themselves—they may have hoped to augment their own authority and limit the politi-cal influence of the Church. But popular devotion to icons prevailed. A Church council held at Nicaea in Asia Minor in 787 confirmed the legitimacy of icons, and in 843 the Empress Theodora restored the legality of their veneration throughout the empire.

Images of the Inner Life

Icons are spurs to wonder, visible and magical signs inspiring belief and respect. To contemplate an icon is to reflect on the relationship between reality and imagination. Thus, they are of interest not only to Orthodox Christians, but they are visual artifacts that can tell each of us something about the inner life.

▼ ANDREI RUBLEV (c. 1360–after 1430).
The Trinity. c.1411. Tempera on wood panel,
55½ x 44⅛ inches. Moscow, Tretyakov Gallery
The Christian Trinity of Father, Son, and Holy Spirit are here portrayed as three identical angels seated at a table and sharing a single goblet of wine.

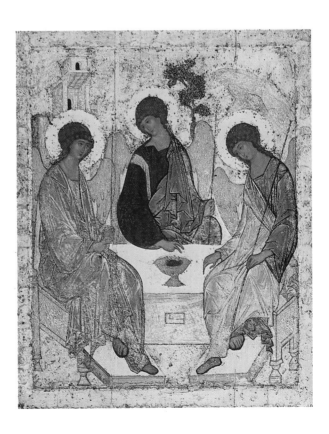

THE MEDIEVAL ARTS OF COLOR

Very few stained-glass cathedral windows and illuminated manuscripts survive to remind us of the importance of color in the medieval period, and we have learned to delight in the bare stone of medieval buildings and sculpture in their present state. From a historical perspective, however, this view is misguided. Initially, almost everything in the churches was painted: vaults, capitals, portals, and statues. The art of fresco, then, was essential in the period. Furthermore, tapestries decorated the interiors of cathedrals as they did the halls of castles. Today the manuscripts preserved in libraries, which retain all their original freshness of color, give the best idea of the medieval sense of color.

A Monumental Art: Medieval Fresco

"The art of painting is used in churches so that those unable to read can learn from the walls what they cannot learn from books," wrote Gregory the Great, who reigned as pope from 590 to 604.

Medieval frescoes, then, were intended to illustrate and comment upon biblical texts, but they also filled the house of God with a world of color and light that delighted the faithful.

Beginning in the first century CE, the Christian catacombs of Rome were decorated with paintings depicting scenes from the Bible and the gospels. This tradition continued over the centuries. Ninth-century frescoes in Auxerre, France, tell the story of St. Stephen. In the eleventh and twelfth centuries, during the Romanesque period, mural painting blossomed, as evidenced by large cycles that can still be appreciated today. As they worked, the painters took the architecture into account, placing their compositions on the vault, within arcades, and on portal tympanums, and coordinating the rhythms of their paintings with those of the building. Each region had its own style, and its characteristic themes and color schemes. In Spain, for example, colors tend to be glossy and saturated, while in western France they are matte and light. Perhaps the most magnificent surviving frescoes are in the abbey church of Saint-Savin-sur-Gartempe,

▲ **French School, early twelfth century.** *Noah's Ark.* **Fresco from the nave vault, Saint-Savin-sur-Gartempe, France**
This fresco is from a sequence depicting events from the Biblical books of Genesis and Exodus, including the creation of the world, the Tower of Babel, and the Jews crossing the Red Sea. Here Noah's ark, with its dragonhead prow, recalls a Viking ship. The luminous palette of these frescoes includes light greens, pale ochers, and pinks.

 See: The First Christian Churches, p. 56; Romanesque Churches, pp. 58–59; Gothic Cathedrals, pp. 60–61; The Renaissance, pp. 136–147.

near Poitiers, in western France, whose single barrel vault was conceived to accommodate an immense Old Testament cycle. The life of St. Savin is represented in its crypt, the Apocalypse on its porch.

At the end of the thirteenth century, in Italy, the popes summoned the finest contemporary painters to the Italian town of Assisi to decorate the walls of its basilicas. One of them, Giotto di Bondone (c. 1266–1337), was an altogether exceptional artist. After executing some of the frescoes in the church of San Francesco there, he traveled to Padua to decorate a chapel belonging to the Scrovegni family. The chapel is near an ancient Roman arena, and is therefore often called the Arena Chapel (p. 218). The frescoes on the wall of this chapel represent scenes from the life of Christ and the life of the Virgin. These compositions introduced a new vision of the world to Western art. With only a few architectural elements, Giotto created a number of convincing illusionistic spaces. The figures themselves are substantial, their bodies apparently real volumes that exert weight and actually seem to occupy the spaces they stand in. Giotto's astonishing creation marks the earliest beginning of the achievements of the Italian Renaissance.

Stained Glass

In the late twelfth and the thirteenth centuries, the architectural evolution of the Gothic cathedral led to a gradual elimination of mural painting in favor of stained glass. Colorful cycles depicting stories from scripture, sacred legends, and even scenes from the lives of ordinary people filled the windows. Churches were infused with light that never violated the purity of their architectural forms. The cathedrals of Chartres and Bourges, and the Sainte-Chapelle—Louis IX's royal chapel, virtually a showcase for its stained-glass windows (p. 61) —are the most famous examples.

To make a stained-glass window, a designer first prepared a full-scale drawing on a wooden panel matching the size of the window to be filled. Next, pieces matching sections of the drawing were cut from sheets of colored glass with a red-hot iron. These pieces were first laid out on the panel, and then painters added faces, drapery folds, and decorative patterns in

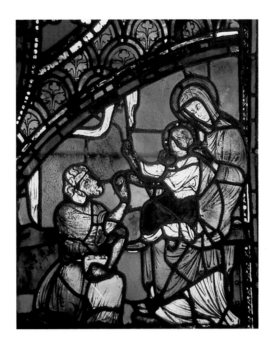

black enamel paint. The pieces of glass were then fired at a temperature between 700° and 800° C to fuse the enamel. Finally, the pieces of glass were set into a network of interconnected strips of lead to make the finished window.

Manuscript Painting

As the printing press did not exist in the Middle Ages, books were manuscripts, that is to say, they were written by hand, copied one page at a time by scribes onto calf skin (called parchment or vellum). Manuscripts were extremely expensive, and could be afforded only by the Church or by people from the highest levels of society. They were often decorated with illuminations, small paintings intended to clarify the text for the reader. Such paintings are also known as miniatures, not because they are small but because of the red pigment minium (cinnabar, or red lead), which was used in them. The first letters of chapters or paragraphs might also be decorated, in which case the letters are called historiated ("storied") initials. Text, illustrations, and subsidiary ornamentation were often closely linked.

Irish Illumination

Ireland was converted to Christianity by St. Patrick in the fifth century, and the influence of its many monasteries was felt throughout Europe until the eighth century. Irish manu-

◄ *Adoration of the Magi, 1217–20. Stained glass. Window 28, Chartres Cathedral, Chartres, France*

Chartres Cathedral is illuminated by 160 windows containing 2,600 square meters of stained glass. Since the church is dedicated to the Virgin, images of her are everywhere in the cathedral. Here she is shown seated with the infant Jesus on her lap. The rich colors of the glass, the formal balance of the composition, and the delicacy of the drawing testify to the mastery of the stained-glass artists of the thirteenth century.

See: Giotto, pp. 217–218.

▶ Irish, seventh century. PAGE FROM THE ECHTERNACH GOSPELS, showing the lion, emblem of the evangelist Mark. c. 690. Illuminated manuscript, 10⅛ x 7⅝ inches. Paris, Bibliothèque Nationale de France

This manuscript of the Gospels of Matthew, Mark, Luke, and John— the first four books of the Christian New Testament —is a particularly fine example of Irish illumination, combining Christian subjects with decorative devices from ancient Celtic metalwork.

script copyists adapted pre-Christian forms to suit the books they produced, using the ancient Celtic and Germanic motifs that can also be seen in contemporary metalwork. Using such decorative devices as elaborate interlacing, they created a fantastic and original art governed by an idiosyncratic sense of harmony, in which both lines and figures are used ornamentally. The earliest surviving example of this style is the seventh-century Gospel known as the Book of Durrow.

The Court of Charlemagne
Illuminated manuscripts of the Carolingian period (see p. 57) are among the most splendid of all painted books. Charlemagne established several *scriptoria*, or workshops for scribes and illuminators, that maintained close ties with his court, although they were generally housed in large monasteries and directed by monks. The work most often copied and decorated was the Bible, followed by the Gospels, the book of Psalms, and the Apocalypse.

Artists of the Court School revolutionized the art of book illustration. First, the various Merovingian letter forms were codified to form a new alphabet: the minuscule, which is still in use today. Furthermore, Carolingian painters drew upon both classical and earlier Christian models to produce large illustrations of great

originality. The eventual result was a revival of antique forms, as exemplified by the early ninth-century Coronation Gospels, where the evangelists are depicted in large blocks of color and set against illusionistic landscapes. Another, more expressionist, Carolingian style can be seen in the famous Ebo Gospels. Here the evangelist is presented as a writer transported by divine inspiration, his excitement conveyed by the folds of his drapery, which twist and turn in agitated patterns.

The Gothic Period
In the thirteenth century, manuscript workshops shifted to the cities, close to the universities, where professors and students were a growing clientele. Many members of the royal and ducal courts were also avid book collectors with large libraries. In this climate of abundant patronage and production, opulent versions of such secular works as *The Romance of the Rose*, as well as religious ones such as the *Psalter of Saint Louis* (ca. 1253–70) attained a rare perfection and beauty.

In the late fourteenth century a style of exceptional elegance and refinement emerged in the princely courts of Europe. Known as the International Gothic style, it is characterized by sensuous color and rhythmic compositions dominated by sinuous arabesques. One type of sumptuous book popular with the nobility in this period was the so-called Book of Hours, a prayer book that opened with a calendar describing the natural cycles of the year month by month. In Paris, the duke of Berry commissioned three highly accomplished Flemish illuminators, the Limbourg brothers, to produce an elaborate book of hours for him. This book, the *Très riches heures* ("very rich hours"), although incomplete at the duke's death in 1416, was the Limbourg brothers' masterpiece, and certainly one of the finest examples of International Gothic painting.

Panel Paintings and Altarpieces
In addition to book illuminations and large frescoes, there was also a demand for paintings on independent, readily transportable panels (usually made of wood). The portrait of John the Good of France (reigned 1350–64), painted about 1350, is the earliest known independent portrait. Rather than appearing as part of

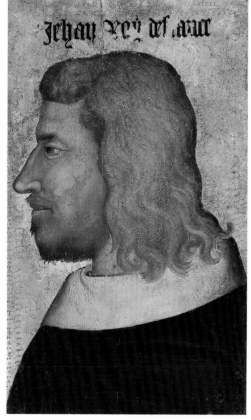

◀ THE LIMBOURG BROTHERS
(early fifteenth century). *The Very
Rich Hours of the Duke of Berry,*
December page: Stag Kill at
Vincennes. 1413–16. Manuscript
illumination. Chantilly,
Musée Condé
*In the forests of the château of
Vincennes, a stag hunt ends with the
famished dogs throwing themselves on
the captured animal. The exceptional
originality of the three Limbourg brothers
is exemplified by this monumental com-
position, in which the natural world is
meticulously but lovingly rendered in
brilliant colors.*

a larger composition, the king is shown alone
and in profile; the inscription above his head
identifies him as the king of France.

In the churches, new formats for altarpieces
evolved. Now they might be polyptychs, con-
sisting of several panels, often shaped like
Gothic arches. Especially in Italy, France, and
Spain, this multipaneled form was used to
depict sequential incidents from the lives of
Christ, the Virgin, or the saints, or from other
significant events described in the Bible, such
as the Apocalypse.

▶ French School,
fourteenth century.
*Portrait of John II, The
Good, King of France.*
ca. 1350. Tempera on oak
panel, 23⅝ x 17¾ inches.
Paris, Musée du Louvre

*This portrait by an unknown artist, one of the most famous of all French paintings, depicts
Jean II, the Good, king of France from 1350 to 1364. The artist rendered the sitter with realism
and immediacy, showing him in profile against a uniform gold background.*

THE RENAISSANCE:
Italy During the Fifteenth Century

In Europe, the fifteenth century marked a profound break with the Middle Ages, and in many respects signaled the beginning of the modern era. The period was characterized by new political and economic developments: the rise of a prosperous middle class and the increasing independence of cities; more efficient forms of production and economic organization; and the exploration of territories in Asia and the Americas. There were also new movements in philosophical and religious thought, and an astonishing outburst of creativity in literature and the visual arts. Because much of the artistic and literary accomplishment of the fifteenth century was based on models from Greek and Roman antiquity, many people at the time thought of the period as a rebirth of classical civilization. For this reason, it has been known historically as the Renaissance, the French word for "rebirth."

Exactly when the Renaissance began is a question that is still debated, but certainly the early years of the fifteenth century saw an upsurge of interest in the intellectual achievements of ancient Rome, a development that was closely associated with the emergence of humanism. In the fifteenth century the term "humanism" meant one thing, and one thing only: the study of the ancient Greek and Latin languages, and their literatures. Since most of the writings that had survived from antiquity were secular, humanism encouraged scholars, who in the Middle Ages had largely confined themselves to religious issues, to take an interest not only in poetry and drama but also in natural history, mathematics, and architecture. Similarly, artists found new sources of inspiration in Greek and Latin history and poetry, while Roman sculpture and architecture (no Greek art being available) were taken as authoritative aesthetic models.

▲ MASACCIO (1401–28). *The Trinity.* ca. 1426–28.
Fresco, Florence, Sta. Maria Novella
The carefully constructed perspectival space of this painting represents a barrel-vaulted chapel of a type made fashionable by the architect Filippo Brunelleschi. Illusionistic paintings of this kind fascinated artists and patrons alike in fifteenth-century Italy.

 See: The Great Models of Antiquity, pp. 90–91; The Medieval Arts of Color, pp. 132–135; Fra Angelico, p. 176; Botticelli, p. 183; Brunelleschi, p. 187;

Italian scholars, artists, and patrons were the original leaders of this cultural revolution, but Flemish, French, German, and English scholars and artists also made important contributions. Although there was no consistent style in painting and sculpture at the time, certain pervasive tendencies can be discerned: a striving for realism; an intense interest in a more scientific way of depicting space, light, and shadow; and a new focus on both human beings and the natural world. All of these developments had been pioneered by Giotto in the previous century, but now they became mainstream preoccupations.

Fifteenth-Century Florence

One of the most important figures in Florentine art in the early fifteenth century was the architect Filippo Brunelleschi (1377–1446), who, in addition to his revolutionary building designs, is thought to have developed the system of scientific, or one-point, perspective used by Renaissance artists to define pictorial space. Stated briefly, this system organizes the painting around a (usually) central "vanishing point" toward which every line perpendicular to the picture plane recedes. Distant objects thus seem smaller than those close-up, in roughly the same proportions as they appear to our eyes when we observe the natural world.

One of the first painters to make use of Brunelleschi's system was Masaccio (Tommaso di Ser Giovanni; 1401–29). Masaccio's figures in his fresco of the *Trinity* in the church of Santa Maria Novella in Florence stand in an illusionistic niche, clearly defined by the vanishing point and converging lines of Brunelleschi's system. The donors—the couple who paid for the work—kneel on either side and in front of the niche, as if in the church itself, sharing their space with the viewer. The mystery of the Christian Trinity is thus made to seem approachable.

Masaccio died very young, but in the course of his short career he revolutionized Florentine painting. His frescoes in the Brancacci Chapel in the church of Santa Maria del Carmine (1425–26) in particular set a new course for art.

With so many new ideas in the air, the fifteenth century must have been a time of great excitement for artists. The Florentine painter Paolo Uccello (1397–1475) became positively obsessed with perspectival calculations, as can be seen in his most famous work, the three panels depicting the *Battle of San Romano*, a Florentine military victory over the Sienese in 1432, now distributed among three museums. The panel in the Louvre (p. 273) reveals Uccello's success in creating a sense of depth. Despite the tangle of legs, lances, and bodies, some horses and riders appear to be closer to us than the others. Uccello also excelled in depictions of movement.

At about the same time, the painter Fra Angelico ("Angelic Brother"; c. 1394–1455) a Dominican monk, was pursuing very different goals. Beginning in 1435, he painted frescoes in forty of the monks' cells, and in the courtyard arcade as well, of the Dominican convent of San Marco in Florence. Much of his work is notable for its feeling of piety and quiet serenity, for these values, as well as beauty of execution, mattered more to him than the technical feats so evident in the work of Masaccio and Uccello. Even so, Fra Angelico mastered the rules of perspective and modeling with light and shadow, and handled them with marvelous control.

The painter Sandro Botticelli (1445–1510) fully embraced the ideals of Florentine humanism. The mythological themes of his two most famous works, *The Birth of Venus* and *Primavera* ("Spring") (p. 183), were unusual when they were painted, as were their dependence on antique models for some of the figures, such as the three graces in the left foreground of *Primavera*. In the same painting, the figure of Venus, the Roman goddess of love, represents a type of dignified beauty highly prized by artists of the period.

The Fifteenth Century Elsewhere in Italy

Even as the Renaissance had begun, artists in many Italian cities continued to paint in the Gothic style, not through backwardness, but simply as a matter of taste. Antonio Pisanello (before 1395–1455), who worked in Verona, Venice, and Rome, was an exponent of the refined International Gothic style, which was still much appreciated in the

▼ ANTONIO PISANELLO (c. 1395–1455). *Portrait of a Princess of the Este Family.* Tempera on wood panel, 16⅞ x 11¹³⁄₁₆ inches. Paris, Musée du Louvre
This ravishing portrait of a young woman is typical of the precious art of Pisanello. The precisely modeled face is shown in profile, as in the many medallion portraits by this artist. In accordance with contemporary fashion, the sitter's hair is worn up and her forehead is plucked clean to accentuate its height, considered a sign of intelligence.

◀ ANDREA
MANTEGNA (1430/31–
1506). Illusionistic
oculus in the ceiling of
the *Camera degli Sposi.*
c. 1473. Fresco. Mantua,
Palazzo Ducale

*On the walls of this room,
Mantegna painted scenes
from the life of his patron,
Lodovico Gonzaga, Duke
of Mantua, and his family.
For the center of the ceiling,
the artist devised an
illusionistic depiction of a
balustraded oculus, or
round opening, through
which women of the court
peer into the room below.
The cupids clinging to the
railing, a small tree in a
tub sitting precariously on
the ledge, and a perching
peacock all contribute to
the playful effect of this
dazzling work of virtuoso
perspectival painting.*

courts of northern Italy. Although Pisanello shared the contemporary interest in antiquity and perspective, he remained committed to a poetic vision close to that of the Limbourg brothers (p. 135). In his *Portrait of a Princess of the Este Family*, the sitter appears in a profile format reminiscent of ancient coins. The background of flowers and insects, however, is typically late Gothic.

Other Italian artists assimilated Masaccio's modeling and mastery of perspective. Andrea Mantegna (c. 1430–1506), who was fascinated by archeology, began his career in Padua. For the church of San Zeno in Verona, he executed an altarpiece in which a pensive, enthroned Madonna surrounded by angel-musicians is flanked by saints convincingly represented in the same architectural space. One of the small panels from the *predella* (pedestal) of this altarpiece shows a *Crucifixion* (p. 239) set amid figures whose costumes evoke the ancient world. But Mantegna was perhaps most celebrated for his mastery of perspective. His painted oculus on the ceiling of a reception room in the

Gonzaga palace in Mantua (above) was the first illusionistic *sotto in sù* ceiling (Italian for "seen from below") of the Renaissance. Here, skillful foreshortening appears to show a view upward through a railed opening to the sky.

Piero della Francesca (1406/12–92), a contemporary of Mantegna's, worked in the towns of Arezzo and Urbino. His feeling for volume owes much to Masaccio, but his use of atmospheric light, as in the *Dream of Constantine* (opposite), is entirely his own. Both Piero's subtle approach to illumination and his compositional clarity were highly influential on his contemporaries.

Venice, the commercial capital of northeastern Italy, was slower than the rest of Italy to adopt the new formal language of Renaissance painting. Although born in Sicily, Antonello da Messina (c. 1430–79) worked in the city, where he influenced a number of Venetian artists. He was one of the few fifteenth-century masters of the oil technique working outside of Flanders, where he may have learned its use. Antonello was also a ground-

breaking portraitist. His *Portrait of a Condottiere* (mercenary soldier), for example, reflects the increasing focus on naturalism and the inner life fostered by humanism.

Venetian painters were masters of the use of color, and Giovanni Bellini (c. 1430–1516) was especially brilliant in this regard. Influenced by the work of Antonello da Messina, Giovanni was a superb portraitist, but he is best known today for his many compositions depicting the Virgin and Child. His *Madonna of the Meadow* (p. 178) shows them resting serenely in a precisely executed, almost jewel-like landscape, bathed in clear, diffuse light.

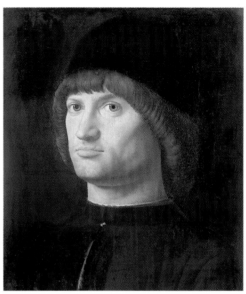

▲ ANTONELLO DA MESSINA (c. 1430–79). *Portrait of a Condottiere.* 1475. Oil on wood panel, 14⅛ x 11¹³⁄₁₆ inches. Paris, Musée du Louvre
The psychological force of this portrait is due in part to the surface realism permitted by the use of oil paint, to the masterful interaction of light and shadow, and to the three-quarter pose of the sitter.

◀ PIERO DELLA FRANCESCA (c. 1415–92). *The Dream of Constantine.* c. 1460. Fresco. Arezzo, San Francesco
Both the carefully constructed geometry and the light, which the artist has used expertly to model his forms, contribute to a remarkable illusion of depth in this painting.

THE RENAISSANCE:
Italy During the Sixteenth Century

The period between 1500 and 1520 in Italy is often called the High Renaissance, because to many art historians it has seemed that in these years the achievements of the fifteenth century were brought to their highest, one might say classic, expression. These were the years in which some of the greatest masters of Western painting—Leonardo da Vinci, Michelangelo, and Raphael—competed for pre-eminence, their activity fostered by cultivated patrons capable of understanding the subtlest of meanings. The painting produced during these years is characterized by harmony, symmetry, and a seemingly perfect comprehension of the formal language of classical antiquity. Following this moment, in the 1520s and later, two coexistent tendencies developed: the Late Renaissance, a more lyrical (and less grand) version of High Renaissance style exemplified by the work of Correggio, Titian, Veronese, and Tintoretto; and the somewhat artificial, courtly style generally called Mannerism.

▶ LEONARDO DA VINCI (1452–1519). *The Virgin and Child and Saint Anne*. c. 1510. Oil on wood panel, 66⅛ x 51⅛ inches. Paris, Musée du Louvre

Leonardo's characteristic pyramidal composition lends stability to this dynamic group, whose figures twist toward one another. The interaction of their gazes, and the gestures, which often echo one another, concentrate and intensify the work's emotional impact.

The Sixteenth Century in Florence

Leonardo da Vinci (1452–1519) was a man of extraordinary gifts, of which painting was only one. He was also an architect, engineer, musician, and a scientist who made original contributions to a number of fields, including anatomy, botany, hydraulics, and geology. He learned to paint in the workshop of one of the finest artists of the day, the painter and sculptor Verrocchio, but quickly formulated his own style. *The Virgin and Child and Saint Anne* (below, left) illustrates two important features of Leonardo's manner: a pyramidal composition, which, owing to Leonardo's influence, became almost ubiquitous in the High Renaissance; and the use of *sfumato* (Italian for "smoky"), a technique he invented. *Sfumato* is modeling with soft, almost imperceptible gradations of shadow that seem to create a tangible atmosphere and subtly fuse the figures with the background. These effects can also be seen in Leonardo's portrait of Lisa Gherardini, known as the *Mona Lisa* (p. 234).

Michelangelo Buonarroti (1475–1564) was not only a great genius but one of the most influential artists of all time, as a sculptor as well as a painter. He studied painting with the portraitist and fresco painter Domenico Ghirlandaio, and at a young age joined the circle of scholars and humanists surrounding the Medici, the ruling family of Florence. Michelangelo's gifts as a draftsman were exceptional. His complex, powerfully modeled figures with their noble expressions suggest the most elevated spiritual and moral states.

In 1506 Pope Julius II (reigned 1503–13) commissioned a reluctant Michelangelo to paint frescoes on the vast ceiling of the Sistine Chapel in the Vatican. Covering nearly 6,000 square feet, the finished work represents the Biblical account of the history of the world from the Creation to the Great Flood. These events are set within an illusionistic architectural framework, among the projecting cornices of which are seated figures of Old Testament prophets and classical sibyls (female prophets) who were believed to

 See: Painting: The Baroque and Seventeenth-Century Classicism, pp. 148–151; El Greco, p. 220; Leonardo da Vinci, p. 233; Michelangelo, p. 244; Raphael, p. 259.

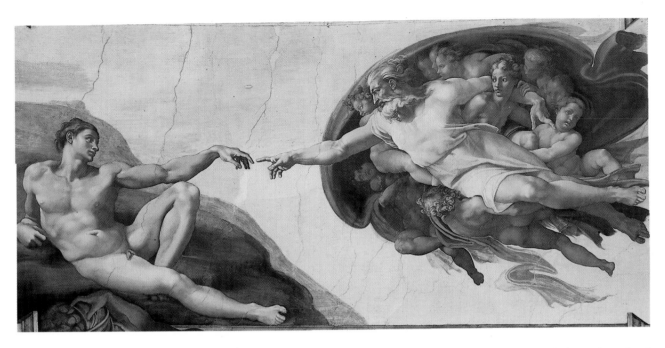

▲ MICHELANGELO (1475–1564). *The Creation of Adam.* 1508–12.
From the center of the ceiling of the Sistine Chapel. Fresco. Rome, Vatican Palace
Adam, the first human being, receives the spark of life from the hand of God.

▶ RAPHAEL (1483–1520). *The Virgin and Child with the Young Saint John,* also known as *La Belle Jardinière.* 1507. Oil on wood panel, 48 x 31½ inches. Paris, Musée du Louvre

The Virgin is shown seated in a meadow with her son Jesus and his cousin, St. John the Baptist, who are still young children. On her left arm, she carries a book of prophecy toward which the infant Jesus reaches, as if embracing his mission in the world. The Virgin leans forward, as if to dissuade him, while the slightly older child St. John, who carries the cross on which Jesus will one day be sacrificed, kneels reverently.

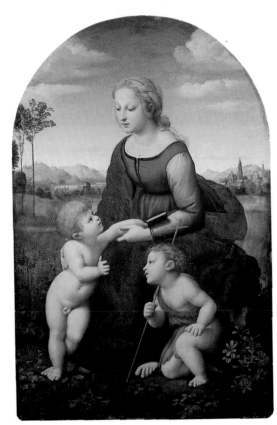

have foretold the coming of Christ. Completed by the artist in four years of exhausting and solitary work, most of it carried out while lying on his back, the Sistine Ceiling is without doubt one of the great masterpieces of Western art.

In 1504 a young artist from the town of Urbino, Raphael Sanzio (1483–1520), arrived in Florence. Although he had been trained by a leading painter of central Italy, his exposure to the work of Leonardo and Michelangelo had prompted him to rethink his approach to painting. Under their influence, Raphael's Madonnas came to embody a harmonious ideal of beauty, which was imitated by generations of later artists. While they seem straightforward, these Madonnas are the result of considerable thought and preparatory work. The *Virgin and Child with the Young Saint John,* for example, which shows the influence of Leonardo in its pyramidal composition, is a masterpiece of balance and harmony. In his large-scale frescoes for the Vatican Palace in Rome (p. 260), Raphael depicted both Biblical and mythological subjects. Such an intermingling of pagan, Judaic, and Christian themes was typical of the High Renaissance.

The Sixteenth Century Elsewhere in Italy

Correggio (Antonio Allegri, c. 1494–1534), who worked in north-central Italy, achieved new effects of light and illusion. His major innovation was his unprecedented illusionistic inte-

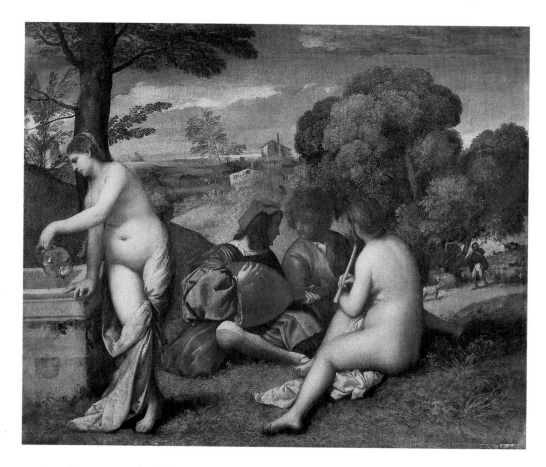

gration of paintings and architecture. In his fres-
coes representing the Assumption of the Virgin
in the dome of the cathedral of Parma, Correg-
gio's highly foreshortened figures appear to be
hovering in the actual space of the dome, an ef-
fect that anticipates the great ceiling paintings of
the Italian Baroque period. Correggio's handling
of light is especially revolutionary. In the Parma
dome it is almost impossible to distinguish be-
tween the light represented in the fresco and the
light that actually illuminates it. Similarly, in a
nocturnal *Adoration of the Shepherds*, Correggio
illuminated the center of the composition with
brilliant light to direct the viewer's gaze there.

The Sixteenth Century in Venice
Venetian artists of the sixteenth century were
intent on representing the world with what
might be called an idealized realism. Mytholog-
ical and historical subjects were made to appear,
as much as possible, to belong to the contempo-
rary world. Venice was perhaps the most cos-
mopolitan city in Renaissance Europe, and in
the cultivated atmosphere of its society works of

art were increasingly appreciated for the beauty
of their color and execution, not simply for
what they represented.

Giorgione (Giorgio da Castelfranco; c. 1477–
1510) was an important innovator in the tech-
nique of oil painting. He deliberately softened
his forms, blurring their edges and deemphasiz-
ing their details. The result was a pictorial im-
agery that was both idealized and sensuous. One
of the most intriguing of his rare surviving
paintings is *The Tempest* (p. 217). Although the
subject is enigmatic, the landscape weaves an
unforgettable and disquieting spell.

The extraordinary longevity of Titian (Tizi-
ano Veccellio; c. 1478?–1576) made him a
major force in both the High Renaissance
and the Late Renaissance. As a young man he
studied with Giorgione, and the glowing, sensu-
ous figures and mysterious landscape in his *Con-
cert Champêtre* ("concert in the countryside,"
above), are highly reminiscent of Giorgione's
work. As in Giorgione's *Tempest*, the subject of
Titian's painting is elusive, but the viewer is
nonetheless drawn in by its dreamy, pastoral

atmosphere. As time went on, Titian modeled his figures with increasingly large, bold brushstrokes, producing remarkably varied effects of light and texture (p. 269). His portraits were so lifelike that one of his sitters remarked that his own image by Titian would make him immortal.

After Titian, the two greatest artists of the Late Renaissance in Venice were Veronese (Paolo Caliari; 1528–88) and Tintoretto (Jacopo Rubusti; 1518–94). Veronese, called after his hometown of Verona, is notable for his sense of pageantry. A superb example of his work is the *Wedding at Cana* (p. 279), painted in 1563 for the dining hall of the monastery of San Giorgio Maggiore in Venice. Veronese carefully designed the architectural setting for the feast as an extension of the hall where the monks ate their own meals. The scene portrayed is Christ's first miracle, the changing of water into wine at a wedding feast, which was considered by theologians as a precedent for the transformation of Communion wine into the blood of Christ. The brilliant colors and complex composition of this painting display Veronese's gifts at their height.

Tintoretto approached painting quite differently from either Titian or Veronese, seeking not only beauty but dramatic intensity. His execution was rapid, and many of his paintings therefore exhibit a sketchlike fluidity. Some of his best works were painted for religious societies, such as the superb *St. Mark Rescuing a Christian Slave* (p. 268), painted for the brotherhood of St. Mark in 1548. Here the saint intervenes miraculously to save a Christian slave from a horrible death. The contorted, muscular figures illustrate Tintoretto's admiration for Michelangelo, while the brilliant, saturated colors place him firmly in the Venetian school.

Mannerism

Mannerism developed in Florence in the 1520s and spread throughout Europe, flourishing until the 1590s. It began as an elaboration of the High Renaissance styles of Leonardo, Michelangelo, and Raphael by younger artists who were trying to achieve different effects. Mannerism is deliberately artificial, and in this respect it is almost the opposite of High Renaissance art. It is characterized by elongated figures, complicated ("mannered") poses, rather strange, nonprimary colors, self-conscious displays of technique, and subject matter that is often difficult to understand.

A characteristic Mannerist work is the *Allegory with Venus, Cupid, and Time*, painted by the Florentine artist Agnolo Bronzino (1503–72) around 1545. The subject is a highly complex allegory in which Time—the angry, white-bearded male figure at the upper right—reveals the many deceits of love, which are detailed in a number of arcane symbols. The elongated figures and deliberately complicated poses exemplify Mannerist aesthetics.

▼ **Agnolo Bronzino (1503–72).** *Allegory with Venus, Cupid, and Time.* c. 1545.
Oil on wood panel, 57½ x 45⅝ inches. London, National Gallery

Love, personified by a beautiful woman, is embraced by an adolescent Cupid while an ecstatic infant is about to hurl roses at them. The two masks at the lower right signify deceit. The young woman behind the child displays her beautiful face, but her body is monstrous and her hands are backwards. At left, an old woman pulls out her hair. This group, meant to evoke the torments of love, has just been uncovered—or is about to be obscured—by Time, while Truth, in the upper left, is only a mask.

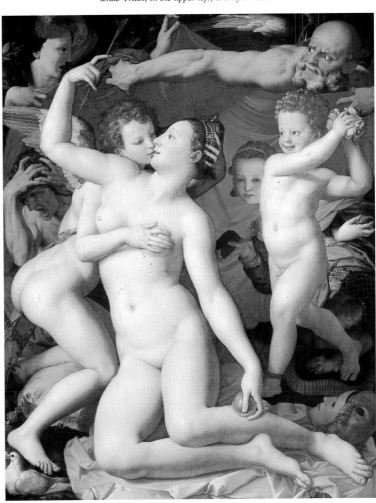

THE RENAISSANCE
in France

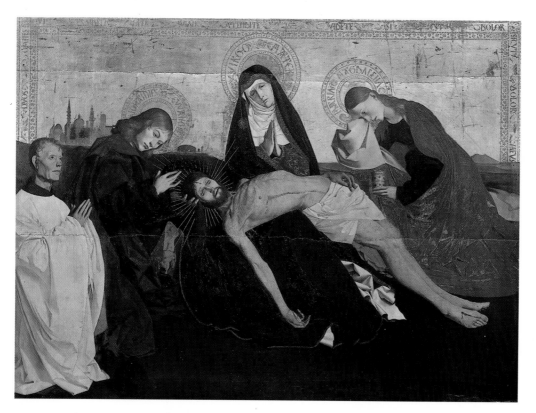

◀ **Attributed to
ENGUERRAND
QUARTON** (documented 1444–1466).
Pietà of Villeneuve-lès-Avignon. c. 1455.
Oil on wood panel,
64⅛ x 85⅞ inches.
Paris, Musée du Louvre
*The mourning Virgin
recites a passage from
the Lamentations of
Jeremiah, inscribed in the
gold ground: "All you who
pass by, look and see if
there is any sorrow like
my sorrow." She offers
the world—represented
by the donor at left—the
image of her pain and the
example of her acceptance
of her son's sacrifice.*

In 1309 the popes moved to the southern French town of Avignon, where they continued to reside until 1378. While the popes lived in Avignon, they summoned a number of Italian artists, such as the Sienese painter Simone Martini (p. 240), to work there, transforming the city into an artistic center. After the popes returned to Rome, there was little artistic activity in Avignon until the mid-fifteenth century, when the counts of Provence encouraged the work of a new school of Avignon, which developed a powerful and original style. The most important artist of this group was Enguerrand Quarton (c. 1420–c. 1466), who came from the northern French province of Picardy, where he was exposed both to Gothic art and to recent developments in Flemish painting. Quarton has been credited with having painted the masterpiece of the Avignon school, a *Pietà* from the town of Villeneuve-lès-Avignon. The painting is a sublime interpretation of the *pietà*, a traditional devotional image of the Virgin mourning the dead Christ. Here the figures combine incisive contours with simplified volumes for an extraordinarily expressive effect.

Jean Fouquet (c. 1420–c. 1481), a contemporary of Quarton, was master of both panel painting and manuscript illumination. As a young man he traveled in Italy, learning much about the new architecture, which he often included in the backgrounds of his compositions. Fouquet preferred to set the pictorial spaces of his paintings apart from viewer's space, as in his portrait of Charles VII of France (p. 209). His delicate handling of light owes much to the example of Piero della Francesca.

▼ ANTOINE CARON
(1521–99). *The Emperor
Augustus and the
Tiburtine Sibyl.* c. 1575–
80. Oil on canvas, 49¼ x
66⅞ inches. Paris,
Musée du Louvre

*In this strangely open
urban landscape, fantastic
monuments meant to sug-
gest ancient Rome appear
alongside actual buildings
in sixteenth-century Paris.
Augustus kneels before
the sibyl, who points to a
vision of the Virgin and
Child, as she foretells the
coming of Christ.*

The French military campaigns in north-
ern Italy in the late fifteenth and early six-
teenth centuries marked the end of a purely
French art as the French kings saw the artis-
tic treasures of Italy. Francis I (reigned 1515–
47) in particular summoned a number of
Italian artists to provide paintings, sculptures,
and other decoration for his palace at
Fontainebleau. The artists who came to work
at the palace from 1530 to around 1570 are
known as the First School of Fontainebleau.
Three Italian artists dominated the group:
Rosso Fiorentino (1495–1540), Francesco
Primaticcio (1504–70), and Nicolo dell'Abate
(1512–71). Working together, they devel-
oped a courtly art of great sophistication.
The figures that these artists painted are elon-
gated and elegant; the colors they used tend
to be brilliant, but somewhat strange and

acidic; and the subjects they favored, which
were often drawn from ancient mythology and
epic poetry, were usually treated allusively
and allegorically. These characteristics have
led many art historians to categorize the style
developed at Fontainebleau as a variety of
Mannerism.

The French artist Antoine Caron (1521–
99), who worked under the direction of the
Italian masters at Fontainebleau, imitated
their graceful, elongated figures and bright,
acidic palette. Caron's painting of *The Emper-
or Augustus and the Tiburtine Sibyl* illustrates a
medieval legend that the Tiburtine Sibyl, a
famous prophetess, foretold the coming of
Christ to the Roman emperor Augustus. The
painting, with its many small figures, Manner-
ist palette, and discontinuous treatment of
space, is typical of Caron's eccentric style.

THE RENAISSANCE
in the Northern Countries

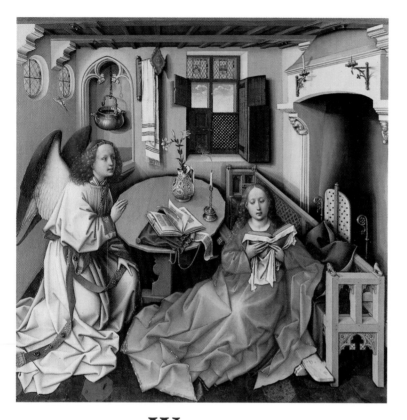

▲ ROBERT CAMPIN (first documented 1406; d. 1444). *The Annunciation*, central panel of the Mérode Altarpiece. c. 1425–28. Oil on wood panel, 25⅜ x 10¾ inches. New York, The Metropolitan Museum of Art.

While the artists of fifteenth century Italy were beginning their pictorial revolution, the painters of Flanders were embarking on one of their own. These two movements took place within very different artistic worlds, however, and the Italian and Northern schools were to remain distinct throughout the fifteenth and sixteenth centuries. Generally speaking, Flemish images were built up with many precisely rendered, highly realistic details, the Northern expression of a common Renaissance fascination with the natural world.

Robert Campin (d. 1444) introduced a new degree of realism to Flemish painting by presenting the events of Biblical history as if they were taking place in contemporary Flanders, and integrating religious symbols into these settings. Campin's masterpiece is the Mérode Altarpiece, a superb example of this approach to religious pictorialism. The lilies on the table, the suspended water basin, the candle that has just gone out, even the carved figures on the furniture, all have sacred associations that contribute to the painting's meaning.

Jan van Eyck (d. 1441) is traditionally credited with the invention of oil painting. He certainly perfected its technique, rendering the tiniest details of his paintings with an astonishing virtuosity, and producing smooth surfaces unmarked by brushwork. An exquisite example of his art is the *Arnolfini Wedding Portrait* (p. 275), which appears to represent the wedding of Giovanni Arnolfini, an Italian merchant living in Flanders. Van Eyck had a particular gift for depicting intimate interiors, enlivening them with precisely painted descriptions of a variety of textures—glass, fur, wood, velvet, metal—and above all, of the action of light.

Rogier van der Weyden (c. 1399–1464) was a master of understated emotional expression and powerful dramatic feeling. One of his great masterworks was a large polyptych (multipaneled altarpiece) depicting the Last Judgment (p. 274), at the center of which are the majestic figures of the judging Christ, seated on the rainbow, and the Archangel Michael, who is shown weighing the souls of the dead. The contrast between the archangel's calm and the various states of emotion in the raised dead—from apprehensive hope, to terror, to despair—is a signal example of van der Weyden's genius.

Germany and the Netherlands

▲ **ALBRECHT DÜRER (1471–1528).** *Adam and Eve.* 1504. Engraving, 9⅞ x 7⅝ inches. Paris, Bibliothèque Nationale

This engraving reflects Dürer's study of ideal human proportions. Unlike Italian figural works of the same period, its aesthetic is distinctly northern.

▶ **HANS HOLBEIN THE YOUNGER (1497–1543).** *The Ambassadors.* 1533. Oil on wood panel, 81⅞ x 82⅝ inches. London, National Gallery

The French ambassador to England, Jean de Dinteville, commissioned this painting of himself with his friend Georges de Selve. The objects on the table reveal the interests shared by the two men. The enigmatic form below them is an anamorphosis, a deliberately distorted representation—in this case of a skull—which, when viewed from the proper angle becomes legible.

In the early sixteenth century the effects of Italian Renaissance art began to be felt north of the Alps. Albrecht Dürer (1471–1528), a painter and printmaker working in Nuremberg, was fascinated by the Italian artists' construction of perspectival space and their rendering of anatomy. His style has features of both Northern and Italian schools. His *Self-Portrait with a Sprig of Eryngium* (p. 206) and his meticulously executed watercolors (p. 207) exhibit the precise details that characterize the work of his great Flemish forebears. However, he rejected much of the Northern Renaissance sensibility in favor of Italian ideals of beauty. His attempt to integrate Northern and Italian tendencies may have created conflicts in his mind; Dürer's *Melancholia II* of 1513–14, which explores the tormented creative longings of an artist-philosopher, may be an expression of these conflicts.

The German artist Mathias Grünewald (c. 1475/80–1528) took little interest in the art of Renaissance Italy. His *Isenheim Altarpiece* (p. 221) of 1510–15 contains a number of scenes, including a Crucifixion and a Resurrection. Grünewald's imagery was concerned with the communication of religious feeling. His crucified Christ is an embodiment of physical agony, while the Virgin, John the Evangelist, Mary Magdalen, and John the Baptist, who appear as witnesses to Christ's suffering, are powerful representations of spiritual and psychological pain.

Northern Europe was deeply affected by Protestantism (p. 148). The more radical reformers condemned religious imagery, and as a result, a number of art works were destroyed, and there was a drastic drop in the patronage of art in the Protestant countries. The German artist Hans Holbein (1497–1543), unable to make his living as a painter of religious subjects, specialized in portraiture. His painting, *The Ambassadors* (right), exemplifies his technical mastery as well as his capacity for psychological insight.

The Dutch artist Hieronymus Bosch (c. 1450–1516) seems to have drawn his inspiration from the medieval past, for his paintings are populated by devils, monsters, and fantastic animals reminiscent of similar creatures in Romanesque sculpture (p. 97). Bosch's *Garden of Delights* (p. 182) is a complex allegory of human folly. The panel on the left depicts the disobedience of Adam and Eve in the Garden of Eden; the middle panel apparently represents the temptations of the world, which end in damnation on the panel on the right.

A tradition of painting genre—scenes of everyday life—continued in Northern Europe from the Middle Ages into the Renaissance. During the Protestant Reformation, Northern genre paintings took on the serious meanings of moral allegory. The greatest artist specializing in such subjects was the Flemish painter Pieter Brueghel the Elder (1525/30–69). Brueghel's work is remarkable for its closely observed details, earthy humor, and often biting satire, all of which can be seen in *Children's Games* (p. 186) of 1559. Like Bosch, Brueghel was preoccupied with the folly of human affairs, the true subject of this painting.

See: Brueghel, p. 186; Dürer, p. 206; Grünewald, p. 221; Holbein, p. 223.

PAINTING: THE BAROQUE AND SEVENTEENTH-CENTURY CLASSICISM

Protestantism and Catholic Renewal

In 1517, the German priest and scholar Martin Luther challenged a number of the doctrines and practices of the Catholic church. He rejected the authority of the pope, proclaimed the Bible the exclusive ground of belief, and insisted that salvation came from faith alone. Luther quickly attracted followers, especially in Northern Europe, who formed themselves into a number of Reformed, or Protestant, churches. To combat the Protestant movement, Pope Paul III convened a church council in 1545 at Trent, in northern Italy. The Council of Trent, which continued to meet until 1563, codified Catholic doctrine, reformed a number of church practices, and reaffirmed the authority of the pope. The council also initiated the Counter-Reformation, a program that aimed to renew the church by preaching and proselytizing, and more importantly for the history of art, through images deliberately designed to affect the emotions of its viewers. As part of this program, new churches were built throughout Europe, and painters were commissioned to produce doctrinally correct art of this type for them.

▲ German School, sixteenth century. *Portrait of Martin Luther*

This was the historical context that gave birth to Baroque art. To propagate the Catholic message, artists were encouraged to create large-scale, emotionally moving, even overpowering images that would excite the faith of believers, and persuade nonbelievers of Catholic truth. It took several decades for artists to absorb and implement this vision, and indeed, Baroque images only began to appear in Italy in the late sixteenth century. A superb example of the early Baroque style is the *Conversion of St. Paul* (p. 189), painted in

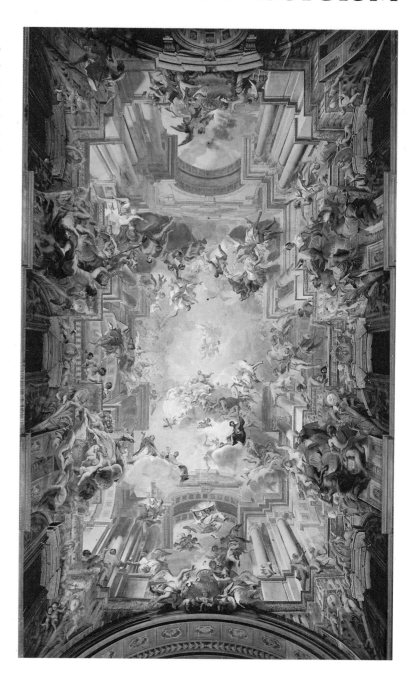

1601 by Michelangelo da Caravaggio (1571–1610). As the seventeenth century progressed, however, artists all over Catholic Europe embraced the Baroque style with enthusiasm.

Some artists preferred to paint in a more

"classical" manner closely allied to High Renaissance art. The Bolognese artist Annibale Carracci (see below) and his followers worked in this mode, as did the French artist Nicolas Poussin (p. 258). Using Renaissance and antique models, these artists cultivated a style characterized by balance and restraint, which sought to exhort the viewer to ethical reflection.

Palaces and Churches: Ceiling Decoration

In 1597 Annibale Carracci (1560–1609) was commissioned to decorate the ceiling of a long gallery in the Farnese Palace in Rome. The program was to be a series of mythological love scenes in honor of the marriage of one of the sons of the Farnese family. Framing these incidents with illusionistic architecture and sculpture in a manner reminiscent of Michelangelo's treatment of the Sistine Ceiling (p. 140), Annibale divided the vault into compartments, each dedicated to a particular incident from one of the love stories. The decorative conception, mythological subject matter, light palette, and powerful modeling make the ceiling of the Farnese Gallery one of the finest examples of seventeenth-century classicism.

The Farnese Palace fresco exerted a profound influence on the decoration of the famous Hall of Mirrors at Versailles. The ceiling of this room, which was begun in 1678, was painted by Charles Le Brun to glorify Louis XIV of France. Its compositions represent important events from the king's reign in symbolic and allegorical guise.

A truly Baroque ceiling design first appeared in 1633, when Pietro da Cortona (Pietro Berrettini; 1596–1669) began to paint the vast fresco depicting the *Triumph of Pope Urban VIII* to fill the vault of the great hall of the Barberini Palace in Rome. In contrast to Annibale's neat divisions and careful framing, Pietro's ceiling is a single, unified composition crowded with gesturing allegorical figures, with illusionistic architecture opening into the sky. This conception was carried even further in the 1690s by Andrea Pozzo, in his painting for the vault of the church of Sant'Ignazio in Rome. Here, a gigantic palace seems to rise into the heavens, drawing the viewer up with it. The ample space left between the airborne figures lightens the overall effect.

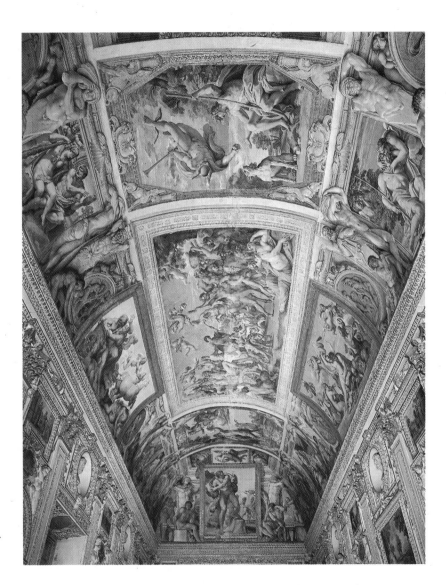

▲ ANNIBALE CARRACCI (1560–1609). Ceiling of the gallery in the Palazzo Farnese. 1597–1602. Fresco. Rome, Palazzo Farnese. The many scenes on this ceiling represent the loves of the gods of classical antiquity.

◄ ANDREA POZZO (1642–1709). *The Missionary Work of the Jesuit Order.* 1691–94. Fresco. Rome, Sant'Ignazio

Classicism and the Baroque Style

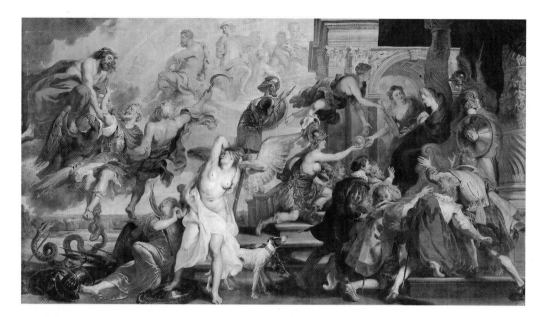

◀ PETER-PAUL RUBENS (1577–1640). *The Apotheosis of Henry IV and the Proclamation of the Regency of Marie de Medici, May 14, 1610,* 1622–25. Oil on canvas, 155¼ x 286½ inches. Paris, Musée du Louvre

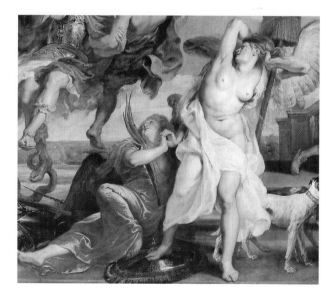

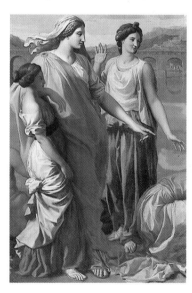

Left: Rubens, more painterly.

Right: Poussin, more linear.

Restraint and Exuberance

The term "classical" in art is used to denote a style that is clear, balanced, emotionally restrained, and meticulously drawn. The term "Baroque" suggests a style with quite different qualities: complexity, deliberate sensuality, eccentricity, and a manner that is emotionally appealing. But these terms are not simple op-posites, and thinking of them as such leads to drastic oversimplifications. In fact, the wider meanings of the terms "classical" and "Baroque" are difficult to define precisely.

In 1915 the Swiss art historian Heinrich Wölfflin outlined the characteristics that in his view distinguished the classical (in which he included Renaissance art) and the Baroque styles

in his book *Principles of Art History*. According to Wölfflin, classic and Baroque were stylistic categories that exhibited certain tendencies, and the definitions he evolved for them have proved remarkably useful in discussions of the artistic styles that emerged in Europe from the fifteenth through the eighteenth centuries. A comparison of two representative paintings, using Wölfflin's definitions, may serve to clarify what qualities "classical" and "Baroque" have come to suggest.

Let us consider *The Apotheosis of Henry IV and the Proclamation of the Regency of Marie de Medici, May 14, 1610* by the Flemish artist Peter-Paul Rubens (1577–1640) as an example of the Baroque style, and *The Finding of Moses* by Nicolas Poussin (1594–1665) as an example of classical art. In Wölfflin's terms,

• Rubens's painting is more "painterly," that is, it accords greater prominence to color and brushwork than Poussin's work. Poussin's painting is, by contrast, more linear, emphasizing drawing and balanced design.

• Standing before the Rubens, the viewer

▼ NICOLAS POUSSIN (1594–1665). *The Finding of Moses*. 1638. Oil on canvas, 36⅞ x 47⅝ inches. Paris, Musée du Louvre

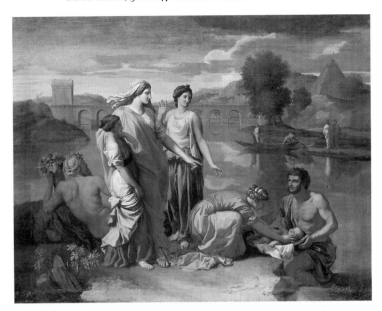

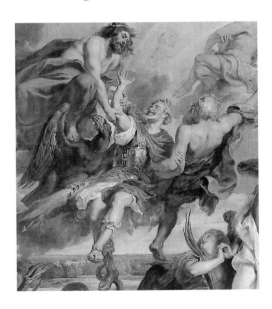

Right: Poussin's figures assume static poses.

has an impression of continuous recession into space; Poussin's composition, on the other hand, can be broken down into planes, as if the figures were placed in a theater set.

• The *Apotheosis* seems to continue beyond its frame; some of its figures are slightly cropped, suggesting open space and movement. Poussin's scene unfolds completely within the boundaries of its visual field; its outer figures turn their backs toward the frame, further enclosing the space.

• In Rubens's painting, the forms seem to fly and the figures to swirl, interacting with one another in complex ways; those around Moses rest solidly on the ground and seem autonomous; they are crisply delineated from one another.

• The darks and lights in Rubens's painting encourage the eye to play freely over the composition, while in the Poussin each element is illuminated with diffuse light intended to define the forms with clarity.

Left: Those of Rubens tend to be more active.

NEOCLASSICISM AND ROMANTICISM

Antiquity as a Model

Without the powerful religious concerns of the seventeenth century, and perhaps in reaction to the grand rhetoric of the Baroque style, the early eighteenth century saw the development of a personal and intimate manner known as the Rococo. An early example of this style is the painting of the clown Pierrot, or Gilles, by the French artist Jean-Antoine Watteau (1684–1721). Here the artist's concern is not a lofty, overarching moral issue or a literary theme; it is the melancholic inner life of Pierrot, one of the stock characters from the Italian comedy.

Watteau's painting is solemn, and even tragic. Often, however, Rococo artists depicted lighthearted or erotic subjects with very little serious content. In the middle of the century there was a reaction against the Rococo, which seemed to its critics overly frivolous and sensual. The new style that emerged in the 1760s as part of this reaction is called Neoclassicism.

Neoclassical artists sought to develop a sense of civic responsibility in the public, using Greek and Roman antiquity as models, both of physical beauty and moral elevation.

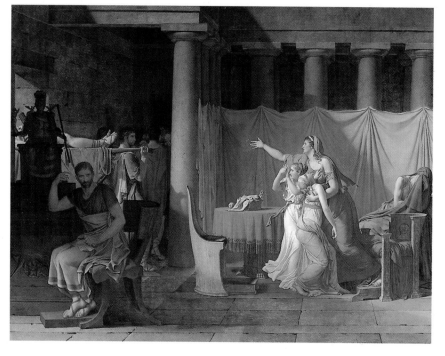

◀ JACQUES-LOUIS DAVID (1748–1825). *Lictors Bringing to Brutus the Bodies of his Two Sons.* 1789. Oil on canvas, 127⅛ x 166⅛ inches. Paris, Musée du Louvre
A hero and founder of the Roman Republic in the sixth century BCE, Junius Claudius Brutus condemned his two sons to death for treason. The intense but restrained emotion of the father's stoic demeanor is contrasted with the despairing cries of the women, a device that emphasizes the consul's unshakable patriotic virtue.

 See: Delacroix, p. 204; Friedrich, p. 210; Géricault, p. 215; Goya, p. 219; Ingres, p. 224; Watteau, p. 281.

Drawing in the Service of Great Subjects

Neoclassical painting valued both archeological precision and the anatomical knowledge that was so admirably taught in the classes in drawing at such fine arts schools as the Royal Academy of Painting and Sculpture, which had been established in Paris in 1648. Instruction in these schools was centered on drawing, especially of the human figure, which students studied by drawing both from live models and from casts of ancient sculpture. The paintings that this curriculum fostered—like those of Neoclassicism in general—are austere works composed with great clarity, and with almost no anecdotal details to detract from their principal subjects. Their figures, often life-size, are placed side by side in the foreground, as in ancient reliefs. The draftsmanship is meticulous, with color taking second place to the drawing. In the words of Jean Auguste Dominique Ingres (1780–1867), one of the last Neoclassic painters: "Drawing is more than three-quarters of painting. If I had to hang a sign above my door, it would read: 'Drawing School,' but I'm sure I would turn out painters."

Neoclassical artists chose their subjects in accordance with a hierarchy established in the seventeenth century. The most important category of images was history painting, which encompassed mythological, religious, and historical subject matter. History painting was followed, in descending order, by genre (scenes from daily life), portraiture, landscape, and still life.

Neoclassical artists of the eighteenth century such as Jacques-Louis David (1748–1825) often looked to Greek and Latin writings for subjects to paint. Homer's *Iliad* and the Roman historian Livy's *History* were particularly favored. Some of these paintings, however, were actually disguised portrayals of contemporary political events. Indeed, the Neoclassical spirit had a lot in common with the republican fervor that sparked the French Revolution of 1789 and overthrew the Bourbon monarchy. After the Revolution, French Neoclassic artists began to engage contemporary events more directly. Notable examples are David's *The Death of Marat*, which shows the revolutionary leader Jean Paul Marat (1743–93) just after he had been assassinated in his bath, and *The Coronation of Napoleon* of 1806 (p. 25).

Expressing Feelings

At about the same time that Neoclassicism was emerging, another tendency, Romanticism, was also coming to the fore. The primary aim of Romantic painters was the expression of feeling. Sometimes their landscapes are menacing, dominated by wind-twisted trees and violent storms; at other times they depict serene sunsets and moonlit views, prompting revery or meditation. But Nature never left these painters unmoved.

Tragedy and Exoticism

Romantic artists were often inspired by great dramatic writers such as Dante, Shakespeare, Goethe, and Byron. As their period was rich in historical watersheds—the Revolution of 1789, the Napoleonic wars, the Revolution of 1830, and others—these painters often depicted current events. Some of the resulting works have a tragic cast, for example Goya's *Executions of the Third of May, 1808* (p. 219); Delacroix's *Scenes from the Massacre at Chios*; and Géricault's *Raft of the Medusa* (p. 215). Others, such as Delacroix's *Liberty Leading the People* (below), are exhilarating.

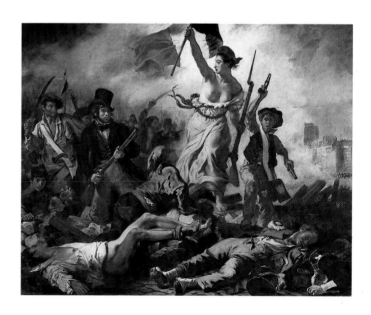

▼ Eugène Delacroix (1798–1863). *Liberty Leading the People.* 1830. Oil on canvas, 102⅜ x 128 inches. Paris, Musée du Louvre
The Revolution of 1830 offered the young Delacroix, a passionate exponent of large historical compositions, an occasion to record contemporary events. Acquired by King Louis-Philippe at the Salon of 1831, this famous masterpiece epitomizes a Romantic commitment to political liberty.

PAINTERS OF REALITY

To Make a Living Art

In 1848, France was again shaken by revolution. Louis-Philippe, the country's last king was overthrown and the Second Republic proclaimed. Artists were much affected by these events; they also grew interested in the social condition of workers and peasants, and some became ardent republicans.

Even painters who did not openly express their political convictions in their work felt a new involvement with contemporary life, rejecting Biblical and antique themes in favor of subjects drawn from the world around them.

The leader of the Realist school, Gustave Courbet (1819–77), explained himself as follows: "To translate the morals, ideas, and appearance of my era as I understand it . . . in a word, to make living art: such is my goal." In 1855, when his works were rejected by the jury of the first Universal Exhibition in Paris, he decided to exhibit them on his own in a "Pavilion of Realism" erected nearby. It had few visitors, but his action was much discussed and some critics took up his cause, notably the Socialist writer Jules Champfleury, who published a *Realist Manifesto* in 1857.

Social Reality

The painter Jean-François Millet (1814–75) was profoundly interested in peasant life and the world of rural agriculture, which can be seen by reviewing the titles of his most important paintings: *The Winnower, The Sower, The Harvesters' Meal, The Gleaners* (right), *The Potato Planters.* Millet had himself grown up in rural France and knew its people well. He chose to live and work in the country; in 1849 he settled near the Forest of Fontainebleau in the village of Barbizon, previously the center of an important group of landscape painters. Millet was only one of many artists to concentrate on peasant life in a period when many rural people were migrating from the land to the cities, drawn by the prospect of employment in the growing number of factories.

The Realists depicted industrial and domestic laborers, too, in such paintings as Honoré Daumier's *The Washerwoman* and François Bonhomme's *Horse Entering a Mine.* Those impoverished by progress were not forgotten. Alfred Stevens, painting *What Is Known as Vagabondage* depicts a beggar and her two children being led through the snow to prison.

To Paint "Things That Really Exist"

After an early series of landscapes and portraits, Gustave Courbet turned to genre subjects, that is subjects drawn from daily life. In a letter of 1861, he advised his students to do likewise, to paint "things that really exist." At the 1849 Salon—the annual exhibition held by the Academy of Fine Arts in Paris— Courbet's large genre painting depicting inhabitants of his native town, *After Dinner at Ornans*, won a gold medal. The following

▼ Jean-François Millet (1814–75).
The Gleaners. 1857. Oil on canvas,
32⅞ x 43⅜ inches. Paris, Musée d'Orsay

These poor country women are at work on a backbreaking task: gathering shafts of wheat left behind by the harvesters.

See: Courbet, p. 198; Daumier, p. 201; Manet, p. 237; Millet, p. 246.

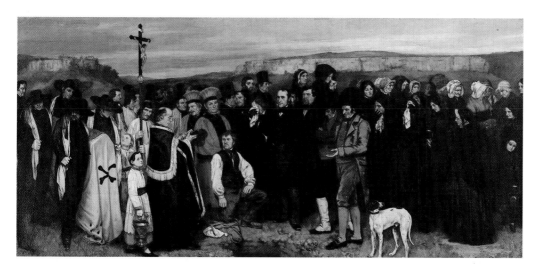

◀ GUSTAVE COURBET (1819–77). *Burial at Ornans.* 1849–50. Oil on canvas, 124⅛ x 263³⁄₁₆ inches. Paris, Musée d'Orsay

This painting, almost twenty feet long, represents the inhabitants of Ornans at a burial. Recognizable are Bonnet, the village curate, as well as the painter's mother and sisters. The artist has transformed this common event of country life into a monumental history painting.

year, however, his immense *Burial at Ornans* (above) was widely condemned. Courbet was reproached for many reasons: for rendering the figures "as they were," without idealization, in their customary dress and in all their banality and ugliness; for making the townsfolk just as prominent as the priest and other local worthies, a "democratic" gesture; for representing a scene from daily life on the monumental scale of history painting; and for allowing his brushstrokes to show. "If democratic painting amounts to using the dirtiest and commonest tones, modeling the grossest of forms, and a general preference for ugliness, then I certainly would not deny that Monsieur Courbet is a democratic painter," wrote one reviewer of the exhibition.

The Painter of Modern Life

In 1845, at the end of a published Salon critique, the poet Charles Baudelaire wrote: "The real painter will be he who manages . . . to make us see and understand, through color and drawing, how great and poetic we are in our cravats and polished boots." This was his way of saying that each period has a poetry of its own that artists should aim to discover and convey. Édouard Manet (1832–83) was among the first painters to attempt such ambitious depictions of contemporary life in the midnineteenth century. He represented crowds at open-air performances (*Music in the Tuileries*)

and in bars (*A Bar at the Folies-Bergère*), as well as controversial current events (*The Execution of Maximilian*) and fashionable Spanish dancers (*Lola de Valence*). When it came to the female nude, he had no need of any mythological pretext: his *Olympia* (below) is blatantly presented as a courtesan, and the model he used is clearly recognizable. As Manet himself put it: "I render the things I see as simply as possible. As for *Olympia*, what could be more naive? There are harshnesses in it, I am told. They were there. I saw them. I painted what I saw."

▼ ÉDOUARD MANET (1832–83). *Olympia.* 1863. Oil on canvas, 51¼ x 74¾ inches. Paris, Musée d'Orsay

Manet portrayed his subject completely without idealization. As she stares coolly at the viewer, she seems naked rather than nude in any classical sense.

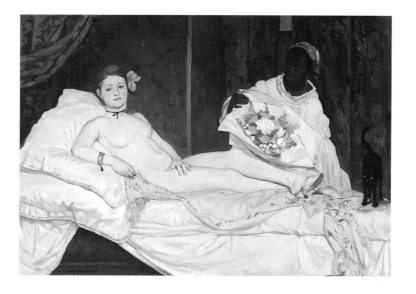

IMPRESSIONISM

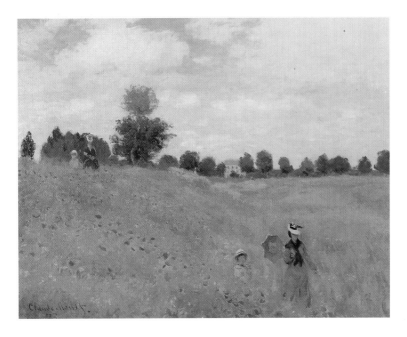

Independence . . . and Critical Mockery

In 1874, an art exhibition opened on the boulevard des Capucines in Paris. It was organized by a group of artists including Edgar Degas (1834–1917), Claude Monet (1840–1926), Auguste Renoir (1841–1919), Camille Pissarro (1830–1903), Paul Cézanne (1839–1906), and Berthe Morisot (1841–95), all in their thirties at the time, as a protest against the regular rejection of their work by the jury of the official Salon exhibition.

One of Monet's paintings, entitled *Impression, Sunrise,* provoked one critic to mockery: "Impression, I was sure of it; I even said to myself: 'Since I was impressed, there must be an impression there somewhere.'" (*Le Charivari,* April 25, 1874). Thus the term "Impressionism" was born.

Between 1874 and 1886, there were eight Impressionist exhibitions. The critics were unsparing, especially in the early years. One critic, reviewing the second exhibition, wrote: "Five or six lunatics, including a woman, a group of unfortunates struck by the madness of ambition, have joined forces to exhibit their works. . . . These self-designated artists call themselves intransigents and impressionists; they take canvas, pigment, and brushes, throw on a few colors haphazardly, and then sign the result." (*Le Figaro,* April 3, 1876).

But this "new painting" gradually found defenders. The journalist Émile Zola took up their cause, describing them as "true painters, gifted artists of the greatest merit."

Painters of Landscape or of Light?

The Impressionists rejected subjects drawn from the past, whether historical, religious, or mythological. Instead, they resolved to paint what they saw and only what they saw, and indeed, almost everything that they saw.

Beginning in 1863, following in the footsteps of their elders in the Barbizon school, the young artists Monet, Renoir, Alfred Sisley (1839–99), and Frédéric Bazille (1841–70) had left the Parisian studio of Charles Gleyre to work in the countryside around Paris. The recent development of commercially prepared pigments sold in tubes made it easier for them to move about and work in the open air, although they still completed their canvases in the studio. They sought to paint nature as it appeared to them, especially changing effects of light. Around the Seine estuary, they attempted to capture elusive conditions at the seashore at specific times, an approach they soon applied more generally in different kinds of weather. Figures are often prominent in their landscapes. In his *Women in the Garden* (p. 250), Monet made visual poetry out of the instantaneous play of light and shadow over dresses, faces, and foliage.

Railroads, Entertainment, and Urban Sociability

The Impressionists were very much of their time, and they sought to depict contemporary life in all its aspects.

Railroads were the emblem of French modernization, and these painters embraced them as a subject, depicting smoke-spewing trains moving through the countryside and across new bridges. Monet even painted a series of works of the Gare Saint-Lazare, a train station in Paris. They rode the trains themselves, escaping the city with other Parisians in search of weekend diversions along the Seine. These suburban pleasure spots became some of their favorite subjects, resulting in images of casual restaurants and popular dance halls (*Luncheon of the Boating Party*, Renoir).

Back in Paris, they turned their attention to its wide boulevards, sometimes eerily empty and sometimes bustling with energetic crowds (*The rue Montorgueil, Celebration of June 30, 1878*, Monet).

Parisian theater, too, offered rich subject matter. In addition to opera and ballet (*The Orchestra of the Opéra*, Degas), they represented racecourses, popular cabarets, and entertainment in public gardens (*Music in the Tuileries*, Manet).

As if to affirm their own existence in the midst of this teeming urban energy, they often painted each other, producing intimate portraits of their families and friends.

Painting in Series

When the group dispersed in the mid-1880s, Monet began to produce works in series, depicting the same subject as it appeared at different times of day: *Wheat Stacks* (1890-91), *Poplars* (1891), *Rouen Cathedral* (1892-93, p. 26), then the *Water-Lilies* (p. 250) in his own gardens at Giverny, including the panoramic canvases he gave to France in 1918, which are now in the Orangerie Museum in Paris.

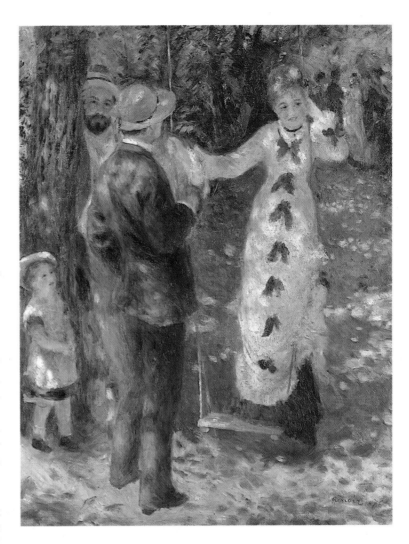

▲ AUGUSTE RENOIR (1841–1919). *The Swing.* 1876.
Oil on canvas, 36¼ x 28¾ inches. Paris, Musée d'Orsay

To render the light falling through the trees onto this relaxed scene of open-air sociability, Renoir used warm hues—pink and yellow—for the spots of light, and cool ones—blue and violet—for areas of shadow. The traditional academic approach to the same problem would have been to use dark browns and blacks for the shadows. The Impressionists, however, thought the traditional technique misrepresented the realities of vision, maintaining that shadows were always tinted. Today we are accustomed to this way of seeing, but these violet shadows at first struck Renoir's contemporaries as a monstrous departure from what a painting should look like.

AFTER IMPRESSIONISM: AN EXPLOSION OF STYLES

What was a young painter to do after Impressionism?

The Legacy of Liberty

At the end of the nineteenth century, an ambitious young painter in France could avoid the Academy school, attending instead one of the many private art schools that had opened, where much freer approaches to painting than that of the Academy were taught. The official Salon exhibitions were no longer the only venue where artists could make their works known to the public, for smaller exhibitions without juries or prizes were becoming more frequent. There were also more galleries where they could hope to show and sell their work.

The example of artistic independence set by the Impressionists was hard to ignore, and many young painters were impelled either to embrace their goals or to reject them. Over a period of twenty years there was a virtual explosion of artistic styles, which flourished simultaneously rather than in orderly succession. At the same time, artists like Paul Cézanne and Vincent Van Gogh (1853–90) remained somewhat apart from these many groups, pursuing their work in relative isolation.

Reconciling Art and Science: The Neo-Impressionists

Without renouncing the work of their Impressionist predecessors, a group of artists dominated by Georges Seurat (1859–91) and Paul Signac (1863–1935) sought to reframe its goals. This group, which accepted the name Neo-Impressionists, or new Impressionists, given them by a critic, sought to place scientific knowledge in the service of art by exploiting the contrast of complementary colors and the phenomenon called optical mixture.

Each primary color—red, yellow, and blue —has as its complementary color a mixture of the two other primaries. Thus, the complementary of red is green (blue + yellow), that of yellow is violet (blue + red), that of blue is or-

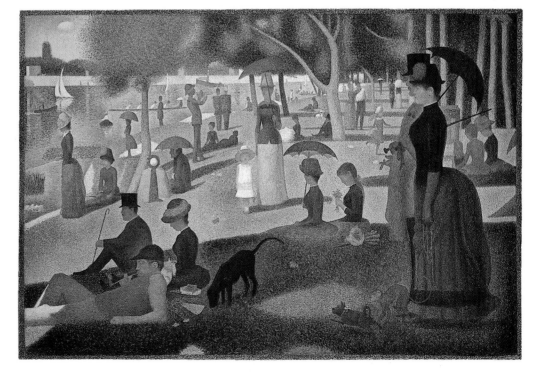

▶ GEORGES SEURAT (1859–91). *Sunday on the Grande Jatte.* 1884–86. Oil on canvas, 81 x 120½ inches. Chicago, The Art Institute

Seurat produced thirty-three painted studies and twenty-six preparatory drawings for this work. He made oil sketches at the site in the morning, returning to his studio to spend his afternoons and evenings working on the final canvas.

158 See: Japanese Prints, pp. 128–129; Bonnard, p. 181; Cézanne, p. 192; Gauguin, p. 214; Matisse, p. 241; Seurat, p. 266; Van Gogh, p. 276.

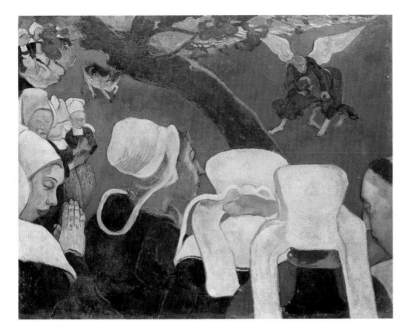

▲ PAUL GAUGUIN (1848–1903). *Vision after the Sermon.* 1888. Oil on canvas, 28¾ x 36¼ inches. Edinburgh, National Gallery of Scotland

This painting is considered one of the first Symbolist works, for what it represents is more an "idea" than a reality, namely the vision of these Breton women—and of the artist himself, visible at the far right—of Jacob wrestling with the angel.

"There are no paintings, only decorations"

The group known as the Nabis (from the Hebrew word for "prophet") included young painters like Pierre Bonnard (1867–1947) and Edouard Vuillard (1868–1940), who admired Gauguin's work and were fascinated by Japanese art, which they had just discovered in Paris.

They wanted art to be everywhere, and they embraced a decorative ideal. Besides conventional canvases, they painted folding screens, murals, stained glass, wallpaper, posters, and theater sets, working on whatever support interested them.

◄ PAUL SÉRUSIER (1864–1927). *The Talisman.* 1888. Oil on wood, 10⅝ x 8¼ inches. Paris, Musée d'Orsay

This painting by one of his followers exemplifies Gauguin's revolutionary principles. "How do you see these trees?" Gauguin once asked Sérusier. "If yellow, then use yellow. If this shadow seems bluish, paint it with pure ultramarine. The leaves are red? Use vermilion."

ange (red + yellow). Two adjacent complementary colors reinforce one another. Optical mixture occurs when juxtaposed points of unadulterated color are blended by the eye, as opposed to on the artist's palette.

The Neo-Impressionists applied small touches of pure color to their canvases next to one another. Since this technique involved "dividing" more conventional brushstrokes, these artists are also known as "divisionists."

The Neo-Impressionists, like the Impressionists, depicted landscapes, scenes of leisure, and places of entertainment. But where the Impressionists sought to capture ephemeral effects of light, Seurat and his associates cultivated an effect of timeless permanence. Rather than painting spontaneously, they planned their work carefully, producing many preparatory drawings, studies, and oil sketches.

Reconstructing Reality

Paul Gauguin (1848–1903) made fun of Neo-Impressionist technique, dismissing it with a made-up term of derision, "ripipoint." He began to work instead in large unmodulated areas of bright color, sometimes using emphatic dark contours to isolate each element. This technique is known as "Cloisonism" (from the French word *cloison*, "compartment").

Gauguin and his friends depicted subjects from the world around them, but they used their original style of bright color blocks to reconstruct it, renouncing the spatial illusionism of perspective.

The Turn of the Century

Henri Matisse (1869–1954), André Derain (1880–1954), Maurice de Vlaminck (1876–1958), and a few others benefited from the example of the Neo-Impressionists, Gauguin, and the solitary Van Gogh. These younger artists painted patternlike compositions with pure color, abandoning both perspectival space and Impressionist light.

At the 1905 Salon d'Automne (the "Autumn Salon")—an exhibition first organized in 1903 as an alternative to the official Salon exhibition—their paintings were shown in the same room as a small bronze sculpture in the Renaissance style. This prompted one critic, shocked by the violence of the colors, to exclaim: "Here we have Donatello among the wild beasts (*fauves*)!" Thereafter their movement was known as Fauvism.

CUBISM

In 1907 Pablo Picasso (1881–1973), a young Spanish artist working in Paris, completed his painting *Les Demoiselles d'Avignon*. The Avignon referred to in the title was not the town in southern France, but a street in the red-light district of Barcelona. The painting itself, which depicted a group of nude prostitutes ("demoiselles"), was composed of flat, simplified, angular forms. We know from what the artist later said about the work that his treatment of the faces and figures was influenced by the abstract, geometric appearance of African and Oceanic masks. The painting is thus an important work from what has been called Picasso's "primitivist" period. The artist's friends, however, were baffled by the painting's harsh outlines, fragmented shapes, and distorted figures, which seemed to suggest aggression rather than sensuality, and several denounced it severely. At first only a young German collector, Daniel-Henry Kahnweiler, understood the work's importance; later, the painter Georges Braque (1882–1963), initially among the skeptics, changed his mind about the painting and became, with Picasso, the cocreator of Cubism, the new style that developed in the wake of Picasso's "primitivist" phase. Other artists were also attracted to the style, among them Juan Gris (1887–1927), Jean Metzinger (1883–1956), Fernand Léger (1881–1955), Roger de La Fresnaye (1885–1925), and the sculptor Henri Laurens (1885–1954).

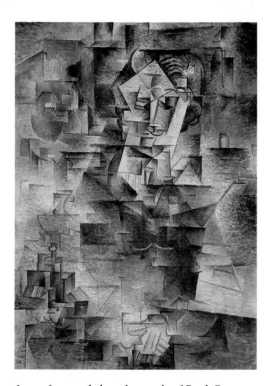

▶ PABLO PICASSO (1881–1973). *Portrait of Daniel-Henry Kahnweiler*. 1910. Oil on canvas, 39⅝ x 28⅝ inches. Chicago, The Art Institute
In Analytic Cubism, the subject represented is broken down into facets tilting toward the plane of the canvas.

▲ GEORGES BRAQUE (1882–1963). *Bach Aria*. 1912. Black paper, oil-cloth, charcoal, and white crayon on white paper, 24⅜ x 18⅛ inches. Washington, D.C., National Gallery of Art
This Synthetic Cubist work represents a stringed instrument, a favorite Cubist theme.

It is often said that the work of Paul Cézanne (1839–1906) set the stage for Cubism (p. 192). Cézanne believed that all natural forms could be analyzed as cylinders, spheres, or cones, and his mature works were based on these geometric reductions. This same essential idea underlay *Les Demoiselles d'Avignon*, although Picasso carried it much further than Cézanne had.

The first phase of Cubism proper, called Analytic Cubism (1910–12), is more complex than mere geometric reductivism. Hitherto, painting had represented objects from a single point of view and made them seem to recede into depth. Braque and Picasso rejected both of these assumptions, and instead tried to depict some of an object's hidden sides on a single plane, the idea being to paint not only what they saw of it, but what they *knew* about it. They renounced natural colors in favor of a simplified palette dominated by greens, browns, and grays. This phase was particularly decisive, for it marked a break with classical vision.

Synthetic Cubism (1912–14), the second phase, simplified forms to the extreme, with objects often being reduced to a few lines. The palette is less muted than in Analytic Cubism, and the compositions often incorporate collage elements such as pieces of wallpaper, sheets of music, newspaper clippings, and the like.

 See: Braque, p. 185; Cézanne, p. 192; Léger, p. 232; Picasso, p. 254.

FUTURISM

Speed is our God, the new canon of beauty: a race car is more beautiful than the Winged Victory of Samothrace." This provocative statement made by the Italian poet Filippo Tommaso Marinetti (1876–1944) in his *Futurist Manifesto* of 1908 conveys the essence of the Futurist aesthetic. The Futurists worshiped energy, both productive and destructive, using formal innovation to convey the speed of modernity and the dynamism of the machine. Exalting the future, they condemned everything belonging to the past, especially museums, which they vowed to destroy.

In December 1908, in Milan, Marinetti issued the *Futurist Manifesto* to the international press. A month later he published the same text in the French newspaper *Le Figaro*, thus launching a multidisciplinary movement whose members included the painters Giacomo Balla (1871–1958), Umberto Boccioni (1882–1916), Carlo Carrà (1881–1966), Luigi Russolo (1885–1947), Gino Severini (1883–1966), the architect Antonio Sant'Elia (1888–1916), and the photographer Anton Giulio Bragaglia (1890–1960), as well as composers and film makers. A second statement, the *Manifesto of Futurist Painting* appeared in 1910, and in 1912 the Bernheim-Jeune Gallery in Paris organized a large exhibition that traveled throughout Europe and even to Chicago. Throughout the group's existence, Marinetti organized conferences and exhibitions calculated to provoke and even antagonize the public. Sustained by the magazines *Poesia* and *Lacerba* as well as by Marinetti's strategy of shock, the movement quickly became widely known.

The Futurists glorified war as "the world's only hygiene," but when war actually materialized as World War I, it took a heavy toll of the movement. Two of their number, Boccioni and Sant'Elia, were killed, and Russolo was badly injured and remained an invalid for years. The movement was paralyzed until the appearance of a new group of artists after the war (Gerardo Dottori, Mario Guido Dalmonte, and others), most of whom, at Marinetti's urging, supported the fascist dictator Benito Mussolini, although they never won his support. More newcomers revitalized the group in the 1930s, but the movement died after Marinetti's death in 1944.

◀ GIACOMO BALLA (1871–1958). *Young Girl Running on a Balcony.* 1912. Oil on canvas, 49¼ x 49¼ inches. Milan, Grassi collection, Civia Galleria d'Arte Moderna
Futurist artists made many attempts to portray movement. Here, an action's successive stages are represented side by side, as in photographic movement studies made decades earlier.

▼ UMBERTO BOCCIONI (1882–1916). *The City Rises.* 1910. Oil on canvas, 78½ x 118⅝ inches. New York, Museum of Modern Art
In this whirling, brilliantly colored composition, the city, emblem of the modern world, is rendered as a vortex of energy and light.

EXPRESSIONISM

Expressionism, the representation of subjective emotions rather than objective realities, is a recurrent stylistic tendency in art as well as a specific art-historical movement. It is characterized by deliberately distorted forms and intense colors, which the artist uses to express emotional reactions to terrifying, painful, or otherwise overwhelming events. Such intense color and formal distortions can be found in late medieval paintings of Hell, in the *Crucifixion* by the sixteenth-century German artist Mathias Grünewald (p. 221), and in the visionary works of the late fifteenth-century painter Hieronymus Bosch. Moreover, the same strain of artistic expression has resurfaced in the work of groups or individuals throughout the twentieth century. Expressionism is rooted in a strongly felt awareness of the precariousness of life; it is often intensified by anger at social injustice, and tends to flourish in periods of crisis or shock.

Expressionism is not limited to painting; it occurs in music, literature, poetry, and film, and while it is traditionally associated with Germanic culture, Expressionism in art can be found throughout the world.

The Expressionist movement had its roots in the late nineteenth century. Vincent van Gogh may be considered one of its precursors, for his paintings often exhibit the chromatic intensity, distorted contours, and atmosphere of desperation typical of the leading Expressionists, such as the Norwegian painter Edvard Munch (1863–1944). Munch's subjects, which are infused with morbid sexuality, are treated in an intensely personal style fraught with moralizing overtones (p. 252). The imagery of the Belgian James Ensor (1860–1949) is similar, but his masked faces and costumed skeletons are less confessional and more grotesque than Munch's figures.

A second Expressionist generation appeared in Dresden, Germany, in 1905 with the establishment of the group *Die Brücke* (The Bridge). Its members, who included Max Ernst (1891–1976), Ludwig Kirchner (1880–1938), Erich Heckel (1883–1970), Karl Schmidt-Rottluff (1884–1976), and Emil Nolde (1867–1956), sometimes lived and worked together.

Der Blaue Reiter (The Blue Rider) was the title of an exhibition organized in 1911 in Munich by Franz Marc (1880–1916) and the Russian painter Vasily Kandinsky (1866–1944; p. 226). Its catalogue asserted: "We do not seek to endorse any specific approach to form; our goal is to demonstrate, through the variety of represented forms, the multiplicity of ways artists' inner desires can manifest themselves."

The First World War, which erupted in 1914, had a decisive impact on the German Expressionists. Georg Grosz (1893–1959), Otto

Dix (1891–1969), and Max Beckmann (1889–1950) found the country's political bankruptcy and social inequities so disturbing that they felt compelled to denounce them. Using imagery of almost unbearable violence, they condemned the horror and brutality of war.

Vienna was another important center. Oskar

▶ OSKAR KOKOSCHKA (1886–1980). *Self-Portrait.* 1917. Oil on canvas, 31⅛ x 24⅛ inches. Wuppertal, Von Der Heydt Museum
Kokoschka was gravely wounded on the Russian front in 1915. In 1917, after his recovery, he settled in Dresden, where he produced many portraits of himself and his friends. His nervous, agitated style was well suited to convey the suffering and anxiety of a world devastated by war.

◀ GEORG GROSZ (1893–1959). *Gray Day.* 1921. Oil on canvas, 45¼ x 31½ inches. Berlin, Nationalgalerie
Rendered in a linear caricatural style, the figures in this painting, simultaneously grotesque and sad, suggest dehumanized puppets.

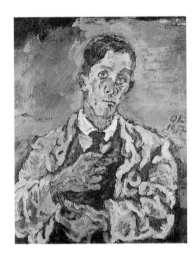

Kokoschka (1886–1980), one of the most important Viennese Expressionists, is best known for his tortured portraits, which convey the inner life of their models in ways that evoke the new field of psychoanalysis, developed in precisely these years in Vienna by Sigmund Freud. His compatriot Egon Schiele (1890–1918), who specialized in the contorted human body, gave the pale skin of his models lurid highlights, creating a strange and morbid effect.

French Expressionists included Georges Rouault (1871–1958), who specialized in social and religious subjects, and the later artist Francis Gruber (1912–48), whose emphatically articulated skeletal nudes convey sadness and lassitude. Chaim Soutine (1893–1943), a Lithuanian who worked in Paris, painted dislocated, almost grotesque figures in incandescent colors—the reds are especially intense—as well as unforgettable images of rotting meat.

Pablo Picasso, the coinventor of Cubism (p. 160), shifted styles throughout his life with dizzying facility, and some of these could be described as Expressionist. This strain in his work can be seen in *Guernica* of 1937, a large canvas painted in black and tones of gray whose tormented forms capture the horror of the bombing of a small Basque village during the Spanish Civil War.

An Expressionist tendency also emerged in Mexico. After the revolution of 1910, the government encouraged artists to paint murals in a simple, direct style that would speak to the people of their work and struggles. Diego Rivera (1886–1957), José Clemente Orozco (1883–1949), and Rufino Tamayo (1899–1991) took up the challenge with relish, producing distinguished works of vibrant color. In Brazil, in 1944, Cândido Portinari (1903–62) executed a Biblical cycle in a style of extreme violence.

In the United States, a movement known as Abstract Expressionism emerged in the late 1940s, partly in reaction to the horrors of the Second World War. Jackson Pollock (1912–56; p. 257), perhaps the best known artist of this group, used dripping and pouring to generate skeins of paint over large canvases placed on the floor. Mark Rothko (1903–70) and Franz Kline (1910–62), too, embraced abstraction in their pursuit, respectively, of pictorial sublimity and hieroglyphic power. Another member of the group, the Dutch émigré Willem de Kooning (1904–97), despite his strong emphasis on brushwork, never completely abandoned the figure.

▼ WILLEM DE KOONING (1904–97). *Woman I.* 1949–50. Oil on canvas, 75⅞ x 58 inches. New York, Museum of Modern Art
De Kooning was a major Abstract Expressionist painter. His work is characterized by vigorous, slashing brushstrokes and dissonant colors.

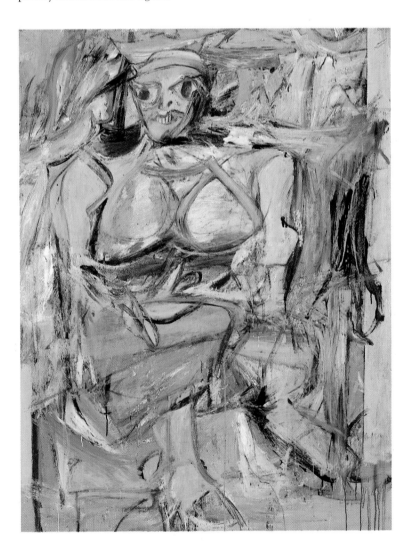

ABSTRACT ART

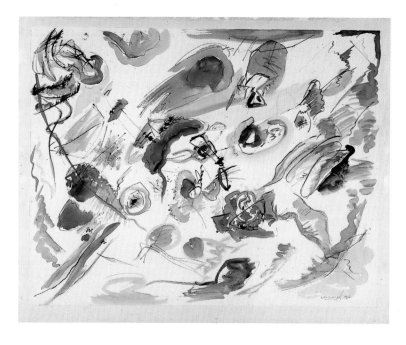

Born in the early twentieth century, abstract art is by definition opposed to the representational art that had prevailed until that time. Subjects depicted by painters and sculptors could sometimes be difficult to construe, but previously it had been inconceivable for them to deliberately compose images that did not depict recognizable objects. Some artists now set out to create a completely nonrepresentational art, among them the leading pioneer of abstraction, the Russian Expressionist Vasily Kandinsky.

▲ VASILY KANDINSKY (1866–1944). *Untitled.* 1910. Watercolor on paper, 19½ x 25½ inches. Paris, Musée National d'Art Moderne, Centre Georges Pompidou
This sheet is inscribed on the reverse: "abstract watercolor, 1910."

Kandinsky reported that one day, as he looked at one of his paintings hung on its side, he perceived that, although the subject was unrecognizable, it nonetheless retained considerable expressive force. This insight spurred him to prolonged reflection that bore fruit in 1912, in a book entitled *On the Spiritual in Art,* considered a fundamental text of abstract art. The history of painting is full of instances in which artists found ways to break free of the constraints of visual reality. They distorted forms, illuminated their subjects intensely, or worked with high-keyed colors to give their compositions greater visual impact, and to emphasize their own imaginative understanding of what they were painting. However, a complete rejection of mimesis—the imitation of reality—had never been attempted. Now, with the invention of photography in the mid-nineteenth century, technology offered an excellent means of recording the appearance of objects. Kandinsky thus took the final step, abandoning representation altogether, and vastly expanding the horizons of artistic inves-

tigation. Henceforth, abstraction, which offered artists a virtual universe of new expressive possibilities, flourished in a host of guises.

Of course, abstract art was not generated solely by Kandinsky. Other artists in other places were moving in the same direction at about the same time: the Czech artist Franz Kupka (1871–1957) exhibited abstract canvases with musical titles (*Fugue in Red and Blue*); the Frenchman Robert Delaunay (1885–1941), intoxicated with color, painted chromatic disks; and in Italy, Alberto Magnelli (1888–1971) also produced abstract paintings. But it was in Russia and Holland that abstraction was first pushed to its limits.

In Russia, Mikhail Larionov (1881–1964) and his wife, Natalia Goncharova (1881–1962), founded Rayonism, a movement that, while short-lived, was important in the development of abstraction. As early as 1911 Larionov exhibited the first work in this style (*Glass*), dominated by colored "rays." Kazimir Malevich (1879–1935), a theorist and founder of a strictly geometric style called Suprema-

tism, is one of the major figures of early abstraction. In 1915 he exhibited in Petrograd, at an exhibition entitled "0.10," his famous 1913 canvas *Black Square on White Ground,* along with thirty-seven other Suprematist compositions consisting exclusively of rectangles, circles, triangles, and crosses. The movement peaked in 1918, when Malevich exhibited *White on White* at the Tenth State Exhibition in Moscow. In response to Malevich's experiments, the Constructivist Alexander Rodchenko (1891–1956) used ruler and compass to produce geometric compositions, notably *Black on Black* of 1918.

Around 1913, the Dutch artist Piet Mondrian (1872–1944) rapidly passed from a Cubist-inspired style to one based on vertical and horizontal lines. Soon thereafter he began to produce compositions consisting of rectangles in primary colors (red, blue, yellow) delineated by black lines of various widths and set against white grounds, a style called Neo-Plasticism. Mondrian quickly joined forces with another Dutch artist, Theo van Doesburg (1883–1931), and together they founded the magazine *De Stijl* (*Style*) to publicize their theories, which influenced many architects and designers.

Abstraction was briefly eclipsed in the 1920s, when many artists were attracted to Surrealism. In 1930, however, the first international exhibition of abstract art was held in Paris. Sponsored by the magazine *Cercle et carré* ("Circle and Square"), it brought together works by Kandinsky and by various geometric abstractionists. While the Spanish Civil War and

the Second World War inspired artists to embrace Expressionism as a way of communicating their outrage at the atrocities that occurred during these conflicts, the postwar years generally were a period of expansion for abstraction.

Postwar abstraction can take many forms, from the geometric images of the German artist Josef Albers (1888–1976) and the Americans Barnett Newman (1905–70) and Ad Reinhart (1913–67) to the energetic, intensely gestural work of such Abstract Expressionists as Jackson Pollock (p. 257) and Willem de Kooning (p. 163).

▼ **KAZIMIR MALEVICH** (1879–1935). ***Black Square on White Ground.*** **1918. Oil on canvas, 31¼ x 31¼ inches. New York, Museum of Modern Art** *The border of the skewed square is scarcely visible; the composition is virtually reduced to monochrome.*

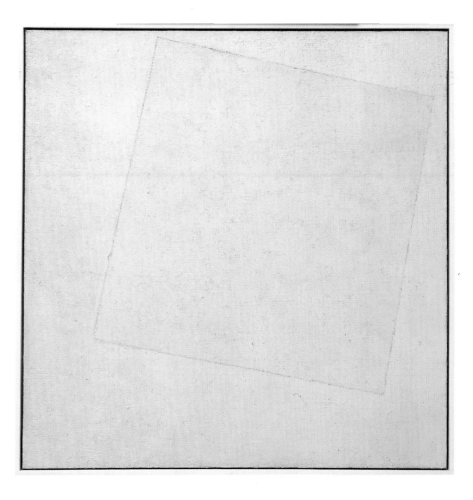

DADAISM

Dadaism was officially born on February 8, 1916, at the Cabaret Voltaire in Zurich. Its name—which means "hobbyhorse" in French, "quack-quack" in German, and "yes yes" in a number of Slavic languages—was chosen at random from a dictionary. Founded by a collection of refugees gathered in Switzerland, including the Rumanians Tristan Tzara (1896–1963) and Marcel Janco (1895–1984), the Germans Hugo Ball (1886–1927) and Richard Huelsenbeck (1892–1974), and the Alsatian Jean Arp (1888–1936), its adherents foreswore bourgeois society, which they held responsible for the tragedy of the First World War, as well as conventional literary and artistic values. They rejected painting in favor of montage and sculpture in favor of monumental assemblage.

The Dadaists maintained that artistic creation should be spontaneous and haphazard. They sowed confusion by mixing up artistic genres, producing images resembling written manifestos and accompanying poetry readings with bizarre sound effects. Their quest to provoke resulted in real artistic discoveries, notably phonetic poetry, photomontage, and assemblage (the combination of diverse materials), all of which they infused with humor, irony, and derision. Dadaism appeared almost simultaneously in Europe and the United States, where Man Ray (Emmanuel Radnitsky; 1890–1976), Francis Picabia (1879–1953), and Marcel Duchamp (1887–1968) also questioned conventional notions of art.

The movement took a revolutionary turn in 1918, when Picabia's New York-based magazine *391* published the *Dada Manifesto* by Tristan Tzara, which affirmed the destructive force of Dada. Thereafter it broke with everything relating to art in its quest for a fresh start. The public grew smaller, having lost patience with the abusive performances at the Cabaret Voltaire. The movement then dispersed. Huelsenbeck went to Berlin, where he was soon joined

▲ **RAOUL HAUSMANN (1886–1971).** *The Art Critic.* 1919. Photomontage and collage, 12⅜ x 9¾ inches. London, Tate Gallery

Photomontage—images clipped from magazines, newspapers, and the like and combined in unexpected ways—was a Dadaist specialty.

by Raoul Hausmann (1886–1971) and Georg Grosz (p. 162), whose caricatures denounced German middle-class complacency. Jean Arp joined the German Dadaist Max Ernst (1871–1976) in Cologne; and in Hanover Kurt Schwitters (1887–1948) began to produce his "Merz"—a word that Schwitters derived from *Kommerz*, German for "commerce"—assemblages from detritus gathered in the street. In 1920 Tzara moved to Paris, as did Max Ernst in 1922; both were welcomed by the French Dada writers André Breton (1896–1966), Louis Aragon, and Philippe Soupault. The Dadaists continued to mount their performances, which sometimes injured their spectators. In 1923 a group of artists led by Breton, who were to become the Surrealists, broke away from the group, judging its spirit too negative.

▼ **MARCEL DUCHAMP (1887–1968).** *Bicycle Wheel.* 1913–64. Ready-made, 49¾ x 12½ x 25 inches. Paris, Musée National d'Art Moderne, Centre Georges Pompidou

Duchamp abandoned painting in favor of more neutral procedures that called conventional artistic categories into question. Here he attached a bicycle wheel to a stool and dated and signed it, thereby giving it the status of a work of art. He called works produced in this way "ready-mades."

See: Dalí, p. 200; Ernst, p. 208; Magritte, p. 235; Miró, p. 247; Picasso, p. 254.

SURREALISM

Psychic automatism, by which we propose to express, either verbally, in writing, or in still other ways, the real operations of thought."

Such was André Breton's definition of Surrealism in his *Surrealist Manifesto* of 1924. The aim of Surrealism was to liberate thought from the control of reason, regardless of the aesthetic or moral consequences. Surrealist painting and writing were to become media for expression of the subconscious.

The first Surrealist exhibition took place in 1925, in the Pierre Gallery in Paris. Bringing together Max Ernst, Jean Arp, Man Ray, the Catalan painter Joan Miró (1893–1983), Picasso, and the Italian artist Giorgio de Chirico (1888–1978), it challenged prevailing notions of artistic decorum, good taste, and bourgeois morality. André Breton became editor of the magazine *La Révolution surréaliste*, and in 1929 he published a *Second Surrealist Manifesto*. The Catalan painter Salvador Dalí (1904–89) made a spectacular entry into the group with a bizarre film he co-directed with his compatriot Luis Buñuel; entitled *Un Chien andalou* ("An Andalusian Dog"), it created a sensation.

The Surrealist movement, centered on the pleasure of artistic creation, cultivated complete spontaneity. Its painters wrote (Max Ernst) and its poets painted (Robert Desnos). Its artists favored the media of collage and polyglot assemblage, developed the technique of *frottage* (taking "accidental" rubbings), engaged in "automatic writing"—random writing thought to be impelled by the subconscious—and invented a game they called "exquisite corpse." Named after a poem obtained according to its rules, this procedure consists of passing a collage, drawing, or poem from person to person, each of whom adds something to the sequence without being able to see most of the previous contributions.

Surrealist painting encompasses works of enormous variety, including the nightmarish visions of Dalí, the sand paintings of André Masson (1896–1987), the outlandish juxtapositions of René Magritte (1898–1967), the desolate urban views of Giorgio de Chirico,

the clotted landscapes of Max Ernst, and the calcified forms of Yves Tanguy (1900–55). But all of these artists aimed to unlock the secrets of the subconscious.

By the end of the 1920s the movement had become international. Breton's death in 1966 brought it to an official close, but its effects can still be felt today.

◄ MAX ERNST (1871–1976). *Loplop Introduces a Young Girl.* 1930. Oil on plastered wood with various objects, 76⅝ x 35 x 3¹⁵⁄₁₆ inches. Paris, Musée National d'Art Moderne, Centre Georges Pompidou

Painter, poet, and theorist of Surrealism, Max Ernst depicted himself in his works in the guise of a strange birdlike surrogate he called Loplop. In this composition he incorporated a motley array of real objects, to enigmatic but witty effect.

POP ART AND NEW REALISM

The Second World War was followed by a period of reconstruction in Europe and increasing prosperity there and in the United States. There was also a sense of collective exhilaration at what seemed to be the dawn of a new era of possibilities. Yet there was also an undercurrent of pessimism. The war had caused enormous destruction, and many of its horrors had shown human nature at its worst. Now the world was entering the Cold War, with its attendant threat of nuclear holocaust. Abstraction flourished in the 1950s, both in Europe and the United States. In the 1960s, however, the emerging consumer society brought on a new return to realism.

▲ ROY LICHTENSTEIN (1923–97). *M-Maybe (A Girl's Picture)*. 1965. Magna on canvas, 60 x 60 inches. Cologne, Ludwig Museum

The primary colors are flatly applied, and the face is composed of giant dots imitating the benday dots used in comic-strip printing.

British Pop Art

In the mid-1950s, the small Independent Group, made up of both artists (Eduardo Paolozzi, Richard Hamilton) and critics (Lawrence Alloway), began to study commercial culture, focusing on inexpensive products, advertising, and their role in modern life. An exhibition held in 1956 at the Whitechapel Art Gallery in London marked the birth of what the critic Lawrence Alloway (1926–92) christened "Pop Art" in 1958.

Richard Hamilton (b. 1922) depicted cars, pin-ups, and electric appliances; Peter Blake (b. 1932) concentrated on comic strips and pop singers; and Eduardo Paolozzi (b. 1924), a magazine collector, made collage prints, recycling advertisement and comic-strip imagery.

American Pop Art

During the 1950s the art world in the United States was dominated by Abstract Expressionism; in the early 1960s American artists and critics embraced Pop Art enthusiastically. In 1962 the Sidney Janis Gallery in New York organized an exhibition entitled "New Realists" that included work by Jim Dine (b. 1935), Roy Lichtenstein (1923–97), Claes Oldenburg (b. 1929), Andy Warhol (1928–87), Tom Wesselman (b. 1931), and James Rosenquist (b. 1933).

In 1962, Andy Warhol became famous for his paintings of Campbell's Soup cans, first rendered individually and then in immaculate rows (*One Hundred Campbell's Soup Cans*, p. 281). He also silk-screened the faces of celebrities such as Marilyn Monroe and Jackie Kennedy by the hundreds. Repeated in this way, these images acquired a surprising power, offering ambiguous commentary on consumer and celebrity culture.

Roy Lichtenstein worked with comic-strip imagery. Beginning in 1960, he painted hugely blown-up images of individual comic-strip frames, complete with the enlarged benday dots of color newsprint.

At the same time, Claes Oldenburg began to make large painted plaster sculptures of sandwiches and cakes, which were soon followed by giant "soft" plastic appliances that droop disconcertingly.

Tom Wesselman brought together objects and collage elements in scenes and tableaux evoking everyday life, sometimes also incorporating reproductions of works of art.

New Realism

In France, in 1960, the art critic Pierre Restany organized several artists into a movement he dubbed New Realism, of which he became the theorist. The work produced by its members was diverse, but always centered on the ambiguities of consumer culture. Far from celebrating it, their works critique the staggering waste that this culture generates. Daniel Spoerri (b. 1930), for example, suggests this

► DANIEL SPOERRI (b. 1930). *Throwing Out the Baby with the Bathwater.* 1967. Various objects on plywood, 59⅛ x 37⅜ inches. Saint-Étienne, Musée d'Art Moderne

Here the artist uses found objects in a playfully literal rendering of a proverbial expression.

with his assemblages of cheap store-bought and thrown-away toys and other commercial objects.

Arman (Armand Fernandez; b. 1928) is an accumulator. "My technique of accumulation consists in letting the objects that I use place themselves. In the long run, nothing is easier to control than chance. . . . Chance is my basic material, my blank page." He used this approach to create accumulations of everything from gears to gloves to musical instruments.

The collaborative artists Christo (Christo Javacheff; b. 1935) and his wife, Jeanne-Claude (Guillebon; b. 1935), wrap things, thereby rendering them mysterious. Christo began with objects as small as bottles and pushcarts, but in the 1960s he and Jeanne-Claude progressed to works on an enormous scale. Their work *Running Fence* (1972–76) was an eighteen-foot-high nylon fence that crossed two counties in northern California and extended into the Pacific Ocean. Later they wrapped several

islands in Biscayne Bay off the coast of Florida, and in 1995, six years after the reunification of Germany, they realized a long-planned project to wrap the Reichstag, the vast building in Berlin where the German National Assembly had met before the Second World War.

Among the New Realists, Raymond Hains and Jacques de la Villeglé (both b. 1926) are unique. They stole and exhibited weather-worn street posters ripped by passersby to reveal the manifold layers beneath. According to Hains, these "works existed before but were not seen because they were right under people's noses." Martial Raysse (b. 1936) incorporated objects and materials of all kinds into his paintings, producing playful critiques of a culture forever in pursuit of leisure.

Yves Klein (1928–62), one of New Realism's most prominent figures, proceeded very differently. In April 1958, he held an "exhibition" entitled "The Void Pure and Simple" at the Iris Clert Gallery in Paris, where visitors arrived to find a room empty save for the artist himself. He made "paintings" with flame-throwers, or by fixing canvas to the roof of his car and driving through inclement weather. His search for scandal climaxed in a series of performances in which he used the paint-soaked bodies of nude women as "paint brushes." His monochrome paintings are probably his most beautiful works; whether they are painted in gold or in the pigment he copyrighted and christened "International Klein Blue," they are perfect emblems of his quest for boundlessness and immateriality.

◄ YVES KLEIN (1928–62). *Anthropometry of the Blue Age (Ant 82).* 1960. Paper with canvas backing, 61⅜ x 111¼ inches. Paris, Musée National d'Art Moderne, Centre Georges Pompidou

The live woman covered with blue paint was the "brush" used to make these imprints.

COBRA

The Cobra group (sometimes written "CoBrA") was founded in Paris in 1948 and remained active until 1951. Its name is an acronym created from the first letters of Copenhagen, Brussels, and Amsterdam, where the affiliated painters and writers originated. It brought together three principal tendencies: the Danish avant-garde, represented by the painter Asger Jorn (Asger Jorgenson; 1919–73); Belgium's revolutionary brand of Surrealism, especially that of the painter and theorist Christian Dotremont (1898–1969), coauthor of its founding manifesto *The Cause Was Understood*, published in the first issue of *Reflex* in 1948; and Dutch experimental painting, represented by Karel Appel (b. 1921), Constant (Constant Nieuwenhuys; b. 1920), and Corneille (Corneille Beverloo; b. 1922).

Cobra was characterized by spontaneity and a communal poetics that fostered collaboration: the painting *Cobra Modification* was a collective production by Jorn, Appel, Constant, and Corneille. Jorn and Dotremont incorporated writing into their "word-paintings." Karel Appel, who cofounded the group Reflex with Corneille in 1949, was the group's instigator; he was a fervent adept of collective projects like the *Works by Four Hands*, which he realized with the help of his friend, the Belgian painter Pierre Alechinsky (b. 1927).

Cobra rejected contemporary movements like Socialist Realism, Expressionism, and geometric abstraction. In the realm of high art, it was influenced by the Swiss artist Paul Klee (1879–1940; p. 226), Joan Miró (p. 247), and Kandinsky's pre-1914 work, but it also drew inspiration from popular art, as well as from African and Oceanic art, all of which it deemed consistent with its program of spontaneity and social change. Its artists sought to dismantle boundaries; while remaining experimental, they valued individual idiosyncracy over theory. In their magazine *Cobra* as well as other publications—short artist's monographs, brochures ("The Small Cobra"), and broadsheets ("The Very Small Cobra")—they attacked all manner of conformism.

The group's collective activity came to an end when Jorn and Dotremont became ill, and its members chose to dissolve it after three years, although they remained on friendly terms.

▲ KAREL APPEL (b. 1921). *Inquisitive Children*. 1948.
Pieces of wood nailed to wooden panel and painted, 33½ x 22 inches.
Paris, Musée National d'Art Moderne, Centre Georges Pompidou
The exuberant forms and colors and the primitive character of this work make it a characteristic work by Karel Appel. Partial to thick paint, crude handling, and wood, he here transformed the figures into grimacing masks recalling the art of children.

ART BRUT

▶ ADOLF WÖLFLI (1864–1930). *The Whale Karo and the Demon Sarton I.* 1922. Colored crayon, 19⅝ x 25⅞ inches. Château de Beaulieu, Art Brut Collection

Wölfli was a major figure of Art Brut. He was successively a farmhand, laborer, miner, and prisoner, and was eventually committed to a psychiatric clinic, where he drew in his cell for twenty years, first in black pencil and then in color. Working in series, he neither made sketches nor retouched. Between 1908 and 1930 he filled voluminous notebooks with images recounting the events of his life, both real and imagined. Shortly before his death he began to work in collage, including words in his compositions. He refused to play according to the rules of the art market, preferring to sell his works at fairs instead of in commercial galleries. The left panel of this double composition shows the whale Karo saving the three-year-old Wölfli from drowning.

The term *Art Brut* ("raw art"), coined by the artist Jean Dubuffet (1901–85; p. 205) in 1945, was meant to designate works characterized by spontaneity and unbridled creativity.

In Dubuffet's own words, it applies to "productions of all kinds, drawings, paintings, embroidery, modeled and sculpted figures, presenting a spontaneous and strongly inventive character . . . and authored by obscure individuals foreign to professional artistic circles."

In principle, such artists remained free of all influence and constraint, seeking neither celebrity nor the sale of their works. Anonymous, their pure creativity was a function more of need than of aesthetic concerns. They could be unknown old people, self-taught artists, or psychiatric patients. *Art Brut* should not be reduced to an art of the mad, but psychiatrists have been interested in the productions of disturbed minds since the century's early years. In 1921, for example, the Swiss psychiatrist Walter Morgenthaler wrote a book about the schizophrenic Adolf Wölfli (1864–1930). The next year, another psychiatrist, Hans Prinzhorn, published *The Expression of Madness*, the first systematic study of the art of the insane. In 1948 the Compagnie de l'Art Brut was established; consisting of sixty members led by Dubuffet and André Breton, its mission was to collect such works. In 1976, a Museum of Art Brut was established in the Château de Beaulieu in Switzerland. Dubuffet's idea continues to live in the English-speaking world under the rubric of "outsider art," which likewise encompasses the work of variously disturbed and alienated artists.

See: Dubuffet, p. 205.

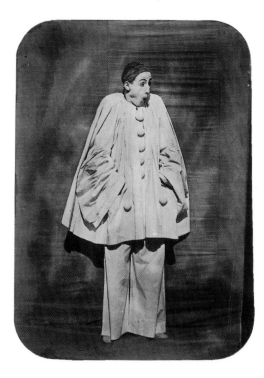

PAINTING AND PHOTOGRAPHY

The invention of photography was announced in Paris on August 19, 1839, by François Arago, a member of the French Chamber of Deputies, at a historic meeting attended by both the Academy of Sciences and the Academy of Fine Arts.

▲ Félix Nadar (1820–1910) and Adrien Tournachon. *Pierrot Surprised.* 1854–55. Albumin paper print, 11⁷⁄₁₆ x 8⁵⁄₁₆ inches. Paris, Musée d'Orsay

With his brother Adrien, Nadar photographed a series of "expressive heads" to promote their newly established photography studio. The figure of Pierrot, popular with the Parisian public, was created by Baptiste Debureau, the greatest mime of his day, at the Théatre des Funambules, and revived after his death by the actor's son Charles. A lovelorn clown, Pierrot was famous for his roguish expressions and inventive, fantastic poses.

The Invention of Photography

The two inventors of photography, Nicéphore Niépce (1765–1833) and Jacques Daguerre (1787–1851), joined forces in 1829 to develop a method to fix images on copper or other metal plates by the action of light. In 1839 they announced that they had perfected their process, which they called daguerreotype, and in the following years these first photographic pictures met with worldwide success. In 1841, an English scientist, William Henry Fox Talbot (1800–77), who had long been pursuing his own research, patented an alternative process, which he called calotype, in which several paper prints of an image could be made from a single negative. The first calotypes were rather blurry, however, and it was ten years before prints on paper replaced the unique-image daguerreotypes. Calotypes were in turn replaced by glass-plate negatives, which, coated with a chemical mixture called collodion, produced multiples with greater clarity.

World Conquest

In the 1850s, enthusiasts of all backgrounds began to take up photography with a passion. Amateurs, artists, and scientists shared their work, compared experiments, and exhibited their photographs. Trained painters also began to experiment with photography, capturing images of cities, small towns, and views of the countryside.

Travelers and archeologists began to bring back views of the ancient monuments of Egypt, South America, the Mediterranean, and China, making it possible to see the world from an armchair.

As technical breakthroughs favored the development of portrait photography, studios sprang up in the great cities, where everyone clamored to be photographed. At the end of the 1850s, portraits began to appear on calling cards. One of the most famous portrait studios was that of Félix Tournachon, known as Nadar (1820–1910). At age thirty, he abandoned a career as a caricaturist to establish a small

studio in Paris, which soon became a Mecca for artistic and literary personalities eager to sit for his lens. In portraits such as his famous one of the poet and critic Charles Baudelaire, Nadar focused attention on the facial features, which are delicately lit against neutral backgrounds. Nadar also took aerial photographs from his balloon, "The Giant."

The Kodak

When awkward glass plates were replaced by chemical emulsions on paper, photography became wildly popular. A series of discoveries culminated, around 1887, in the American George Eastman's invention of the small box camera, which Eastman christened the Kodak. Now virtually anyone could take photographs, capturing ephemeral movements and expressions, and photography became an integral part of everyday life. Ordinary people began taking photographs of their holiday trips, making scrapbooks to record their adventures, and keeping photographic journals.

Photography as an Art

Liberated from technical constraints, by the 1890s photography came to be considered a means of expression comparable to painting. The Photo-Secession, a group of pictorialist photographers founded in New York in 1902 by Alfred Stieglitz (1864–1946), deliberately set out to make photographs that exemplified the same aesthetic values as the paintings of the period. Photo-Secessionist photographers such as Gertrude Käsebier (1852–1934) and Edward Steichen (1879–1973) emphasized fine printing, and often emulated paint or pastel in their use of soft focus and textural effects. In a similar spirit, the French photographer Robert Demachy (1859–1936) used various gum-bichromate processes and brush retouching to achieve painterly images.

In 1903 Stieglitz founded the magazine *Camera Work,* which he continued to publish until 1917, the most important of many avant-garde periodicals addressing the nature of the relationship between photography and art. In 1905, he founded a gallery to exhibit Photo-Secession work. In the following years interest in photography flourished in the United States, where the medium was rapidly accepted as a serious alternative to painting and sculpture.

Photography was less than a century old at the outbreak of World War I, but its place in the world of art was by then secure. In the ensuing years, a number of talented photographers have continued to expand the repertoire of the medium. The photojournalism of Robert Capa (1913–54), the "decisive moments" captured by Henri Cartier-Bresson (b. 1908), the fashion photographs of Richard Avedon (b. 1923), and the protean self-portraits of Cindy Sherman (b. 1954) all confirm that, despite its technological foundation, photography is a supple means of artistic expression.

▼ ROBERT DOISNEAU (1912–94). *The Clock.* 1956. Photograph. *From 1930 until his death in 1994, Robert Doisneau photographed the world of ordinary people that he saw dancing in the street on Bastille Day and kissing on the Seine embankments. With a bemused but tender gaze, Doisneau conveyed his immense love of life. Children figure prominently in his work. This poetic image of an elementary school classroom recalls an innocent time when all that seemed to matter was lunchtime.*

All of the figures profiled here played an important role in the development of Western art. Names in *italics* indicate that biographies of these artists are included in this section.

The entries were written by:
Françoise Bonnefoy, Violaine Bouvet-Lanselle, Françoise Chatillon-Pierront, Vanina Costa, Vinca Costard, Sophie Dufresne, Brigitte Govignon, Laura Gutman, Laurence Madeline, and Laure Murat.

FRA ANGELICO (FRA GIOVANNI DA FIESOLE)

ca. 1400–1455

painter

The painter known to us as Fra Angelico ("angelic brother") was originally named Guido di Pietro, but from 1423 on he appears in documents as Fra Giovanni da Fiesole. He apparently trained as a painter before entering the Dominican convent in Fiesole, near Florence, where he painted altarpieces and miniatures in sacred books. His fame soon spread beyond Tuscany, and in the course of his life he painted in churches throughout Italy.

Between 1438 and 1446, Fra Angelico oversaw the decoration of the convent of San Marco in Florence, which had just become affiliated with the Dominican order. Here he painted meditational images in fresco on the walls of the chapter house, the corridors, and fifty-four of the individual monks' cells. These compositions, most of which depict episodes from the Gospels, exhibit a simplicity and serenity well suited to the silence of the monastery.

Pope Eugenius IV summoned Fra Angelico to Rome in 1445, where he provided altarpieces and frescoes for St. Peter's Basilica and for other churches in the city. Unfortunately, almost all of these paintings are lost. His only surviving works in Rome are the frescoes he painted in the private chapel of Eugenius's successor, Pope Nicolas V, which depict episodes from the lives of St. Stephen and St. Lawrence.

Although Fra Angelico's paintings, with their brilliant colors and graceful figures, are beautiful in an otherworldly way reminiscent of Gothic manuscripts, they show clearly that he was well aware of contemporary developments in Renaissance painting. Indeed, such innovations as the use of scientific

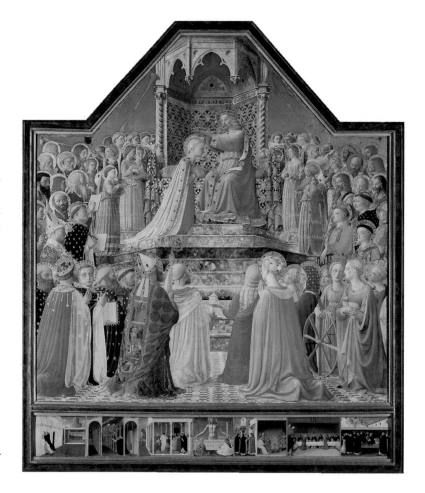

▲ FRA ANGELICO. *Coronation of the Virgin.* 1434–35. Oil on wood panel, 82⅜ x 81⅛ inches. Paris, Musée du Louvre
This work was painted for one of the three altars of the convent of St. Dominic in Fiesole, a small town overlooking Florence. To the strains of angelic choirs, Christ, seated on a canopied Gothic throne hung with gold draperies, crowns his mother, the Virgin Mary, Queen of Heaven. The figures in the foreground kneel on geometric flooring that seems to recede into depth. Beyond them, nine steps lead to the throne, which is flanked by a crowd of the blessed and angels blowing golden trumpets. In the left foreground kneel male saints, including Dominic, whose head is turned toward the viewer, and Nicholas, wearing his bishop's miter and a green mantle decorated with scenes from the Passion. On the right kneel female saints, among them Mary Magdalen holding a yellow jar, St. Catherine with her wheel, and St. Agnes, cradling a lamb.

perspective to define pictorial space and the technique of working with highlight and shadow to portray volume were being pioneered in Florence by the architect *Brunelleschi* and the painter *Masaccio* in the very years that Fra Angelico was at work there. Fra Angelico's paintings reconcile these Renaissance breakthroughs with the delicate world of manuscript illumination.

FRANCIS BACON

1909–1992

painter

Francis Bacon was born in Dublin, Ireland. At age sixteen he moved to London and then visited Berlin and Paris, where an exhibition of works by Picasso persuaded him to become an artist.

After returning to London in 1929 he became a decorator and furniture designer, but he soon began to paint, exhibiting his first canvases alongside his furniture. Dissatisfied with his early work, he destroyed most of it. Painting did not become the central focus of his life until after World War II.

In his incredibly disordered studio, Bacon accumulated reproductions of paintings, magazines, old photographs, images of animals, and even film stills (Eisenstein's *Battleship Potemkin* made a huge impression on him). Strange and distorted for the most part, these images were to nourish his own pictorial universe.

In 1944, at age thirty-four, he painted *Three Studies of Figures at the Foot of a Crucifixion*, the starting point of his mature work. Exhibited the following year in London, these figures—half human and half animal, screaming and apparently ready to bite—outraged the public. Unclassifiable and provocative, Bacon's painting is frequently astonishing.

In Bacon's large paintings, generally triptychs, enclosed spaces—such as bathrooms, cages, or operating rooms—contain single or coupled figures. Painted in violent reds and oranges flatly applied, these figures seem almost to leap off the canvas. Their solitary forms are represented as dislocated or mutilated as if by modern combat; they often lack heads and appendages, and seem wracked with pain.

Bacon also painted many portraits of his family, his friends, and himself, but these are never conventional likenesses; their features are deformed in an attempt to capture the sitters' inner life, to strip their souls bare.

Bacon once said that he "... hoped someday to make the best painting of the human scream." And indeed, his paintings resound with screams.

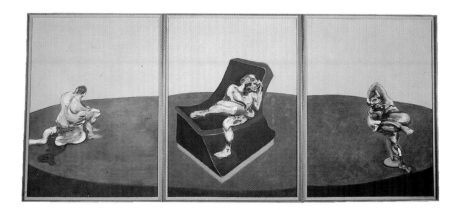

▲ FRANCIS BACON. *Three Figures in a Room.*
1964. Triptych, oil on canvas. Each panel 78 x 57⅞ inches.
Paris, Musée National d'Art Moderne, Centre Georges Pompidou

*Triptychs—groups of three adjacent compositions conceived as a set—have been created
by artists in many periods. Bacon often used this format to evoke three moments in a single event.
In this case the event is simply a man sitting. At left, he is seated on a toilet with his back
to the viewer. In the center, he assumes a contorted position on what looks like a
devouring armchair. At right, he seems to whirl in endless vertigo on a pedestal stool.*

THE BELLINI FAMILY
painters

Three notable painters of the Bellini family, a father and his two sons, were active in Venice in the fifteenth and early sixteenth centuries.

Jacopo, the father, is unrecorded in documents before 1423, when he was listed as a student in Florence of the painter *Gentile da Fabriano*. The next year Jacopo established his own workshop in Venice, where he continued to work until his death in 1470. His rare paintings are rather conservative images of the Madonna. However, two albums of his drawings survive, and these are highly adventurous, full of carefully observed figures and perspective studies.

Gentile Bellini (1429–1507) was Jacopo's elder son. The entire family worked in Jacopo's studio until his death in 1470, when Gentile and his brother Giovanni began to share it. Gentile was a gifted portrait painter. In 1474 he was named official portraitist to the doges, the rulers of the Venetian Republic. In 1479–80 he was sent on a diplomatic mission to the court of Sultan Mehmet II in Constantinople, where he painted a three-quarter view of the sultan, one of his finest and most precise likenesses.

Three large compositions painted between 1496 and 1501 for Venetian *scuole*, or charitable lay confraternities, depict episodes from the lives of the saints. *The Procession to San Marco* and *The Miracle of the Cross at the San Lorenzo Bridge* contain large, solemn crowds arrayed against colorful Venetian backgrounds.

Giovanni Bellini (c. 1430–1516), Jacopo's second son, entered the family workshop at age nineteen. His early work resembles that of his father, but an encounter in nearby Padua with *Mantegna*, who became his brother-in-law, was a decisive influence on his work. Giovanni imitated Mantegna's

incisive draftsmanship as well as his new approach to spatial articulation. In contrast to Mantegna's hard-edged linearity, bright color, and harsh lighting, however, Giovanni's images are painted in a warm palette and his compositions are filled with soft, diffuse light.

Giovanni received many commissions from the Venetian Republic as well as the lay religious brotherhoods (*scuole*) that were so influential in Venetian society. These fraternities, which performed such charitable functions as running hospitals, and caring for the poor, often commissioned famous artists to decorate their churches and meeting houses.

Giovanni traveled in northern Italy, especially to Urbino, where his contact with the work of *Piero della Francesca* influenced his mature style. His *Coronation of the Virgin* (1471) in Pesaro reveals a full mastery of scientific perspective, indeed of all that was new in contemporary painting. Thus it is not surprising that many students came to his workshop to study with him.

Beginning in 1480, Giovanni was placed in charge of work in the doge's palace, but he was often reprimanded for the slow pace of work there. Endlessly inventive, he repeatedly recast the archetypal image of the Madonna and Child, which became one of his

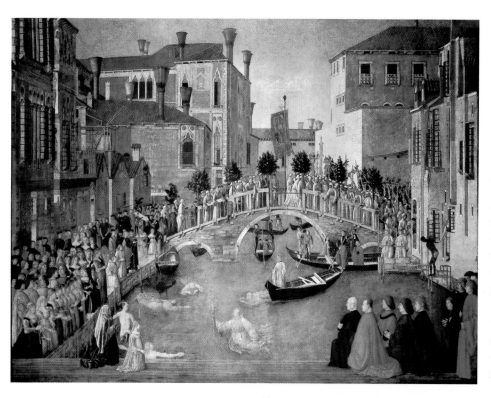

◀ GENTILE BELLINI. *Miracle at the Bridge of San Lorenzo.* 1500. Tempera on wood panel, 127¼ x 169⅜ inches. Venice, **Accademia**

The San Lorenzo Bridge crossed one of the canals in Venice. It no longer exists, but many bridges like it are still standing in the city. During a religious procession a relic of the True Cross—the prize possession of the Confraternity of St. John the Evangelist—was jostled into the canal. The metal reliquary miraculously floated on the water until it could be recovered. Here a silent crowd watches as the miracle takes place. This is a faithful—and delightful—depiction of Venice as it appeared in Gentile Bellini's day. The architectural details are meticulously rendered, with every window, chimney, and roof tile perfectly legible.

▶ GIOVANNI BELLINI. *Madonna of the Meadow.* 1505. Oil on wood panel, 26⅜ x 33⅞ inches. London, **National Gallery**

It is autumn, for there are only a few leaves on the trees. In the foreground, in a sumptuous cascading blue robe, the seated Virgin forms an almost perfect isosceles triangle as she cradles the sleeping infant Jesus on her lap. The solemnity of this group of mother and child is set off by an evocative depiction of the landscape of the Veneto, the region of the Italian mainland surrounding Venice.

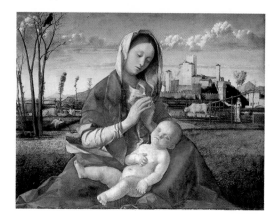

 See: The Renaissance, pp. 136–147.

specialties. These intimate devotional images often feature characteristic landscape backgrounds with soft hills and fortified villages, flooded with a golden light that softens the volumes and suggests a harmony between man and nature.

Even at age seventy, Giovanni remained a leading figure among Venetian artists. By that time, the members of a new generation, notably *Giorgione*, Lorenzo Lotto, and *Titian*, were presenting him with formidable challenges, which he continually met. In 1505, his San Zaccaria Altarpiece combined a majestic composition with a sumptuously atmospheric handling of color quite the equal of anything that his younger rivals could offer.

After 1510 he developed a new interest in antique and mythological themes. In *The Feast of the Gods* (1514), which depicts a joyous band of divinities relaxing after an open-air meal, the young goddesses are charming evocations of girlhood.

Woman with a Mirror, completed when the artist was eighty-five, represents a nude young woman arranging her hair in a pearl-ornamented cap, which is reflected in a mirror on the wall behind her. This serenely beautiful work may well be an aging painter's philosophical reflection on youth. Giovanni died the next year, in 1516.

GIANLORENZO BERNINI
1598–1680

painter, sculptor, and architect

The young Bernini was trained in the studio of his father, a Florentine sculptor who had settled in Rome in 1605. A passionate student of both Renaissance and antique works, early evidence of his astonishing gifts brought him to the attention of Cardinal Scipione Borghese, the nephew of Pope Paul V, for whom, between the ages of twenty and twenty-four, Bernini carved a series of magnifi-

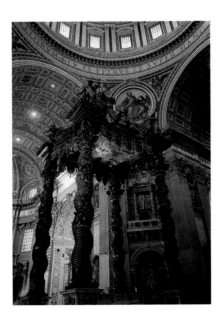

▼ GIANLORENZO BERNINI. The Baldacchino. 1624–33. Gilt bronze, height: approximately 100 feet. The Vatican, St. Peter's Basilica
Impressive in scale, invigorated by its massive serpentine columns, and enriched by gilding, this architectural sculpture bears witness to Bernini's endlessly inventive imagination.

cent marble groups surging with life and dynamism (*Apollo and Daphne*, 1622–25).

Thanks to the patronage of Cardinal Borghese and the pope, Bernini soon began to play a prominent role in the artistic life of Rome. His years working for two subsequent popes, Urban VIII (reigned 1623–44) and Alexander VII (reigned 1655–67), were especially productive. The beginning of this remarkably creative period began in 1624, when Urban VIII commissioned an enormous bronze baldachin to rise over the grave and altar of St. Peter, the first pope, in St. Peter's Basilica in the Vatican. Supported by four huge twisted columns and culminating in an elaborate bronze canopy, this astonishing structure animates the immense space beneath the vast dome designed by Michelangelo in the previous century.

A few years later, in 1629, Bernini was named architect of St. Peter's Basilica, which had been under construction since the early years of the sixteenth century. He began to integrate architecture, sculpture, and painting in ways never before seen. As the dominant artistic figure in Rome, he had the resources to produce work of immense grandeur, power, and vitality. In many ways he is the founder of the Italian Baroque.

Architect and master of urban stagecraft, he gave St. Peter's its definitive appearance. After completing the great bronze baldachin, between 1627 and 1641 he renovated the surrounding transept crossing, designing four colossal statues of the saints whose relics are enclosed in the great piers that support the church's dome. These heroic statues, accompanied by relief sculptures narrating the legends associated with the relics, are set into niches in the four piers. The result is an impressive ensemble evoking the primacy of St. Peter and his papal suc-

See: Baroque Art, pp. 62–63.

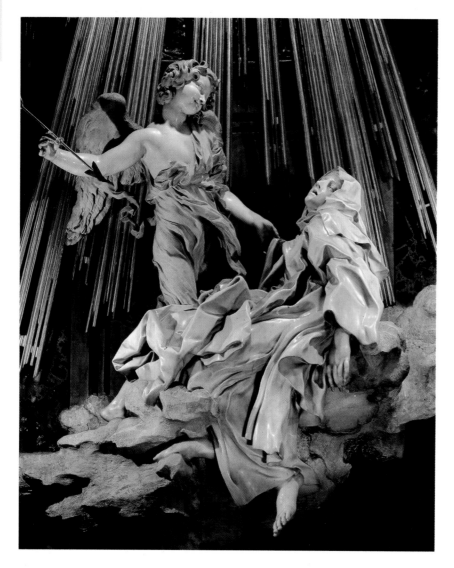

◀ GIANLORENZO BERNINI.
The Ecstasy of St. Teresa. 1644–52.
Marble, height: 11 feet 6 inches. Rome,
Sta. Maria della Vittoria, Cornaro Chapel
This work reenacts a vision described in the autobiography of the mystic St. Teresa of Avila. According St. Teresa's account, an angel appeared to her, and repeatedly pierced her heart with a fiery arrow, after which she was "utterly consumed by the great love of God." In Bernini's conception, gilt-bronze rays signifying divine illumination descend from a window above the marble group. St. Teresa and the angel seem to float toward heaven, as if transported by intense religious fervor.

cessors, and the Christian examples of the four saints portrayed.

Between 1656 and 1665, Bernini redesigned the square in front of the basilica by constructing an elliptical colonnade supported by four rows of columns and surmounted by 140 statues of saints. Its arms seem to draw the crowds of pilgrims into the heart of the church (p. 62).

For the church of S. Andrea al Quirinale (1658–70), Bernini devised an original octagonal plan, hinted at by its convex entry portico. In the interior, the principal axis is defined by chapels that establish strong visual rhythms. All the architectural lines seem to converge on the altar, where a statue of St. Andrew ascends heavenward.

In 1665, invited by Louis XIV of France to provide a new façade for the Louvre, Bernini traveled to Paris for four months, where he was accorded every honor. However, his baroque design for the palace with its undulating façade was ultimately rejected as inconsistent with French taste and was never built. After returning to Italy Bernini completed an equestrian statue of Louis XIV that is now installed outside the Louvre.

In addition to being an important architect, Bernini was the preeminent sculptor of seventeenth-century Italy. His early work was dominated by antique themes (*The Rape of Proserpina*), but around 1630 he also began to carve marble busts of great vitality and psychological penetration. Among his most ingenious inventions are the elaborate architectural tombs designed for his papal patrons in St. Peter's Basilica, especially those of Urban VIII and Alexander VII. He also produced remarkably moving devotional tableaux, notably the spectacular *Ecstasy of St. Teresa* in Sta. Maria della Vittoria (left).

Bernini enriched the city of Rome with monumental fountains, the most impressive of which is the *Fountain of the Four Rivers* in the Piazza Navona (1641–51), commissioned by Innocent X. Dominated by an Egyptian obelisk, its dynamic figures, personifications of four great rivers of the world, seem to respond to the façade of the nearby church of S. Agnese, filling the square with life and energy.

PIERRE BONNARD
1867–1947

painter

Pierre Bonnard was born in 1867, near Paris. An excellent student, he early manifested a gift for drawing. He entered law school, but at the same time he pursued art studies at the Académie Julian, where he became friendly with painters influenced by *Gauguin*, notably *Paul Sérusier*, painter of *The Talisman* (p. 159). Soon he helped to found the group known as the *Nabis* (the Hebrew word for "prophet"), whose young members sought to break down barriers between easel painting and the decorative arts.

Bonnard's interests were wide-ranging, encompassing music, literature, and the theater. In 1891, he exhibited at the Salon for the first time and designed a poster for champagne that won him much attention.

He was much influenced by the arabesques, unorthodox compositions, and striking color combinations of Japanese art—to such an extent, in fact, that his friends called him the "very Japanesy Nabi."

Bonnard depicted contemporary subjects set in the streets or in his own house. In 1893 he met the woman who would become his companion, Maria Boursin, who called herself Marthe. She became his favorite model, and a constant in both his life and his painting. He represented her nude many times, bathing or drying herself, and it is also she who appears at the luncheon table in his painting *The Red Checkered Tablecloth*.

Around 1910 Bonnard became interested in landscape, leaving Paris with increasing frequency for the south of France, with its brilliant light and dazzling colors. He was fond of taking long walks, during which he made pencil sketches of whatever struck his fancy.

While influenced by the light

palette of the Impressionists, Bonnard never painted in the open air, preferring to compose his landscapes, with their plunging perspectives and surprising croppings, in the studio. Working on unstretched canvas tacked to the wall, he applied brilliantly hued pigment in short strokes. One of his favorite themes was the open window, which provided him with a clear structural framework and allowed him to combine lush landscapes and brilliant light with domestic interiors.

Bonnard continued to paint until his death in 1947, but after 1939 he kept to a small repertory of subjects: landscapes, nudes, and the occasional still life. In *Studio with Mimosa*, one of his last masterpieces, the plant of the title virtually explodes with the luminous color that is Bonnard's trademark. Indeed Bonnard's marvelous color and his compositional audacity together make his paintings among the most seductive of twentieth-century art.

▶ PIERRE BONNARD. *Nude in the Bath.* 1936. Oil on canvas, 36⅝ x 57⅞ inches. Paris, Musée d'Art Moderne de la Ville

In his painting Bonnard sought to "show what one saw when entering a room suddenly." And indeed, in this work he has done just that. From an unexpected angle, the viewer is shown an intimate view of Marthe, Bonnard's companion; her body seems to float in a luminous atmosphere of blues, yellows, and pinks.

See: After Impressionism, pp. 158–159; Japanese Prints, pp. 128–129.

HIERONYMUS BOSCH
ca. 1450–1516
painter

Hieronymus Van Aken took the nick-name by which he is now known from the last syllable of the Dutch town where he was born, s'Hertogenbosch. Both his father and his grandfather were also painters. For most of his adult life he belonged to a lay religious society, the Confraternity of Our Lady, which organized church events and sponsored a theatrical troupe specializing in sacred dramas. In addition to being enormously productive, he was a prominent and much respected figure in his home city, which organized an elaborate funeral for him when he died in 1516.

Bosch often painted large folding triptychs (sets of three adjacent compositions), and his themes were invariably religious (the creation of Adam and Eve, the Last Judgment, the temptation of St. Anthony). His compositions are frequently populated by hideous monsters or teem with small figures engaged in curious activ-ities. In the triptych known as *The Garden of Delights*, for example, the Hell panel depicts a sinister landscape illuminated by the devil's fire; sneering dragons pursue and kill naked, panic-stricken men and women, animals in human dress celebrate black masses, and an immense vehicle made of a pair of ears bestriding a knife seems to move about under its own power. In the Paradise panel, by contrast, all is beatific, with little blue and pink mountains emerging from a ground scattered with gigantic fruit.

As is often true with Bosch, the meaning of this work remains mysterious, for the religious content of its peculiar imagery has never been fully explained. This does not detract from the fascination of his visionary world, however, which seems shot through with the madness of dreams. Bosch was a master of his medium, deploying color and line with exceptional skill. Although his precise intentions continue to elude us, he was clearly a moralist. Depicting a hierarchical universe rising from a depraved Hell to an exalted Heaven, his works continually explore the depths of human sin and depravity.

▼ HIERONYMOUS BOSCH. *The Garden of Delights.* c. 1505–15. Triptych, oil on wood panel, 153⅛ x 86⅝ inches. Madrid, Prado Museum *This is the largest and most fantastic of Bosch's triptychs. On the left panel, Christ introduces Adam and Eve to an exotic Paradise in which plants and animals coexist in harmony. In the central panel, a teeming multitude of elegant nudes disports around the Fountain of Youth in the Garden of Delights. At right is a horrific musical hell dominated by the broken white husk of a man-tree, precariously supported by boats floating in a dark lake.*

▼ *Right:* **Musical Hell panel.**

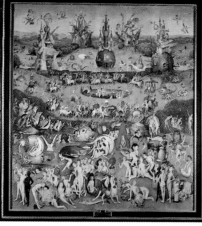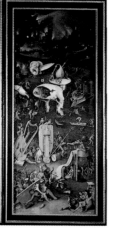

BOTTICELLI (SANDRO FILIPEPI)

1445–1510

painter

Sandro Filipepi was born in Florence in 1445. The son of a tanner, as a youth he entered the studio of the painter Filippo Lippi and adopted the nickname of his elder brother, Botticello ("small cask"). By age twenty-five he already had his own studio. After painting many images of the Virgin and Child, he came into his own with elegant, harmonious paintings of great originality.

Botticelli's early paintings, such as his *Fortitude* and his *St. Sebastian*, were admired by the cultivated Medici family that had ruled Florence since the beginning of the century, and he soon became the favorite painter and friend of the head of the family, Lorenzo de' Medici. Between 1478 and 1485, he painted *Primavera (Spring)* and *The Birth of Venus*, allegorical celebrations of beauty inspired by an-cient mythology and the antique civi-lizations so highly admired by the Ital-ian humanists.

In 1481, Botticelli was summoned to Rome by Pope Sixtus IV to paint three frescoes in the Sistine Chapel, two scenes from the Life of Moses, and one from the Life of Christ. When the artist returned to Florence the following year his prestige had in-creased considerably, and he was now offered a great number of commis-sions. During this period he painted many exquisite Madonnas, which are among his best known works. He also produced a superb series of drawings illustrating the *Divine Comedy*, the great epic poem written by Dante in the previous century.

In 1492, Botticelli was much af-fected by the death of Lorenzo de' Medici. Two years later Lorenzo's son Piero de' Medici was exiled from the city, which was now riven by religious and political tensions. The cultivated world in which the artist had flour-ished was crumbling. His *Pietà*, paint-ed around 1498, is a tragic image in which the Virgin faints on seeing her son's lifeless body. Now profoundly uneasy, Botticelli henceforth painted only small religious works infused with a nervous drama; monumental, almost overpowering architectural set-tings replaced the flowered green-swards of his earlier paintings, and in one of his last Crucifixions the city of Florence is beset by a lowering storm. An increasingly solitary figure, he died in 1510.

▼ SANDRO BOTTICELLI. *La Primavera (Spring)*. 1478. Tempera on wood panel, 79⅞ x 123⅜ inches. Florence, Uffizi Gallery
Botticelli here devised a highly personal treatment of an ancient myth well known in his day from a poem by Poliziano, a humanist in the circle of Lorenzo de' Medici. Although the painting has been interpreted in many ways, it is almost certainly about the arrival of spring and the awakening of love. Venus stands at the center; above her a blindfolded Cupid prepares to launch his first arrow. In the left foreground are Mercury and the Three Graces; to the right of them are Flora, goddess of spring, in a flowered dress, and the mythological lovers Zephyrus and Chlorus.

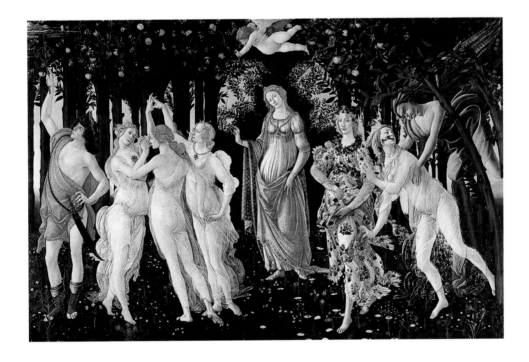

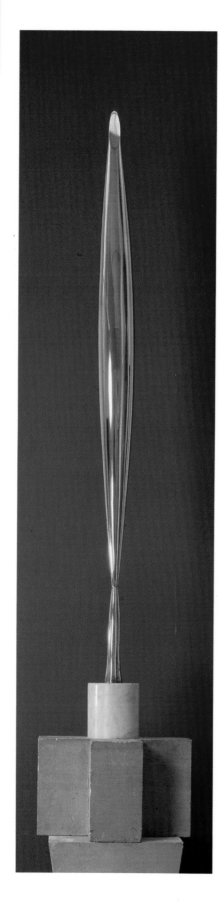

CONSTANTIN BRANCUSI
1876–1957
sculptor

Constantin Brancusi was born in Rumania in 1876. The son of poor country people, he soon left their farm to become an apprentice cabinetmaker, and in 1898 he enrolled at the School of Fine Arts in Bucharest. At age twenty-six he embarked on an extended European tour on foot that finally, in 1904, brought him to Paris.

In Paris, the young artist was much impressed by the work of Rodin. After Rodin's first exhibition, he asked Brancusi to work for him, but the Romanian sculptor, jealous of his freedom, refused. In 1908 he carved *The Kiss*, a cubic, "primitivist" depiction of a couple embracing, and in 1913 he had his first exhibition in the United States. His work began to sell.

Almost all of Brancusi's sculpture derives from a few basic shapes, notably ovoids and cubes, of which he never tired. He worked in stone, marble, and plaster, suppressing details to produce objects of stunning purity and simplicity. His quest was for the universal shape, the primal form. In 1924 he completed *The Beginning of the World*, a superb marble egg.

◀ CONSTANTIN BRANCUSI. *Bird in Space.* c. 1941. Polished bronze, height: 75⅛ inches. Paris, Musée National d'Art Moderne, Centre Georges Pompidou

Brancusi often went to the botanical garden in Paris to draw birds, trying to capture their postures. Here he reduced their form to a slender projectile poised on a marble pedestal, splendid in its polished elegance.

Brancusi sometimes spent several years on a single composition, repeating it again and again in various sizes and materials. Between 1912 and 1931, for example, he made seventeen versions of one of his best known works, a representation of the slightly turned head of a woman, entitled *Mademoiselle Pogany*. He worked with a goldsmith's refined eye, polishing and repolishing his marbles and bronzes to obtain the silken reflections he desired. As a result, the works glitter and seem to change shape subtly as one moves around them.

The bases Brancusi designed for his pieces, often of contrasting forms, colors, and materials, are interrelated with the sculptures they support. Thus his *Birds* seem about to take flight, while his *Cock* remains firmly planted on its pedestal.

When carving wood Brancusi used a hatchet with vigor and skill, producing not only studio furniture but drolly enigmatic pieces like *Sorcerer, Eve,* and *Socrates*. His constant desire for reduction led him to create the vertiginous *Endless Column*, composed of identical segments repeatable to infinity. In 1937, a gilded steel version of this work approximately a hundred feet high was erected at the foot of the Carpathian mountains in his native Rumania.

Proud and solitary, Brancusi disdained honors, preferring to remain in his large whitewashed studio in Montparnasse. He was a tireless worker even in old age, when he continued to pursue the perfect form.

When he died at age eighty-one, having become a French citizen, he left his entire studio to his adopted state. It now belongs to the Georges Pompidou Center in Paris.

GEORGES BRAQUE
1882–1963

painter and engraver

Born in Argenteuil, France, in 1882, Georges Braque grew up in Le Havre, where he learned his father's craft, decorative painting. By the time he was eighteen, he was working in Paris and around 1905 he began to paint broadly handled, brightly colored landscapes influenced by the *Fauves*.

Then, in the autumn of 1907, two events changed his life. First, he discovered the work of *Cézanne*, and he was introduced to Picasso, who had just completed the *Demoiselles d'Avignon* (p. 254). He was at first stupefied by this work, but he soon grasped its importance as a breakthrough in modern painting.

Braque began to produce landscapes composed of simple geometric forms—of small cubes, as one critic put it—and to limit his palette to grays, browns, and greens. In his still lifes, he tried to paint the space he sensed around objects. Braque and Picasso now saw each other every day in Montmartre, comparing and discussing their work. The result of their collaboration was Cubism, a style in which the objects they painted, notably musical instruments, were broken down into a multitude of facets. Some of the canvases by Picasso and Braque from this period are so similar that it is difficult to determine which of the two artists painted them.

In 1912, Braque produced the first *papier collé* ("pasted paper") by gluing three pieces of oilcloth printed to resemble wood onto one of his drawings. This invention, born of his passion for varied materials, marked the beginning of a new interest in color.

Gravely wounded in World War I, Braque set to work again in 1917, but his new works were quite different

▲ GEORGES BRAQUE. *The Duo.* 1937. Oil on canvas, 51⅝ x 64 inches.
Paris, Musée National d'Art Moderne, Centre Georges Pompidou

Arrayed as in the double-page spread of an open book, the dark silhouettes of two women face one another in a music room. One, a singer, holds a musical score by Debussy while the other plays an upright piano. The latter's head is set off by a reddish triangular form that merges with a painting on the wall, and both figures stand out against the design of the wallpaper, whose patterning accentuates the play of lights and darks.

from what he had produced earlier—broader, flatter, and often combining spatial play with carefully interlocked shapes. While he never completely renounced Cubism, he continually reinvented his personal idiom.

Still life was his favorite genre. The same objects—fruit, musical instruments, pitchers of ample form—reappear from one canvas to another, arrayed on marble mantels or pedestal tables. Sometimes set off by yellow or pink cloths, they seem to project into space.

As Braque grew older his paint became richer and thicker, sometimes because he had mixed it with sand. His muted colors acquired a new density, whether brilliant yellow for lemons or more somber for black boats on the deserted beaches of Normandy.

In 1950, at age sixty-eight, he began a series of eight *Studio* paintings, compositions in which the odds and ends of his craft became vehicles for free meditations on space and the creative process. Some of these feature an airborne bird, a motif he repeated on a ceiling in the Louvre in 1953.

Braque also designed stained-glass windows for a small church perched on a cliff in Varengeville, on the Norman coast near Dieppe, and it is here that he was buried after his death in 1963.

See: Cubism, p. 160.

PIETER BRUEGHEL THE ELDER
1525/1530–1569
painter

Pieter Brueghel is thought to have been born near Breda, Holland, between 1525 and 1530. Nothing is known of his life until 1551, when he was listed as a master in the Antwerp painters' guild. Immediately thereafter he went to Italy for two years, making superb drawings of the Alpine landscapes that he passed through on the way. He was almost thirty when he executed his first paintings. In 1563 he married and settled in Brussels, where he died in 1569. He is sometimes called Brueghel the Elder to distinguish him from his two sons,

Pieter the Younger and Jan, who were also successful painters.

Many of Brueghel's compositions feature monsters and devils, reflecting the influence of the fantastic creations of *Hieronymus Bosch*. In his remarkable and enigmatic painting *Dulle Griet* ("Mad Meg"), for example, a giant woman is shown striding across a hellish landscape devastated by war, fire, and human folly.

Brueghel also found a number of subjects in the lives of the Flemish peasantry, rendering their celebrations, dances, and traditions with bemused affection. He is said to have dressed as a peasant and walked among the revellers at country feasts, the better to observe the customs of the people, as well as details of their clothing and behavior. Brueghel was also a superb landscapist, embellishing the lakes of the

Flemish plain with distant mountain peaks, which he remembered from his trip across the Alps. In 1565 he began a series of the Labors of the Months, a traditional Northern European subject, commissioned by a wealthy Antwerp financier. The five surviving compositions of the series show peasant life unfolding to the rhythms of nature. In *The Harvest*, a great mass of yellow wheat stretches to the horizon, while *Hunters in the Snow* depicts hunters and their dogs setting out to track foxes while their children skate on frozen ponds in the far background.

Brueghel's paintings are luminous and brightly colored. His landscapes, organized in simple bands proceeding from brown to green to blue, lead the viewer's gaze into the distance, encouraging exploration of a world full of interest and animation.

◀ PIETER BRUEGHEL THE ELDER. *Children's Games.* 1559. Oil on wood panel, 47¼ x 63 inches. Vienna, Kunsthistorisches Museum
One of many paintings by Brueghel that shows the world out of sorts, this one is set in a typical sixteenth-century Flemish village. All the children seem to be in the street, and are gathered in small groups to play eighty-four different games. Dressed in grown-up clothing, they are as absorbed as any adult might be in their activities. Brueghel seems to be suggesting that many of the concerns of the adult world are also "games."

FILIPPO BRUNELLESCHI
1377–1446
sculptor and architect

Born in Florence in 1377, Filippo Brunelleschi trained as a goldsmith and then worked as a sculptor until 1401. After a trip (1404–9) to Rome to study ancient monuments with his friend, the sculptor *Donatello*, he devoted himself exclusively to architecture, and was soon considered the preeminent architect in Italy by his contemporaries. Although his solutions to problems of engineering are much dependent on Gothic building methods, the aesthetics of his architecture, including his sense of modular relationships between the parts of buildings, his feeling for balance and structural harmony, as well as his favorite decorative motifs, were derived from the Roman architecture that he had studied so carefully on his trip to Rome. All of his important buildings are in his native city.

In 1417, Brunelleschi was commissioned to build the dome of the cathedral of Florence. An immense cupola had been planned since 1367, and its octagonal foundation was already in place. The dome itself, however, had not been built, because no one quite knew how to construct a vault over such a vast space. Brunelleschi's solution to this problem was an ingenious construction of two interlocked ribbed domes—an idea clearly derived from Gothic ribbed vaulting—which he completed in 1436. In addition to establishing Brunelleschi's reputation for technical virtuosity, the graceful dome, with its elongated profile, became a symbol of the city of Florence. Following this project, Brunelleschi designed a number of other buildings in which he blended Roman elements with an early Renaissance sensibility—lighter forms, more elongated proportions, and few but delicate, crisply carved de-

tails—suggesting an antique derivation but avoiding any feeling of archeological coldness. The most successful of these are the Ospedale degli Innocenti (foundling hospital; 1421–24), the church of San Lorenzo (1421–46), the Pazzi Chapel in the cloister of Santa Croce (1430–44), and the churches of Santa Maria degli Angeli (1434–37) and Santo Spirito (1436–46), all of them notable for their symmetry, formal harmony, and structural lucidity.

Brunelleschi is thought to have discovered the rules of scientific perspective, a system for creating the illusion of three-dimensional space in two dimensions that is linked to the rationality of his architectural work. This breakthrough had an immense impact on contemporary painters, including *Masaccio*, *Fra Angelico*, and *Paolo Uccello*. Brunelleschi died in Florence in 1446.

▲ FILIPPO BRUNELLESCHI. **The Dome of the Cathedral of Florence (Sta. Maria del Fiore). 1420–36. Florence, Italy**
Because of the dome's enormous height and width, conventional scaffolding that rested on the floor of the church would have been precarious and almost prohibitively expensive. To solve this problem, Brunelleschi devised a system of suspended platforms for the workmen that could be adjusted upward as the structure was built. The dome itself was supported by massive ribs, rising in a high, pointed profile to give it stability, with panels between the ribs billowing like inflated sails. This design was not only an innovative work of engineering; it was also marvelously elegant in a distinctive way never seen before.

See: The Renaissance, pp. 136–147.

ALEXANDER CALDER
1898–1976

sculptor

Alexander Calder was born in Philadelphia, Pennsylvania, in 1898. Passionately interested in mechanics and mathematics, he received an engineering degree at age twenty-one. Two years later, however, he decided to become an artist and began to study painting in New York. In 1926 he sailed to Europe on a freighter and settled in Paris, where he began to make witty figures and animals out of wire that showcased both his ingenuity and his engineering skill. Soon he had produced an entire miniature circus, which he presented at the Salon of Humorists the next year.

A visit to the studio of the painter *Mondrian* proved a revelation, and Calder resolved to make his colored rectangles move. Thus was born the "mobile"—"worlds of movement," as he put it, consisting of abstract and figurative shapes delicately balanced on wires hanging from the ceiling. One of the earliest, entitled *White Ball, Black Ball*, is a perfect combination of form and motion.

He carefully calculated the weight of each element, forged the pieces himself, assembled them, and painted them in bright colors. Responsive to the slightest breeze, these aerial pieces animate the spaces in which they hang.

Some years later he began to produce "stabiles," sculptures solidly anchored to the ground. Usually installed in the open air, these large pieces have quirky shapes and are often brightly colored. First Calder prepared a maquette, or model, in his studio, making sure its proportions were perfect; then workmen produced a large version out of heavy metal plates. Often resembling fantastic animals (*The Red Spider*), these pieces are sometimes enormous.

Calder also painted simple, brightly colored compositions, illustrated poetry, made jewelry, and designed theater sets. Whether on an intimate or a monumental scale, whether motionless or designed to flutter and twist in the wind, Calder's works are always full of a poetic wit and fantasy that was his alone.

▼ ALEXANDER CALDER. *Rudders.* 953–54. Painted steel wire and sheet aluminum. 59 x 55⅛ inches. Saint-Paul de Vence, Fondation Maeght

Installed in the open air, this piece combines Calder's two inventions, the stabile and the mobile. Using the former as a support, the delicately balanced metal panels of the mobile move through space, propelled by the breeze.

CARAVAGGIO (MICHELANGELO MERISI)
1573–1610

painter

Born in Italy in the small town of Caravaggio (hence his nickname), Michelangelo Merisi spent several years as an apprentice to a painter in Milan, then traveled in northern Italy, and finally to Rome at age twenty-one. Dominated by the Catholic church, Rome in the 1590s was a cosmopolitan center that attracted artists from all over Europe, who came both to study its many treasures and to find patrons.

Initially without resources, Caravaggio led a Bohemian existence, frequenting taverns and just managing to eke out a living with his painting. In 1595 he became acquainted with Cardinal dal Monte, who became his patron.

Caravaggio flourished under dal Monte's protection, and it was while he was living in the cardinal's palace that he began to paint his distinctive genre paintings. In some of these works gods are boldly made to resemble the young boys from the streets who posed for them. Preferring down-to-earth images to idealized ones, Caravaggio adopted a similar approach to his treatment of both religious themes (*The Rest on the Flight into Egypt*, set in the Italian countryside) or more contemporary ones (*The Fortune Teller*).

After 1600 Caravaggio painted only religious themes, increasingly using chiaroscuro (Italian for "light-dark")—stark contrasts of light and dark—to intensify the drama of his subjects. He made a point of representing the Virgin and the saints as common men and women, but he portrayed them with a dignity worthy of any saint in a High Renaissance painting. Examples of this revolution-

▶ MICHELANGELO DA CARAVAGGIO. *Gypsy Fortune Teller.* 1595. Oil on canvas, 39 x 51⅜ inches. Paris, Louvre

Caravaggio painted two versions of this composition (the other is in Rome). Encountered at a street corner, a young gypsy with a disarmingly direct gaze takes the hand of a young man, who waits to hear what the future holds for him, not noticing that she is subtly loosening the ring on his finger. The light falling on the wall behind the two also highlights the crucial interplay of hands, while the half-length format makes us eyewitnesses to this dubious transaction. Caravaggio's seventeenth-century followers painted many such scenes of tricksters, card-sharps, and petty thieves.

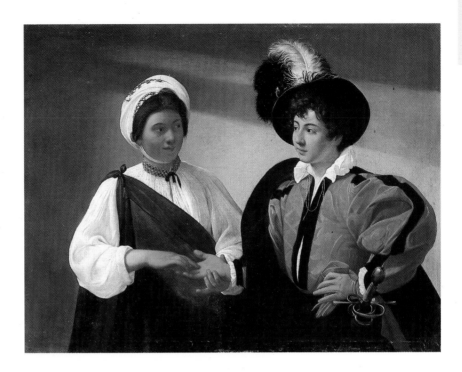

ary approach to his subjects are two large compositions that he painted in 1601 for the Cerasi Chapel in the church of Santa Maria del Popolo, *The Crucifixion of St. Peter* and *The Conversion of St. Paul.* In the latter of these he audaciously broke with earlier pictorial conceptions of the event by depicting Paul as a rough-hewn young man who has just fallen from his horse, stricken by the force of the presence of Christ. In Caravaggio's conception, Paul lies on a diagonal in the foreground, and seems almost to be in danger of falling out of the painting. The presence of Christ is implied by the bright spotlight falling from the upper left side of the composition on the dazed young man who is being called to God's service. In the background, his horse and its groom, who looks like a man of the Roman streets, are oblivious to the miracle that is taking place before their eyes. Particularly powerful are Caravaggio's dramatic staging, his use of light to isolate details and to intensify emotions, and his rejection of the idealized physical types favored in Italy

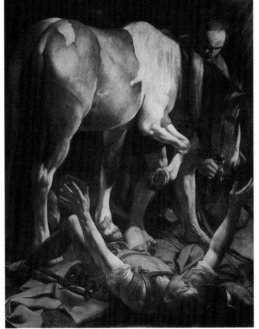

◀ MICHELANGELO DA CARAVAGGIO. *The Conversion of St. Paul.* 1601. Oil on canvas, 90½ x 68⅞ inches. Rome, Sta. Maria del Popolo

Caravaggio painted two works for the Cerasi Chapel in this church, the painting illustrated here and a Crucifixion of St. Peter. The intensity of the drama is expressed with startling verisimilitude. Paul has been literally struck from his horse and rendered helpless by the force of divine illumination, here represented by the intense spotlight on the animal's flank. The stunned saint, his eyes closed, raises his arms as if to embrace the presence of God.

throughout the sixteenth century. These innovations are the signal characteristics of Caravaggio's immensely expressive style.

Caravaggio's life in Rome was violent and scandalous. He often got into fights, was arrested a number of times, and on several occasions he was even imprisoned, only to be released thanks to the intervention of his well-connected friends. In 1606 he was accused of murder and had to flee to Naples, where he had no trouble finding new patrons. He eventually

See: Painting: The Baroque and Seventeenth-Century Classicism, pp. 148–149.

continued his flight, first to the island of Malta, where he painted a portrait of the Grand Master of the Knights of Malta, and then to Sicily. While traveling back to Rome, he died of a fever at age thirty-seven.

Caravaggio's revolutionary genius transformed ordinary people into the principal actors of his tormented world. So great was his influence that the term "Caravaggism" was coined to designate paintings produced in his distinct style by his many seventeenth-century followers. Like Caravaggio, these artists represented scenes from the Bible and the lives of the saints as if they were contemporary events, portraying them with the dramatic staging and strong chiaroscuro that distinguishes the master's powerful vision.

▼ VITTORE CARPACCIO. *St. George and the Dragon.* 1502–07. Oil on canvas, 56¼ x 141¾ inches. Venice, San Giorgio degli Schiavoni

Near the city of Selen in Asia Minor lived a dragon who ate young boys and girls. The king's daughter, visible at right, had been selected by lot to be his next meal. She was saved by St. George, who, upon seeing the girl's plight, rushed forward on his horse and first wounded and then captured the animal. The ground is littered by half-devoured bodies, remnants of the monster's earlier feasts. In the distance is the city, from whose towers the people observe the scene.

VITTORE CARPACCIO
ca. 1465–1526

painter

Vittore Carpaccio lived his entire life in Venice. He was successful early in life, receiving his first commissions at the age of twenty-five. Curious and erudite, he was familiar both with the latest developments in Italian painting, such as the rules of scientific perspective, and also with the meticulous details and fine articulation of Flemish painting. A marvelous storyteller with a fertile imagination, he occupies a unique place in Venetian fifteenth-century painting.

The *scuole* (singular, *scuola*) of Venice were charitable lay religious organizations. Influential and rich, their governing boards often commissioned paintings for their churches and chapter houses. Carpaccio benefited from this patronage, providing several cycles of paintings for scuola buildings. For the Scuola di Sant-Orsola between 1490 and 1496 he painted a nine-canvas cycle of the *Life of St. Ursula* based on the medieval legend of the martyrdom of this Breton princess. The cycle depicts episodes from the saint's life, including a prince's request for her hand in mar-

riage, her subsequent pilgrimage to Rome to visit the pope with 11,000 virgin companions, and all of their martyrdoms by the Huns at Cologne on their way home. Carpaccio's paintings are poetic fantasies, full of anecdotal events and picturesque details, but he was also a master of Renaissance technique. His use of perspective is adept, his figures are substantial, and his palette is warm and luminous.

In the Scuola di San Giovanni Evangelista, Carpaccio contributed to a cycle of *The History of the True Cross* under the direction of Gentile Bellini. *The Miracle of the Relic of the Cross* features a superb view of Renaissance Venice.

A series that Carpaccio painted between 1501 and 1507 for another scuola, that of San Giorgio degli Schiavoni—the national brotherhood of the Dalmatians living in Venice—is his only cycle that still remains in its original location. Rather than one continuous narrative, it depicts episodes from the lives of Sts. Jerome, Tryphon, and George, the three patron saints of the Dalmatians. These works feature broad perspective views alive with fantasy, made all the more enchanting by the many details, striking color, and the compelling visual rhythms characteristic of this artist's best work.

JEAN-BAPTISTE CARPEAUX
1827–1875

sculptor

The son of a mason, at age ten Jean-Baptiste Carpeaux was apprenticed to a plasterer. On the advice of his master, he enrolled at the Academy of Architecture in Valenciennes in northeastern France. In 1838, the Carpeaux family moved to Paris, where Jean-Baptiste attended first a drawing school and then the École des Beaux-Arts, where he studied with the sculptor François Rude, who instilled in him the importance of studying nature closely.

At twenty-seven, on his seventh attempt, Carpeaux won the coveted Rome Prize, which allowed him a year's study at the French Academy in Rome. During his sojourn there he wandered the city studying ancient sculpture. He also visited Naples and Florence, where he was enthralled by Michelangelo's Medici tombs. He produced his first masterpiece in Rome, a sculptural group inspired by an incident described in the *Divine Comedy* of Dante (1265–1321). This work depicts one Ugolino, who, locked in a tower without food by his enemies, devoured his own sons before he finally died. Carpeaux's version, which depicts the seated Ugolino gripped desperately by his children, was influenced by the *Laocoön*—an ancient Roman sculptural ensemble that shows a father and his sons being strangled by a giant serpent—as well as by drawings by Michelangelo.

In 1863, after returning from Italy, Carpeaux was presented at the court of Napoleon III, which assured his success. His portraiture was especially admired for its elegance and expressive force (*The Prince Imperial and His Dog Nero*). Thanks to the emperor's support, Carpeaux won prestigious commissions to provide sculpture for the Pavillon de Flore at the Louvre (1863) and the new Paris Opera (1865–69). He also produced the large fountain of *The Four Parts of the Globe* featuring four women supporting a sphere, for a site near the Observatory in Paris. All of Carpeaux's works combined tradition and modernity in novel ways, and he had a special gift for evoking dynamic motion.

After the fall of Napoleon III in 1870, financial difficulties obliged Carpeaux to establish a studio producing reproductions of his work, even though his reputation guaranteed him a steady flow of portrait commissions. He died at age forty-eight from cancer, shortly after having been made a member of the Legion of Honor.

▲ JEAN-BAPTISTE CARPEAUX.
The Dance. 1869. Original plaster, 91⅜ x 58¼ x 45¼ inches. Paris, Musée d'Orsay
In August 1865, Carpeaux was commissioned to create a group of three figures for the façade of the new Paris opera house. Charles Garnier, the building's architect, was favorably disposed toward Carpeaux's design, but it met with opposition from conservative sculptors. Carpeaux's group incorporated eight figures performing a round dance, from which one exultant dancer has broken free. The realism and sensuality of these nude, joyous figures shocked many people, who thought the work indecent. One passerby went so far as to fling a pot of ink on the completed piece. The group now on the building's façade is a copy.

PAUL CÉZANNE
1839–1906

painter

Paul Cézanne was born in Aix-en-Provence in 1839. After studying classical literature, at age twenty he decided to become a painter and was soon traveling back and forth to Paris, where he was reunited with his childhood friend, the novelist Émile Zola. He frequented the independent Académie Suisse, copied paintings in the Louvre, and admired the work of Delacroix in the Luxembourg Museum.

He was never admitted to the École des Beaux-Arts, and his paintings were refused time and again by the jury of the Salon, which found them provocative, crudely executed, violently lit, and excessively agitated. In 1866 Cézanne became interested in still life, and in *The Black Clock* (ca. 1870) he hit upon an idiosyncratic rigor and balance that set his future course.

In 1872, he settled in Pontoise for a time to paint alongside Camille Pissarro, who taught him the joys and advantages of painting in the open air. His palette lightened thereafter and he began his quest for modern landscape compositions of classical solidity. In 1874 he took part in the first Impressionist exhibition in Paris. Disappointed by its poor reception, he renounced public exhibition and returned to his family's estate outside Aix-en-Provence.

In Provence he was able to work in solitude, with a minimum of distraction. While he continued to paint in the open air, he reacted against the Impressionist search for the ephemeral moment, seeking instead a formal equilibrium based on the cone, the cylinder, and the sphere. As an object's various sides appear to have different colors, he used hue to convey volume. Working like a mason, he built up his compositions using color and geometric form. While rigorously composed, his landscapes, still lifes,

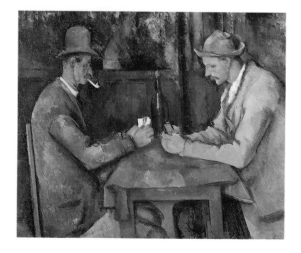

◀ PAUL CÉZANNE. *The Card Players.* 1892–93. Oil on canvas, 18 x 22½ inches. Paris, Musée d'Orsay

This composition seems to have particularly intrigued the artist, who painted five different versions of it. In the rather narrow space of the painting the table placed at the center masterfully sets off the masses of the players' hunched bodies.

▶ PAUL CÉZANNE. *Mont Sainte-Victoire.* 1885–87. Oil on canvas, 25¼ x 32⅛ inches. New York, The Metropolitan Museum of Art

In this magnificent view of Cézanne's beloved mountain as it appears from a point near the city of Aix-en-Provence, the artist has constructed it as an irregular triangle whose right side, after a sudden drop, descends gently toward the plain below. Blue like the Provençal sky into which it seems to blend, the mountain's imposing mass dominates the colored checkerboard of the fields spread at its feet.

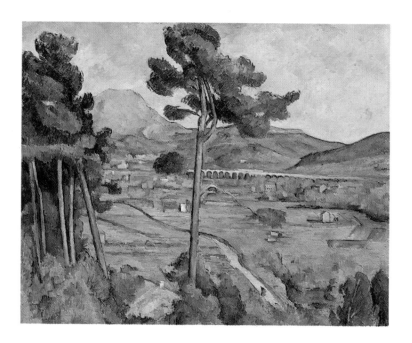

 See: Impressionism, pp. 156–157; Cubism, p. 160.

and imposing portraits manage to convey the fracturing nature of the painter's gaze. He sometimes applied his pigment in short parallel strokes that align like iron filings to a magnet.

The year 1886 was a turning point in Cézanne's life. He finally married Hortense Fiquet, who had become the mother of his son Paul in 1872. Six months later his father died, leaving him an immense fortune. Finally, Emile Zola published a novel, *The Masterpiece*, depicting Cézanne in an unflattering light, prompting the artist to end their long friendship.

In 1895, Cézanne had his first one-man exhibition in the gallery of the great dealer Ambroise Vollard. Although there were many bad reviews, his painter friends were enthusiastic. A handful of critics, too, had begun to understand his artistic aims, and expressed admiration for them.

Cézanne continued to live a withdrawn life in Aix-en-Provence, working intensely in a new house and studio built to his specifications on the city's outskirts. With dogged determination, he depicted a few themes over and over: still lifes of flowers and fruit, the nearby Mont Sainte-Victoire, portraits, and three large compositions of bathers. Painted slowly over a period of many months in a limited but rich palette, these last works feature massive female figures that seem to fuse with the surrounding landscape.

In the autumn of 1906, while painting in the environs of the city, the aged artist was caught in a sudden rainstorm; shortly after, he fell gravely ill and died.

A posthumous exhibition mounted at the Paris Salon d'Automne in 1907 marked the public acceptance of Cézanne's greatness. His work had brought painting to the threshold of abstraction; his example proved crucial for the birth of Cubism, and indeed for that of modern art as a whole.

MARC CHAGALL
1887–1985
painter

Born into a poor Jewish family in Vitebsk, Russia, in 1887, Marc Chagall began to paint at an early age. When he was twenty he entered the studio of Léon Bakst in St. Petersburg, where he discovered the work of *Cézanne* and *Van Gogh*. In 1910 he realized his dream of going to Paris.

Finally he could see many examples of the painting that had so excited him. Astonished by the freedom with which Parisian artists used color as well as by the revolution effected by the Cubists, under their influence he began to depict subjects drawn from the folk tales of his youth. He populated fractured, brilliantly hued pictorial spaces with figures—village sages and violin players—painted in a deliberately awkward style. "My subjects, I brought them from Russia, and Paris threw its light on them," he wrote.

Guillaume Apollinaire, the French poet and critic, was enthralled by the poetic quality of the work of this young Jewish painter from the land of the tsars. Thanks to his intervention, Chagall was able to exhibit in Berlin in 1914.

The outbreak of the Russian revolution in 1917 found the artist in Vitebsk, where he founded an art school. He was named its director, but before long he came into conflict with Russian avant-garde artists like Malevich. In 1922 he resigned his post and

▼ MARC CHAGALL. *Noah and the Rainbow* (Genesis 9:12). 1961–66. **Oil on canvas, 80¾ x 115⅛ inches. Nice, Musée National du Message Biblique**
Between 1954 and 1966, Chagall completed seventeen paintings inspired by Genesis, Exodus, and the Song of Songs for the Calvary Chapel in Vence, France. In these Biblical compositions, infused with images from the artist's childhood, color is the primary means of organizing space. In Chagall's world of dream and fantasy, weightless figures of people and animals float through the sky.

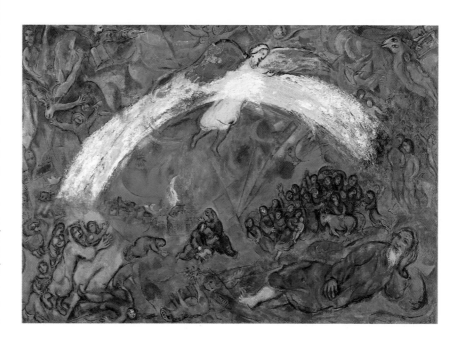

left Russia, impatient to return to Paris. However, he first stopped for a time in Berlin, where he learned printmaking and produced illustrations for his autobiography, *My Life*.

After Chagall's return to Paris in 1923, the art dealer Ambroise Vollard asked him to illustrate the *Fables* of La Fontaine and the Bible. The artist began a lengthy series of color lithographs, the intense color of which expresses an impassioned religious fervor. This highly emotional strain of his art reached its zenith in the large canvases of biblical themes that he painted after 1950.

Childhood memories are ever present in Chagall's compositions. Brightly colored bouquets often figure in them as symbols of his joy in life. A case in point is *The Married Couple of the Eiffel Tower*, which shows a young couple floating through the air—one of his favorite devices—accompanied on their way by flowers, a fish, a rooster, angels, and musicians.

During World War II, Chagall fled to the United States, where, tragically, his beloved wife Bella died. *The Fallen Angel*, a typically despairing work from this period, features burned villages, fleeing figures, and martyred Jews.

Upon returning to France in 1950, he settled in Saint-Paul-de-Vence in southern France and set right to work, for there was no shortage of commissions. His art now developed in many directions; he produced sculpture, designed stained-glass windows, made ceramics, and in 1964 painted the ceiling of the Paris Opera. In 1966 he produced a series of enormous murals for the Metropolitan Opera House in New York City.

One of the twentieth century's preeminent painter-poets and image makers, Chagall was equally at home with enchanting fantasy, meditative spiritual themes, and apocalyptic subjects.

PHILIPPE DE CHAMPAIGNE
1602–1674

painter

Philippe de Champaigne was born in Brussels in 1602. He began his painting studies at age twelve. On his way to Italy in 1621 he stopped in Paris, where he met *Poussin* and the two collaborated on decorations for the Luxembourg Palace. Impressed by the young painter's gifts, Marie de' Medici, the queen mother, offered him a position as an official painter to the court.

Champaigne's work was admired by Richelieu, the chief minister, and as a result the artist received many portrait commissions, for example, his *Louis XIII Crowned by Victory* of 1635. Richelieu also awarded him a number of prestigious religious commissions, including the decoration of the dome of the church of the most important college of the University of Paris, the Sorbonne.

Neither Richelieu's death in 1642 nor that of Louis XIII the following

▲ PHILIPPE DE CHAMPAIGNE. *Ex-Voto*. 1662. Oil on canvas, 65 x 90⅛ inches. Paris, Musée du Louvre

This ex-voto was given by the artist to the Abbey of Port-Royal in Paris after the miraculous recovery of his daughter Catherine, a nun at the convent, whose legs had been paralyzed. Champaigne depicts her praying with Angélique Arnauld, her mother superior, their faces radiant with serene faith that their request will be granted. A ray of light falls across the center of the canvas, signaling the supernatural presence of God. The two nuns do not look at one another but are each absorbed in their own meditations. The composition could hardly be simpler; the colors are limited to off-whites, grays, browns, and black, except for the blue cushion and the muted red of the crosses on the nuns' habits.

year diminished Champaigne's favor at court. In 1645 he became one of the founders of the Royal Academy of Painting and Sculpture and, at the request of the regent, Anne of Austria, painted a series of four scenes depicting the *Lives of the Holy Fathers in the Desert* for the Parisian convent of Val-de-Grâce. He remained in great

demand as a portraitist, too; many important French ministers, princes, and men of the church wanted a likeness from his hand. The resulting works are remarkable for their simplicity and rigorous beauty as well as for the meditative expressions of the sitters.

Champaigne established very close ties with the Carthusian order, whose commitment to poverty he found admirable. In 1655, he painted a *Dead Christ on the Cross* for the order's largest Parisian monastery. But he was still closer to the two abbeys of Port-Royal, centers of the austere, intensely rigorous movement within French Catholicism known as Jansenism. Both of his daughters became nuns at the abbey of Port-Royal, and he painted many portraits and religious works for the two institutions (*Last Supper, Dead Christ*). In thanks for the recovery of one of his daughters from grave illness, he donated the *Ex-Voto of 1662*, a masterpiece testifying to his skills both as portraitist and religious painter as well as to his own faith.

In 1666, Louis XIV commissioned several more paintings from him, but court tastes were shifting toward the opulence epitomized by Versailles, which was at odds with his work. By the time of his death in Paris in 1674, Champaigne had become a marginal figure. Today, however, he is acknowledged as the greatest French portraitist of the seventeenth century.

JEAN-BAPTISTE-SIMÉON CHARDIN
1699–1779
painter

The son of a furniture maker, Jean-Baptiste-Siméon Chardin probably originally intended to work in his fa-

ther's trade. In 1718, however, he was apprenticed to a painter, and being quite gifted, soon acquired the basics of this craft. At age twenty-eight he presented two paintings to the Royal Academy hoping to gain admission. The academicians were so dazzled by these works—especially *The Ray Fish*, which represents an enormous, glistening, disemboweled ray fish suspended from a hook and a cat tiptoeing toward the foreground over open oysters—that Chardin was immediately accepted as a full member.

Chardin specialized first in small still lifes of kitchen utensils and food laid out for the cook. Around 1733 he began to paint genre subjects—scenes from everyday life—starting with the charming *Lady Sealing a Letter*, hoping to widen his repertory and win new clients. Thereafter he produced many such scenes showing, for example, maids doing the laundry or a governess helping children dress for school. His paintings of children are especially poetic, showing them as rather grave young adults, completely absorbed in their games.

His work was much appreciated both in Paris and at the great courts of Europe. The delicacy of these little masterpieces caught the eye of Louis XV, who in 1751 commissioned *The Bird-Song Organ*, which depicts a woman trying to teach her caged canary to sing by playing a mechanical bird-song organ to it. This was among Chardin's last genre paintings, however, for he soon returned to still life. In *The Silver Tumbler* (1767–68), a polished vessel deftly reflects a bowl and three apples, and the whole composition is bathed in the atmospheric, almost palpable light that was Chardin's particular gift.

At age seventy the artist was living a peaceful existence in an academician's apartment in the Louvre, but his health was declining, and he gradually abandoned oil painting for pas-

tels, which did not require elaborate preparation for use. His self-portraits from these years, which show him eyeing us through his glasses, pastel stick in hand, are marvelous images of old age, made all the more piquant by the vulnerability of this powdery medium. By this time most of the public had lost interest in his work, and his death in 1779 evoked little comment. But he left behind a body of work full of understated tenderness and gravity, in which life's simplest pleasures are infused with rich poetry.

▼ JEAN-BAPTISTE SIMÉON CHARDIN. *Saying Grace*. 1740. Oil on canvas, 19½ x 16⅛ inches. Paris, Musée du Louvre
Chardin presented this painting to Louis XV in 1740. The table is set for the midday meal; the mother listens, waiting for her children to finish their prayer. The boy, sitting in a small chair from which he has hung his toy drum, perhaps impatient for lunch, seems to be having trouble remembering the words his mother has taught him. The heart of the composition is the triangle of glances that unite this family gathered around their table.

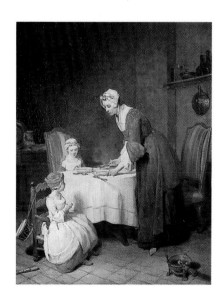

CIMABUE
(CENNI DI PEPI)
ca. 1240–after 1302

painter

According to Florentine tradition, Cimabue was the teacher of Giotto; however, we know next to nothing about his youth and training. Documents show that he was in Rome in 1272 and in Pisa in 1301. In Florence, where he was regarded as the greatest painter of his generation, we know that he collaborated on a cycle of mosaics in the cathedral baptistry.

The evolution of Cimabue's art can be traced through his crucifixes. The art of his day was still dominated by the Byzantine vocabulary, in which Christ, the Virgin, and the saints were rendered in a limited palette, and in accordance with venerable, highly schematic models. The resulting images were majestic and imposing, painted on gold grounds suggesting divine light and the richness of the divine realm.

The earliest work attributed to Cimabue is a crucifix in Arezzo, painted before his sojourn in Rome. This work still honors Byzantine tradition: Christ's body appears stiff and the flat drapery folds are outlined in gold. In the crucifix for the Florentine church of Santa Croce (damaged in the 1966 flood), painted some years later, Christ's body seems less rigid and the draperies more supple, even seeming to blow slightly in the wind. The palette is richer, too, featuring blue, pink, and mauve.

It was in his paintings of the Virgin and Child in majesty, a type known in Italian as the *Maestà*, that Cimabue instilled his figures with a new sense of depth and volume.

Between 1277 and 1280 Cimabue painted several frescoes in the church of San Francesco in Assisi (now in poor condition): on the walls, scenes from the life of the Virgin and the Apocalypse; on the ceiling, the four evangelists. His participation in this important project indicates the great reputation he enjoyed at the time. He was certainly the most influential Tuscan artist of his day.

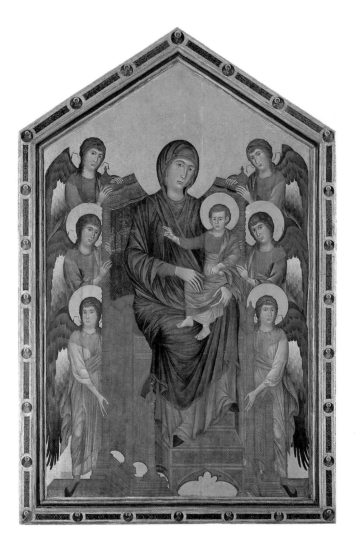

▲ CIMABUE. *Virgin and Child in Majesty with Six Angels.* **Tempera on wood panel, 168⅛ x 110¼ inches. Paris, Musée du Louvre**

The image type known as the Virgin in Majesty (Maestà in Italian) shows the Virgin enthroned and directly facing the viewer. In this example the Virgin wears long, richly draped antique garments and is flanked by six angels with gold halos. Here Cimabue has modeled his figures slightly, allowing them to project somewhat from their gold background. Their apparent solidity is enhanced by Cimabue's perspectival treatment of the Virgin's throne.

JOHN CONSTABLE
1776–1837

painter

John Constable's father initially intended him to be a priest, then a miller, but the young man himself preferred to spend his time drawing from nature. Sir George Beaumont, the founder of London's National Gallery, took note of the young man's gifts and persuaded his father to send him to the Royal Academy in London to be trained as a painter. After a few years Constable withdrew from the school to pursue his favorite activity, landscape painting.

Many English painters of the late eighteenth century were drawn to landscape painting. Reynolds used landscapes to enrich the backgrounds of his portraits, as did Gainsborough, who also produced pictures in which the landscape is dominant. Constable painted landscape for itself, as a part of straightforward depictions of figures going about their daily lives.

In 1824, when Constable was almost fifty, he received his first important commission. The archbishop of Salisbury asked him to paint a view of the cathedral there. Five years later he became a member of the Royal Academy in London. He was not able to enjoy the official limelight for long, however, for he died suddenly in 1837, bringing his brilliant but belated career to a premature end.

His work had little impact in England, but it greatly influenced such French landscape painters as Boudin and *Monet*, who were fascinated by his practice of painting in the open air and his attentiveness to ephemeral atmospheric effects. Constable made a point of carefully noting on the backs of his studies—those of clouds are the most famous—the date and time at which they had been made as well as the prevailing weather and lighting conditions.

JEAN-BAPTISTE CAMILLE COROT
1796–1875

painter

Camille Corot, who was determined to be a painter, refused to work in the family shop on the rue du Bac in Paris. When he was twenty-five his parents gave in to his desire, agreeing to pay him a small stipend. Finally free, he took the advice of his first teachers and began to explore the landscape, recording what he saw and painting what he felt.

In 1825 Corot went to Italy, where he remained three years. He preferred the gardens of Rome and Naples to their museums, closely studying effects of light and air. In pursuit of his ambition to become a recognized landscape painter, he made large compositions depicting an idyllic nature, serene and harmonious. When he worked in the open air he gave free rein to his emotions, producing stud-

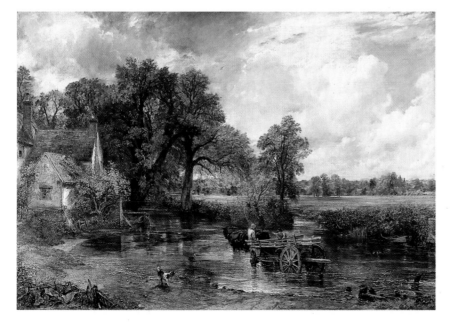

◄ JOHN CONSTABLE. *The Hay Wain.* 1821. Oil on canvas, 51⅛ x 72⅞ inches. London, National Gallery

When Constable exhibited this work at the Paris Salon of 1824, it was much admired, both by the public and by the French Academicians, who awarded it a gold medal. Eugène Delacroix, full of admiration for the painting's luminous color and the atmospheric vibrancy created by Constable's use of small juxtaposed strokes of contrasting color, declared that the English artist was "an admirable painter and the glory of the English school."

ies of great spontaneity and originality. He also liked to paint portraits of his family members. The sincerity and freshness of the faces in these works reflects Corot's genuine affection for the world of his childhood and adolescence.

After returning to France he led an itinerant life, moving through town and country in search of landscape views. In fine weather he often went to Fontainebleau or Ville-d'Avray outside Paris, where there were woods and lakes; he was especially fond of the light of early morning. During the winter he worked in the studio perfecting his compositions, refining his renderings of the elusive dawn light, of the firm, precise lines of trees, or of a street flanked by old houses. For thirty years he led this life in solitude, little known and misunderstood.

He made two more trips to Italy, and beginning in 1835 he exhibited regularly at the Paris Salon, showing elaborate Biblical and mythological pictures with landscape settings.

Around 1850 Corot developed a taste for northern light. The humid atmosphere of mist-covered rivers be-

came a specialty, with silvery gray now his favorite color. The public was quite taken with these melancholy landscapes, which sometimes featured the tiny silhouettes of nymphs and young girls dancing in the forest.

He also painted life-sized female figures and nudes, works of great simplicity and serenity. The masterpiece of this strain of his work is *Woman with a Pearl* (1869).

The inheritor of eighteenth-century traditions, Corot belonged to no school. In the words of *Delacroix*, "He is a rare genius and the father of modern landscape."

▼ CAMILLE COROT. *The Bridge at Mantes*. 1868. Oil on canvas, 15⅛ x 21⅞ inches. Paris, Musée du Louvre
The silvery palette of this picture is accentuated by a single touch of brilliant color, the red cap of the fisherman sitting motionless and silent in his boat. The horizontals of the bridge are countered by the verticals of the tree trunks, which stabilizes and harmonizes the serene composition, so characteristic of Corot's work of this period.

GUSTAVE COURBET
1819–1877
painter

Gustave Courbet was born in 1819 in Ornans, in Eastern France. At age twenty, he settled in Paris determined to be a painter. Rejecting official training, he went to the Louvre on his own to copy works that he loved. Aware of his worth and determined to succeed, he wrote: "I want to make great painting. . . . Before five years are up I must make a name for myself in Paris." He began by executing portraits of his family, followed by a series of self-portraits in which he cast himself in romantic roles reflecting events in his life.

In 1847 Courbet went to Holland, where the work of Rembrandt impressed him greatly. He resolved to paint reality as he saw and felt it. At the 1850 Salon in Paris, he exhibited one of his first masterpieces, *Burial at Ornans* (p. 155). This work provoked something of a scandal, for although it was a scene from daily life, it had been painted in the huge format normally reserved for history painting. Furthermore, Courbet presented the countrified roughness of the figures utterly without dissimulation. This event made him a leader of the *Realist* movement.

The jury of the 1855 Universal Exposition in Paris refused the large paintings he had submitted. Furious, he built his own exhibition space, a "Pavilion of Realism" housing some forty works including *The Studio*, which summed up in a single composition the ideas and intentions of his previous seven years as a painter.

Opposition only increased his notoriety. None of his paintings left viewers indifferent, for he confronted them with undisguised, unobliging visions of reality. He had his admirers, but he was also hated and ridiculed by those

shocked by his unvarnished truth. When he showed his *Young Women on the Banks of the Seine* at the 1857 Salon, many found the figures vulgar and provocative while others judged it a "sumptuous piece of painting."

Courbet traveled in the French provinces as well as abroad, where exhibitions of his work were multiplying, but he always returned to Ornans. He was very fond of the landscape near his native town, whose undergrowth he painted with his solid, thick touch in a dark palette dominated by greens and browns.

In 1871, Courbet took part in the socialist uprising in Paris known as the Commune. On May 16 of that year, the Vendôme column—which then supported a figure of Napoleon —was demolished. Accused of having incited this act, Courbet was sentenced to six months in prison and obliged to pay for the column's recon-struction. Bankrupted by this judgment, in 1873 he sought exile in Switzerland, where he fell ill and died in solitude at the age of fifty-eight.

▼ GUSTAVE COURBET. *Self-Portrait,* also known as *The Wounded Man.* 1844–54. Oil on canvas, 31⅞ x 38¼ inches. Paris, Musée d'Orsay

The dying man pictured here is Courbet himself. A long relationship with a woman had just ended, and the artist thus chose to portray himself as a lover mortally wounded in the heart. This death-haunted, highly dramatic self-image is typical of Romantic portraiture, a genre dear to the young Courbet.

LUCAS CRANACH THE ELDER
1472–1553
painter

Lucas Cranach, son of the painter Hans Cranach, was born in the small German town of Kronach, from which he probably took his name. All we know of his youth is that in 1500 he left his father's studio and went to Vienna.

There, much influenced by the work of *Albrecht Dürer*, his imagination and powers of observation increased. He introduced into his painting the wild, mountainous landscapes he had encountered during his trip. In works like *Rest on the Flight into Egypt*, such landscapes became a vital, poetic presence full of charm. He expressed himself passionately, conceiving several Crucifixions of exceptional dramatic and tragic force in this period. Also remarkable was his skillful use of intense greens and vibrant harmonies of red and brown.

In 1505 he was summoned to Wittenberg to serve as court painter to the Electors of Saxony, and he remained there until his death in 1553. He was now famous, and many students sought him out in his new studio, assisting him in the execution of his many court commissions, including Madonnas, altarpieces, decorative paintings for castles, and portraits of members of the court.

He established contact with Martin Luther, the monk and theologian who initiated the Reformation that led to the establishment of Protestantism in northern Germany (p. 148). Cranach painted several portraits of him; with their hardiness of feature and direct light, they convey Luther's character admirably. As in all his portraits, a thin but emphatic contour line sets the face apart from the neutral background, creating a strong sense of relief.

Beginning in 1520 his painting be-

See: The Painters of Reality, pp. 154–155.

came more elegant and refined, although he resisted the perspective constructions and volumetric treatment to the human body associated with the Renaissance. He took the subjects of his paintings from the Bible and mythology, representing such subjects as *Venus and Cupid, Lucretia, Adam and Eve,* and *The Nymph of the Spring,* for example, countless times. All of these works featured nudes, most of them exaggeratedly thin, in mannered postures, and placed against dark backgrounds. Despite his tendency to treat the same subjects again and again, his imagination and freshness as a painter remained intact until his last days.

His son, Lucas Cranach the Younger (1515–86), collaborated closely with his father; he continued to operate the studio after the older artist's death, retaining both his style and thematic repertory.

▼ Lucas Cranach the Elder.
The Crucifixion. 1503. Oil on canvas, 54⅜ x 39 inches. Munich, Alte Pinakothek
In this highly unconventional composition, Cranach placed the Virgin and St. John at the center, surrounding them with the three crosses of Christ and the thieves. Two of the crosses, including Christ's, are almost perpendicular to the picture plane. As the Virgin and John wring their hands in anguish, the shocking foreshortening and the twisted forms of the landscape seem to echo their inner torment.

Salvador Dalí
1904–1989
painter

Salvador Dalí was born in Figueras, Spain (Catalonia), where he also died. He studied painting in Madrid between 1920 and 1925, where he acquired the academic proficiency characteristic of his work.

As a young man, Dalí read the work of Sigmund Freud, the father of psychoanalysis. Alerted to the subtleties of the subconscious, he set out to transcribe them into what he called his "metaphysical painting." Dreams and their interpretation increasingly came to dominate his work.

In 1928, Dalí met Picasso and the Surrealist writer André Breton, and as a result joined the Surrealist movement, rapidly becoming one of its most conspicuous members. In the following years, he met Gala Éluard, his future muse (whom he married in a solemn religious ceremony in 1958), as well as Giorgio De Chirico and *Max Ernst,* both of whom had a lasting impact on his work.

Blessed with a genius for self-promotion, Dalí devised a public persona for himself that was mystical and intriguing. He made eroticism, scatology, scandal, humor, and provocation his stock in trade, incorporating them into both his life and his work. The resulting compositions, for example, his famous vision of melting watches in a desolate dream landscape, are often surprising. Dalí frequently depicted the seashore of his youth behind strange hallucinations in which, for example, shells become eyes and a mountain seems to change into the head of a dog. Playing on the magic of associations, these inventions, rendered in technique of great precision and high finish, insist on the multiple hidden meanings of things.

Dalí also applied his gifts to movie-making. He collaborated with Luis Buñuel on *An Andalusian Dog* (1928) and *The Golden Age* (1930), and he also designed a dream sequence for Hitchcock's *Spellbound* (1945).

During the 1930s, Dalí's indifference to politics caused a growing rift with Breton and the other Surrealists, and his flippant 1937 series of paintings "celebrating" Adolf Hitler brought about his outright expulsion from the movement. After this, Dalí astonishingly reverted to a more classical style of painting, exploring traditional imagery and producing such works as the extraordinarily foreshortened *Christ of St. John of the Cross* (1951) and the visionary *Sacrament of the Last Supper* (1955).

Like many European artists, Dalí spent the Second World War in the United States, where he cultivated a high-society clientele, had a retrospective at the Museum of Modern Art in New York (1941–42), and published a sensational autobiography, *The Secret Life of Salvador Dalí* (1942). In 1948 he returned to his native Catalonia, where he resided until his death, although he was a frequent visitor in New York into the 1980s.

To the end of his life, Dalí continued to cultivate a provocative, living-myth persona, openly declaring his love for authority and money. On occasion he styled himself "Avida Dollars" (an anagram of his name), and he often proclaimed himself the last surviving historical Surrealist.

▼ SALVADOR DALÍ. *Partial Hallucination: Six Images of Lenin on a Piano.* 1931. Oil on canvas, 44⅞ x 57½ inches. Paris, Musée National d'Art Moderne, Centre Georges Pompidou
Dalí, obsessed by the idea of dictators who had brought havoc to the world, incorporated images of them into several of his paintings. Here, small portraits of Lenin hover over the keys of a piano, while the pianist, apparently transfixed by these apparitions, withdraws into the shadows. The juxtaposition of such anomalous elements as a piano, Lenin heads, and cherries (on the chair) is typical of Dalí's eccentric vision.

HONORÉ DAUMIER
1808–1879

painter and caricaturist

An extremely gifted draftsman, Daumier tried his hand at several crafts before he became a student of Alexandre Lenoir, founder of the Museum of French Monuments. He also frequented the independent Académie Suisse, where he drew the live model, and the Louvre, where he copied ancient sculpture.

In 1825, while working in Paris as an apprentice for the printer Béliard, he discovered lithography, which provided him with his principal source of income for the rest of his life. At age twenty, he began his career as a caricaturist with contributions to the weekly humor magazine *La Silhouette*. This was the beginning of a stream of sharply critical prints exposing the faults of the powerful, the egotism and cowardice of the bourgeoisie, the ignorance of doctors, and the rapacity of lawyers. By the end of his life he had produced some 4,000 of these images, which made him famous, and to an astonishing degree both their ferocity and their acumen remain undiminished even in his later years.

Daumier captured the flaws of the types he pictured with merciless pre-

▼ HONORÉ DAUMIER. *Gargantua.* 1831. Lithograph, 8⁷⁄₁₆ x 12 inches. Paris, Bibliothèque Nationale de France
This lithograph, an unsparing lampoon of the greed of Louis-Philippe, was inspired by Rabelais's book of the same title. It represents a giant resembling the French king who, mouth agape, consumes sack after sack of coins. As a result of its appearance, Daumier, his publisher, and the printer were all fined and sentenced to six months in prison for having "incited hatred of and contempt for the government, and offended the person of the king."

See: Surrealism, p. 167.

cision, often placing them in comic situations. In 1830 to took part in the July Revolution and began to work as a cartoonist for *La Caricature*. He also modeled thirty-six small terra-cotta bust caricatures parodying contemporary French political personalities.

In 1835, new laws limiting freedom of the French press obliged Daumier to give up political caricature, and he turned his attention instead to the foibles of everyday life. After the revolution of 1848, he participated in the open competition for an official emblem of the new Republican government, and his oil sketch was among the works selected by the jury.

▶ JACQUES-LOUIS DAVID. *The War of the Romans and Sabines.* 1799. Oil on canvas, 151⅜ x 205½ inches. Paris, Musée du Louvre
According to the Roman historian Livy, early in their history the Romans had few young women for their young men to marry. To remedy this, the Roman King Romulus organized a feast, to which he invited the Sabines, a people living in the hills to the east of Rome. At a prearranged moment in the festivities, the Romans seized the Sabine women and drove the men out of the city. In response, the Sabines declared war on Rome. By the time the war was actually begun, the Sabine women had been living with their Roman husbands, and many had had children with them. Rather than see their kinsmen and their husbands kill one another, the Sabine women flung themselves into the battle, begging both sides to make peace. Traditional representations of this story had shown its first episode, the abduction. David instead chose the moment when the women intervened in the war to make peace.

He was a superb painter, and in this medium he favored simplified forms of great amplitude and power, dividing his compositions into large, clearly contrasting areas of light and shadow.

Despite the admiration of painters like *Delacroix* and *Millet* and the praise of his poet friends, notably Baudelaire, he was little appreciated in later life and died in poverty.

JACQUES-LOUIS DAVID
1748–1825
painter

Having dreamed since childhood of becoming a painter, David eventually entered the studio of Vien, an early French exponent of Neoclassicism. On his fourth try, he won the Rome Prize which gave him the next five

years on scholarship at the French Academy in Rome. There the beauty of the ancient monuments struck him with the force of a revelation.

He returned to Paris in 1780 and undertook a series of impressive works based on ancient subjects. For his first official commission, he chose to paint *The Oath of the Horatii* (1784–85), which depicts an incident from Roman history in which three brothers swear to their father that they will fight to the death to defend their city. This remarkable painting is tautly controlled by lines that direct the viewer's gaze and executed in a rich but muted palette. Its deep reds announce the impending death of the three brothers. This rigorous composition established David's reputation as the leading Neoclassical painter.

David became increasingly politicized after the Revolution of 1789, placing his art in the service of the nation to produce works memorializing recent

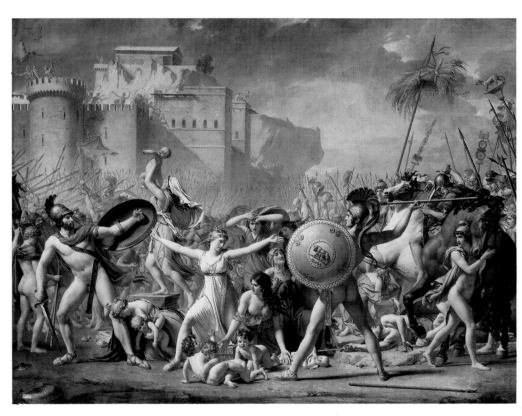

See: Neoclassicism, p. 152.

events (*The Tennis Court Oath*, never completed; *The Death of Marat*, 1793). He was also a superb portraitist, producing likenesses that combine finesse with psychological penetration (*Lavoisier and His Wife*, 1788; *Monsieur and Madame Sériziat*, 1795). After the fall of Robespierre in 1794, David was twice imprisoned in the Luxembourg Palace in Paris, but even there he continued to work. *The War of the Romans and Sabines* (p. 202), completed in 1799, was conceived during his incarceration.

When Napoleon became First Consul he offered David his protection, and in 1804, when he proclaimed himself emperor, he named David his court painter. One result was *The Coronation of Napoleon* (p. 25), which pictures the recently crowned Bonaparte turning to crown his wife Josephine in the cathedral of Notre-Dame in Paris.

When Napoleon fell from power, David fled into exile. Italy refused to receive him, so he settled in Brussels, where he reverted to ancient subjects, spending his last years producing mythological paintings as well as portraits.

David's political activities made him both admired and detested (as a delegate to the National Assembly he had voted for the execution of Louis XVI). However, his great history paintings, powerful draftsmanship, and pedagogic rigor proved immensely influential, winning him a reputation in the nineteenth century as founder of the modern French school.

HILAIRE GERMAIN EDGAR DEGAS
1834–1917
painter and sculptor

Born into a family of bankers, Degas pursued law studies before switching to painting. In 1855 he entered the studio of Lamothe, whose teaching honored the Neoclassical precepts of *Ingres*. He was also admitted to the École des Beaux-Arts, but he attended it only for a short time, preferring to work on his own. In 1856 Degas left for Italy, where he discovered the great Florentine painters. His youthful work is dominated by portraits of himself and members of his family. Combining rigorous composition with refined color, *The Bellelli Family* (a depiction of his aunt's Florentine household) bears witness to his fidelity to the principles of Ingres, whom he considered the greatest contemporary painter.

At the end of the 1860s, he became interested in scenes of contemporary life. Influenced, like the future Impressionists, by the Japanese prints then becoming available, he experimented with unconventional compositional arrangements, adopting eccentric points of view, from corners, from behind columns, and the like. Degas took part in the first Impressionist exhibitions, but he did not share the group's interest in landscape, preferring instead to paint urban life (*Portraits at the Stock Exchange*), Parisian workers (*Women Ironing*), and scenes worthy of Zola's novels (*In a Café*). He tried to depict figures informally, as they appeared when working or relaxing. His favorite subjects were racehorses and ballet dancers, both of whom he represented in moments of extreme physical exertion. In *The Orchestra of the Opera*, primarily a portrait of the bassoonist, Désiré Dihau, he juxtaposed the musicians in the pit with the pink and blue fairyland of the stage illuminated by footlights.

In 1870 he began to paint washerwomen, prostitutes, and singers in popular cabarets. Many of these are in monotype, a technique of making single prints from an ink drawing onto another sheet. He often heightened these unique prints with pastel, as in *Song of the Dog*, which shows the famous singer

▲ EDGAR DEGAS. *In a Café,* also known as *The Absinthe Drinker.* 1876. Oil on canvas, 36¼ x 26¾ inches. Paris, Musée d'Orsay

Sitting in the Nouvelles-Athènes, a Parisian café frequented by the Impressionists, these two figures are lost in their solitude. They are audaciously shifted to the right, creating a void which accentuates their isolation. The viewer, implicitly seated behind the table visible at the lower left, is made a witness to the scene.

Thérésa imitating an open-mouthed canine in a performance at an outdoor café. Degas worked in a wide variety of techniques (oil, drawing, watercolor, pastel, even photography), but his sight began to fail, and by 1898 he was almost blind. He then focused on sculpture (which he had been producing since 1881), modeling more than a hundred wax figurines discovered in his studio after his death in 1917.

Degas took in the world around him with unflinching lucidity, depicting moments of urban life in unorthodox compositions enriched by his remarkable sense of color.

See: Impressionism, pp. 156–157.

EUGÈNE DELACROIX
1798–1863
painter

Orphaned at the age of sixteen, Delacroix entered the École des Beaux-Arts in 1817 and became friends with the slightly older *Géricault*, who shared his passion for horses. The first work he exhibited, *The Barque of Dante* (Salon of 1822), was acquired by the French state. Thereafter he turned his attention to current events, scenes from ancient history, and Biblical subjects.

In 1824 he exhibited *Scenes from the Massacres at Chios*, a bloody episode from the recent war between the Greeks and the Turks, and in 1827 *The Death of Sardanapalus*, inspired by a play by the English poet, Lord Byron. This innovative work, steeped in violence, exoticism, and extreme emotion, marked his emergence as leader of the Romantic movement. He set out to make drawing subservient to color, although he did also use forceful lines to establish atmosphere and translate feelings.

Delacroix had long been attracted to the Near East. In 1832 he set sail from Toulon for Morocco with the Count of Mornay, head of a French delegation to the sultan. This exciting trip proved a landmark in the artist's development. In sketchbooks full of drawings and watercolors, he tried to capture the magic of North Africa: its beautiful women, impressive equestrian combats, and wild animal hunts. Newly conscious of the importance of color and light, he began to experiment with the mutual interaction of adjacent hues, as in *Women of Algiers* of 1834 (p. 31).

Delacroix was extremely prolific, producing many canvases both large and small. During the 1840s the French state commissioned him to

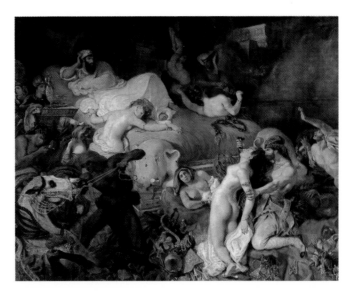

▲ EUGÈNE DELACROIX.
The Death of Sardanapalus. 1827.
Oil on canvas, 154⅜ x 195¼ inches.
Paris, Musée du Louvre

Sardanapalus, king of Nineveh, decided to sacrifice his slaves, his horses, and all the women of his harem as well as himself before the arrival of a rebellious army. Constructed on a diagonal and sustained by brilliant reds, this frantic, murderous assemblage is presided over by the king, who serenely observes the horror from his bed. The painting provoked a scandal when it was first exhibited, for many were offended by its monumental depiction of pointless carnage.

decorate the ceilings of the libraries in the Chamber of Deputies and the Senate as well as that of the Apollo Gallery in the Louvre. In 1861 he completed two large frescoes in the church of Saint-Sulpice, but he lived only two more years, during which time illness confined him to his studio on the Place Furstenberg (now the Musée Delacroix).

The greatest of French Romantic painters, Delacroix was also a remarkable writer. His *Journal*, begun in his youth, is full of vivid observations about the period in which he lived.

DONATELLO (DONATO DI BARDI)
1386–1466
sculptor

Born in Florence in 1386, Donatello entered the sculpture studio of Ghiberti at the age of eighteen. He became friends with the architect *Brunelleschi*, with whom he studied ancient ruins during a trip to Rome and who greatly influenced his stylistic development, helping him to understand the importance of spatial organization and proportion in the achievement of formal harmony, whatever the medium. In 1408, Donatello executed a marble *David*, and in 1415 a *St. John the Baptist*. But it was the *St. George*, realized between 1416 and 1420 for the armorers guild, that first revealed the dynamism of which he was capable. This work powerfully conveys the physical force of a young man wearing armor. Critics of the time were greatly impressed by its striking realism.

Donatello also carved statues of the prophets *Jeremiah* and *Habakkuk* for Florence Cathedral, figures that are monumental in scale and astonishingly expressive. The suffering of Habakkuk, for example, is evoked by

 See: Romanticism, p. 153.

▼ DONATELLO. *David*. After 1428.
Bronze, height: 5 feet 2¼ inches.
Florence, Museo Nazionale di Bargello

This sculpture represents the Israelite boy David, just victorious over the giant Goliath. Although the slim, graceful figure is hardly muscular, it nevertheless conveys a sensation of strength. The boy's left arm rests on his hip and his left leg on the giant's head, severed shortly before by the sword held in David's right hand. This revolutionary free-standing nude recalls many classical prototypes, but it exhibits several contemporary features as well, including the boy's hat and boots, which are like those worn by young men in fifteenth-century of Florence.

his gauntness, sad expression, and grimacing features. Sometime after 1428, Donatello executed one of his masterpieces, the bronze *David*, an image of disturbing beauty inspired by ancient sculpture, yet full of strange psychological ambiguities. Around 1433–39 he produced the marble *Cantoria*, a singers' balcony for Florence Cathedral. With its frieze of running dancers and musicians, this work demonstrated his total mastery of space suggested by varying heights of relief as well as his ability to convey unbridled movement.

Summoned to Padua to execute a bronze equestrian monument of Gattamelata, a famous *condottiere* (mercenary soldier), he remained there for twelve years. Increasingly, he concentrated on the inner lives of his subjects. Some of his later figures are emaciated, their expressions angst-ridden, as if suffering from extremes of penitential emotion (*St. John the Baptist*, 1457).

His final works were a series of bronze bas-reliefs for the pulpit of San Lorenzo in Florence (1460–66), whose intensely dramatic compositions convey a deeply felt piety.

Combining elements drawn from ancient models with a realistic expression of human drama, Donatello was the most adventurous sculptor of his day. His work long inspired those who came after him, notably *Michelangelo*.

JEAN DUBUFFET
1901–1985
painter and sculptor

Born in Le Havre, France, Jean Dubuffet moved to Paris in 1918, where he studied painting intermittently at the Académie Julian, pursued his interest in languages, literature, and music, and entered into the family wine business. He even founded his own business in 1930, probably without relinquishing his artistic interests, for he later confessed to having destroyed all his work predating 1942. Only then, when France was occupied by the Germans and he was forty-one, did he fully commit himself to painting.

Jean Dubuffet was categorically opposed to what he called "cultivated" art, in other words, the art learned in schools and museums. At his first exhibition in 1944 he showed humorous, intentionally awkward paintings suggestive of children's art, for example *Below the Capital*, which represents a colorful crowd in the Paris métro, or subway.

In 1948 he established the Art Brut Company to support the work of madmen, children, and, in his words, "obscure individuals foreign to professional artistic circles." He thought that "art should be born from materials and tools and retain traces of the struggle between the tool and the ma-

▶ JEAN DUBUFFET. *Train of Clocks*.
1965. Vinyl on paper fixed to canvas, 49¼ x 157½ inches. Paris, Musée National d'Art Moderne, Centre Georges Pompidou

The mechanism of an endlessly ticking clock propels it forward, where it unites with other clocks to form a train of interlocking shapes that suggest the viewer be more conscious of time.

See: The Great Models of Antiquity, pp. 90–91; The Renaissance, 136–147.

terial," an approach he never abandoned. He combined oils with other materials (sand, plaster, dust, gravel, tar), as in the portrait series "More Beautiful Than They Think" (1947) and "Ladies's Bodies" (1950), deliberately crude, summary, and funny works literally sculpted out of crusty material.

His "Materiologies" and "Texturologies" from the late 1950s, for example, are made of papier mâché instead of oil paint, and they unsettle the traditional orientation of paintings, presenting "groundlines" that are usually horizontal as verticals instead. Dubuffet composed strange landscapes of his own invention, scattered his canvases with butterfly wings, and, after a trip to the French province of Auvergne in 1954, he created a "Cows" series. All of these materials suppose a strange way of painting that, in Dubuffet's words, makes "beings appear, one might just as well say objects and figures, where culture doesn't see any."

Beginning in 1962, Dubuffet began his "Hourloupe" series. The earliest of these works consisted of forms resembling puzzles painted in bright colors (red, blue, black, and white), but they soon invaded the third dimension, becoming sculptures (p. 37), large architectural structures (*Winter Garden,* 1968–70), and even houses (Villa Valbala, built near Paris in 1971).

In addition to being an inventive artist and a provocateur of genius, Dubuffet was also a prolific author. In texts like *Prospectus to Amateurs of All Kinds* and *Asphyxiating Culture,* he articulated his principles and analyzed contemporary art in simple but savory language, never ceasing to rail against official culture.

ALBRECHT DÜRER
1471–1548
painter and printmaker

In his father's goldsmithing workshop in Nuremberg, Albrecht Dürer learned that meticulous and precise craft before beginning, at age fifteen, to master the rudiments of German Gothic painting. After completing his apprenticeship in 1490, he traveled for four years. After a trip to the Low Countries to study the work of *Van Eyck* and *Rogier Van der Weyden,* he proceeded to Colmar in hopes of meeting Martin Schongauer, a great engraver whose draftsmanship and compositional mastery he admired. Upon learning that Schongauer had died, he continued to Basel, where he frequented a cultivated humanist circle. Throughout this period he produced woodcut illustrations for books.

In 1493, he painted his first self-portrait, which already indicates an awareness of his superior gifts. For several years he continued to use himself as a model, noting the changes in his personality; in an astonishing work of 1500, he unmistakably gave himself the appearance of Christ.

In 1494 he married and departed immediately for Venice, where he discovered the Renaissance painters *Mantegna, Carpaccio,* and *Bellini.* He copied their work, studying their use of perspective and their approach to the human figure. This encounter with Venetian art greatly enriched his work.

At age twenty-five he returned to Nuremberg, then a vibrant crossroads

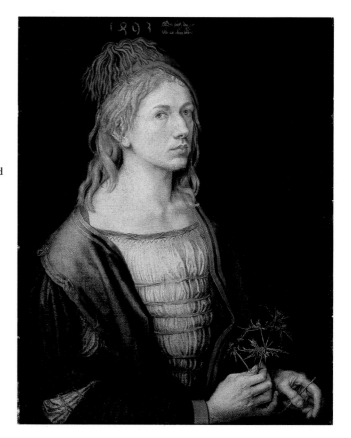

▶ ALBRECHT DÜRER. *Self-Portrait.* 1493. Tempera on parchment mounted on canvas, 22¼ x 17½ inches. Paris, Musée du Louvre

Dürer was only twenty-two when he executed this first painted self-portrait, picturing himself as a young lover holding a thistle, a symbol of fidelity. It probably refers to his impending marriage, which took place the following year.

between Venice and the Low Countries. Dürer opened his own studio there and devoted himself exclusively to painting and printmaking. An admirable portraitist, in 1496 he painted a likeness of Frederick the Wise in which he renounced all decorative elements, the better to focus on the sitter's character. He also produced religious works. The central Nativity panel of the Paumgärtner Altarpiece (1502–4) shows the scene in one-point perspective, and the saints depicted on the side panels are immensely sophisticated formally, evidencing the artist's determination to master human bodily proportions also apparent in many surviving drawings.

Thanks in part to the engraver Jacopo de' Barbari, whom he met in Venice, Dürer mastered printmaking, and he set about liberating himself from the medieval traditions still prevalent in Germany. First he produced woodcuts, but increasingly he favored copperplate engraving. Around 1495–1500, his depictions of space became more convincing and his renderings of architecture acquired a new amplitude, as evidenced by his *Apocalypse* woodcuts (1498).

In 1505, fleeing Nuremberg to escape the plague, he returned to Venice to study Venetian oil paintings, particularly the way the Venetian artists used color. Now famous as a printmaker, he was warmly received by both artists and men of state. In the first commission that he painted in Venice Dürer set out to demonstrate his own skill as a colorist. The result was the *Madonna of the Rose Garlands* (1506), a masterpiece in which the Virgin, the pope, and the emperor, arranged pyramidally in the center, are plunged into the poetic atmosphere of a landscape panorama behind them. In this painting, color is the unifying element of the composition.

Dürer's second Venetian sojourn was immensely important for him,

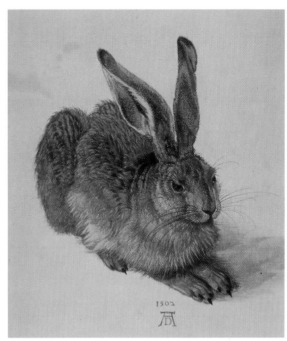

▶ ALBRECHT DÜRER. *Hare*. 1502. Watercolor, 8½ x 8¹⁵⁄₁₆ inches. Vienna, Albertina

Dürer often worked in watercolor, a technique whose lightness and rapidity of execution made it possible for him to paint the details of nature with marvelous precision. In the case of this hare, the artist painted every hair of its fur to convey its velvety softness. He even represented the reflection of a window in the nervous creature's eye.

leading him to a deeper understanding of how color and the human body could serve as vehicles for the expression of passionate feeling. This comprehension made it possible for him to integrate important elements of Renaissance art into the northern tradition.

Beginning in 1510, when Dürer began to focus primarily on printmaking, he was especially productive. In 1513–14 he created his most beautiful copperplate engravings, *The Knight, Death, and the Devil* and *Melancholia*. The superb draftsmanship and spiritual impact of these images have lost none of their impact over the centuries. He worked for Emperor Maximilian I on an extensive series of prints for his prayerbook. These images were widely disseminated and influenced many European artists of the period. The emperor also provided him with a stipend, and sent him on diplomatic missions elsewhere in Germany, during which he completed two portraits of the ruler.

Disturbed by the death of Maximilian, as well as concerned about the Reformation (p. 148) and the peasant uprising of 1525, Dürer began to paint less, spending much of his time writing artistic treatises: *Instructions for Measuring with Rule and Compass*, completed in 1525, and *Four Books on the Proportions of the Human Body*, published after his death. His knowledge of human anatomy was so extensive that the latter book remained in use by artists for generations.

In 1526, two years before his death, he painted the *Four Apostles*, considered his artistic testament. Monumental and majestic, these figures reflect study of classical models, but they also have a spiritual dimension particular to this man of the Renaissance.

Heir to the German Gothic tradition, Dürer ushered the art of the Germanic nations into the Renaissance through his intense study of nature, scientific perspective, and human anatomy.

See: The Renaissance, pp. 136–147.

MAX ERNST
1891–1976

painter and sculptor

Max Ernst studied philosophy and psychology in Bonn, Germany, where he met August Macke, who introduced him to Expressionism, and Jean Arp. He then went to Cologne, where he joined the Dada movement. He perfected an idiosyncratic collage technique, composing works from fragments of photographs and prints which he then retouched with gouache or ink. The results are always surprising and often comic. Some of these collages also incorporate typography and are in fact poems. Later Ernst was to produce extended "collage-novels" (*The Woman With a Hundred Heads*, 1929; *A Week of Goodness*, 1934).

In 1921 Ernst went to France, where he became acquainted with André Breton, Paul Éluard, Man Ray, and others of the Surrealist group. He set out to do for art what the Surrealists were doing for writing, namely jettison tired conventions and free the medium from constraints. In 1925, he began to use another new technique, "frottage." This involved placing a sheet of paper on an irregular object (unpolished wood, leaves, textiles), rubbing it with a pencil, and reworking the result to obtain fantastic images shaped largely by chance.

Ernst often used a highly traditional, smooth, illusionistic technique in his painting to accentuate the strangeness of his compositions, often shaped by nightmarish dreams, as indicated by their titles (*Monument to Birds*, 1927; *Blind Swimmer*, 1934; *Barbarians Marching Westward*, 1935). He also tried his hand at sculpture on several occasions. In 1938 he bought a house in the Ardèche Valley of southern France, restored it himself, and decorated it with concrete sculptures freely representing sirens, chimeras, a sphinx, and a minotaur. Like many other artists, Ernst fled France at the beginning of World War II, arriving in New York in 1941. There he introduced a number of young American artists to the Surrealist automatism, a technique of painting in which the artist makes random gestures in paint to allow the subconscious to create the work without rational intervention. Automatism strongly influenced the work of a number of Abstract Expressionists, particularly *Jackson Pollock* and Willem de Kooning.

Ernst married the American Surrealist artist Dorothea Tanning, and returned with her to France in 1955, becoming a French citizen in 1958. He continued to paint and sculpt until his death, his ever-singular imagination producing images that seem to recall his childhood memories.

▼ MAX ERNST. *Garden Airplane Trap.* 1935. Oil on canvas, 21¼ x 29⅜ inches. Paris, Musée National d'Art Moderne, Centre Georges Pompidou

In this strange image, Max Ernst presents the "reality" of imaginary gardens into which planes crash, releasing pulpy flowers.

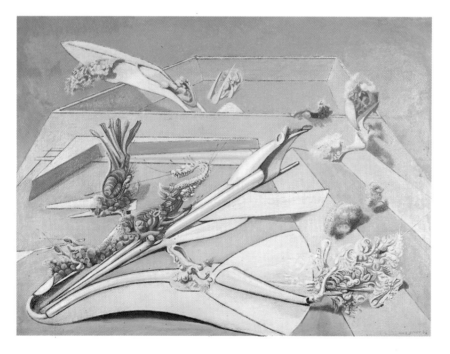

 See: Dadaism and Surrealism, pp. 166–167.

Jean Fouquet
1415/1420–ca. 1480

painter

Famous in his own day but later forgotten until the early nineteenth century, Jean Fouquet was the greatest French painter of the fifteenth century. Many of his paintings have been destroyed, and only a few episodes of his training and his career are known, notably a trip to Italy crucial to his development—probably 1444–46—and his having settled in Tours, where the king and his court often resided.

Fouquet was trained in the Gothic tradition, but he assimilated the innovations of Flemish painters, and during his Italian trip he developed a new understanding of space revealed to him by paintings of such Roman and Florentine artists as *Masaccio* and *Fra Angelico*. They also taught him to simplify volumes and to construct his compositions using geometry and perspective. He was the first French painter whose work reflects Renaissance influence.

Fouquet painted the portrait of *Guillaume Jouvenel des Ursins*, chancellor of France: the background is gilded and bears the sitter's coat of arms, which underscores his social success. He also executed several works for Étienne Chevalier, treasurer of France, including the *Melun Diptych*. An enamel medallion that originally decorated the frame bears an image of Fouquet himself, the earliest known self-portrait of a French painter. The portrait of *Charles VII, King of France* was perhaps painted after Fouquet's return from Italy; in any event, it greatly influenced painters like Jean Clouet, who used it as a model for his own portrait of Francis I.

Like most French painters of the fourteenth and fifteenth centuries, Fouquet produced manuscript illuminations. He painted miniatures for the prayer books known as "books of hours" as well as for translations of ancient texts for the libraries of important people of the realm. Charles VII commissioned him to illustrate his copy of the *Grandes Chroniques de France*, a history of the French monarchy. The most famous of Fouquet's illuminated manuscripts is unquestionably the *Book of Hours of Étienne Chevalier*, executed between 1452 and 1460. In this masterpiece, Fouquet's art takes on a monumental aspect shaped by the work he saw in Italy; its lively depictions of daily life and the lives of saints as well as its ample, luminous landscapes reveal a convincing mastery of spatial illusion.

▼ JEAN FOUQUET. *Charles VII, King of France.*
c. 1445–50. Oil on wood panel, 33⅞ x 28 inches. Paris, Musée du Louvre
The inscription on the frame of this portrait identifies the sitter as Charles VII (reigned 1422–61), "the very victorious king of France," who finally drove the English out of France during the Hundred Year's War. An official portrait, it has the commanding majesty suitable to such an image. The striking realism of the face, the three-quarter presentation, the palette, the lighting, the meticulous handling of the rich fabrics, and the inscribed frame all reflect the influence of such fifteenth-century Flemish artists as Jan van Eyck.

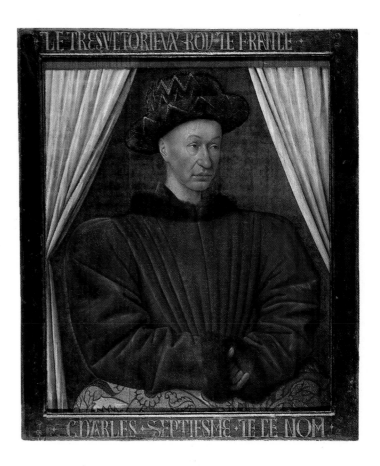

LE TRESVICTORIEVLX ROY DE FRANCE

CHARLES SEPTIESME DE CE NOM

Jean-Honoré Fragonard
1732–1806

painter

Jean-Honoré Fragonard was born in Grasse, France, in 1732. After winning the French Academy's Rome Prize at age twenty, he spent four years in the Eternal City, where he painted scenes from popular life. In the summer of 1760 he accompanied the abbé de Saint-Non, a wealthy art lover, to Tivoli, near Rome, where he produced a superb series of red chalk drawings of the gardens of the Villa d'Este.

After returning to Paris, in 1765 he presented a history painting, *Corésus and Callirhoé,* to the Academy. The painting was a triumph. The king acquired it and Fragonard was granted a studio in the Louvre. In 1769 he married a young woman from Grasse. As grand historical subjects were beginning to bore him, he turned instead to scenes like *The Swing,* in which a young man looks on in delight as a ravishing young woman rides a swing, her petticoats wafting upwards provocatively. A growing clientele was prepared to pay high prices for such works that combined gaiety, wit, and sensuality, with delicious results.

Using a free and rapid technique, Fragonard executed a series of so-called "fantasy portraits" that seem to have been conceived as an ensemble, for they are all in the same format and all the sitters wear fancy-dress costumes. Both male and female, some of them are well known figures (Diderot) and others evoke history or music, but all of these playful likenesses have a remarkable vivacity.

Before a second trip to Italy, during which he produced a remarkable series of landscape drawings, he painted *Fête at Saint-Cloud* (1773), which shows an idyllic park of rich greenery and refreshing fountains radiant with golden light, in which pantomimists and puppeteers entertain their audiences.

Fragonard's work remained in demand for a few more years, but soon a new generation of painters began to establish itself. The death of his daughter Rosalie was a great blow to him, and the Revolution was disastrous for many of his clients. Beginning in 1790, he gave up painting and obtained a post at the new museum, the future Louvre. He died in Paris in 1806, surrounded by his family.

Fragonard's favorite theme was love, and he had a special gift for conveying the joy of life. His brushstrokes, readily apparent on the canvas, seem to have been applied in haste. Everything in his paintings—trees, clouds, figures—seems to move, bathed in yellow tones and kissed by the sun.

▼ **Jean-Honoré Fragonard.** **The Bolt.** **Before 1784. Oil on canvas, 28¾ x 36⅝ inches. Paris, Musée du Louvre**
A partially undressed young man leaps up to bolt the bedroom door. The young woman in his arms makes a mild gesture as if to restrain him, but her seductive posture suggests that she welcomes his visit. The diagonal composition is simple but masterful; a strong ray of light rakes from the upper right to the lower left, highlighting the rich folds of the couple's clothing, and the bedding as well. It also illuminates a single apple on the bedside table, a witty reference to the story of Adam and Eve.

Caspar David Friedrich
1774–1840

painter

Born into a German Protestant family, Caspar David Friedrich received a very strict education. His childhood was marked by a series of dramatic events: the death of his mother and sisters when he was seven, followed by that of his brother, who drowned trying to save his life. As a result Friedrich spent much of his youth in solitude, taking long walks in the countryside. Nature was an endless source of inspiration for him and provided him with a means to express his religious feelings.

At age twenty he left for Copenhagen, where he enrolled at the Academy of Fine Arts. Dissatisfied with the training there, in 1798 he

◄ CASPAR DAVID FRIEDRICH.
Traveler Looking Over a Sea of Fog.
1818. Oil on canvas, 38⅝ x 29½ inches.
Hamburg, Kunsthalle

The traveler, seen from the back overlooking a magnificent mountain landscape, has apparently paused to reflect on his life and beliefs. Friedrich infused each element of his compositions with elements of Christian symbolism; the man signifies the terrestrial world, the fog corresponds to errors he has committed in the past, and the rocks rising above it suggest the faith that leads to salvation.

HENRY FUSELI
1741–1825
painter

Thanks to his father, a Swiss painter and writer, Fuseli frequented the literary and artistic circles of Zurich from his youth. He began his training by copying works in his father's collection. Friends introduced him to the work of the English poets Shakespeare and Milton, who became his main sources of inspiration.

Beginning in 1764, Fuseli traveled to Rome and London, where he met the great portraitist Joshua Reynolds, was influenced by the classicizing theories of the German archeologist

moved to Dresden, then an important artistic center, where he met painters and writers of the new Romantic school. In 1805, when he showed his work at an exhibition in Weimar, the German poet Goethe awarded him first prize for his sepia watercolors.

Friedrich then turned to oil painting, in which he developed a highly individual style. His landscapes were rooted in a close study of nature, which he infused with religious feeling. He made studies during his walks that served as the basis for his paintings, which he executed in the studio. His *Cross in the Mountains* (1808) provoked controversy, for some were scandalized by the artist's use of a landscape as a devotional image. But the resulting attention brought him fame and clients, among them the crown prince of Prussia, who acquired his most recently completed works, *The Monk by the Sea* and *Abbey in the Oakwoods*. He was nominated for membership in the Academy of Berlin and also elected a member of the Academy of Dresden, which secured his reputation.

In 1818, at age forty-four, Friedrich married and finally found happiness. Some years later he was seriously incapacitated by illness, but he contin-

ued to paint, and his later works reveal a new sensitivity to color. The figures in *The Stages of Life*, which depicts a family by the seashore, features a sky richly tinted with orange and purplish blue.

In 1840, when he died, Friedrich was all but forgotten. It was not until the end of the nineteenth century and the emergence of the Symbolist movement that his work once again attracted serious attention. In the intervening years he has come to be regarded as the greatest of German Romantic landscape painters.

▼ HENRY FUSELI. *The Nightmare.* 1781. Oil on canvas, 40⅛ x 50 inches. Detroit, Institute of Arts

A sleeping young woman, her head and arms akimbo over the bed, is having a nightmare personified by a gnome, who crouches on her stomach and stares fixedly at the viewer. According to English popular tradition, gnomes travel by night on mares, which explains the horse's head between the curtains at left. Here Fuseli combines a literary subject with an atmosphere of fantasy.

See: Romanticism, p. 153.

Johann Winckelmann (author of *The History of Ancient Art*), and fell further under the sway of the poetry of John Milton.

In 1779 he made London his permanent home. It was here that he developed the new genre that became his specialty, an extravagant form of fantasy painting (*The Nightmare*).

Beginning in 1786 he returned to his first sources of inspiration, painting two sets of canvases after works by Shakespeare and Milton. Nine of these visionary paintings illustrate episodes from *Macbeth*, *A Midsummer Night's Dream*, and *King Lear*. Others were based on Milton's *Paradise Lost*, a vast Biblical poem exploring humankind's conflicting attractions to Satan's temptations and the service of God.

In 1800 Fuseli became a professor of painting at the Royal Academy, where he continued to teach until his death. Most of his last paintings are inspired by Greek, English, and German mythology, notably the legends surrounding the downfall of an ancient Germanic royal family, the Niebelungs, which later became the subject of Richard Wagner's great cycle of operas, *The Ring of the Niebelungs*.

Fuseli greatly influenced the art of the English artist William Blake, who became his friend in 1787. His preference for literary subjects anticipated the Romantics, and his dreamlike imagery influenced the Surrealist painters.

THOMAS GAINSBOROUGH
1727–1788
painter

The son of a draper, Thomas Gainsborough's earliest artistic efforts were landscape drawings he made in the Suffolk countryside. In 1740 he traveled to London, where he worked

with the French engraver Gravelot, probably the catalyst for his admiration of contemporary French painting. His early landscapes are also strongly influenced by Dutch landscapists, especially Jacob van Ruysdael, whose attention to detail he emulated.

Soon, however, Gainsborough turned his attention to portraiture. His *Couple* (ca. 1746) and especially *Mr. and Mrs. Andrews* (1748) revealed his gift for the genre, which he treated with realism. He received his first important commission in 1755 from the Duke of Bedford, for whom he painted works combining rustic imagery with a grace suggestive of Boucher (*Peasant with Two Horses*; *Woodcutter Courting a Milkmaid*). His career now launched, he departed for Bath, where the elegant society which gathered there to enjoy its thermal baths proved a rich source of portrait commissions, his principal source of income.

Gainsborough's talent, strengthened by his rivalry with the other great English portraitist of the day, Sir Joshua Reynolds, quickly won him official acknowledgment. In 1761 he exhibited at the Society of Artists, and in 1768 he entered the rolls of the Royal Academy, becoming its only member to reside outside London. He was impetuous by temperament, and in 1784 he resigned from this prestigious body—presided over by Reynolds—on the grounds that the Academy had not exhibited a series of his works in the order he had prescribed.

Disdaining allegory and antique garb (he always preferred contemporary dress), Gainsborough excelled at rendering the psychological traits of

▼ THOMAS GAINSBOROUGH. *Mr. and Mrs. Andrews.*
1748. Oil on canvas, 27½ x 46½ inches. London, National Gallery
Gainsborough here creates an unusual effect by placing the couple emphatically off-center.
Relegated to the left, assuming poses that manage to be simultaneously hieratic and casual,
they look intently at the viewer. The main focus of the composition seems to be the
receding landscape, which is effectively treated as a third sitter.

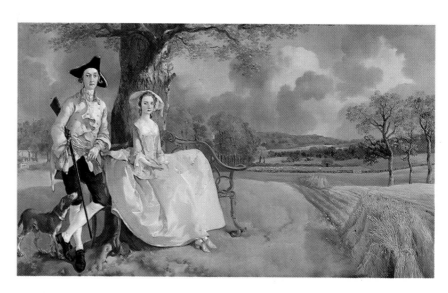

 See: Romanticism, p. 153; Surrealism, p. 167.

his sitters, some of whom complained about his excessive realism. His official portraits of the royal family—Gainsborough became a protégé of George III and Queen Caroline in 1781—bear witness to the acuity of his gaze.

At the end of his life, Gainsborough continued to pursue his career as a portraitist, but he did not abandon landscape, despite the fact that his efforts in the genre only met with success after his death. The rustic figural paintings of his final period, however, were well received (*Girl with Pigs; Harvesters*). Gainsborough was an artist of many gifts (he was an accomplished viola da gamba player as well as an author of great brio), but above all he was, with Reynolds, one of the great English painters of the eighteenth century.

ANTONI GAUDÍ
1852–1926
architect

Born in 1852 in Reus, near Taragona, Antoni Gaudí always considered himself to be more Catalonian than Spanish. In 1869 he began his architectural training in Barcelona, receiving his diploma in 1878, the same year that street lamps he had designed for the city were installed. He paid for his studies by working in architectural firms and taking part in the reconstruction of the Montserrat monastery, which had been destroyed by Napoleon's armies. After reading the works of the architectural historian *Eugène Viollet-le-Duc* he became a passionate admirer of medieval architecture, and his work was to be greatly influenced by the Gothic and Moorish structures of his native region. He was also inspired by natural forms, both vegetal and mineral, which provided him with decorative motifs and determined his organic approach to construction.

▶ ANTONI GAUDÍ. **Church of the Sagrada Familia. 1883–1926. Barcelona**
In 1883 Gaudí was commissioned to complete the principal church of Barcelona, dedicated to the Holy Family, which had been begun in a Neo-Gothic style. He first built its Nativity façade; animated with a carved decor teeming with animals and plants, its pediments recount the childhood of Christ. Twelve bell towers symbolize the twelve disciples, who are also the first bishops; hence the bishop's miter at the peak of each one. These lofty structures and the abundant sculpture, handled with immense freedom, reflect Gaudí's visionary imagination. When Gaudí died the building was unfinished. Construction is still underway.

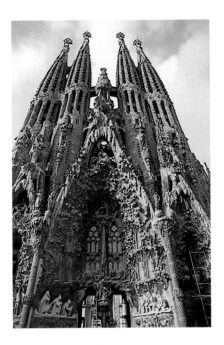

Barcelona was developing rapidly, and Gaudí received many residential commissions (Casa Vicens, 1883–88; Casa Batlló, 1904–06). These buildings are striking, for Gaudí used unusual materials, for example colored ceramic tiles on their façades, as well as surprising curved forms that bring Art Nouveau to mind. Casa Milá (1906–10), nicknamed the Pedrera (Spanish for "quarry"), is an apartment house whose shapes are so serpentine that it has no corners. The façade is richly modeled like a work of sculpture, and the chimneys resemble creatures out of a fairy tale.

Fascinated by Gaudí's imagination, the industrialist Eusebi Güell commissioned him to design his residence, Palacio Güell (1886–89). The façade gives no hint of its prodigious central hall, lit by a cupola and outfitted with an organ in its upper reaches. For the same patron Gaudí also designed a park and residential complex, Parc Güell (1900–14), of which only the gardens and two houses were built. The delicate supports of its retaining walls seem to defy the laws of gravity; the use of colored mosaic and inset fragments of shattered plates lend an air of fantasy to the whole.

Gaudí also received commissions from religious institutions. He completed the Thérésien College (1888–89), for which he used extremely attenuated arches, and, above all, he was entrusted with the design of the church of the Sagrada Familia (Holy Family; 1883–1926), which became the project of his life. Instead of conventional plans, Gaudí preferred to work with models of his own invention, made from small suspended bags of sand corresponding to the weight to be borne by the building's columns and pillars.

Despite its being incomplete, the church of the Sagrada Familia has become the emblem of Barcelona, and Gaudí is the most famous of all Catalonian architects.

PAUL GAUGUIN
1848–1903
painter and sculptor

When Gauguin was one year old his parents left France for Peru. With his mother, a member of a noble Peruvian family, he settled in Lima with his uncle, a period of which he always retained fond memories. On returning to France in 1871 after serving as an officer in the merchant marine, Gauguin worked as a stockbroker. He became friends with the painter Pissarro, who encouraged him to paint and sculpt. Before long one of his landscapes was accepted for exhibition at the Salon, and he also showed at the Impressionist exhibitions between 1879 and 1886. Thus encouraged, he decided to devote himself completely to painting and sculpture.

It was in the French province of Brittany, where he spent three sojourns, that Gauguin's chronic longings for new surroundings were first

satisfied. The encounter there of his own ideas with those of other young artists, notably Émile Bernard, helped shape the group of artists working there known as the Pont Aven school. Under the influence of the Celtic Breton culture, which Gauguin found crude and primitive but infused with primal energy, Gauguin's work became increasingly free in color and composition. In *The Yellow Christ* he combined reality and fantasy, placing a Christ on the cross against a yellow and red landscape and surrounding it with women in Breton caps. His abstract manner of applying bright colors in uniform patches separated by thin blue lines occasioned a name for the new style: *cloisonnisme,* from the French word for compartment (as in stained glass).

After returning to Paris Gauguin resolved to leave the West, which he judged to be "spoiled by industrial civilization." He organized a public sale of his pictures, which raised enough money to allow him to depart for Tahiti in 1891. During this first stay

there, Gauguin, enchanted by the beauty of the inhabitants and the landscape, painted their daily lives as well as episodes from Polynesian folk tales in colors still brighter and richer than before, and with ever greater compositional freedom. His forms became simpler, his flatly applied colors became even more remote from reality, and all pretense of perspectival illusion was abandoned. This later, more reductive style, known as *synthetism,* is epitomized by a pastoral work entitled *Arearea* ("amusements"), which depicts two beautiful Tahitian women seated beside a lagoon. Its brilliant colors are completely fantastic, as evidenced by a red dog in the foreground.

His money having run out, in 1893 Gauguin returned to France, hoping to make a name for himself with his recent work. Unfortunately, he failed to do this, and within two years he was back in Tahiti, disappointed and ill. But he continued to paint. In 1897, a few months before a suicide attempt, he completed a large painting conceived as his artistic testament. This was *Where Do We Come From? What Are We? Where Are We Going?,* the result of his reflections on death and his will to paint in total freedom.

In 1901, Gauguin settled on one of the Marquesa Islands, Hiva Hoa. He lived as its natives did, building a hut for himself that he dubbed the *Maison de Jouir* (house of delight), which was inscribed on a painted relief above its door. During the two years of life that remained to him, Gauguin painted (solely for his own pleasure), wrote letters to his friends, and drafted *Avant après* (Before after), the story of his life. An exhibition organized after his death greatly interested many Parisian artists. Picasso was overwhelmed by the power and brute force of his drawings, while Matisse was immensely impressed by the color and facility of his final canvases.

◀ PAUL GAUGUIN. *The White Horse.* 1898. Oil on canvas, 55½ x 35⅞ inches. Paris, Musée d'Orsay

Painted in Tahiti, this elaborate composition represents two horseback riders seen through leafless branches and, in the foreground, a horse drinking water. Using intense colors to evoke an earthly paradise, Gauguin depicts the Tahitians as intimately linked to the abundant nature around them. Gauguin later said that when he painted this work he had thought of the horses in the Parthenon frieze as well as of the hobbyhorses of his childhood.

THÉODORE GÉRICAULT
1791–1824
painter

Théodore Géricault developed a life-long passion for horses during his childhood in Rouen, and he was to paint them throughout his life. He first studied with Horace Vernet, a famous painter of horses, and then with Pierre-Narcisse Guérin, who taught him the techniques and principles of Jacques-Louis David. Géricault also frequented the Louvre, studying its collections of Greek and Roman antiquities and copying many paintings, a task then considered an essential part of an artist's training.

Horses and military men were the subjects of his first works. The monumental format, vigorous color, and fiery steed with flaring nostrils of his *Charging Chasseur* attracted the attention of his contemporaries. A journey to Italy in 1816–17 made it possible for him to absorb both the ferocity of Michelangelo and the balanced harmony of Raphael.

After returning to Paris, Géricault opened a studio and developed an interest in provocative contemporary events, such as a political assassination in southern France, and the scandalous shipwreck of the frigate *Medusa*. The Parisian public was shocked by the dark tonality and horrific details of *The Raft of the Medusa* (1819 Salon), but the painting was well received in England, where Géricault exhibited it the following year. During his trip to England the artist once more took up lithography, with which he had experimented early in his career, using it to depict street scenes, horse races, and boxing matches.

After returning to Paris in 1821, the artist squandered his fortune and proved unable to complete his paintings. His last works are five portraits of

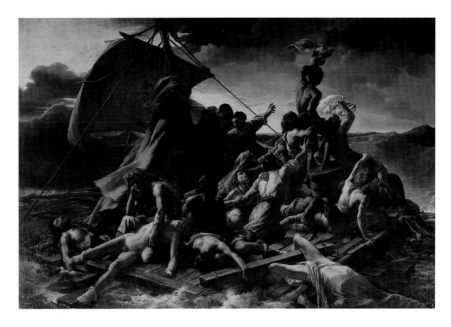

▲ THÉODORE GÉRICAULT. *The Raft of the Medusa.* 1818–19. Oil on canvas, 193⅛ x 281⅞ inches. Paris, Musée du Louvre

Géricault was horrified by the story of the shipwreck of the Medusa, *whose 149 passengers and crew were adrift for fifteen days without food or water. Although the figures are gathered into a pyramidal form reminiscent of High Renaissance composition, the nudes are rendered with unflinching realism, the result of the artist's studies of cadavers.*

mental patients commissioned by the psychiatrist Georget, probably for use in his lectures on madness. Despite their probable clinical origins, they are immensely powerful and disturbing works of art.

As a result of poor medical treatment received after a riding accident, the painter died at age thirty-three after a long illness.

Géricault opened the way to Romantic painting and demonstrated that the modern world could provide heroic subjects for history painting.

ALBERTO GIACOMETTI
1901–1966
sculptor and painter

In opposition to the prevailing tendencies of modern sculpture, which favored assemblage, Alberto Giacometti reverted to conventional modeling techniques. He had received traditional training from his father, a post-impressionist painter, and the sculptor Antoine Bourdelle, with whom he studied at the Academy of the Grande-Chaumière between 1922 and 1925. He quickly established contact with the Surrealists André Masson, *Miró*, *Max Ernst*, and *Dalí*.

By 1930 Giacometti had assimilated the art of his time (from Cubism to *Brancusi* by way of African art) and produced sculptures in a playful erotic mode (*Man and Woman*). In collaboration with his brother Diego, he had also produced many objects and accessories for a famous decorator of the day, Jean-Michel Frank. Around 1935 he renounced Surrealism in favor of a more solitary road, returning to the human figure.

See: Romanticism, p. 153.

Giacometti's later sculpture has its monumental, almost religious aspect, but appreciation of it is increased when it is compared with the artist's drawings and paintings. The "indecisive" modeling of the bronzes becomes superimposed lines in the drawings and multiple, readily apparent brushstrokes of almost monochrome tonality in the paintings. In all these media, the artist's goal was to stress the figure's interaction with the environment, to prevent compartmentalized perception that would make it seem separate from the world around it. In the 1950s his figures grew incredibly thin, a strategy meant to increase the

viewer's awareness of his or her own body. Then he increased their scale, producing stick-men whose attenuated limbs are rooted in the ground by enormous feet.

A Swiss citizen, Giacometti spent much time in Geneva. After the Second World War he exhibited extensively in the United States, and in 1962 he was awarded the Grand Prize at the prestigious Venice Biennale. Worried about the destiny of humanity, Giacometti's late work suggests something of the horror of Nazi atrocities. The thread-thin silhouettes of his figures in the 1950s seem ever more fragile, as if threatened by hostile forces.

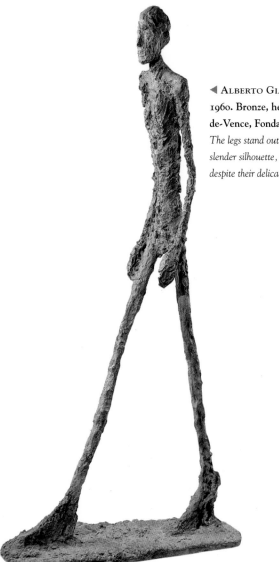

◀ ALBERTO GIACOMETTI. *Walking Man.* 1960. Bronze, height: 72 inches. Saint-Paul-de-Vence, Fondation Maeght

The legs stand out with the greatest clarity in this slender silhouette, infinitely long and vigorous despite their delicacy.

GIORGIONE (GIORGIO DA CASTELFRANCO)
1477/1478–1510
painter

We know neither the precise date of Giorgione's birth nor his family name. Even the nickname Giorgione ("great George") is first mentioned in 1548, more than forty years after his death. Giorgione learned the fundamentals of painting in Venice; his early work betrays the influence of *Giovanni Bellini* as well as of northern painters such as Albrecht Dürer, whose work he could have admired in the private collections of Venetian nobles. At an early date he became interested in landscape, revealing a preference for dense color and light.

According to Vasari, the famous sixteenth-century artists' biographer, Giorgione was an educated man thoroughly familiar with Latin and Greek literature. Stimulated by Renaissance humanism, he frequented cultivated circles and preferred subjects in which man and nature were dominant. He treated nature not as a mere decorative background but as an element in intimate dialogue with the figures.

His *Laura* (1506), a soft-contoured portrait of a pensive young woman with one breast exposed, represents an ideal of feminine beauty. Its atmospheric treatment reveals the degree to which Giorgione had freed himself from the dry, linear handling of fifteenth-century painting to attain the maturity evidenced by his masterpiece, an enigmatic painting known as *The Tempest* (left). The technique of glazing that he perfected gave his work a new luminosity and transparency. In *The Three Philosophers*, painted shortly before his death, both the skillful composition and the setting suggest the stages of human life.

Giorgione died in 1510, at age

thirty, during an epidemic of the plague. His young and gifted student, *Titian*, completed the canvases his master had left unfinished. This has resulted in some confusion in the attribution of paintings such as the *Concert Champêtre* in the Louvre, which is now considered a work entirely by Titian (p. 142).

Carried away at the peak of his fame, Giorgione acquired a mythic aura that has survived into the present. His new approach to color and light as well as his vision of the organic relation between man and nature marked a turning point in Venetian painting, indicating a new direction that was followed by Titian, Sebastiano del Piombo, and even the older master, *Giovanni Bellini*.

▼ GIORGIONE. *The Tempest.* c. 1508.

Oil on canvas, 30¾ x 28⅜ inches. Venice, Accademia

Radiographic analysis of this enigmatic painting executed between 1506 and 1508 reveals that
the artist revised it repeatedly. The final composition represents a nude woman, sitting on a rock and
holding her child in her arms, and a young soldier standing in the foreground. In the distance,
a storm breaks over the walls of a city. The real subject of the picture may be, simply, nature,
of which human beings are only one element among many.

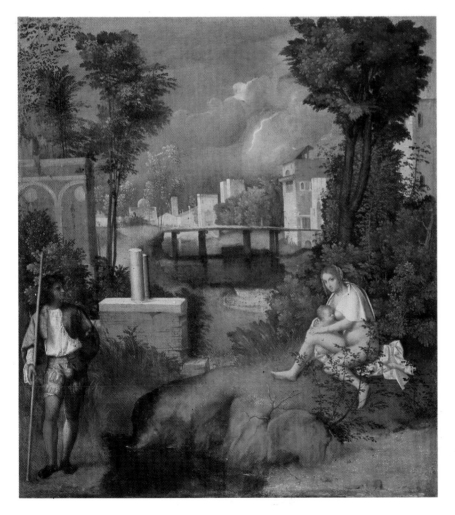

GIOTTO (GIOTTO DI BONDONE)

ca. 1266–1337

painter

The sixteenth-century biographer and theorist Giorgio Vasari repeats the legend that *Cimabue* discovered the boy Giotto, the son of peasants living near Florence, drawing the sheep in his father's flock with a sharp stone on a flat rock. The boy was subsequently apprenticed to a painter, perhaps Cimabue himself. Otherwise, we know very little about his training and his early years.

As a young man Giotto may have been one of the artists who worked on the frescoes in the upper church of San Francesco in Assisi, as these compositions show a marked departure from the late Byzantine manner common in the period in Italy. Certainly, Giotto broke definitively with Byzantine tradition in his later work, depicting individuals instead of stereotyped figures imposed by decorative or iconographic tradition. Dante, the great Italian poet and a contemporary of Giotto's who doubtless met him, wrote: "Once Cimabue thought to hold the field in painting, now Giotto has the cry" (*Purgatorio*, Canto XI).

Giotto quickly established himself, opening his own studio and employing many students and apprentices. He was the first Tuscan painter to receive commissions in northern Italy, being summoned first to Rimini and then to Padua, where he decorated the chapel of Enrico Scrovegni with an elaborate fresco cycle. Executed between 1302 and 1305, the Scrovegni Chapel (also called the Arena Chapel) in Padua is regarded as his major achievement. Recounting the lives of both Christ and the Virgin, it also incorporates allegories of the Vices and Virtues and a large *Last Judgment*. Giotto's innova-

See: The Renaissance, pp. 136–147.

tions in this cycle were many: his convincing depiction of space, his powerful and monumental projection of the human figure, his free use of color, and the dramatic intensity that he achieved in each composition.

Among the important works painted after the Padua cycle are his frescoes in the church of Santa Croce in Florence: cycles illustrating the lives of St. John the Baptist and St. John the Evangelist in the Peruzzi Chapel, and the St. Francis cycle in the Bardi Chapel.

Between 1328 and 1333 Giotto worked in Naples, in the service of Robert of Anjou. After returning to Florence, he was placed in charge of building the cathedral bell tower. This was his only architectural project; he died before its completion, and was buried in the adjacent cathedral.

Giotto's fame has remained a constant since his lifetime. The revolutionary import of his art was fully assimilated only a century after his death, by *Masaccio* and the other artists of the fifteenth century.

▼ GIOTTO DI BONDONE. *Lamentation.* c. 1303–05. Fresco,
78¾ x 90½ inches. Padua, Scrovegni Chapel

The individual scenes in this elaborate fresco cycle are linked to one another by landscape elements as well as by the blue "sky"
of the vault and the walls. The figures are solidly constructed, and the draperies are modeled to create an illusion of volume.
The Virgin, staring in anguish at the face of her dead son, is a powerful image of overwhelming grief.

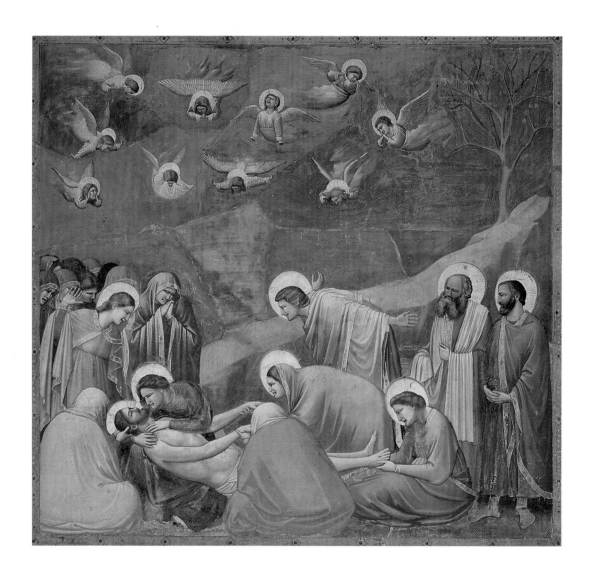

Francisco de Goya y Lucientes
1746–1828

painter and printmaker

The son of a master gilder in Saragossa, Spain, Goya became a student of Francisco Bayeu, future painter to the Spanish court, whose sister he married in 1773 and who procured him his first royal commissions. After a trip to Italy during which he completed his education and studied the classical heritage, he returned to Spain in 1771. He produced a series of tapestry cartoons for the Royal Manufactory of Santa Barbara in Madrid, the compositions of which reveal the influence of the Venetian painter *Tiepolo*, who had worked in Madrid shortly before. These cartoons feature figures in colorful apparel pursuing all manner of amusements in picturesque landscape settings.

As Goya's reputation grew, his portrait commissions increased, and within a few years he became the preferred portraitist of the Spanish elite. This is surprising, for he often penetrated beyond the elegant dress of his sitters to depict both their physical features and their characters with unsparing lucidity. Even in the official portrait of Charles IV and his family, painted shortly after his appointment as court painter in 1799, Goya did not shrink from rendering the queen's unattractive face as well as making the king appear feeble, even moronic. Goya seems to have been determined to be the faithful witness to his times.

After becoming deaf in 1792, Goya withdrew from public life for several years, producing small, bleak pictures of madness, witchcraft, and fanaticism (*Burial of the Sardine*). In 1795 he became President of the Royal Academy, a prestigious official post, but this did not prevent him from continuing to attack stupidity, vice, and superstition. In 1799 he published *Los Caprichos*, a series of etchings ferociously satirizing Spanish life, which the king immediately ordered withdrawn from sale.

In 1808 Charles IV, having become unpopular, was obliged to abdicate to his son, Ferdinand VII; shortly thereafter, French forces invaded Spain under the leadership of Napoleon, who installed his brother Joseph on the throne. Goya remained in Madrid and was even honored by the occupying government. Initially, the French Revolution had seemed to him a force that might bring an end to the injustice and inequality pervasive in Spain. However, he was horrified by the cruelty and bloodshed that he witnessed, and in another series of etchings, *The Disasters of War*, he denounced the war's viciousness and suffering in images of wrenching violence. For the same reasons, he painted two large canvases—the *Second of May* and *Third of May*—that represent the occupying forces' brutal repression of all those suspected of having taken part in the patriotic resistance.

After the return from exile of Ferdinand VII, Goya withdrew to the Quinta del Sordo (House of the Deaf Man), his residence outside Madrid, whose walls he decorated with his so-called "black paintings." Dark and fantastic, these terrifying visions depict witches, vampires, and the god Saturn devouring one of his own children.

Meanwhile, Ferdinand VII set about consolidating his power and began to persecute those with liberal sympathies. In 1824 Goya voluntarily exiled himself to Bordeaux. His final works are portraits of friends and scenes of popular life, for example the gracious and delicate *Milkmaid of Bordeaux*. He died at the age of eighty-two.

An unstinting chronicler of contemporary events, Goya established the model for the modern history painter, setting an example that was to be immensely influential among young artists of the nineteenth century.

▼ Francisco de Goya. *The Third of May* (executions on May 3, 1808, in Madrid). 1814. Oil on canvas, 104¾ x 135⅞ inches. Madrid, Prado Museum
Everyone in Madrid suspected of having taken part in the rebellion against Napoleon's occupying forces was executed. Horrified, Goya depicted one of these massacres, delineating the reaction of each victim. The soldiers aiming their rifles are portrayed as an anonymous, mechanistic mass, in shadow and seen from the back. The most prominent victim's bright yellow trousers and white shirt accentuates the terrifying drama.

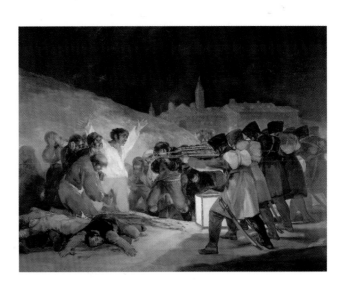

EL GRECO (DOMENIKOS THEOTOKOPOULOS)

1541–1614

painter

Domenikos Theotokopoulos was born on the Greek island of Crete, which explains his nickname in Spanish ("the Greek"). When he arrived in Toledo, Spain, in 1577, he came from Italy, where he had spent almost ten years completing his training in Venice and in Rome, to which he may have fled to avoid the plague of 1575. He settled in Toledo with his common-law wife, whom he never married but with whom he had a son the following year.

In Spain, the Escorial, a large royal palace rising outside of Madrid, was then monopolizing the energies of many artists. El Greco tried to obtain a commission there by presenting his *Martyrdom of St. Maurice* (1582) to Philip II, but the strategy failed, for it was not to the king's liking. Spain being a very pious nation, however, its principal patron was the church. Unlike the king, many religious institutions appreciated El Greco's work and offered him commissions.

El Greco produced a few portraits which convey the solemn grandeur of Castilian nobles, for example, the famous *Gentleman with His Hand on His Breast*. His primary focus throughout his life, however, was religious painting. The elongated figures typical of sixteenth-century Italian painting (compare *Tintoretto*) are present in his work. His figures seem insubstantial, as though purged of materiality by the religious emotion and profound faith so pervasive in the Spain of his day. El Greco repeatedly depicted penitent saints, scenes from the Passion, and the life of the Holy Family as did other artists working in his studio, including his son, Jorge Manuel (*The Disrobing of Christ*, *The Adoration of the Shepherds*, *St. Martin and the Beggar*, *The Burial of Count Orgaz*).

After 1595, El Greco distanced himself still farther from reality. His compositions grow increasingly vertical and linear, and the figures seem to be ascending toward heaven. His palette becomes lighter and paler; his handling grows broader, and his bodies no longer seem to have volume (*The Assumption*, after 1607). In this period he painted one of the earliest landscapes in Spanish painting, the *View of Toledo* (ca. 1605–10), and it, too, seems infused with a deeply-felt spirituality.

Gifted with an exceptional imagination enriched by his Byzantine background, the heritage of the Italian Renaissance, and Spanish devotional traditions, El Greco produced mysterious and dramatic visions animated with a rarefied religious feeling.

▼ EL GRECO. *The Burial of Count Orgaz.* 1586. Oil on canvas, 191¾ x 141¾ inches. Toledo, Spain, Church of Santo Tomé

The division of this composition into two levels recalls Byzantine models, but here the divine realm, with its light colors, animated crowd of saints, and expressive figures, is made to seem more vividly alive than the terrestrial world. The Spanish noblemen in the earthly register are arrayed in the form of an archaic frieze. The palette is dominated by pale greens, acid yellows, and cool grays, which further accentuate the discrepancy between the painting and reality.

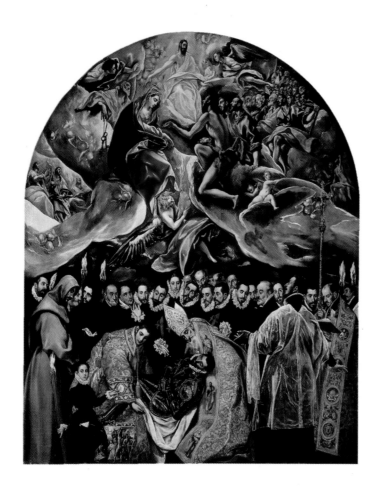

 See: The Renaissance, 136–147.

MATHIAS GRÜNEWALD
ca. 1475/1480–1528

painter

Very few important artists are cloaked in as much mystery as Mathias Grünewald, the painter of the *Isenheim Altarpiece*. His name appears for the first time in 1675, but no document records his precise name, and both his origins and his life remain obscure. All of his known paintings are either altarpieces or religious images. The totality of his surviving work consists of ten paintings and thirty-six magnificent preliminary drawings for them.

Born in Würzburg, Germany, he traveled to Frankfurt to be trained as a painter. Around 1505 he entered the service of the Archbishop-Elector of Mainz. He completed the altarpiece for the hospital in Isenheim in 1516, after which he returned to Mainz to enter the service of Cardinal Albrecht, Elector of Brandenburg. He is mentioned as an engineer in Frankfurt in 1526. He died two years later in the city of Halle.

▼ MATHIAS GRÜNEWALD. *Isenheim Altarpiece.* 1511–17, **Oil on wood panels, 180½ x 132¼ inches. Colmar, Unterlinden Museum**

This great altarpiece, commissioned for the hospital-convent of St. Anthony in Isenheim, is a polyptych, made of several panels that could be opened or closed in accordance with the church calendar. Each panel is painted with a different subject, including an Annunciation, Nativity, Crucifixion, and Resurrection, as well as figures of St. Anthony and St. Sebastian.

The central panel depicts the Crucifixion. A sinister and tragic treatment of the subject, it details Christ's suffering with horrific specificity. In the center, the dead weight of his body causes the arm of the cross to bow. His greenish skin is covered with bloody pustules, and his hands seem twisted in agony; the nail piercing his two feet is of monstrous size.

The three witnesses at left seem to suffer with equal intensity. The kneeling Mary Magdalen wrenches her hands in anguish, while the pale, despairing Virgin faints in the arms of John the Evangelist. At right, the commanding figure of John the Baptist, accompanied by the sacred lamb, points to the dead Christ. Grünewald's exceptional gifts as a colorist make the scene particularly terrifying. The red mantles of the men and the Virgin's white robe seem to pierce the darkness, intensifying the supernatural atmosphere. Christ's gigantic body is resolutely at odds with Renaissance ideals of beauty; disturbing, almost grandiose in its ugliness, it bears witness to the powerful emotions of the painter and the intensity of the drama.

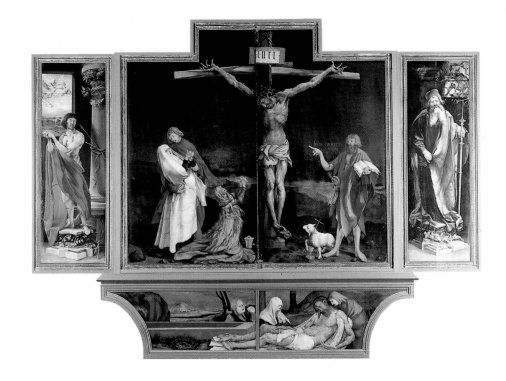

See: The Renaissance, pp. 136–147.

FRANCESCO GUARDI

1712–1793

painter

Francesco Guardi, born in Venice in 1712, first worked in the family workshop, already well established under the direction of his elder brother, Gian Antonio. Only gradually did his gifts reveal themselves, in the form of a nervous, rapid manner of paint-handling and a unique way of using luminous atmosphere to unify figures and landscape.

Francesco was almost fifty when his brother died in 1760, but from that point forward he devoted himself exclusively to the Venetian views that were to make him famous.

These views—or *vedute*, as they are known in Italian—are panoramas of Venice and its lagoon incorporating the city's monuments and festival celebrations. Avidly sought by foreign collectors, they secured his fame. Initially influenced by Canaletto, he soon gave freer hand to his fantasy. His images of Venice, awash in the shifting, shimmering light of its lagoon, have a silvery cast, and he made the city's monuments and inhabitants alike seem full of vitality.

Guardi also painted less conventional works combining real and invented elements. These are his *capricci*, or imaginative landscapes, incorporating antique ruins and triumphal arches inhabited by tiny, wiry figures.

Guardi also chronicled the life of Venice in vivacious drawings as skillfully composed as his paintings, true documents of the daily life of eighteenth-century Venice. In 1782, the government commissioned him to create two sets of paintings depicting state festivals, some of them honoring Pope Pius VI. These works have a new uneasy quality; executed in paler colors, their light more elusive, they suggest the meditative, melancholy cast of mind of an artist now old and solitary.

▼ FRANCESCO GUARDI. *Festivals of the Doge:*
The Bucintoro Leaving the Riva degli Schiavoni on Ascension Day.
c. 1766. Oil on canvas, 26 x 39⅛ inches. Paris, Musée du Louvre
This painting is one of a series depicting the ceremonies that accompanied the installation and reign of Doge Alvise IV Mocenigo. Here, the doge's personal vessel—accompanied by a swarm of richly decorated gondolas—departs for the church on the Lido where the annual symbolic marriage of the city with the sea was given divine benediction. Fully half the composition is occupied by the sky, which casts a silvery glow over the scene, and provides a counterpoint to the sparkling highlights on the figures in the foreground.

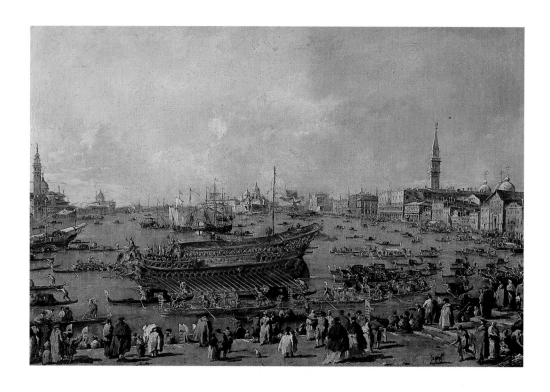

FRANS HALS

ca. 1580–1666

painter

As with many seventeenth-century artists, the origins and training of this painter are poorly documented. We know that, like his brother Dirk, he spent his early years in Haarlem. His earliest known painting of certain attribution is a portrait dated 1613, by which time Hals was already thirty-three years old. Shortly thereafter, about 1616, he suddenly emerged as one of the finest portraitists of the Dutch school.

Frans Hals painted a great many portraits of the Dutch seventeenth-century middle class, both as individuals and in groups. The large group portraits depict guilds, administrative bodies, and militia companies who commissioned collective likenesses from him (*Banquet of the Civic Guard of St. George*, 1616; *Assembly of the Officers and Subalterns of the Guard of St. Hadrian*, 1633; *Women Regents of the Old Men's Home*, 1664). The figures in these works are worthies happy with their lives and conscious of their responsibilities, but Hals sometimes had difficulty arranging them in satisfying groups. To avoid monotony in rendering the black dress of the regents, for example, he devised an ingenious zigzag composition punctuated by the sitters' hands and starched linen collars. The Civic Guard of St. George presented fewer formal problems, for their brilliant scarves and rolled banners could serve as richly colored accents. Since the sitters were feasting, Hals could also treat parts of the composition as if they were at a cabaret. With his singularly rapid brushstroke, Hals was able to capture the personality of each participant as if he had caught them unawares. He was immensely inventive when it came to varying these potentially unwieldy military and civic gatherings, always managing to instill his compositions with life and zest. The *Regents* is subdued, but even here there is a landscape painting on the wall behind the figures, and the figures in the *Officers and Subalterns* are shown in a large hall lit by high windows overlooking greenery.

Hals also produced many individual portraits and images from daily life, for example, *Portrait of a Couple* (1622), *The Merry Drinker* (1628–30), and the famous *Gypsy Girl* (1628–30), with her ample figure and unkempt hair.

Frans Hals now seems a precursor of things to come. In the nineteenth century, painters like *Manet* celebrated his vivacious and summary way of handling paint.

▼ FRANS HALS. *Man with His Hand on His Heart*. 1632. Oil on canvas, 24⅜ x 20½ inches. Bordeaux, Museum of Fine Arts
This simply composed portrait creates a marvelous illusion of spontaneity. Before his model could become fatigued by his pose, the artist had captured both it and the sitter's personality in the full bloom of its vitality. Despite the casual appearance conveyed by the artist's rapid brushstroke, however, this vivid composition is the result of careful planning and methodical execution.

HANS HOLBEIN THE YOUNGER

1497–1543

painter

Many members of the Holbein family were painters, including Hans the Elder, his brother Sigmund (virtually unknown), and his two sons Ambrosius and Hans, who worked together for several years. But the fame of the latter, known as Hans the Younger, soon eclipsed the others.

Young Hans learned his craft in the workshop of his father in Augsburg, Germany. A gifted student, he soon assimilated the German tradition as well as the art of the Italian Renaissance, whose achievements had been disseminated in Germany through the work of Albrecht Dürer. In 1516 he settled in Basel, where he received many important commissions from wealthy middle-class businessmen, and also decorated the façades of houses. All of these architectural paintings are lost, but surviving preliminary drawings for them demonstrate the artist's mastery of perspective. In this early period of his career he also painted religious works. The harmonious composition of *The Virgin with the Family of Burghermaster Meyer* (1528), in which the donors flank a Virgin of great beauty and majesty, brings to mind *Giovanni Bellini* and *Raphael*.

In 1526 Holbein went to London to escape the difficulties in finding work created by the Reformation (p. 148). A protégé of Sir Thomas More, the British statesman and philosopher, he painted portraits of many prominent figures at the English court. After a brief return to Basel (1528–31), he settled definitively in London.

In 1536 Holbein became a court painter to Henry VIII. Although he no longer treated religious subjects,

he did design sets and costumes for royal entertainments. Most of his energies, however, were devoted to court portraiture. In 1532 he painted *George Gisz,* and the following year *The Ambassadors* (p. 147); these were followed by such works as *Anne of Cleves* (1539), *Henry VIII* (1540), and *A Young Merchant* (1541).

This astonishing group establishes Holbein as one of the greatest portraitists of all time. Blessed with a gift for psychological observation as well as remarkable technique, he was a master at capturing subtleties of personality in images of meticulous elegance. While full of details of decor and costume indicative of social rank and personal interests, Holbein's compositions always place these in the service of his larger aim to convey the

sitters' personalities. He died of the plague in 1543 at age forty-six, at the height of his fame.

▼ HANS HOLBEIN. *Portrait of Georg Gisze, a German Merchant in London.* 1532.
Oil on wood panel, 37⅞ x 33¾ inches.
Berlin, Staatliche Museen, Gemäldegalerie
Georg Gisze is depicted in his shop, seated in three-quarter view, a pose Holbein often adopted in his portraiture. Everything in the painting is meticulously described: the sitter's calm, youthful face, his rich velvet clothing, and every detail of the objects surrounding him.

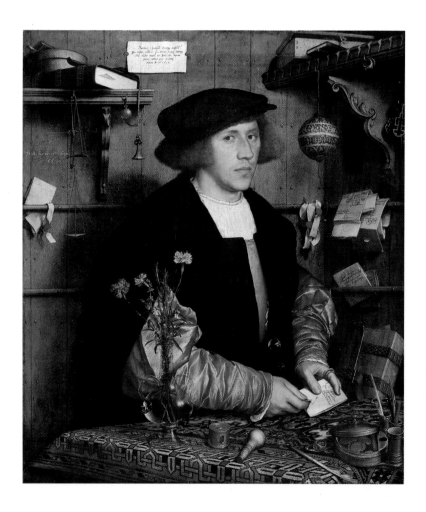

JEAN-AUGUSTE-DOMINIQUE INGRES
1780–1867
painter

Thanks to his father, himself a painter and sculptor, Ingres learned to draw at a very young age. He also learned to play the violin, which remained his favorite pastime for the rest of his life.

In 1791 he enrolled in the Royal Academy in Toulouse, and at age seventeen he went to Paris and was admitted into the studio of the great Neoclassical painter *David.* In 1801 he won the Rome Prize and began to receive his first commissions, all of them portraits (*Napoleon on His Imperial Throne,* 1806).

In 1806 he arrived in Rome, where he admired the ancient monuments as well as Raphael's great frescoes in the Vatican *Stanze* (p. 260). As a scholarship student at the French Academy, he was obliged to send works back to Paris each year. In 1811 he painted the *Jupiter and Thetis,* but when exhibited at the Salon the goddess's neck was criticized as being deformed. Ingres's quest for feminine beauty led to him alter actual bodily proportions, which he was perfectly capable of rendering accurately. This idiosyncrasy has occasioned many jokes, for example, one about his having added three extra vertebrae to the spine of his *Grande Odalisque* to perfect her form.

After many difficult years, in 1820 Ingres was commissioned by the French government to paint *The Vow of Louis XIII,* depicting the king praying before a vision of the Virgin and Child. This time the work was a triumph at the Salon. Marked by the artist's memories of the Madonnas of Raphael, it struck many as the epitome of the classical tradition. Henceforth Ingres became the standard-bearer of

order and balance in painting as opposed to the impetuosity and dynamism of Delacroix.

Ingres opened a painting studio that was immensely successful. He painted *The Apotheosis of Homer* for a ceiling in the Louvre and, in another vein, his famous portrait of Monsieur Bertin (1832), an imposing image of the new bourgeoisie whose power and assurance were growing.

In 1824, Ingres agreed to become director of the French Academy in Rome, where he served for seven years. To his students, he stressed the necessity of copying works by the old masters to attain beauty and insisted that drawing and line were more important than color.

After returning to Paris, Ingres was commissioned to execute large wall paintings for the château of Dampierre and for the Paris Hôtel de Ville, or city hall (*Apotheosis of Napoleon I*). He continued to paint religious works, but his full imaginative scope is best revealed in *The Turkish Bath*, a painting of female nudes that is the masterpiece of his final years.

▼ JEAN-AUGUSTE-DOMINIQUE INGRES. *Louis-François Bertin. 1832. Oil on canvas, 45⅜ x 37⅜ inches. Paris, Musée du Louvre* Founder of the periodical Débats, Louis-François Bertin seems the perfect representative of the prosperous French bourgeoisie of the 1830s. Ingres managed to convey both the social status of the sitter and his willful personality, apparent in the pose. After seeing this work, the great poet and critic Baudelaire pronounced Ingres the only man in France then painting "real portraits."

VASILY KANDINSKY
1866–1944
painter

Kandinsky was born in Moscow, but he subsequently became a citizen of Germany, then of France.

He began his artistic life in 1896, when, aged thirty, he renounced his career as a lawyer, left Moscow, and settled in Munich, then a center of the avant-garde, and especially of Expressionism. He studied painting, traveled between 1903 and 1908 in Italy, Tunisia, and France, and developed friendships with other artists. Like many painters of his day, Kandinsky thought that the power of painting was in color. He gradually abandoned representation, and in 1910 he produced his first abstract work, thought by some to be the first abstraction in Western art (in fact, the Czech painter Frantisek Kupka has equal claims to this honor).

The group of painters he formed in 1911, together with Franz Marc, was dubbed *Der Blaue Reiter* (The Blue Rider), after one of Kandinsky's paintings. Its members organized several exhibitions, but, more important, they published a periodical containing theoretical texts about painting and music, poems, prints, children's drawings, and reproductions of works by *Gauguin* and *Van Gogh*. All forms of artistic expression found a place in its pages, and the activities of the Blaue Reiter encompassed the full panorama of pre-1914 modern art.

This period of intense activity, during which Kandinsky painted his large *Compositions*, came to an end in 1915, when he returned to Moscow. He painted less there, but after the 1917 revolution he helped to found a number of museums and art schools in the young Soviet Union. Unfortunately, government policies in the

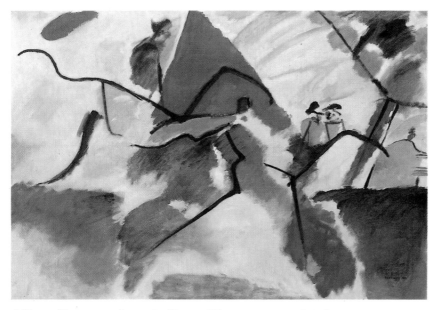

▲ VASILY KANDINSKY. *Impression V.* 1911. Oil on canvas, 41⅜ x 62 inches. Paris, Musée National d'Art Moderne, Centre Georges Pompidou

The forceful presence of the triangular red form in the center is set off by black lines, which unify the composition and articulate the subsidiary areas of color.

▼ PAUL KLEE. *Florentine Villas.* 1926. Oil on cardboard, 19¼ x 14⅛ inches. Paris, Musée National d'Art Moderne, Centre Georges Pompidou

Klee often created patchwork compositions, which allowed him to break down space. Distinctions between interior and exterior, and between detail and whole, are confounded in these schemas, where recession is replaced by superimposed levels.

new state discouraged artistic independence. In 1921, Kandinsky followed the example of many other artists and left the country, joining *Paul Klee* at the Bauhaus, the innovative interdisciplinary school established by the architect Walter Gropius. But the rise of Nazism followed and again obliged him to move. When the Bauhaus was closed in 1933, Kandinsky settled in France, where he joined his painter friends Robert Delaunay and Jean Arp. From this point until his death he painted unceasingly, leading a discreet, rather withdrawn life.

Kandinsky's brand of abstraction is not gestural and spontaneous; his compositions were carefully planned and constructed. He explained his approach in several publications (*On The Spiritual in Art*, 1912; *In Retrospect*, 1913; *Point Line Plane*, 1926), but the best way to grasp how he went about his work is to study the paintings themselves.

PAUL KLEE
1879–1940
painter

Born in Berne, Switzerland, into a family of artists and musicians, Paul Klee long hesitated between music, literature, and the visual arts. After completing college in 1898, he enrolled in the Munich Academy, studied anatomy, and then left for Italy, where he drew unceasingly. The turning point for him came in 1911, when he met *Kandinsky* and Franz Marc, who were then launching the group known as *Der Blaue Reiter* (The Blue Rider), which pioneered abstraction. At about the same time, he also discovered Cubism in Paris and was excited by works by Matisse.

In 1914 Klee went to Tunisia, which provided another shock that confirmed him in his vocation. There, as Matisse had two years earlier, he discovered the light and color of

North Africa. Watercolors from this period already contain in germ all the elements of his later work. Geometricization, deconstruction of optical space, and discreet patches of color became the foundations of his new approach to composition. It was at this point that he first "dared" to paint in oils, a medium he began to use regularly only in 1919.

In 1920 Klee became a professor at the Bauhaus, where he taught for ten years. During this period he explored linear motifs and refined his palette, as can be seen in his famous "patchwork" compositions. In 1929, Klee's fiftieth birthday was celebrated by many great museums. The first retrospective of his work opened in Berlin and traveled to the Museum of Modern Art in New York.

After the Bauhaus, Klee was named to the chair of pictorial technique at the Düsseldorf Academy, but in 1933 the Nazis obliged him to withdraw from the post. There followed a bleak period; Klee developed scleroderma, the illness that eventually killed him, and the motifs in his work became increasingly serious. The faces grew somber, and poetic irony was replaced by spiritual symbols evoking sadness, anguish, and death. The titles of his paintings are telling: *Fear* (1934), *Death and Fire* (1940), *Dark Voyage by Boat* (1940).

Klee died in 1940. With his death the world lost one of the greatest artists of the twentieth century, a painter who, like *Kandinsky* and *Picasso*, helped to lay the foundations of contemporary art. His work exemplifies his own motto: "Art does not render the visible, it renders visible."

GUSTAV KLIMT
1862–1918

painter

The sons of a goldsmith, Klimt and his younger brother Ernst enrolled at the School of Decorative Arts in Vienna. The talent of the two young men was soon recognized, and they opened a studio. In 1886 Gustav Klimt received his first important commission, decorations for the staircase of the new theater in Vienna. Then, for the largest museum in the city, he painted frescoes whose symbolic figures with delicate contours are characteristic of his original style.

In 1894—two years after the death of his brother, which affected him deeply—Klimt accepted a commission from the University of Vienna, for which he painted three allegorical compositions, *Philosophy*, *Medicine*, and *Jurisprudence*. However, Klimt's female nudes were considered ugly and indecent. From this point forward, Klimt, hitherto regarded as a fine painter in the academic tradition, allied himself with the avant-garde. In reaction against official taste, in 1897 he joined with other artists and decorators to found the Vienna Secession. This group, of which Klimt was the first president, organized exhibitions of modern art and crafts. It took as its motto: "To each era its art, to art its liberty."

After a trip to Italy, where he was especially struck by the mosaics at

▶ GUSTAV KLIMT.
Fulfillment. 1905–09.
Gouache on paper with wood backing, 76 x 47¼ inches. Strasbourg, Musée d'Art Moderne
A cartoon for a fresco executed in the dining room of the Palais Stoclet in Brussels, Fulfillment *depicts a subject dear to Klimt: a couple locked in an embrace. The two bodies, rendered without any illusion of relief, dissolve into brightly colored abstract patterns; only the woman's face and the back of the man's head survive intact.*

See: Abstract Art, pp. 164–165.

Ravenna, Klimt entered his so-called "gold" period, using this precious metal to create a sacred aura and to reinforce the mystery of female eroticism. His *Danae* (1905–8), for example, evidences this devotional approach to flesh. During the same period he painted many portraits of people from the upper middle class, in which the hands and faces are rendered realistically but the sitters' bodies dissolve into a profusion of geometric ornament reminiscent of Byzantine and Far Eastern art. The same flattening effect characterizes many of the artist's landscapes, which are painted with small nondescript strokes that evoke the weave of cloth. After developing this economical style, a combination of selective realism and ornamental symbolism, Klimt remained faithful to it until his death in 1918.

GEORGES DE LA TOUR
1593–1652

painter

Georges de La Tour was born in Vic-sur-Seille, in Lorraine, in 1593, into a family of bakers. We know nothing about his training, but he can only have benefited from the brilliant artistic life characteristic of the region at the time. He probably went to Italy to study the work of its famous artists, notably Caravaggio. At age twenty-six he married a young girl from a wealthy family in Lunéville, where he settled the following year. His talent was soon recognized, and in 1623 the duke of Lorraine bought some pictures from him at very high prices.

In 1638 he went to Paris and presented a painting to Louis XIII (*St. Sebastian Tended by Irene*, now lost). The king so liked this work that he hung it in his bedroom, and he at-

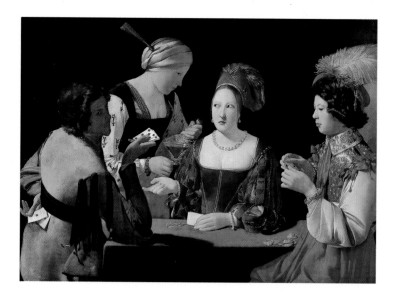

▲ GEORGES DE LA TOUR. *Cardsharps.* c. 1630.
Oil on canvas, 41¾ x 57½ inches. Paris, Musée du Louvre

At the left of this painting, a professional cheater, his face cloaked in shadow, pulls the ace of diamonds from his belt. In the center, a beautiful courtesan awaits the glass of wine that her servant-accomplice has prepared to intoxicate their next victim, the wealthy young man at right. Unaware of the conspiracy taking place before him, he is about to lose all of his money. Unlike the cardsharp at left, the courtesan is brilliantly lit, her white face made all the more striking by the sparkling jewels, sumptuous silks, and dark background that surround her.

tached the artist to the court. But La Tour chose to live in Lunéville, where he was the only artist of renown. In addition, despite his arrogance and greed, he had been accepted by the aristocracy of the region.

La Tour's paintings were in great demand both for private houses and churches. As he was productive, he quickly amassed a fortune. Only some forty of his paintings survive, however, for many perished in the course of the devastation of Lorraine during the Thirty Years' War. La Tour died from the plague in 1652.

La Tour's early paintings depict brilliantly lit scenes enlivened by bright, sparkling colors and glistening embroidery. Typical themes include young cardsharps and a wrinkled old fortune-teller.

The "night pictures," most of which were painted after 1640, are lit

by candlelight. In these works, almost all of which depict religious subjects, the painter suppressed architectural and landscape details, aided by the nature of his chosen light source, which tends to simplify volumes and amalgamate areas of color. All that matters are the faces—often shown gazing downward—and the motionless, silent figures. In one composition they emerge from the darkness around a newborn baby, while in another the Magdalen, her long hair let down, contemplates death. In yet another, the unfortunate Job is reprimanded by his wife, whose immense silhouette dominates the canvas.

The apparent simplicity of La Tour's work, in fact the result of long study, derives much of its effect from his exceptional mastery of light. In his hands it generates mystery, giving his paintings a unique spiritual dimension.

Charles Le Brun
1619–1690

painter

The son of a sculptor, Charles Le Brun had the most brilliant career of all French artists of his generation. After study with the finest masters, in 1642 he made the traditional trip to Rome in the company of *Poussin*, who greatly influenced his early development. He also met many of the great Italian decorative painters of the age. In 1646 he decided to return to Paris.

Le Brun's portrait of Chancellor Séguier (ca. 1655), his first protector, is rhythmic and open in its composition, but its air of solemnity indicates the true nature of his artistic ambitions. Le Brun wanted to resist everyday life, focusing instead on ideas (religion, mythology, royal and noble grandeur) and decorative effects, especially those produced by coloristic brilliance.

Le Brun was so persuasive about the nobility of his art that he convinced others of his views. He played an important role in the establishment of the Royal Academy of Painting in 1648, meant to serve the glory of Louis XIV. The king, grateful for this service, pardoned him for decorating, between 1657 and 1661, rooms in the château of his newly disgraced treasurer Nicolas Fouquet, and placed him in charge of the Gobelins tapestry factory in 1663. The next year he appointed Le Brun first painter to the king.

At the height of his glory, Le Brun directed work at Versailles and imposed his grandiose style on everything within reach. This made him enemies, for he was an authoritarian and demanding taskmaster. However, this discipline imposed unity on the work produced by the many excellent artists under his direction at the Gobelins and at Versailles. Devoted to the glorification of Louis XIV, he placed his stamp firmly on the art of the new Versailles. He was largely responsible for the Ambassadors' Staircase (now destroyed), the Hall of Mirrors, and the Salons of Peace and War. His powers of invention are perhaps more apparent in the thousands of surviving drawings and studies from his hand—including designs for tapestries and interior decoration—than in some of his canvases, where his obsession with regularity and balance can seem deadly. He fell from royal favor in 1685, and his adversaries pronounced him "finished." However, he continued to paint, producing a superb *Raising of the Cross* in less than three months. Loaded with honors, he seems to have found a new freedom in this enforced retirement in his old age.

▼ **Charles Le Brun.** *The Battle of Arbella.* **1669. Oil on canvas, 185 x 497¾ inches. Paris, Musée du Louvre**
Between 1665 and 1673, Le Brun painted four gigantic canvases depicting episodes from the life of Alexander the Great, the greatest general of the ancient world, to whom Louis XIV liked to be compared. In the center of this vast composition, which teems with the intense, agitated movement of battle, Alexander raises his sword and charges toward his enemy, the Persian king Darius, enthroned on his chariot. This epic work is Le Brun's answer to the challenge posed by the famous battle scenes of Leonardo da Vinci, Michelangelo, and Raphael.

See: Classicism, pp. 148–151.

LE CORBUSIER (CHARLES-ÉDOUARD JEANNERET)
1887–1965

painter, architect, and urbanist

Charles-Édouard Jeanneret, now regarded as one of the major figures of modern architecture, was born on October 6, 1887, in Chaux-de-Fonds, Switzerland. Naturalized a French citizen in 1930, he is known as Le Corbusier, the name he used in his first published articles in the magazine *L'Esprit Nouveau* (1920–25). The author of many designs for buildings as well as many urban plans, both in France and abroad, his career spanned more than half a century.

At the art school in Chaux-de-Fonds, where he studied painting, he was a student of Charles L'Éplattenier, a "remarkable teacher" who convinced the young Jeanneret to take up architecture. In 1907, Charles-Édouard left his native Jura Mountains for Italy—carrying only a backpack—to complete his education, thus beginning an extended period of travel that took him to Germany, central Europe, and Greece. In 1917 he settled definitively in Paris.

In the course of his travels Le Corbusier discovered architectural forms that revealed the "intense spirituality" hidden within "the dead stuff of mute stones." Henceforth he strove unceasingly to release this power in his architecture. But his wanderings also brought him into contact with preeminent architects of the day—including Frantz Jourdain and Tony Garnier—and introduced him to new materials, for example, the reinforced concrete used by the Perret brothers in Paris. The Perrets also initiated him into the problems posed by large industrial projects, with which he grappled at the Berlin firm of Peter Behrens.

▲ LE CORBUSIER. **Chapel of Notre-Dame-du-Haut.**
1950–55. Ronchamp, France

At the dedication of this chapel, Le Corbusier explained his intentions in the following enigmatic terms:
"Freedom: Ronchamp. Free architecture. No program other than to serve the Mass. . . .
A worthy personality was always present, namely the landscape, the four horizons. It is they
who were in charge. A veritable phenomenon of visual acoustics: forms make both noise
and silence; some speak, others listen."

All of these experiences enriched his own work, from the Villa Fallet (1905) to the monumental project of Chandigarh in India (1951–63) and the Chapel of Notre-Dame-du-Haut at Ronchamps, France (1953). He was also the author of provocative books and articles on architecture. His *The Five Points of Architecture* (1928) discussed features central to his early work: "pilotis" (thin columns), the free plan, strip windows, the free façade, and roof gardens. *Towards an Architecture* (1923) insisted on a social role for the architect, whose "obligation is to reestablish or establish harmony between man and his environment."

After completing designs for inex-pensive housing (Maison Citrohan, 1922), he conceived of "habitation units," a notion realized between 1947 and 1952 in the Radiant City built in Marseille. Le Corbusier died on August 27, 1965, at Roquebrune-Cap-Martin, having just completed general sketches for a vast complex commissioned from him by the French government in 1962.

See: Collective Housing, pp. 76–77; Houses in Nature, pp. 74–75; The City, pp. 72–73.

CLAUDE-NICOLAS LEDOUX
1736–1806
architect and designer

Claude-Nicolas Ledoux was born in 1736 in Dormans, France. At age thirteen he was granted a scholarship for study in Paris, and in 1753 he decided to become an architect. He took courses at the Academy's School of Fine Arts, won the protection of Madame du Barry, and soon received important commissions, notably to design the Hôtel d'Hallwil in Paris (1766), a pavilion at the chateau of Louveciennes (1771), and stables at Versailles (1773), the last two for Madame du Barry. These designs were in a classical idiom influenced by the architecture of *Palladio*.

Beginning in 1764, Ledoux worked for the Service of Forests and Waterways, for which he built a number of bridges, fountains, and churches in the provinces. In 1771 he was named inspector of the Royal Saltworks of the province of Franche-Comté in eastern France, an appointment that occasioned the most important undertaking of his career, the building of the new saltworks at Chaux. Finding the existing facilities poorly conceived and inefficient, in 1774 he began to design a complex consisting of workshops, offices, and housing in a new style of monumental classicism characterized by massive, unornamented forms. He continued to invent new designs for the saltworks for many years, conceiving of it as an ideal city, with cemetery, a school, and the like. In 1779 he built a new theater in Besançon, and in 1784–85 the Palace of Justice and a prison in Aix-en-Provence.

Ledoux's fall from favor began before the Revolution, with the controversy that resulted from the construction of his monumental designs for forty-five tariff gates on the perimeter of Paris, commissioned in 1784. The reductive masses of these buildings shocked contemporaries, who found them eccentric, oppressive, and even brutal. Ledoux was relieved of his official duties, and during the Revolution, imprisoned. In 1804, he published *Architecture Considered in Relation to Art, Morals, and Legislation*, a unique book in the history of architecture. Ledoux here defended the humanist ideals of the Enlightenment and defined his notion of an "ideal city," which he illustrated with fantastic designs and agronomic projects of great poetry and inventiveness. He died in Paris in 1806.

While Ledoux was inspired by the past, especially ancient and Renaissance models, he drew upon it to develop a highly geometric, grandiose architectural style characterized by a new conception of space that anticipated twentieth-century approaches to design.

▼ CLAUDE NICOLAS LEDOUX. *Farm Workers' House.* Engraving.
Paris, Bibliothèque Nationale de France

For the château de Maupertuis, Ledoux designed two innovative buildings, one for breeding pheasants, and the other to serve as quarters for the farm workers. This is one of the architect's most startling inventions, a work of pure geometry. Ledoux envisioned it as a perfect sphere rising from a depression in the ground, approached by four stairways. On the lower floor he planned to house the barns and stables; above them were to be the workers' bedrooms and kitchen; on the upper level was to be a granary.

FERNAND LÉGER
1881–1955
painter

The son of a cattle merchant, Fernand Léger began his artistic career by studying architecture. He was refused admission to the Academy of Fine Arts in Paris, but he nonetheless painted a number of canvases influenced by Impressionism and Fauvism, all of which he later destroyed.

In the early years of the twentieth century, Léger's work took a new turn prompted by the shock he experienced on seeing the work of *Cézanne*

▼ FERNAND LÉGER. *The Locomotive.*
1920. Oil on canvas, 41 x 52 inches.
Grenoble, France, Musée

All the elements of this composition are treated as volumes of equal depth. The painting, whose three figures are subordinated to the geometric scheme of the whole, reflects Léger's continuing interest in the city, work, and mechanization.

at the Salon d'Automne exhibitions of 1904 and 1907. During these years, which were marked by intense formalist experimentation, Léger was attracted to abstraction in general, and to Cubism in particular.

Conscripted at the beginning of the First World War in 1914, Léger executed many drawings at the front, where he received the second shock of his life: "I was dazzled by a seventy-five mm. canon in full sunlight; it taught me more about my formal evolution than all the museums in the world." Henceforth objects—especially machines, whose sensuality and force he began to discover—became the center of his universe, as such paintings as *Discs* and *Mechanical Elements* attest. Gradually, human figures in the form of workers, whose cause Léger defended during the Popular Front in 1936, were integrated into these schematic, mechanized representations of the world.

In addition to painting, Léger also became involved in film and avant-garde ballet. In 1923 he worked on the sets for *The Inhuman* by Marcel L'Herbier, and a year later he collaborated on the "first plotless film," *Le Ballet Mécanique.* In 1936 he designed

sets and costumes for the ballet *David Triumphant,* choreographed by Serge Lifar at the Paris Opera. He also became increasingly interested in large mural compositions in these years ("wall illuminations"), again turning his attention to architecture and monumental formats.

To escape the Second World War, Léger lived from 1940 to 1945 in the United States, which he had already visited with *Le Corbusier.* After returning to France his interests shifted; figures assumed increasing importance in his canvases, now populated by circus performers, acrobats, divers, and musicians. Two principal themes came to dominate his work: the social epic of work and leisure culture. He sought to honor his political convictions—he was a member of the Communist Party—by developing an "art understandable to all, without subtlety," but one whose basis remained the opposition of masses and the revelation of contrasts.

Léger tried his hand at ceramics, stained glass, and mosaics, and he also produced many church decors. He died in 1955, his place secure as one of the most original figures in the history of modern art.

▶ LOUIS (?) LE NAIN. *Peasant Meal.*
Signed and dated *Lenain Fecit 1642.*
Oil on canvas, 38¼ x 48 inches. Paris,
Musée du Louvre

With its pendant, Peasant Family, *this painting exemplifies the Le Nain brothers' imposing images of peasant life. The white tablecloth at the center of the composition, the focus of a family gathering before a hearth, creates a relieflike effect in the restricted pictorial space. The heavy folds of the family's clothing are broadly modeled in a restrained palette of browns and grays with a few enlivening notes of red.*

THE LE NAIN BROTHERS

ANTOINE
ca. 1595/1600–1648
LOUIS
ca. 1595/1600–1648
MATHIEU
ca. 1607–1677

painters

Much about the lives of the Le Nain brothers remains obscure, as is so often the case with artists of their period. We know that they were born into a middle-class family in Laon, France, that they arrived in Paris in 1629, and that they soon achieved success there. They were among the first members of the Royal Academy of Painting, established in 1648, but illness carried off the two elder brothers that same year, leaving Mathieu alone. To that point the three had always collaborated, and, despite subtle differences, their work coheres as a stylistic unity.

The light palette and oblique point of view of their *Allegory of Victory* give it a peculiar fascination, but it is exceptional in their output. In general, the Le Nain brothers preferred powerful, high contrast modeling and intimate compositions in which the play of gazes is important, whether in religious works (many of which have disappeared, destroyed by fire or during the Revolution), mythological paintings, portraits, or the many peasant scenes that assured their posthumous reputations. They avoided the amusing anecdotes and picturesque details so often found in other artists' treatments of such themes, instead depicting their figures as silent, serious, dignified, and imposing.

The Le Nains ennobled humble subject matter, bestowing a mysterious allegorical aura on peasant gatherings, but they treated conventional "noble" subjects with a disarming freshness. Their *Nativity* has an unprepossessing meditative quality that is quite moving, but the goddess in their *Venus in the Forge of Vulcan* lacks all solemnity. She has been transformed into a rather buoyant woman who, mischievous Cupid in tow, has just circled the workshop, to the decided interest of its artisans.

LEONARDO DA VINCI
1452–1519

painter, writer, and inventor

Leonardo was born in Vinci, a small town not far from Florence, in 1452. At age seventeen he was apprenticed to the painter Andrea del Verrocchio in nearby Florence, where he received a wide-ranging artistic education. After leaving his master's workshop, the monks of San Donato in Scopeto commissioned an *Adoration of the Magi* from him, which he left incomplete in 1482, when he left Florence to go to the court of Ludovico Sforza in Milan. To convince the duke of his talents, he wrote a long letter detailing his many accomplishments as an engineer and painter. He was hoping to win the commission for an equestrian statue that the duke had planned to erect in memory of his father. Convinced, the duke engaged him. Leonardo spent almost twenty years at the court in Milan, during which he never stopped designing projects for this monument, which he envisioned as gigantic, its rearing horse and rider cast as a single piece of bronze. In the end the work never progressed beyond a wood and plaster model.

As an engineer Leonardo oversaw hydraulic projects, and he also designed sumptuous processions and entertainments for the court. In 1495 he painted one of his most famous paintings, the *Last Supper* for the refectory of the monastery of Santa Maria della Grazie.

Leonardo left Milan after the fall of the duke in 1499 and returned to Florence, where in 1503 he began the portrait of a woman now known as the *Mona Lisa*. At this time the Signoria (town council) of Florence commissioned from him an immense fresco for the Large Council Chamber in the Palazzo Vecchio (town hall).

▲ LEONARDO DA VINCI. *The Last Supper.*
1495–98. Fresco. Milan, Convent of
Sta. Maria delle Grazie

*Commissioned by Ludovico Sforza, Duke of
Milan, for the convent refectory, this fresco depicts
Christ's last meal with his disciples. He has just
announced that one of them will betray him, and
thus bring about his death.*

*Executed in a mixture of oil and varnish on a
damp wall, the painting has deteriorated badly, and
has been damaged—and restored—repeatedly.
Nevertheless, it has retained a surprising force.
Even today the space of the refectory seems to
encompass the table at which Jesus and his twelve
disciples take their last meal together. The disciples,
divided into two groups of six by the figure of*

*Christ at the center, recoil in shock at what they
have just heard. Christ, however, remains serene.*

*Leonardo constructed this perspectival space
with the lines that delineate the room converg-
ing on Christ's head at the center. The other
figures, despite their richly varied postures, are
rhythmically related to his, which forms a pivot
for the composition.*

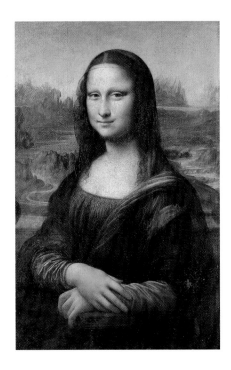

◀ LEONARDO DA VINCI. *Mona Lisa.*
1503–05. Oil on wood panel, 30⅛ x
20⅞ inches. Paris, Musée du Louvre

*This famous portrait is thought to represent Lisa
Gherardini, daughter of Francesco del Giocondo,
which is why it is also called* La Gioconda. *If it
is indeed she, Lisa is shown in a black veil of
mourning for the death of her young daughter.
Perhaps Leonardo intended to express her intense
sadness by placing her against a deserted landscape
of mountains and rocks. She seems to dream sadly
of times past, a hint of a smile barely lifting the
corners of her mouth. To convey a sense of his
sitter's complex interior life, Leonardo used a
technique of his own invention, that of* sfumato,
*a soft modeling of forms that seems to dissolve
the figure into its background.*

This was to be a depiction of a historical victory of the Florentines over the Pisans, the *Battle of Anghiari*. Unfortunately, the fresco was later destroyed, as was the full-scale cartoon from which Leonardo worked, but surviving drawings give us some idea of its composition, a virtual whirlwind of furious warriors on splendid horses in battle.

For ten years Leonardo traveled in Italy, moving between Milan, Rome, and Venice. In 1517 he went to France, where Francis I showered him with honors and named him First Painter, Architect, and Engineer to the King. He died in 1519 at the château of Cloux, in the Loire Valley near Amboise, at the age of seventy-seven.

Leonardo da Vinci is one of the most extraordinary men of history. The almost superhuman power of his intelligence made it possible for him to grasp the scientific principles of nature more fully than anyone else of his time. Mathematician, physicist, biologist, astrologer, architect, painter, sculptor, and musician, he explored the human body, described the flight of insects and birds, and imagined human flight and war machines. He also studied the action of light, the patterns of the movement of rivers and other bodies of water, and the stars and planets.

A secretive man, Leonardo kept notebooks all his life, recording, in great disorder, everything relating to his thoughts and projects, in the form of drawings, fantastic stories, and descriptions of his inventions and discoveries. Written backwards, these notes are unreadable without the aid of a mirror.

Leonardo painted very little and left many works incomplete. Only some ten compositions trace his artistic development, but these reveal his determination to fathom the mysteries of life, and to capture the souls of his models in paint.

RENÉ MAGRITTE
1898–1967
painter

After studying at the Academy of Painting in Brussels, René Magritte discovered Futurism and Cubism, which greatly influenced his way of seeing things. In 1923 the painter Giorgio De Chirico initiated him into Surrealism; three years later he became a member of the Society of Mystery, to which many Belgian Surrealists belonged. It was during this period that he met the writer André Breton in Paris, where Magritte resided between 1927 and 1930, when he definitively returned to Belgium.

During these first decisive years, Magritte developed an original version of Surrealism. He used precise drawing and smooth brushwork to render strange compositions exploring the relations between objects. A means of understanding the world, but in a way "inseparable from its mystery," painting became for Magritte an occasion for surprising transformations. In his idiosyncratic vision, the sky may become a wall, or a pair of lace shoes may gradually transform into two pink feet. The absurdity of some of these images obliges the spectator to question the mechanics of language and representation. Magritte's startling juxtapositions, which often have a rebuslike quality, manage to shake us out of complacency. A painting like *The Use of The Word* (1936) is a good example. In a room with a stairway leading nowhere, the word "siren" appears on the floor, the "I" having been replaced by a giant finger with a bell on its tip. Max Ernst's remark that Magritte "makes collages painted entirely by

▶ RENÉ MAGRITTE. *The Red Model.* 1935. Oil on canvas, 22 x 18⅛ inches. Paris, Musée d'Art Moderne, Centre Georges Pompidou *In this work, painted with the artist's characteristic precision, Magritte delineates one of his strange visions: as a pair of boots stand in front of a nondescript wooden fence, waiting to be pulled on by an unimaginable owner, they are transformed into human feet.*

hand" applies perfectly here.

Within his restricted set of chosen images (the house, the sea, the sky, everyday objects), Magritte manages to evoke the poetry that is always around us. The man in a bowler hat, a recurrent figure that first appears in his work in 1926, has effectively become his emblem. Whether seen from the back or from the front (in which case his face is masked by a passing bird), he retains his mystery, which is that of the human condition in general.

Renowned for his illustrations of Lautréaumont's *Songs of Maldoror* and Paul Éluard's *Necessities* as well as for his pervasive influence on advertising imagery and even Pop Art, Magritte remains above all an incomparable "magician of signs" and a key figure in the history of Surrealism.

ARISTIDE MAILLOL
1861–1944

painter and sculptor

Born into a family of farmers, Aristide Maillol left his native Pyrenees to study at the School of Fine Arts in Paris on a scholarship provided by the local government. At the school, he studied with the academic painters Jean-Léon Gérôme and Alexandre Cabanel, and became friends with the sculptor Antoine Bourdelle, who would later be a great support to him in times of difficulty, and the painter Maurice Denis, who introduced him to the work of *Paul Gauguin*. Maillol began his career as a painter working in a manner related to that of Gauguin, depicting women with simplified forms in bright colors (*Woman with a Parasol*). When the Art Nouveau style became fashionable, Maillol became passionately interested in tapestry, and opened his own workshop in 1893. His work in this medium quickly won admirers and was shown at the Salon de la Libre Ésthétique in Brussels.

In the late 1890s Maillol was struck by an eye disease, which forced him to abandon both painting and tapestry. Almost forty years old and having devoted ten years to painting, he now turned his attention to sculpture, the medium for which he is best known today. He first made wooden reliefs, then female bathers modeled in clay, and soon he had developed his characteristic manner of smooth shapes over which the eye glides unimpeded. Most of his sculptural works are female nudes. For Maillol, these massive yet graceful figures embodied a contemporary restatement of the ideals of ancient sculpture.

Maillol's allegiance to the classical tradition achieved full realization in his archetypal female nude, *The Mediterranean* (c. 1901), which was exhibited internationally and brought him both fame and critical praise. From this point forward his pieces, produced in various materials, were avidly sought by both museums and private collectors.

Maillol's work has continued to elicit admiration long after his death. Today he remains one of the best loved twentieth-century interpreters of the female form.

▶ ARISTIDE MAILLOL. *The Mediterranean* (plaster model). 1902–05. Executed in marble, 1923–27, 43¼ x 46⅛ inches. Paris, Musée d'Orsay

Exhibited at the Salon d'Automne in 1905, this work won Maillol his first state commission, in 1923, for the Tuileries Gardens. Upon seeing this nude woman with a pensive air, free of encumbering narrative, André Gide wrote in the Gazette des Beaux-Arts: "She is beautiful; she signifies nothing; this is a silent work. I think one must revert far into the past to find such a complete disregard for all preoccupations foreign to the simple manifestation of beauty."

ÉDOUARD MANET
1832–1883
painter

Born into a cultivated family, Édouard Manet convinced his father to allow him to study with the painter Thomas Couture. He completed his education with visits to the Louvre and trips to Holland and Italy.

In 1861, he exhibited *The Spanish Singer* at the Salon, which won him his first success. In 1862 he exhibited *Music in the Tuileries*, which depicts the crowd at an outdoor concert, caught in a moment as if by the snap of a camera. To most critics and the public, this picture seemed too casual for a serious painting, its sketchlike brushwork and seemingly random composition unpleasantly chaotic.

The public's annoyance became outrage the following year at the Salon des Refusés of 1863. This event had been organized, with the approval of the emperor Napoleon III, to exhibit paintings rejected by the official Academy Salon. Manet presented *Picnic on The Grass*, a painting of two contemporary French gentlemen in afternoon dress seated nonchalantly on the grass in a park, in the company of a completely nude woman. What Manet had apparently thought of as an updating of the pastoral art of Giorgione and Titian (p. 142) was taken by many observers as a voyeuristic, even mildly pornographic, insult to serious art.

Reluctantly, Manet found himself a leader of a group of young artists who had broken with the official art establishment. Two years later his work became the focus of another controversy when he exhibited *Olympia* (p. 155) at the Salon. In this painting Manet dared to depict a nude woman, not in an antique setting but in contemporary surroundings, staring boldly out at the viewer without a shred of embar-

rassment. As with *Picnic on the Grass*, public and critics were ill at ease with nudity presented without idealization, and they denounced the painting for its "vulgarity."

Disappointed by the incomprehension of public and critics, Manet left France for Spain, where he studied the works of Velázquez. In *The Fifer*, he achieved a synthesis of his Spanish models. Here the figure is set against a solid gray ground; the artist has refused all relief effects and half-tones, playing with the contrast between light and dark colors.

Excluded from the Universal Exposition of 1867, Manet erected a pavilion of his own opposite that of *Courbet*. The works he exhibited were harshly criticized, but they won the admiration of many younger artists. Despite the criticisms, Manet continued to try to exhibit at the official Salons, refusing to participate in independent exhibitions, including the first Impressionist one organized by *Monet* in 1874. Nevertheless, Manet and Monet became good friends, and Manet even spent his summers near Monet's home at Argen-

▲ ÉDOUARD MANET. *Picnic on the Grass*. 1863. Oil on canvas, 81⅞ x 104 inches. Paris, Musée d'Orsay

When this painting was exhibited at the Salon des Refusés in 1863, many young artists considered it to be the manifesto of a new art. Abandoning any attempt at surface finish, Manet worked with a painterly brush, favoring starkly contrasting areas of light and dark. This approach was denounced by the salon critics as painting "by spots." Public and critics alike were also startled by the unprecedented juxtaposition of gentlemen wearing fashionable clothes with a realistic—and obviously contemporary—female nude.

teuil. Indeed, Monet's influence seems to have induced Manet to lighten his palette.

Manet devoted his last years to painting scenes in popular restaurants and cabarets. In 1879 he began his final masterpiece, the *Bar at the Folies-Bergères*, exhibited at the Salon of 1882. This remarkably complex tour de force multiplies mirror reflections around the central figure of a barmaid, who remains aloof from the spectacle unfolding around her.

See: Impressionism, pp. 156–157; The Painters of Reality, pp. 154–155.

FRANÇOIS MANSART
1598–1666

architect

François Mansart was born in 1598, in his father's carpentry workshop in Paris, where he later learned the woodworking trade. Later, he worked in the firm of his uncle, a master mason, where he was introduced to architecture. After an initial commission of 1624 for the façade of the church of the Feuillants in Paris, Mansart quickly found his personal style around 1626, with the construction of the château of Balleroy. Thereafter he remodeled a number of existing châteaus and hôtels (private town houses) in Paris. What Mansart offered his clients was an elegant, and distinctly French, reinterpretation of the classical architectural vocabulary. He achieved this by using antique Roman forms—columns, pediments, cornices, and the like—but instead of incorporating them structurally, he used them as decorative elements, to articulate and enrich traditional French building types. His decorative details are gracefully proportioned and crisply carved, and they give his buildings a majestic and timeless refinement.

In his early remodeling projects Mansart demonstrated an ability to re-think conventional solutions to both practical and aesthetic problems. His work began to attract attention, and in 1635 he received a commission to rebuild part of the château at Blois for the king's brother, Gaston d'Orléans. Only one wing of this planned renovation was realized (1635–38), but it remains an eloquent statement of Mansart's architectural style. Between 1635 and 1645 he built the Hôtel La Vrillière in Paris, which over a period of almost two centuries served as a model for such private houses. In 1642 Mansart received another important commission, this one for the château at Maisons, which he was allowed to design completely himself. This elegant château with its exquisite details stands as an almost perfect example of a seventeenth-century country house.

Incapable of making a firm decision, Mansart never ceased revising his designs. On occasion, as at Maisons, he even demolished portions of a building already erected, hoping to improve it. Not surprisingly, some patrons grew weary of this, fired him, and found a new architect. At the Val-de-Grâce convent in Paris, for example, Mansart was originally commissioned to design both a church and a palace for Queen Anne of Austria, but he was later dismissed and only the church was built according to his plans. Likewise, shortly before his death he received two important royal commissions, one for the façade of the Louvre and another for the funerary chapel of the Bourbons at the cathedral of Saint-Denis. Once again, his inability to settle on a definitive design caused him to lose both commissions. Mansart died in Paris in 1666. His name has entered popular speech in the term "Mansard roof," which signifies a roof with a steep, broken profile that the architect was believed to have invented.

▶ **ANDREA MANTEGNA.** *Calvary.* Panel from the predella of the San Zeno altarpiece. c. 1457–60. Oil on wood panel, 29⅞ x 37¾ inches. Paris, Musée du Louvre

Mantegna painted the large altarpiece of which this panel was originally a part for the church of San Zeno in Verona, in northern Italy. In 1797 the altarpiece was dismembered by soldiers in Napoleon's army and taken to France as war booty. Only the upper portion was later returned to Verona. The costumes worn by the Roman soldiers gambling for Christ's tunic reveal Mantegna's intense interest in accurately reconstructing antiquity. To increase the illusionism of the scene and to augment its tragic import, he constructed a dramatic perspectival space whose lines converge on Christ's cross at the center.

▼ **FRANÇOIS MANSART.** *Château of Maisons.* 1642–46. Maisons-Lafitte, near Paris

In this château Mansart perfected his variant of the classical style. The clarity of the plan and its subordinate forms, and the elegance of Mansart's details are combined here to achieve a uniquely satisfying result.

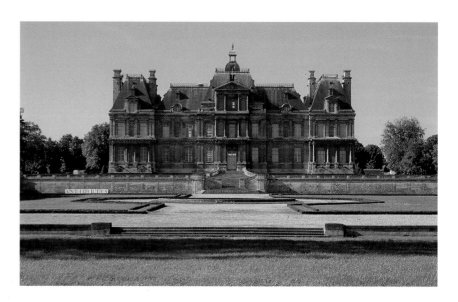

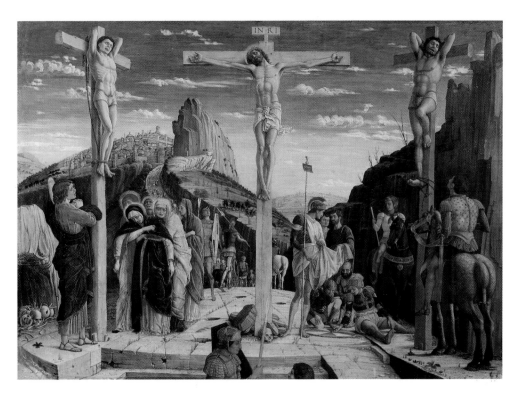

ANDREA MANTEGNA
1430/1431–1506

painter

Born near Vicenza, Italy, Andrea Mantegna was only fifteen years old when he became an apprentice in the Padua workshop of his adoptive father, the painter and antiquarian Francesco Squarcione.

Mantegna was interested all his life in the most recent developments in Renaissance painting; thus, as a youth, he was fascinated with Roman antiquity and scientific perspective. These preoccupations are already apparent in one of his earliest commissions, a series of frescoes relating the life of St. James in the church of the Eremitani in Padua (1454–57). These paintings, executed in Mantegna's rather dry, hard-edged style, are full of antique details that seem to have been quoted directly from Roman reliefs; they likewise show that the young artist's mastery of scientific perspective was complete. Mantegna

also may have pioneered painting on canvas instead of on traditional wooden panels; his *St. Euphemia,* produced in the early 1450s, is thought to be the earliest work in Italy on this support.

Mantegna enjoyed an enormously successful career almost from the beginning. In 1453 he married a daughter of the Venetian painter *Jacopo Bellini* (and sister of *Gentile* and *Giovanni Bellini*), thereby becoming a member of the most important artistic family in Italy. In 1459 he was hired by Ludovico Gonzaga, the marquis of Mantua, as official court painter, a post he occupied until his death in 1506. For the Gonzaga princes he organized court entertainments, painted altarpieces, and decorated their various family residences. The most remarkable of these interiors is the Camera Picta ("painted chamber"), also called the Camera degli Sposi ("bride and groom's chamber"), an audience hall (completed in 1474) in the Gonzaga palace in Mantua (p. 138). In this magnificent room, whose decorative program glorifies the Gonzaga family, the artist has integrated full-length por-

traits of the marquis, his family, and his retainers with illusionistic architecture in a portrayal of court life that extends completely around the room. Especially ingenious is the ceiling, which displays a sharply foreshortened central opening, or *oculus* (Latin for "eye"), with a view upward to an imaginary roof garden.

Mantegna's experiments with perspective reached a climax after a visit to Florence in 1466. Soon after that trip, he painted a drastically foreshortened *Dead Christ,* a view of Jesus's laid-out body looking from the feet toward the head. This dramatic composition, which seems almost to propel the body of Christ into the arms of the viewer, was copied, engraved, and circulated widely throughout Europe. It proved to be extremely influential, not only in Italy but in Germany, where *Albrecht Dürer* and other artists studied and imitated it.

In 1490, the young marquis Francesco Gonzaga married Isabella d'Este of Ferrara, a highly erudite princess with a famous collection of art and antiquities. For Isabella's private study,

where the collection was kept, Mantegna painted two magnificent pictures of antique subjects, *Mount Parnassus* and *Pallas Expelling the Vices from the Garden of Virtue*. These paintings, the artist's last major works, show a smoother, more elegant side to his art.

This original, unclassifiable artist—who was also an excellent engraver—left an extraordinary body of work of exceptional power and erudition. His influence continued to be felt throughout Italy and in Northern Europe well into the seventeenth century.

SIMONE MARTINI

ca. 1284–1344

painter

Born in Siena, Italy, Simone Martini was probably a student of the great early fourteenth-century master Duccio di Buoninsegna, who painted in a highly refined late Byzantine manner. Simone's own style, however, owes more to the influence of Gothic art than to any Byzantine precedent. Simone's fresco of the *Maestà* (Madonna in majesty), a lavish depiction of the Virgin surrounded by saints and angels painted in the Palazzo Pubblico (city hall) of Siena between 1311 and 1317, clearly shows a knowledge of the figure style of *Giotto*. The form of the Virgin's throne suggests a knowledge of French Gothic architecture.

Simone's fame soon spread beyond Siena. He was summoned to Naples, to the court of Robert of Anjou, who made him a knight. Around 1317 he painted *St. Louis of Toulouse Crowning his Brother, Robert of Anjou, King of Naples*, a large altarpiece whose base is decorated with five small scenes depicting the events of the saint's life. These scenes, too, combine Gothic architectural settings with figures

clearly influenced by Giotto.

Simone worked in a number of cities, including Pisa, Orvieto, and above all Assisi, where one of the principal patrons of the Church of St. Francis, Cardinal Gentile da Montefiore, commissioned him to provide frescoes for the Chapel of St. Martin, in the lower church. Executed between 1312 and 1319, these refined and harmonious paintings, full of the rich patterns that often characterize Sienese art, show Simone's narrative art at its best.

In 1333 Simone collaborated with his brother-in-law Lippo Memmi to produce a large *Annunciation* altarpiece, the first in Western art in which this subject—the angel's annunciation to Mary of her impending motherhood—is the whole subject: In the central panel, which is by Simone himself, the Gothic strain in his art has come to the fore. The Virgin's swaying figure and delicate hand gesture, and the elegant

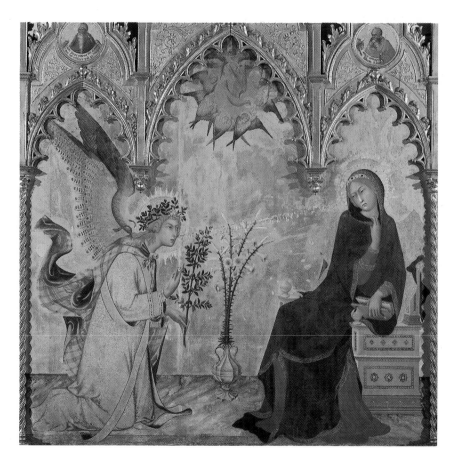

▲ SIMONE MARTINI and LIPPO MEMMI. *The Annunciation*. 1333. Tempera on wood panel, 72½ x 82⅝ inches. Florence, Uffizi Gallery

Against a richly tooled gold ground that reinforces this work's refined opulence, the painters represented the moment in which the archangel Gabriel announced to the Virgin Mary that she would give birth to Jesus. The Virgin recoils elegantly in genteel surprise, pulling her mantle more closely about her.

▶ MASACCIO. *The Expulsion of Adam and Eve from Paradise*. Fresco, 84¼ x 35⅛ inches. Florence, Sta. Maria del Carmine, Brancacci Chapel

With the expressiveness of Eve's remorseful, screaming face and Adam's hunched, shamed posture as he hides his face in his hands, Masaccio introduced a new emotionality to Renaissance art.

curves of her drapery and that of the angel clearly recall the forms of French Gothic sculpture. This composition was highly admired and much imitated in the following years.

Simone spent his last years in Avignon, in southern France, where he traveled in 1336 to work at the papal court, which was in residence there. In Avignon he painted the panels of a polyptych, of which the *Return of Jesus from the Temple*, completed in 1342, was his final work.

Simone's influence was strongly felt on both sides of the Alps. His work in Provence exerted considerable influence on the development of the art of southern France, just as his earlier work was much imitated by younger Sienese artists.

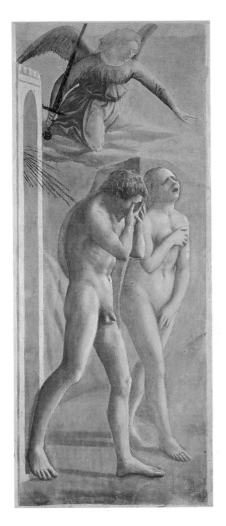

MASACCIO (TOMMASO DI SER GIOVANNI)
1401–1428
painter

Tommaso di Ser Giovanni, known today by his nickname of Masaccio, was born in the upper valley of the Arno River not far from Florence, where he settled as a young man. We do not know who taught him to paint, but his mastery of scientific perspective and his robust, strongly modeled figures owe so much to the examples of the architect *Brunelleschi* and the sculptor *Donatello* that it would not be an exaggeration to call them Masaccio's true teachers.

In 1422–28 Masaccio collaborated with the painter Masolino da Panicale on a cycle of frescoes in the Brancacci Chapel in the church of S. Maria del Carmine in Florence, which represents two events from the story of Adam and Eve, and a number of scenes from the life of St. Peter. In the episodes that Masaccio painted, both the feeling of space and the monumentality of the figures are revolutionary. They represent, in fact, a turning point in the history of Western painting, and the first coherent statement of the Renaissance pictorial style.

Masaccio's scenes—*The Expulsion of Adam and Eve from Paradise; The Tribute Money; St. Peter Healing the Sick with His Shadow*—break totally with the tradition of Gothic painting. First, the artist assigned a new importance to light as a means of modeling forms and projecting volumes. Contributing to this emphasis on volume is a deliberately simplified palette, which is concentrated on the interaction of a few complementary colors. Second, Masaccio's mastery of perspective was total; the space of the paintings is rigorously constructed, with every detail, even the saints' halos, foreshortened in accord with the overall perspective system.

Finally, and most importantly, Masaccio rendered human emotion with an unprecedented intensity. Each figure exhibits a distinct personal presence and force of character that seem utterly true to life.

Masaccio's debt to Brunelleschi is again apparent in his convincing perspectival treatment of the space in the fresco *The Trinity* (p. 136), painted on a wall of the Florentine church of Sta. Maria Novella, as it is in his *Virgin Enthroned with Angels*, the central panel of a polyptych executed in 1426 for a church in Pisa.

One of the most important figures of fifteenth-century Italian art, Masaccio died prematurely at age twenty-seven. Despite his youth, he left a considerable body of work that establishes him as one of the founders of Renaissance painting.

HENRI MATISSE
1869–1954
painter and sculptor

Henri Matisse was born in 1869 in the Cateau-Cambrésis, in northern France. In 1890 his interest in art took him to the Louvre, where he copied old masters, and also to the commercial art galleries, where he discovered the painting of the Impressionists. Matisse then became friendly with the painter Paul Signac and through him became acquainted with the work of the Neo-Impressionists. In 1905, he spent a summer in Collioure, in southern France, with the young painter André Derain. Their passionate discussions focused on color and its use as a means to render the strong Mediterranean light. As Matisse expressed it: "I feel by color." And indeed, for him color was almost a sixth sense. He used pure pigment, just as it came from the tube, so that oranges and violets

sparkle immediately next to burning yellows and acid greens.

When Matisse exhibited his brilliantly colored *Woman in a Hat* along with similar works by his painter-friends at the 1905 Salon d'Automne in Paris, the artists were dubbed *fauves* (wild beasts) by a journalist. This joking remark is the source of the name Fauvism, which now denotes the works that exhibit their brilliant color and excited, rhythmic brushwork.

At the Salon des Indépendants of 1906, Matisse exhibited a large painting entitled *The Joy of Life*, his depiction of the mythical Golden Age of peace and happiness. Here, amid nymphs and satyrs, embracing couples savor the delights of an earthly paradise. This glowing work, animated by outline figures filled with unmodulated color, marks the beginning of Matisse's mature style. Indeed, he was

to express light and happiness in his paintings until the end of his life.

Until 1918, Matisse's favorite models were his wife and children. He generally portrayed subjects drawn from everyday life, but transfigured them with his dazzling use of color. He traveled to Spain, Morocco, and Tahiti, and finally settled in Vence, in southern France. There he flooded his studio with light to paint his favorite subject: women, nude or clothed (often in exotic dress), pensive or asleep. As time went on, he drew more and more, and he also sculpted both male and female nudes.

In the late 1940s Matisse was commissioned to create decorations for the Chapel of the Rosary at a convent in Vence. In this space conceived for meditation, he combined brightly colored windows with walls animated by stark outline compositions in black

▼ HENRI MATISSE. *Dance II*, 1909–10. Oil on canvas, 102⅛ x 154 inches. St. Petersburg, Hermitage Museum

The Russian collector Schukin commissioned Matisse to paint Dance *and* Music *to decorate his residence in Moscow. When he first saw these works, his shock was such that for several days he refused to install them.*

Matisse's strange, savage dance does indeed produce a shocking effect, not unlike that evoked by his earlier Joy of Life. *Here he has managed to convey the essence of the dance solely by means of intense, contrasting colors and simple lines that seem to vibrate with pure energy.*

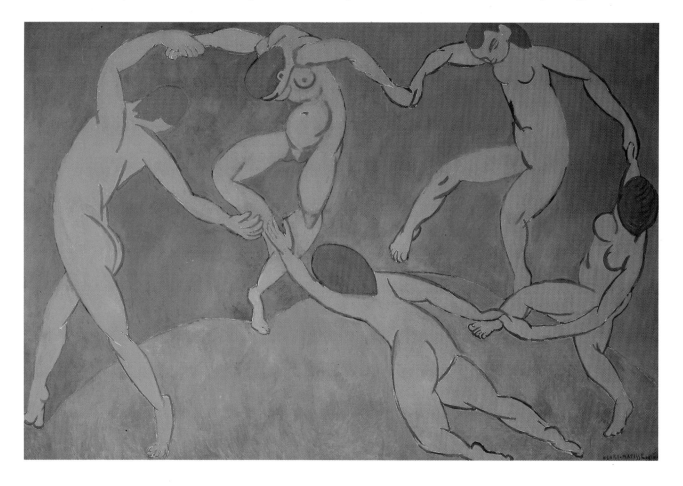

and white, dominated by a tall silhouette of St. Dominic.

When illness made it difficult for Matisse to wield a brush, he took scissors to colored paper, cutting out wonderfully expressive forms. In his new role as a "tailor of light," he continued to make these cut-outs until the end of his life (*The Sadness of the King; Large Blue Nudes*). Henri Matisse died in Nice in 1954, at the age of eighty-four.

HANS MEMLING
c. 1433/40–1494

painter

Hans Memling was a German by birth, and he seems to have spent part of his youth in Cologne. The earliest document that mentions him is from 1465, when he was awarded citizenship of the town of Bruges, in Flanders (now in Belgium). He was to live in Bruges, one of the most important financial centers of Northern Europe, most of his life. There he clearly prospered, receiving commissions from the businessmen of the city, including a number from Italian and English merchants who were living there.

Memling's style suggests that he was a student of *Rogier Van der Weyden*, and indeed, he seems to have quoted certain figures of Rogier's outright in some of his own paintings. His first masterpiece, a *Last Judgment* (1467–71), possibly commissioned by the Florentine merchant Tommaso Portinari, is clearly a reworking of Rogier's own version of this subject (p. 274).

Memling's earliest known works, such as the *Donne Triptych* (c. 1480), which depicts a *Virgin and Child with Donors, Angels, and Saints*, already exhibit the feeling of calm and emotional remove that characterizes all of his work. This, and his remarkably metic-

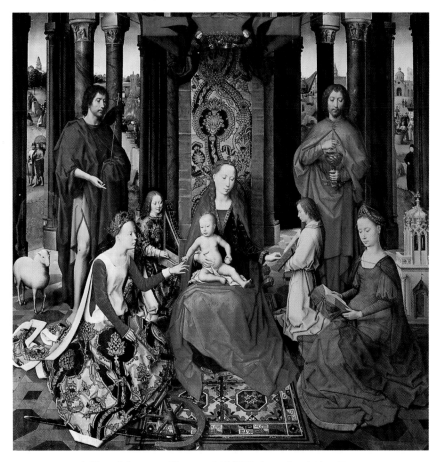

▲ HANS MEMLING. *Virgin and Child Enthroned with Four Saints* (central panel from the *Saint John Altarpiece*). 1474–79. Oil on wood panel, 68⅛ x 68⅛ inches. Bruges, Belgium, St. John's Hospital

This triptych exemplifies Memling's work at its best. The technical virtuosity evident in the meticulous rendering of its details, together with its monumental composition, make this one of the artist's masterpieces.

ulous technique, which often recalls that of *Jan van Eyck*, are especially apparent in the *St. John Altarpiece* (above, right), painted in 1474–79. The central panel shows the Virgin and Child enthroned with Sts. Catherine, Barbara, John the Evangelist, and John the Baptist.

Memling was plainly aware of late Gothic manuscript painting. His *Shrine of St. Ursula*, a reliquary casket decorated along the sides and on the lid with scenes from the saint's life, is much indebted to manuscript illumination. Memling was also a superb portraitist, whose wonderfully vivid likenesses—for example, that of *Mar-*

tin Van Nieuwenhoven in the superb diptych he commissioned, and the single-panel portraits of Sibyl Sambeth and Tommaso Portinari—attest both to his chromatic subtlety and his psychological penetration.

Memling embraced the naturalism of rendering details, space, and volume that characterizes the Renaissance in both Italy and Northern Europe. Yet his serene and graceful images seem also to recall the poetry of the late Middle Ages. He remains an artist poised between two worlds, one of medieval legends, and the other the new world heralded by the dawning Renaissance.

See: The Renaissance, pp. 136–147.

MICHELANGELO (MICHELANGELO BUONARROTI)
1475–1564
sculptor, painter, architect, and poet

In 1488, Michelangelo, the son of a minor Tuscan nobleman, entered the Florentine workshop of the painter Domenico Ghirlandaio. After barely a year he was invited into the household of the ruler of Florence, Lorenzo de' Medici, where he was introduced to a cultivated circle of humanists, and was allowed to study the splendid Medici collection of antiquities. His surviving drawings also show that at this time he was studying the work of three of the greatest Florentine masters, *Giotto*, *Masaccio*, and *Donatello*.

The Sculptor
Michelangelo maintained that as a sculptor he was self-taught; he had spent part of his childhood in Settignano, a village of stonecutters near Florence, and had thus become familiar with the technique of stone carving from a very young age. He always took a keen interest in the marble itself, traveling to the quarries to select his own blocks. According to one of his poems, he believed that certain shapes were inherent in the stone, and that the process of cutting it away was, in a sense, actually liberating a form that dwelt within it. Indeed, sculptures that he left incomplete do often look as if a figure were emerging from the marble.

With the colossal *David*, completed in 1504, Michelangelo recast a familiar figure from the Old Testament as a heroic antique nude animated with exceptional strength. Impressed by the young sculptor's growing reputation, Pope Julius II summoned him to Rome in 1505, to design and carve a monumental tomb for himself in St. Peter's Basilica. Michelangelo's design

was a complex multileveled structure with niches containing a host of marble figures, including an over-life-sized statue of the prophet Moses. The project was interrupted after a year, and was only completed, in a much diminished form, in 1545. The superb *Moses*, however, with its flashing gaze that communicates the moral grandeur of a man chosen by God, is one of the sculptor's finest works.

The tomb of Julius II also started Michelangelo thinking about the integration of figures with architecture, a line of thought that soon bore fruit in his design for the Sistine Ceiling (see below).

Between 1520 and 1530, Michelangelo was in Florence, working in a chapel of the church of San Lorenzo that houses the tombs of the Medici family. These marble monuments are dominated by recumbent female figures of *Day*, *Night*, *Dawn*, and *Twilight*, whose powerful bodies give them a masculine appearance. Until his last days, the sculptor continued to work on a *Pietà* for the Medici tombs. Tormented by the futility of pursuing perfection, he was increasingly unable to complete his marble sculpture.

The Painter
In 1508, Julius II asked Michelangelo to paint figures of the Apostles on the vault of the Sistine Chapel in the Vatican. The artist persuaded the pope to allow him to design a program of frescoes for the entire ceiling. He set to work on this in early 1509, and four years later, after exhaustive months of painting while lying on his back on scaffolding, finally completed it. The full program tells the story of Christian history from the Creation—of the world, of Adam (p. 141), and of Eve —to the Expulsion of Adam and Eve from Paradise, through the story of Noah and the Flood. Michelangelo set these scenes within an elaborate painted architectural framework, sup-

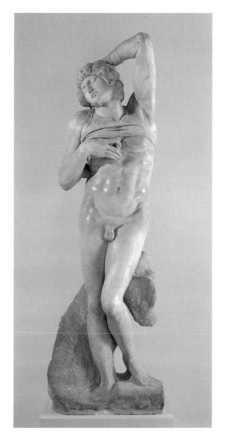

▲ MICHELANGELO. *Dying Slave* (for the tomb of Julius II). 1513–15. Marble, height 89¾ inches. Paris, Musée du Louvre

This figure succumbing voluptuously to unconsciousness was originally intended as a caryatid for the tomb of Pope Julius II. Its supple, exquisitely rendered musculature, exemplifies one of the many sides of Michelangelo's virtuosity.

▶ MICHELANGELO. Figure of Christ from *The Last Judgment*. 1536–41. Fresco. Rome, Sistine Chapel

This powerful figure represents Christ as the judge of humanity at the end of time. Even the Virgin, to his left, seems to shrink from his terrifying majesty.

ported by heroic male nudes, whose elaborate poses express a range of emotions. Between the windows of the upper story he depicted the massive figures of Old Testament prophets and antique sibyls who had predicted the coming of Christ.

Recent cleaning has revealed that the Sistine Ceiling is painted in brilliant colors that seem to make every figure pulsate with life. Thus, although Michelangelo's powerful draftsmanship might be expected to dominate the ceiling, he is revealed here as a colorist of extraordinary originality.

Twenty-four years later, in 1536, Pope Paul III commissioned Michelangelo to complete the Sistine Chapel program with a great fresco of the *Last Judgment* on the wall behind the altar. Completed in 1541, the scene that unfolds is a terrifying vision of the end of the world, swarming with the nude figures of the risen dead, with a majestic figure of Christ as judge at its center. Trumpeting angels welcome the saved to Heaven, as the damned are carried away to Hell in the barque of Charon.

The Architect

In architecture, too, Michelangelo demonstrated real genius. At the age of sixty, at the peak of his fame, he was asked by Pope Paul III to redesign the summit of the Campidoglio, as the ancient Roman Capitol Hill was then called. The pope wanted to erect at the center of this new square one of the few surviving bronzes from Roman antiquity, an equestrian statue of the emperor Marcus Aurelius. Set at haphazard angles on the hilltop were a palace and a church. On this unpromising site Michelangelo laid out a trapezoidal area with an oval space in the center as a setting for the statue. Then he built two palaces fronting on the square, each with a façade defined by magnificent giant columns. The superb balance of these façades creates a monumental stage for public pageantry.

Perhaps Michelangelo's greatest architectural work was his design for the completion of St. Peter's Basilica in the Vatican, which had remained unfinished since the early years of the century. Beginning in 1549, he devoted the final years of his life to this project, giving the exterior of the basilica its characteristic form by emphasizing its compact, central plan, and articulating the outer wall with massive pilasters and cornices. The effect of these powerful members is a grand muscularity that seems akin to that of the knotted torso of his heroic *David*. The dome, which he had envisioned as a hemisphere with a very high lantern, remained unfinished at his death in 1564.

Profoundly religious, Michelangelo was wracked by intense spiritual crises. The weakness and indignity of humanity in the face of God troubled him deeply. This inner torment was expressed in his art, which is perhaps the most majestic manifestation of Renaissance humanism.

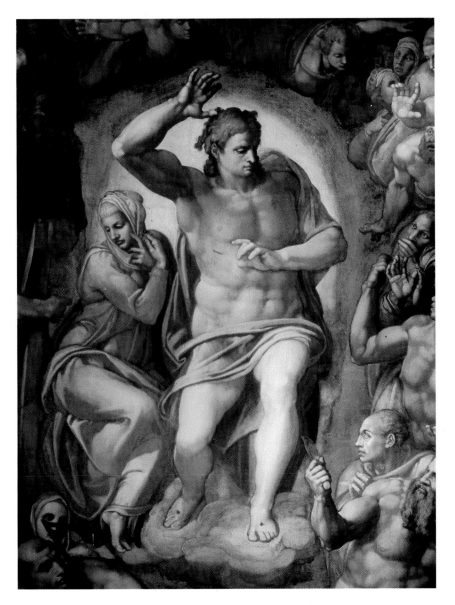

JEAN-FRANÇOIS MILLET
1814–1875

painter

Raised in the French countryside, Jean-François Millet began to draw at an early age. His father sent him to Cherbourg, on the English Channel in northwestern France, where he was taught painting in accordance with the Neoclassical principles of *David*. In 1838, the young man won a scholarship to go to Paris and enter the workshop of Paul Delaroche, a history painter. He made a close study of works by *Mantegna* in the Louvre, and he also greatly admired *Michelangelo* and *Poussin*. He first earned a living by painting portraits, and in 1840 one of his paintings was accepted for the Salon of 1840. During the following years he began to paint fewer portraits, turning his attention instead to nudes and genre scenes, the early manifestation for what would become his main interest, rural genre subjects.

Millet was greatly moved by the popular revolution of 1848, which toppled the government of the last French king, Louis Philippe, and he resolved at this time to devote himself to portraying the lives of common people. The following year he left his family in Paris to settle in Barbizon, a small town to the southeast, where he remained until the end of his life. He rented a farmer's cottage, transformed a barn into a studio, and rediscovered the climate and atmosphere of his youth. Thereafter his painting concentrated on the difficult lives of rural people at a time of profound social change, when country people were migrating in large numbers to the newly industrialized cities.

Some of Millet's contemporaries, uneasy about the threat of a popular uprising, considered his works political and social statements in favor of an oppressed underclass. In fact, the artist sought not to paint the rural poor as a social class but to portray individuals. Although paintings like *The Winnower* (1848), *The Sower* (1850), and *The Gleaners* (1857; p. 154) represent traditional peasant types, the viewer is always aware of the figures' specific humanity.

After 1865, rural themes became fashionable, bringing Millet a fame that his work has enjoyed ever since. Millet finally won official recognition, and in 1868 he was awarded the Legion of Honor. Illness unfortunately prevented him from accepting a commission to provide a painting for the Pantheon, a church in Paris dedicated to national heroes. In 1875 he died at Barbizon. His work influenced many artists, including Van Gogh, who admired Millet's draftsmanship and his genre scenes, and considered him a spiritual guide.

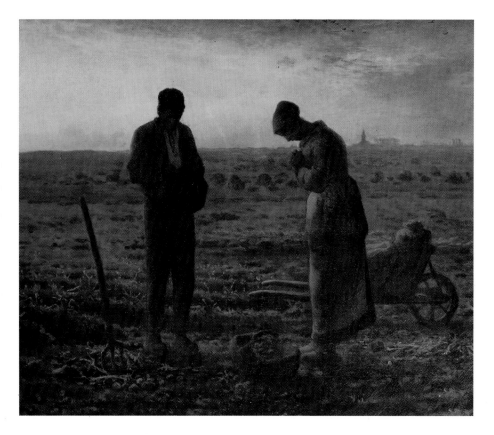

◀ JEAN-FRANÇOIS MILLET. *The Angelus*. 1858. Oil on canvas, 21⅞ x 26 inches. Paris, Musée d'Orsay

Having just heard the bell for evening prayer, a farm couple at work in a field stops to offer their devotions. Motionless and silent, they stand in a classical composition that gives their figures a solemn, monumental dignity. The high horizon line accentuates the impression of extended space in the picture. With its simple forms and somber colors, this work is typical of Millet's straightforward, unidealized depictions of peasant life.

Joan Miró
1893–1983
painter and sculptor

From his early youth, Joan Miró, the son of a Catalan goldsmith and clocksmith, showed signs of a taste for drawing. In 1907 he began business school, but at the same time he took courses at the School of Fine Arts in Barcelona. In 1911 he fell gravely ill and went to a farm owned by his family in Catalonia to recover. There he resolved to become a painter.

Attracted by Fauvism and Cubism, he frequented the Gali academy in Barcelona (where he met the Dadaist painter Picabia), but in 1919 he set out for Paris. There he became friendly with *Picasso* and other members of the avant-garde, notably the Surrealists, whom he soon joined. This was a decisive step. Maintaining that painting had been in a period of decadence ever since the prehistoric art of the Lascaux caves, Miró's motto became: "Assassinate painting!" He began to use new materials such as metal, string, and wood, and to invent a playful, fantastic universe free of all constraint. André Breton, despite his admiration for De Chirico, considered Miró, a painter-poet, as "the most Surrealist of us all." In fact, Miró's inventive forms (most of which derive from either stains or arabesque lines), their freedom, his sense of spatial play, and his use of letters and words in his "picture-poems" result in an art of great singularity.

In 1932 Miró exhibited at the Pierre Matisse Gallery in New York, and he began to explore the possibilities offered by lithography. The Spanish Civil War obliged him to live in France, in Varengeville, on the Normandy coast. After returning to Barcelona, he became interested in ceramics and in large compositions.

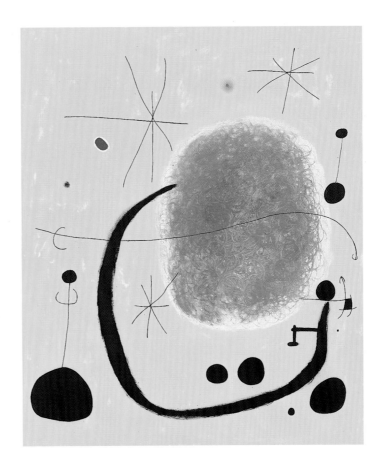

▲ Joan Miró. *Gold and Azure.* 1967. Acrylic on canvas, 80¾ x 68⅜ inches. Barcelona, Joan Miró Foundation

All of Miró's obsessions are brought together in this large canvas: a monochromatic ground against which the various elements of the painting stand out; the star motif; the blue stain (taken from the 1925 painting This Is the Color of My Dreams*); and the black arabesque, the painter's signature. The interplay of these forms and colors gives the composition the lightness and freedom so characteristic of Miró's work.*

Refusing to join forces with a group of abstract painters, dubbing abstraction a "deserted house," Miró pursued his art in solitude, producing his culminating large monochromatic works in the 1950s and 1960s (*Blue I, II,* and *III*). His final years were devoted primarily to ceramics and sculpture.

"I spent a great deal of time with poets, for I thought it necessary to go beyond visible form to attain poetry." This statement by Miró sums up his work. Rarely has an artist so successfully instilled his painting with a sense of the marvelous. This can still be seen at the Miró foundation opened in Spain in 1976, which houses many of his works.

See: Dadaism, p. 166; Surrealism, p. 167.

AMEDEO MODIGLIANI
1884–1920
painter and sculptor

Suffering from tuberculosis, at age fourteen Modigliani convinced his mother to let him devote himself to painting. After study in the museums of Rome, Venice, and Florence, in 1906 he settled in Paris, in Montmartre, where he established ties with a number of people in the Paris art community, including *Picasso*, the Cubist Juan Gris, and the poet Guillaume Apollinaire. Modigliani's good looks, his use of alcohol and narcotics, and his tumultuous love life soon made him a focus of scandal and a tragic hero to his friends. As an artist, he assimilated the most recent avant-garde developments from Fauvism to Cubism by way of African sculpture, which had a crucial effect on his work.

After a brief sojourn in Livorno in 1909, Modigliani returned to Paris. Shortly thereafter, he met *Brancusi*, who so inspired him that he settled in Montparnasse, home to many sculptors, and for three years he devoted himself entirely to that medium. Poor health prevented him from continu-ing his work, but this brief experiment, combined with his discovery of African art, taught him how to evoke volume by means of delicate and precise draftsmanship. He then began a successful career painting society portraits, producing almost two hundred such works within two years. His combination of a dissipated life-style with an elegant dress and manner made him appealing to middle-class art lovers, and his painting, moreover, was much easier to grasp than the fractured forms of Cubism or the inscrutable shapes of pure abstraction. Modigliani deliberately remained on the fringes of the Parisian avant-garde, although he remained thoroughly familiar with the milieu.

Modigliani's figures are strangely, even troublingly, anonymous. He always painted the same woman, whose almond eyes, swanlike neck, and sloping shoulders evoke some African masks, and whose supple nude form fills out his canvases perfectly. Jeanne Hébuterne, his companion from 1917 on, inspired the most beautiful portraits of his final years. Faithful to his legend to the end, Modigliani died in a hospital of infectious meningitis. The following day the distraught Jeanne jumped out of a window to her death.

PIET MONDRIAN
(PIETER CORNELIS MONDRIAAN)
1872–1944
painter

At age twenty, Mondrian obtained a diploma qualifying him to teach drawing, but he soon renounced that career, and enrolled in the Academy in Amsterdam and made his living by painting portraits. He also became interested in theosophy ("divine knowledge"), a mystical doctrine combining Buddhist and Indian theories of pantheism and reincarnation, which was to influence his thought and art from then on.

Between 1904 and 1912, Mondrian roamed the countryside and the seashore observing architecture and the landscape. He was struck by alignments and repetitive vertical forms, and he painted increasingly stylized and schematic depictions of churches, trees, and dunes. The dominance of vertical and horizontal lines was also characteristic of Cubist work, which he saw in Paris in 1912.

After returning to Holland, he resumed his serial paintings, reducing them to patterns of plus and

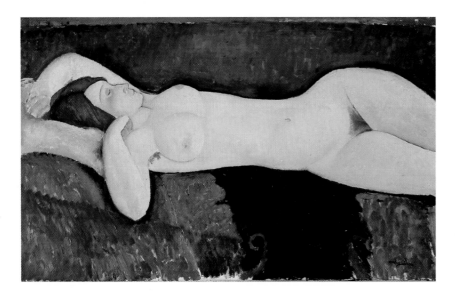

◀ AMEDEO MODIGLIANI. *Large Nude.* c. 1919. Oil on canvas, 28½ x 45⅞ inches. New York, Museum of Modern Art

This is the most imposing of the nudes painted by the artist between 1916 and 1919. In each of them, Modigliani attempted to transform his model into a stylized representation of an ideal woman. The beauty of the female body is emphasized by the imposing masses of the breasts and the roundness of the hips. Modigliani generally painted his canvases in a single session of posing, with the result that they often have an unfinished appearance. Here, the fabrics of the background are barely roughed in.

minus signs, which for him summed up the essential masculine/feminine, spiritual/material oppositions of the universe. In 1915 he met Theo van Doesburg (1883–1931), with whom two years later he founded the group and magazine *De Stijl* (*Style*), where he elaborated a theoretical basis for his approach. This work, a pioneering form of abstraction known as Neo-Plasticism, was based on the oppositions of colors (the primaries red, yellow, and blue) and noncolors (black, white, and gray), as well as of verticals and horizontals.

After a series of diamond-shaped paintings begun in 1918, Mondrian embarked on an extended series of paintings organized by perpendicular black bands of unequal width enclosing blocks of pure color. He spent almost a decade painting close to seventy such works, sometimes introducing important variations in the basic schema.

Between 1919 and 1938 Mondrian resided in Paris, where he belonged to the group Cercle et Carré (Circle and Square), which in 1932 was renamed Abstraction-Creation. As suggested by the names of these groups, abstraction was at the center of his preoccupations. In this rectangular universe, he

simplified his formal means, striving for idiosyncratic, asymmetrical balance between his colored masses.

Fleeing the war, in 1940 he sought refuge in New York. Inspired by the city's energy, he replaced his black bands with colored lines animated by small rectangles of varied color. The results have a new joy and rhythmic vitality suggestive of the jazz dance known as "boogie-woogie," a word that rightly figures in the titles of works dating from 1942 and 1943. He died in New York in 1944.

▼ **PIET MONDRIAN.** *Composition in Black and White.* 1917. Oil on canvas, 42½ x 42½ inches. Otterlo, The Netherlands, Rijksmuseum Kröller-Müller
This work is composed entirely of geometric figures—plus and minus signs—and executed with a minimal palette.

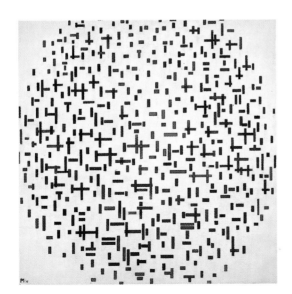

CLAUDE MONET
1840–1926
painter

Claude Monet spent his youth in Le Havre, in northern France. At high school he was bored by his teachers and scribbled caricatures in his notebooks. He met the painter Eugène Boudin, who took him on trips to the countryside, initiating him into the pleasures of painting a subject on site. By this time Monet was almost twenty and eager to learn to paint, but not in a conventional art school, which he expected to find too rigid. Moving between Le Havre, Sainte-Adresse on the Norman coast (where his family had a summer house), and the forest of Fontainebleau southeast of Paris, he simply painted. He became friends with other painters, a few of them, like *Courbet*, already well known, and even more—*Manet, Renoir,* Pissarro—soon to become so. All roughly the same age, they often went together to the seashore or to suburban spots along the Seine, where restaurants and dance halls for weekend leisure provided them with subjects.

Despite his lack of money, Monet painted passionately and unceasingly. His large portrait of Camille, his companion, was admired by the critics at the Salon of 1866. The next year, however, to his great despair, his *Women in the Garden* was refused by a jury increasingly hostile to the young generation of experimenters.

Now a father, Monet was obliged to seek financial support from his friends. He found lodgings in Bougival, outside Paris, that would permit him to paint in the open air, as he wanted. Renoir was his closest neighbor. Together they went to La Grenouillère, a floating restaurant on the Seine frequented by Sunday canoers, where they used rapidly applied flecks and commalike brushstrokes of brilliant hue to convey

▶ CLAUDE MONET. *Women in the Garden.*
1866. Oil on canvas, 100¾ x 81⅞ inches.
Paris, Musée d'Orsay

*Monet was determined to execute this canvas
directly "from the motif," that is, in the open
air. It was the season for gathering flowers. His
companion, Camille, modeled for three of the
figures: first as the one in a striped dress at left,
again as the one whose face is half hidden by a
bouquet, and finally, as the one seated in the
foreground, her face caressed by the shadow of
her parasol. Monet applied the paint thickly and
in broad strokes, dividing his canvas into large
areas of light and shadow.*

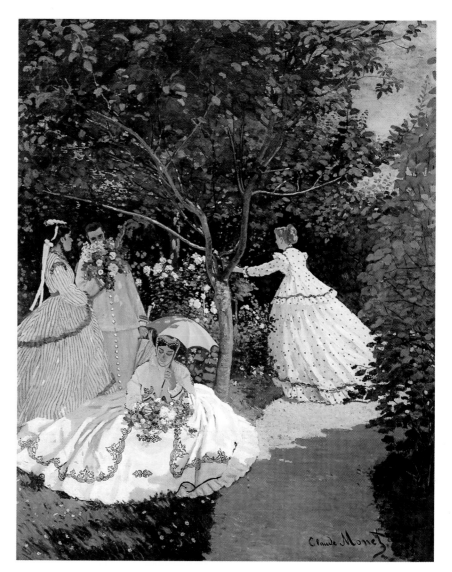

movement and life, and especially to
capture the effect of shimmering water.

The Franco-Prussian War erupted
in July 1870. Monet left France for
London, where he joined Pissarro and
met the dealer Paul Durand-Ruel,
who bought several paintings from
him. Back in France, he settled with
his family in Argenteuil, on the Seine
close to Paris, where his painting ac-
quired a new luminescence. He sup-
pressed dark shadows and developed
a deliberately imprecise manner of
delineating form. He also juxtaposed
bright colors, making them vibrate
with one another by applying thick
strokes directly onto a white ground.

Monet and his friends decided to
organize an exhibition on their own,
without jury or prizes, with, among
others, *Renoir, Cézanne,* Pissarro, and
Degas. The show opened its doors on
April 15, 1874, in the studio of the
photographer Nadar. It was on this
occasion that a critic, commenting on
Monet's *Impression, Sunrise,* coined
what was intended to be a derisive
term, "Impressionist." His response
was typical; the press covered the ex-
hibition with ridicule.

In 1877 Monet left Argenteuil to
settle close to the Saint-Lazare train sta-
tion in Paris. Like Gustave Caillebotte

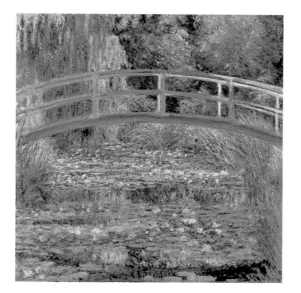

◀ CLAUDE MONET.
*Water-Lily Pond: Harmony
in Green.* 1899. Oil on
canvas, 35 x 36⅝ inches.
Paris, Musée d'Orsay
*As soon as he settled in
Giverny Monet decided to
create a water garden full of
flowers, with irises, water lilies,
and wisteria, surmounted by a
wooden Japanese bridge. He
painted the bridge several times.
Here it seems drenched in the
predominantly green shades of
the garden.*

(1848–94) and *Manet* before him, he was tempted by the theme of the railroad. This aspect of modern life attracted him, and, on several occasions, he set up his easel beneath the large shed roof of the station to paint the locomotives arriving amid clouds of smoke.

Eventually Monet decided to return to the countryside, where he could paint nature. After the death of Camille in 1879 he traveled constantly, carrying his canvases and boxes of pigment and painting. Later, when he had found a new companion, Alice, he sought a place to live with their children, hoping to find a house near the water with a garden for painting in the midst of the countryside. He finally found the house of his dreams in Giverny, on a stream close to the Seine, where he moved in 1883.

Monet was now fifty years old and already famous, with exhibitions of his work becoming more frequent. His painting continued to evolve. In 1890 he began his first series, of grain stacks. Then, in 1895, another series, of Rouen cathedral (p. 26). The exhibition of these works, painted at different times of day, was a revelation to the public, who were astonished by their formal nuances and chromatic subtlety.

Giverny, where Monet planted an elaborate garden with a lily pond, now became his principal focus. In 1909 he exhibited a series of water-lily paintings, in which the viewer's gaze becomes lost in colored reflections. Despite the death of Alice in 1911 and the outbreak of war in 1914, Monet continued to paint with passion.

In 1918, to celebrate the armistice, he presented to France, through the intermediation of the statesman Georges Clemenceau, an ensemble of panoramic water-lily paintings now permanently installed in the Orangerie Museum in Paris. These constituted the final statement of this artist, whose innovative work here approached abstraction. Monet died at Giverny in 1926.

HENRY MOORE
1898–1986
sculptor

The English sculptor Henry Moore rarely left his native country, although he was well aware of contemporary developments in art, and was responsible for introducing modern sculpture to an England previously inclined to favor painting. Beginning in 1925, he pursued his own work and taught as well, training several generations of artists. Even after he had become an internationally established figure his teaching remained inventive. His art always challenged tradition, and remained idiosyncratic to the end of his life.

Moore served as a foot soldier in World War I and was even gassed during the battle of Cambrai. After the war, he was the only student in the newly created sculpture department at the University of Leeds, from which he moved on to the Royal College of Art in London. In 1923 he began a series of trips that took him to Italy and, especially, to Paris. There he met *Brancusi* and *Picasso* and encountered the most revolutionary art movement of the day, Surrealism. He also discovered the *Large Bathers* by *Cézanne*, which greatly impressed him (he described it as "stones in a landscape"). He executed his first sculptures in cement, a material well suited to his characteristic forms, and resistant to weather.

Suppleness and monumentality were constants in Moore's work, generally large-scale figures intended for outdoor settings. These include large standing or reclining nudes, figures of women and children, or abstract pieces. Despite their sometimes enormous size, their fluid shapes make them seem truer to life than either the representational shapes of traditional sculpture or the geometric constructions of Cubism. Moore often played with voids, opening spaces within the bodies of his pieces that suggest their evolution in time and space.

Moore drew prolifically throughout his career, using the same concave and

▼ HENRY MOORE. *Reclining Figure.*
1938. Horton stone, length: 54¾ inches.
London, Tate Gallery

Only a few indications—head, breasts, an elbow, a knee—make it possible to identify this work as a female figure. All his life Henry Moore remained devoted to the forms of the human figure, creating works ideal for placement in the open air, where their organic forms complement the landscape.

See: Surrealism, p. 167.

convex forms, interlocking volumes, and spatial movement as he employed in his three-dimensional work. He produced several series of such drawings (*Studies of Miners at Work*, 1942; *Sheep and Lambs*, 1972), perhaps the most compelling being his series drawn in the bomb shelters during the London blitz, which are remarkable for their almost hallucinatory intensity and sense of suppressed terror. After his studio was bombed in 1940, he established the Henry Moore Foundation at Perry Green, some thirty miles north of London, where he continued to work until his death in 1986.

EDVARD MUNCH
1863–1944

painter

Edvard Munch was five years old when his mother died of tuberculosis; nine years later he lost his sister to the same disease. He was raised by his father, a doctor serving the poor, and his world was always marked by illness and death. At age sixteen he enrolled in the school of arts and crafts in Oslo, Norway, and painted his first portraits, depicting his relatives and friends.

In 1889, having won a scholarship, he traveled to Paris, where he almost immediately fell into a debilitating depression upon learning of the death of his father. It was during this dark period, however, that he discovered the work of Gauguin and the Impressionists.

After returning to Oslo, where an exhibition of his work attracted great attention, he was invited to exhibit his paintings in Berlin in 1892. There the uncompromisingly personal subject matter of his paintings so shocked the organizers of the exhibition that they shut it down after only a week. However, in this short time Munch's work had

deeply impressed a number of young German artists, and it was to exercise a strong influence on German Expressionism. Munch's painting *Evening on Karl-Johann Street* shows the degree to which Munch had assimilated the lessons of Impressionism and distanced himself from realist conventions. He reduced forms to areas of color, often dark and flatly applied, contained within sinuous outlines recalling the arabesques of the Art Nouveau style. The anguished emotional content of his paintings, however, could hardly be more distant from either Impressionism or Art Nouveau. *The Scream* and *Anguish* particularly convey his tragic, almost desperate sense of life. In Paris, at the Salon des Indépendants of 1897, Munch exhibited his *Dance of Life*, a pessimistic vision of human destiny.

A difficult period of instability and depression began in 1898, during which the artist painted somber landscapes (*Summer Night at the Seashore*). With the onset of a serious psychological crisis, he entered a clinic. After his release he remained in Norway, where the University of Oslo commissioned frescoes from him entitled *The Mountain of Men*.

These paintings mark his return to a more figurative art and a lighter palette.

In 1937 Munch took part in the International Exposition in Paris, at the very time when, in Germany, the Nazi government was seizing his canvases, which it considered examples of "degenerate" art. In his old age Munch produced a series of self-portraits recording his unceasing exploration of his own destiny (*Nocturnal Vagabond*, 1939).

A precursor of Expressionism, Munch's work greatly influenced that of a number of German artists, particularly Emil Nolde, Ludwig Kirchner, and Erich Heckel.

▼ EDVARD MUNCH. *The Scream.*
1893. Pastel and tempera on cardboard, 35⅞ x 28¾ inches. Oslo, National Gallery
Munch later recounted how the idea for this painting came to him: "I was walking one evening on a road. On one side was the town and the fjord below me. I was tired and ill. I stood looking out across the fjord. The sun was setting. The clouds were colored red, like blood. I felt as though a scream went through nature." In painting this landscape, the artist infused it with the colors of the anguish experienced by the figure in the foreground.

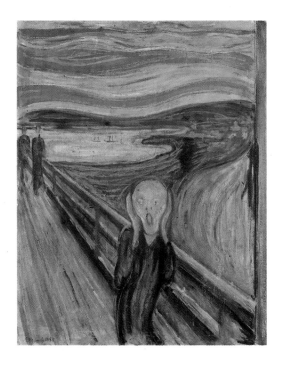

 See: Impressionism, pp. 156–157; Expressionism, pp. 162–163.

PALLADIO (ANDREA DI PIETRO)
1508–1580
architect

Andrea di Pietro was born in Padua in 1508. At age sixteen he left his native town for Vicenza to learn the craft of stonecutting. There he met the humanist scholar Giangiorgio Trissino, who, sensing his talent and looking for a collaborator in his own work, taught him classical art, and introduced him to the writing of the ancient Roman architect and theorist Vitruvius. Trissino also gave him the name Palladio. Palladio resolved to commit himself fully to architecture, which he believed the only means that might permit a reactivation of the achievements of the classical world.

At age thirty, Palladio began to work as an architect. In Vicenza he erected a number of public buildings and palaces (Palazzo Chiericati, c. 1547). Beginning in 1559 he worked in Venice (San Giorgio Maggiore, c. 1566) and throughout the Veneto, where he built a number of superb villas. His spare classical style, grounded in ancient models but always practical and elegant, assured his success.

Palladio seemed to find his greatest expressive freedom in the design of villas. His ideas for these private country dwellings are derived not from Roman houses, but from temples, with central plans and façades with triangular pediments supported by columns. He generally integrated the barns and other service buildings into a unified structure linked to the main residence. However, each of his villa designs embodied new variations on this theme (Villa Godi in Lonedo, c. 1540; Villa Barbaro in Maser, c. 1562; Villa Rotunda, near Vicenza, c. 1567; Villa "Malcontenta" on the banks of the Brenta Canal, c. 1569).

Palladio revealed the full extent of his gifts in his Venetian church designs, which reflect his growing experience and maturity. San Giorgio Maggiore (c. 1566) and the church of the Redentore (c. 1576), with their high domes and pedimented façades, have come to symbolize his art.

In addition to his work as an architect, Palladio published several books, including *The Antiquities of Rome* (1554), an illustrated edition of Vitruvius, and the *Quatro Libri* (*Four Books*, 1570), in which he explained the basic principles of his art: symmetry, ancient inspiration, purity of form, and balanced proportions. This treatise was widely read, and was immensely influential throughout Europe.

Since the seventeenth century, Palladio has been widely recognized as one of the greatest architects of all time. In the eighteenth century particularly, Palladianism, as the widespread adaption of his designs was called, was a mainstream movement in the English-speaking world. Superb examples of this style can be found in Great Britain and in North America, including Lord Burlington's Chiswick House, near London (begun 1725), Willliam Kent's Holkham Hall, in Norfolk (begun 1734), and Thomas Jefferson's Monticello, near Charlottesville, Virginia (begun 1796).

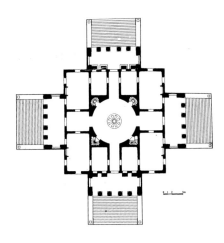

▼ ANDREA PALLADIO. **Villa Capra, known as the Villa Rotunda. 1566–69. Vicenza, Italy**
Above: plan. Below: elevation and cross section. Inspired by the Pantheon in Rome, the Villa Capra was built on a hilltop overlooking the Italian countryside near Vicenza for Canon Paolo Almerico. Its design is symmetrical, with the four branches of its cruciform plan leading outward from its central domed rotunda to four columned porches crowned by triangular pediments. Many people consider it the quintessential Palladian villa.

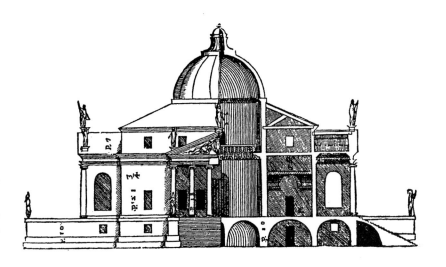

PABLO RUIZ Y PICASSO
1881–1973

painter, sculptor, and printmaker

Pablo Picasso was born in Malaga, Spain, in 1881. Immensely gifted, at a young age he passed all the entry examinations for art school in both Barcelona and Madrid. In 1900 he exhibited for the first time, a hundred drawings in a fashionable Barcelona café called Els Quatre Gats (The Four Cats). He was already eager to leave Spain, however, and he soon moved to Paris. In Picasso's early years in Paris he painted melancholy subjects in a cold, blue palette, and thus this is known as his Blue Period. He settled in Montmartre, in the Bateau-Lavoir, an old wooden building that was a virtual anthill of artists who maintained studios there and often encountered one another on its twisted stairs. The group of friends that Picasso formed at this time, including painters, musicians, and writers, lived in serious poverty, but nevertheless seem to have carried on productive, exciting, even joyous, lives. Around 1904 the art dealer Ambroise Vollard began to buy Picasso's canvases, and as the artist's critical and financial fortunes improved, his palette began to lighten, ushering in his warmer, more colorful Rose Period.

In 1907, at age twenty-six, Picasso painted *Les Demoiselles d'Avignon*. Although his friends were at first horrified by his harsh, angular treatment of the female nude in this painting, he was soon joined in his experiments by his friend, the painter *Georges Braque*. Working together, the two artists invented Analytic Cubism, by breaking down objects into simple volumes and recombining them into single images seen from different angles simultaneously. Thereafter Picasso embarked on a series of stylistic phases that continued to evolve throughout

▶ **PABLO PICASSO.**
Les Demoiselles d'Avignon.
1907. Oil on canvas, 96⅛ x 92 inches. New York, Museum of Modern Art
Picasso often visited the anthropological museum in Paris, where he was fascinated by the African sculptures and masks, which seemed to him almost to possess magical powers. He was especially intrigued by the masks' stylizations of the human face, and they inspired him to explore similar abstract and geometric forms in his own work. In painting this picture, he broke down the forms of the women into faceted shapes, shifting their noses and drawing their ears to resemble figure eights, radical distortions unprecedented in Western art.

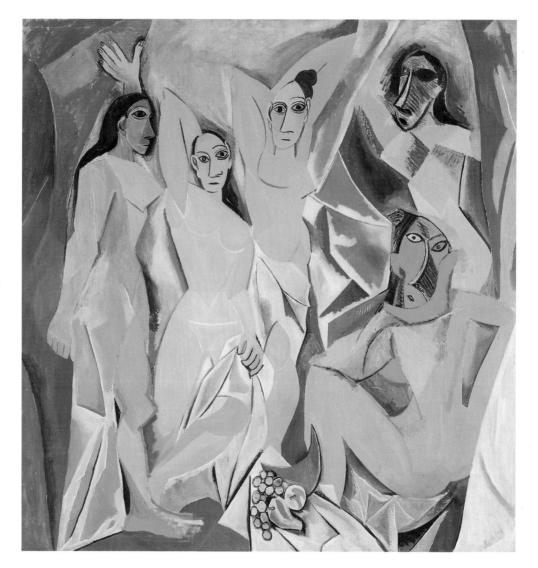

his life. Many critics were unsettled by the Protean character of his art. His subject matter, however, tended to remain personal, being generally derived from his own life and the lives of his friends.

In 1918, Picasso married the Russian ballerina Olga Koklova. The birth of his first child, Paulo, in 1921, filled him with joy; he loved to paint him dressed as Harlequin or Pierrot. In this period Picasso's paintings—for example, one in which two giant bathers cavort on a sun-drenched beach—reveal the depth of his personal contentment.

The marriage, however, was not happy for long. In 1927 Picasso met a young girl still in her teens, Marie-Thérèse Walter, and began a passionate liaison with her that remained a secret until the birth of their daughter, Maya, in 1935. Despite the secrecy, Marie-Thérèse was one of Picasso's favorite models, and he repeatedly sculpted and painted her round, sensuous forms.

In 1936 civil war erupted in Spain between the leftist Popular Front and the fascist Phalangist party, led by General Francisco Franco. In the early years of the war there were atrocities on both sides, and Picasso was increasingly horrified by the news that arrived from his native country. These alarming revelations culminated on May 1, 1937, when the government of Nazi Germany, in support of Franco, bombed Guernica, an ancient Basque town in the north of Spain, almost completely destroying it and killing most of its inhabitants. In shock and outrage, Picasso shut himself in his studio and in a matter of weeks painted an immense canvas, named *Guernica* after the town. The somber black, white, and gray palette expresses the artist's personal feelings of deep mourning. The forms, however, are violent, broken, and twisted, expressing anguish and horror.

Picasso remained in Paris during World War II. This was a difficult period, and indeed, the presence of the war can be felt in his paintings, notably his still lifes, with their skulls and sharp knives. But this was also a creative period, as well. He made new sculptures of surprising materials; from the seat and handlebars of a bicycle, for example, he made an astonishingly lifelike bull's head. His ever-alert imagination seemed to enable him to turn anything within reach into a work of art, transforming an old wicker basket and a pot of ceramic flowers into a goat, or bedsteads and broomsticks into a group of bathers.

His new companion, Françoise Gilot, bore him two children, Claude and Paloma. The family settled at Vallauris, in the south of France, where Picasso began to make ceramics and pottery. Almost seventy, he was now a titan in the world of art, exhibiting his work throughout the world.

In 1955 he separated from Françoise and their children, and retired with his new companion Jacqueline Roque, whom he married in 1961, to La Californie, a villa near Cannes. There he again found calm and delighted anew in painting. Although he was now in his mid-seventies, he worked as if possessed by eternal youth. He had forgotten neither his Spanish youth nor the bullfight, which he still followed passionately and represented in a series of works full of life and color. Picasso loved engraving, especially the speed with which it could be used to produce extended sets of images. He now measured himself against the great artists of the past, painting serial variations on such masterpieces as Delacroix's *Women of Algiers* (p. 31) and Velázquez's *Las Meninas*, translating them into a twentieth-century idiom.

In 1970 a vast exhibition of Picasso's late work—167 paintings and forty-five drawings—revealed that he was still immensely productive. An intimate journal full of the Spain of musketeers and matadors, these images sparkled with new colors. Three years later he died at Mougins, at the age of ninety-one.

Picasso is perhaps the most influential artist of the twentieth century. He was not only immensely prolific but his work was remarkably varied, alternately ironic and ferocious, bemused and tender, and always subject to his formidable passion to paint.

▼ PABLO PICASSO. *Little Girl Jumping Rope.* 1950. Original plaster, 59⅞ x 25⅝ x 26 inches. Paris, Musée Picasso
"How was I to make my little girl jumping rope stay in the air when she jumped?" Picasso asked, and answered himself: "I supported her by having the rope touch the ground." Using a cake mold, a wicker basket, two old slippers from the trash, wood, iron, and plaster, Picasso created this unusual work, full of wit and fantasy.

Piero della Francesca (Piero dei Franceschi)

ca. 1415–1492

painter and mathematician

The son of a shoemaker, Piero was probably trained in Florence, where in 1439 he became an assistant to the painter Domenico Veneziano. Like many artists, he seems to have led a peripatetic life; surviving payment records show that he worked in Arezzo, Ferrara, Rimini, Urbino, Venice, and Rome. The extent of this activity suggests that his work was appreciated from an early date. His reputation continued to grow, and two years after his death one of his students referred to him as "the king of painters."

One of the most important developments in fifteenth-century Italian art was the invention of scientific, or one-point, perspective by the architect Filippo *Brunelleschi* (see p. 137). Piero, fascinated by calculation and geometry, adopted this new system eagerly in his painting, and even wrote a Latin treatise on the subject, *De Prospectiva Pingendi* (*On Painting in Perspective*). He also wrote books on pictorial composition, solid geometry, and even arithmetic. The books on perspective and solid geometry were widely read and used by many artists.

Above all, Piero used his mastery of these disciplines to convey a sense of timeless and majestic silence to his work. In *The Flagellation of Christ* (ca. 1455), the lines delineating the divisions in the floor paving and the ceiling beams seem to rush toward the figure of Christ in the middle distance, where he is shown tied to a column and is being whipped. Despite the violence of the subject, the overall impression given by the picture is one of almost liturgical solemnity. Between 1452 and 1459 Piero painted a fresco cycle in the church of San Francesco in Arezzo, depicting the Legend of the True Cross. Here he portrayed this medieval legend in images of silent intensity. In the 1460s Piero became interested in the work of Flemish painters, whose ability to transcribe the details of the visual world fascinated him. Flemish influence is apparent in his *Madonna of*

Sinigallia (ca. 1470–78), in which light unifies the space and gives the atmosphere a golden tint.

Piero's work is characterized by formal balance, simplified, rigorously constructed volumes, and a novel approach to light, which he used to accentuate the illusion of spatial recession. Despite the mathematical emphasis of his work, it is always suffused with a delicacy of touch and feeling that gives it an ineffable sense of poetry. This, as much as the clarity and elegance of his forms, is ultimately the reason for his great influence.

▼ **Piero della Francesca.** *The Legend of the True Cross: The Adoration of the Holy Cross and the Meeting of Solomon and The Queen of Sheba.* 1452–59. **Fresco. Arezzo, Church of San Francesco** *The harmonious proportions, restrained palette, and solemn mood of this work are all characteristic of Piero's distinctive style.*

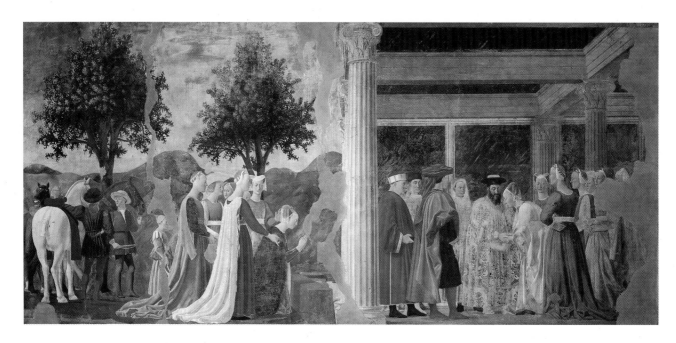

 See: The Renaissance, pp. 136–147.

JACKSON
POLLOCK
1912–1956

painter

Jackson Pollock was one of the leading figures of modern American painting, and one of the most important Abstract Expressionists. After an itinerant and impoverished childhood, he moved with his family to Los Angeles in 1924, and in 1930 made his way to New York. He enrolled as a student at the Art Students League, where he studied with the American regionalist painter Thomas Hart Benton. Later he became interested in the work of the Mexican muralists, and was strongly influenced by *Picasso* and the Surrealists, especially *Max Ernst* and *Joan Miró*.

Alcoholic and self-destructive, Pollock led a turbulent life, but despite his problems, he enjoyed a remarkably successful career. Around 1941 he met his future wife, the artist Lee Krasner, who introduced him to other young painters such as Robert Motherwell and Sebastian Matta. They, like Pollock, were strongly influenced by the Surrealists who had come to America to escape World War II. Pollock also met Peggy Guggenheim, an enthusiastic patron of artists, who commissioned him to paint a monumental work for her New York home. Finally, he attracted the attention of the art critic Clement Greenberg, whose favorable articles made Pollock famous.

In the large mural for Peggy Guggenheim, Pollock broke free of the influence of Picasso and Miró, and he soon began to develop a style that emphasized strong strokes or "gestures" in paint. This style would later be called "action painting," a term given it by the critic Harold Rosenberg in a 1952 essay. In 1947 Pollock started to drip and pour streams of paint onto canvases placed on the floor, shaking the pigment from a stick or simply letting it run from pierced paint cans. The resulting works, the combined product of chance and intention, have an epic sweep that is altogether unique. Pollock's novel technique posed the problem of artistic freedom versus control in a very acute way, and it inaugurated a new conception of the act of painting.

In 1951 Pollock reverted to representation, limiting his palette to black and white in works that look like giant drawings. His development along these lines was cut short, however. In 1956, while deliberately driving recklessly on a country road on Long Island, Pollock and one of his passengers were killed when the car crashed. He was forty-four.

▼ JACKSON POLLOCK. *Autumn Rhythm.* 1950. Oil on canvas, 104¾ x 206¾ inches. New York, The Metropolitan Museum of Art

Autumn Rhythm is one of Pollock's most famous canvases. Works like this, in which pictorial energy is distributed equally throughout the visual field, are known as "all over" compositions. In Pollock's paintings of this type, every portion of the web of paint trails left by his pouring vibrates with compelling intensity.

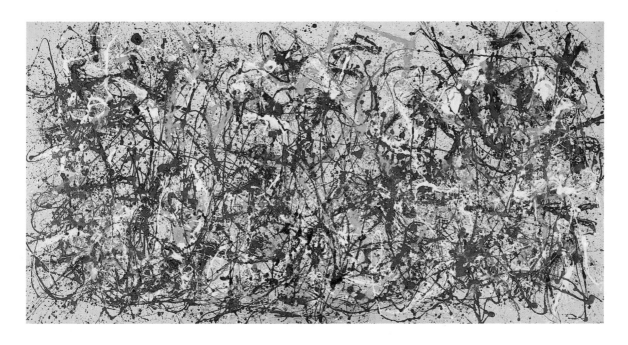

See: Expressionism, pp. 162–163; Abstract Art, 164–165.

NICOLAS POUSSIN
1594–1665
painter

Nicolas Poussin was born in 1594 in Les Andelys, near Rouen, in northwestern France. His father, a notary and member of the lesser nobility, and his mother, the daughter of a magistrate from Vernon, expected their son to pursue a profession worthy of their social status, and thus made sure that he received a good education in Latin, ancient history, and literature. At age seventeen he met an artist, Quentin Varin, who was painting some canvases for the local church. This proved a revelation; the young man decided to become a painter. His parents were dismayed, for most painters led hard lives. Most, like Varin, were nomadic craftsmen perpetually in search of commissions, and those with successful careers were extremely rare. The young Poussin refused to yield, determined to be a painter or nothing. He had to learn his craft in Paris, where he began his training and soon came to prefer the study of ancient sculpture. Fortunately, he was given access to the antiquities in the royal collections, but his most ardent wish was to go to Rome, where the best works of ancient art were to be found. Thanks to the support of Marino, an Italian poet who appreciated his work, Poussin was finally able to move to Rome in 1624. By this time he had built a solid reputation for himself with a number of large compositions that he had painted for churches in Paris.

When Poussin arrived in Rome, he achieved success there with surprising speed. Not long after his arrival, Cardinal Francesco Barberini, the pope's nephew, commissioned him to paint *The Death of Germanicus* (1627), a work that marks the true beginning of Poussin's career. In this painting Poussin presented a morally uplifting example of virtue from ancient history, using well

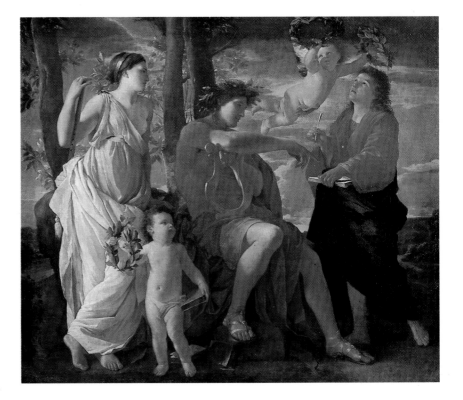

known works of ancient sculpture in Roman collections as models for his figures. The work is, in fact, the first great monument of French classicism, a style of painting that was to be central to French art for more than two centuries.

During his early years in Rome Poussin preferred mythological subjects that allowed him to include beautiful nudes (*Echo and Narcissus; The Childhood of Bacchus; The Triumph of Flora*). Fortunately, the brilliant and refined circle that he frequented not only introduced him to patrons, but it also provided him with opportunities to deepen his knowledge of the historical and philosophical subjects that interested him. He established his reputation as a painter-philosopher with his *Inspiration of the Poet* (1630–31); his painting, *The Arcadian Shepherds*, is an elegy on the fragility of human happiness.

In the 1630s Poussin ceased to paint large official commissions, preferring instead to produce relatively small easel paintings for a select group of cultivated patrons who appreciated

▲ NICOLAS POUSSIN. *The Inspiration of the Poet*. c. 1630. Oil on canvas, 71⅜ x 83⅞ inches. Paris, Musée du Louvre
Here the god Apollo dictates a text to a poet. Behind him stands a goddess, perhaps Calliope, the muse of eloquence. The friezelike composition, restrained gestures, and the absence of extraneous elements make this painting a characteristic work of seventeenth-century classicism.

his work. These works tend to represent subjects taken from the Bible, both the well-known (*The Finding of Moses*; p. 151) and the less familiar (*The Plague of Ashdod*). He also painted a self-portrait for one of his friends and clients, the collector Paul Fréart de Chantelou. Poussin strove constantly for visual clarity, hoping to make his subjects comprehensible even to viewers unfamiliar with them. To achieve this goal, he arranged his figures in dramatic poses and clothed them in colors with specific symbolic

meanings. In general, his use of color was calculated not to please the eye, but to increase a composition's expressive effect (*The Judgment of Solomon*).

Poussin's working methods were slow and meticulous. He made small wax models of the figures, which he then draped and placed in a viewing box to judge the effect they would produce in the finished work. He also kept copious notebooks, recording everything he saw that he might find useful later when composing his paintings.

Poussin's reputation became known as far away as France, where Louis XIII resolved to enlist the artist in his own service. As a result, in 1640 Poussin was called back to Paris, where he spent two highly unpleasant years, working on projects not to his liking—large religious compositions and the decoration of the Long Gallery in the Louvre—and, worse, in an extremely acrid atmosphere. Not surprisingly, the established artists of Paris were jealous of the favors showered on this new

rival, and did whatever they could to make his life disagreeable. Thus, Poussin was glad to return to Rome in 1642.

In the following years Poussin produced the paintings that made him one of the most famous artists in Europe: a set of *The Seven Sacraments* for his friend Chantelou, and other works inspired by ancient history (*The Funeral of Phocion*). During the 1640s he devoted increasing attention to landscape, opposing nature—with which he felt a deep affinity—to human vanity. In *Diogenes Throwing Away His Bowl*, the small figures are surrounded by luxuriant greenery suggesting that the natural world suffices for human happiness. Likewise, the landscape in *Orpheus and Eurydice* almost overwhelms the human drama portrayed. Poussin's final works reflect his increasing detachment from worldly affairs. His last painting, *Apollo and Daphne*, was left incomplete at his death in November 1665.

▼ NICOLAS POUSSIN. *The Judgment of Solomon.* Oil on canvas. 1649. Oil on canvas, 39¾ x 59 inches. Paris, Musée du Louvre
Solomon, king of Israel from 972 to 932 BCE, was noted for his exceptional wisdom. On one occasion two women came before him carrying a dead baby and a live one, each claiming to be the mother of the living child. The king ordered the dispute settled by having the living child cut in half. One of the women instantly renounced her claim,

while the other insisted that the king's judgment be carried out. The king presented the child to the woman who had been willing to give it up to preserve its life, for she, he reasoned, was surely its true mother. Here the king wears red and white, colors which symbolize power and justice. At his feet, the false mother wears muted red and green, which symbolizes her jealousy; the true mother wears bright yellow-orange, signifying intelligence, and blue, which stands for wisdom.

RAPHAEL (RAFFAELLO SANZIO)
1483–1520
painter

Born in Urbino, in central Italy, in 1483, the son of the painter Giovanni Santi, Raphael was orphaned at age eleven. He seems to have received his training as an artist in the workshop of the painter Pietro Perugino, whose style he quickly assimilated. When, in 1504, at the age of 21, Raphael painted *The Marriage of the Virgin*, a work derived from an earlier version of the same subject by Perugino, the young artist's astonishing sense of space and his meticulously drawn figures reveal his extraordinary mastery of his art even at this young age.

In 1504, Raphael arrived in Florence. There he met *Leonardo da Vinci*, whom he admired enormously, and *Michelangelo*, whose rival he soon became. Although Raphael was already an accomplished artist, in these years he continued to work intensely, perfecting his understanding of anatomy, modeling, and the creation of convincing pictorial space. In addition to his great talent as a painter, he was young, handsome, and a charming companion, which made it easy for him to attract the support of would-be patrons.

In the early years of the sixteenth century, Raphael produced a number of superb paintings of the Madonna and Child, and these compact, harmoniously composed images are some of his most appealing works. He painted more than fifty variations on this theme in a variety of settings, incorporating different supporting figures (p. 141). Perhaps the most famous of these almost irresistible images of maternal love is the *Madonna della Sedia* (*Madonna of the Chair*), a classic of the type, vividly exemplifying the

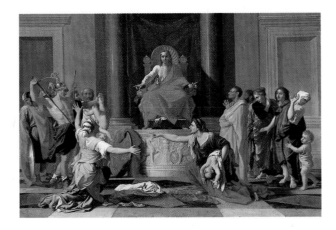

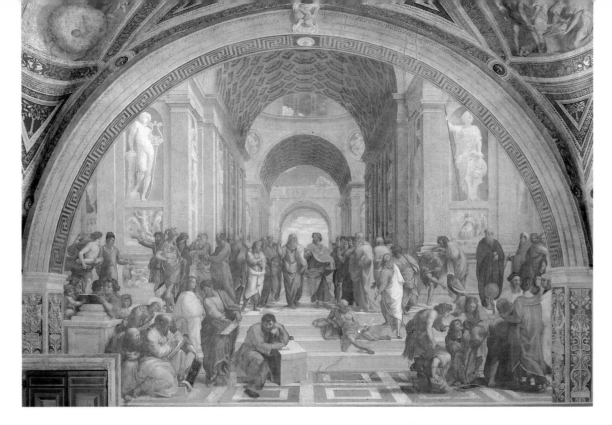

▲ RAPHAEL. *The School of Athens.*
1509–11. Fresco, 19 x 27 feet. The Vatican,
Vatican Palace, Stanza della Segnatura
*Raphael's gathering of philosophers, scientists, and
mathematicians is set in a vast classical building open*
*to the sky and flooded with light. Here, the sages of
the ancient world, dressed in antique robes, con-
verse in small groups. At the center of the compo-
sition stand Aristotle and Plato, the two wisest
men of antiquity. Aristotle gestures groundward to*
*suggest the terrestrial preoccupation of his learning.
Beside him, Plato, whose face bears the features
of Leonardo da Vinci, points toward heaven, the
sphere of the ideal, which is the central focus of
his thought.*

harmoniously balanced composition, beauty of form, and delicate effects of light and shadow that so perfectly characterize Raphael's work.

In 1508 Pope Julius II invited Raphael to Rome. Julius, one of the most energetic and ambitious popes in history, wanted to restore the power and authority of the church. As part of this program of renewal, he commissioned the architect Donato Bramante to design the new St. Peter's Basilica for the Vatican, and Michelangelo to paint the Sistine Chapel ceiling. Raphael was asked to decorate a series of rooms (*stanze*) in the Vatican Palace, a project that continued to occupy him until his death in 1520.

In the first of these rooms, the Stanza della Segnatura (the "Room of the Signature," originally the pope's private library), Raphael painted a large

fresco on each wall. Each of these paintings represents an allegory—of theological truth, scientific knowledge, virtue, and beauty—in the form of gatherings of saints, philosophers, scientists, and poets from throughout history. These complex compositions are masterpieces of clarity and formal integration.

Between 1511 and 1514, Raphael was commissioned to provide frescoes for another room, the Stanza d'Eliodoro (Room of Heliodorus); here the paintings depict events from Biblical history. In a third room, he painted a fresco representing a ninth-century fire in the Borgo, the residential quarter near the Vatican Palace, showing the pope miraculously putting out the flames. This work is especially notable for its dramatic composition and powerful figures.

In addition to painting chapels and palaces, Raphael was also a great portraitist. Executed with flawless technique, his images of powerful men convey their nobility and authority (*Julius II*), but he could also capture extraordinary beauty (*La Donna Velata*, or *Veiled Lady*), or intelligence and refinement (*Balthazar Castiglione*).

When Bramante died, Raphael was appointed architect of St. Peter's and the Vatican Palaces, and then was also placed in charge of archeological excavations in Rome. His fame spread beyond the borders of Italy, and he was thus able to attract a large group of highly talented students and assistants, who helped carry out his many commissions. Prodigiously inventive, Raphael devised new forms for each painting, constructing powerful compositions with assertive vol-

▼ RAPHAEL. *Portrait of Baldassare Castiglione.* 1514–15. Oil on canvas, 32¼ x 26⅛ inches. Paris, Musée du Louvre

Baldassare Castiglione (1478–1529) was the author of The Courtier, a book that sets forth his conception of the ideal gentleman in cultivated society. The discreet elegance and refinement of the figure in Raphael's portrait accurately reflects the book's notions of aristocratic dress and demeanor. Castiglione is posed in three-quarter view, in somber, almost monochromatic clothing that Raphael has portrayed to advantage. The subtleties of the restrained palette, especially the gray of the velvet coat, are heightened by the sitter's blue eyes and by the sudden blaze of white at his throat.

umes and intense but refined colors. In his last years he painted a large *Holy Family* for Francis I of France and a *Transfiguration* for Cardinal Giulio de' Medici. This imposing canvas (it is more than thirteen feet high), begun in 1516, is considered by many art historians to be the culmination of Raphael's artistic development. Here the volumes seem to burst from the canvas. The complex composition, with its interlocking forms and high-keyed colors clearly shows that the artist was beginning to move in a fresh direction, and suggests that his late work strongly influenced the Mannerists in the following decade (p. 143). The painting was almost complete, when tragically, in 1520, Raphael was seized by a violent fever and died suddenly.

REMBRANDT (REMBRANDT HARMENSZ VAN RIJN)
1606–1669
painter

Rembrandt was born in Leiden, in South Holland, in 1606. He abandoned his formal schooling early, and around 1621, at age 15, he became apprenticed to a local painter. Later, after a short period of study in Amsterdam with the painter Pieter Lastman, whose work left a deep impression on him, the young artist returned to live in Leiden. Still in his early twenties, Rembrandt was already able to use light and shadow to achieve mysterious, powerfully charged effects of great originality (*The Presentation in the Temple*, 1631).

At age twenty-five, the young artist returned to Amsterdam, where he quickly began to enjoy immense success as a portraitist to the city's prosperous merchants. A superb example of his

work at this time is *The Anatomy Lesson of Doctor Tulp* (1632), a group portrait, which shows the famous anatomist Nicolaes Tulp—a seeming paradigm of erudition and wisdom—dissecting a cadaver before a group of medical students, each depicted as a distinct personality. The painting is noteworthy for its complex, but strongly unified composition, and for the artist's masterful handling of light and dark.

In 1634 Rembrandt married Saskia van Uylenburgh, the niece of a wealthy art dealer. The following years were an immensely productive period for

▼ REMBRANDT VAN RIJN. *The Company of Captain Frans Banning Cocq, known as The Night Watch.* 1642. Oil on canvas, 141⅜ x 172½ inches. Amsterdam, Rijksmuseum

This masterful group portrait depicts a militia company on the march. The men are just emerging from a massive gateway into a street full of bright light, which illuminates some faces and leaves others in shadow. The sweeping diagonals of the composition gather a marvelous wealth of gesture and detail into a triumphant unity.

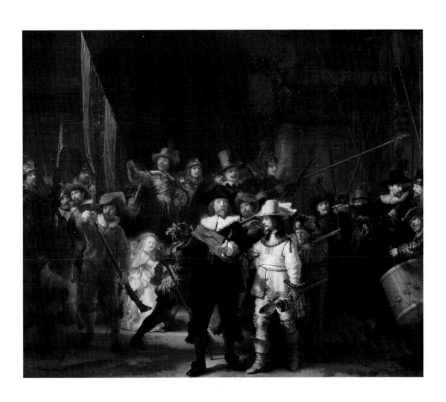

him, in which he painted a great variety of images, including portraits, landscapes, religious works, and mythological paintings. These brilliant works seem to glow as if made from silks, gems, and precious metals. As Rembrandt's exceptional virtuosity developed, his lighting effects grew subtler, his colors richer, his tonal effects warmer. The so-called *Night Watch* (commissioned in 1642), a marvelously complex painting of a militia company on parade, full of insightful portraits and fascinating details, can stand as the emblem of these triumphant years. At the same time, Rembrandt's great success allowed him to indulge a passion for collecting; he filled his house with works of art, jewels, arms, and sumptuous textiles.

Between 1640 and 1660 Rembrandt's creative activity was at its most intense. His paintings in oil acquired a new emotional depth, and in addition to painting, he drew prodigiously and made copperplate etchings of immense power and technical refinement (*The Hundred Guilder Print*, p. 119). *The Slaughtered Ox* (p. 22) and *Jacob Wrestling with the Angel* are only two of the many masterpieces that he produced in this period. He generally preferred to work on a large scale consistent with the scope of his ambition as a history painter. Now he laid on his paint in thick layers, which seemed to illuminate the canvas.

Rembrandt's last years were marked by great financial hardship and personal tragedy. Widowed some years before, he now lost his beloved companion, Hendrickje Stoffels, and his son, Titus, who died at the age of twenty-one. However, Rembrandt continued to produce works of great expressive power. His paint grew thicker and he began to work with unmodulated color. Paintings such as *The Jewish Bride* (c. 1666) and his late self-portraits depict faces marked by tragic experience, the final expression of the profound psychological depth of this artist's vision.

PIERRE-AUGUSTE RENOIR
1841–1919

painter

Born into a family of modest means, Renoir was apprenticed to a decorator of fine porcelain. Although he soon resolved to become a painter, he always remained attached to the artisanal tradition, and to the end of his life he identified himself as a "painter-worker." Having met Monet and Sisley in the studio of the academic painter Marc Gabriel Gleyre, where many of the future Impressionists studied, he exhibited for the first time at the Salon of 1864 and tried to make a living as a portraitist. At the same time he began to work in the open in the Forest of Fontainebleau, but he never ceased to admire the masterpieces in the Louvre.

In 1869, at Monet's urging, the two artists began to paint at La Grenouillère, a fashionable restaurant on the banks of the Seine near Paris. Thereafter they often worked together, painting the same motif side by side, and together they made an important breakthrough in their technique. Using rapid brushstrokes of brilliant

▼ **PIERRE-AUGUSTE RENOIR. *Ball at the Moulin de la Galette*. 1876.**
Oil on canvas, 51⅝ x 68⅞ inches. Paris, Musée d'Orsay
This vivid painting of a crowd of young people dancing and amusing themselves under the trees is Renoir's first large composition. The light filtering through the foliage creates delicious patterns of brightness and shadow that scatter in small patches of luminescence over the figures' faces and clothing. The small dancers in the distance create an illusion of recession that draws the viewer deep into the picture, augmenting its sensation of life and color.

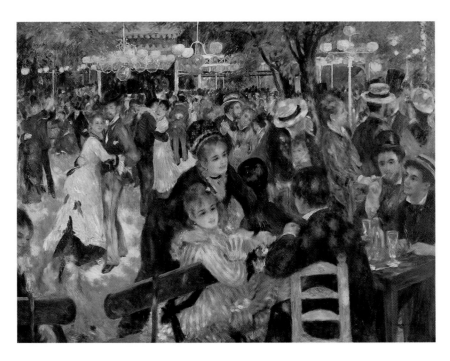

hue, they evoked the reflections of the water and the sky, portraying the optical effects of what they were painting.

Without money for travel, Renoir was forced to spend most of his time in Paris. However, he enjoyed the city's animation, its elegant women, and its cafés frequented by artists and writers. In April 1874, he took part in the first Impressionist exhibition with *The Loge*, his first painting of the world of the theater.

In 1876 Renoir settled in Montmartre, where he often painted his garden, and he also took his easel to the Moulin de la Galette, a bustling outdoor café close to his home, where he socialized with his painter friends. He also cultivated a network of friendships in the world of society, which sustained his career as a portraitist, and allowed him at last to lead a comfortable life.

In 1882 Renoir was able to realize his dream of traveling to Italy to study the art of the Renaissance, and to North Africa, to see its brilliant light. These two trips prompted him to question the tenets of Impressionism and attach increasing importance to traditional draftsmanship. As time went on his brushwork became softer and more delicate, and he began to favor soft pinks in his palette. His favorite subjects were female figures, whether in portraits (*Young Girls at the Piano*) or depictions of nudes in landscape surroundings, which he called "my nymphs."

In 1903 he settled definitively in Cagnes-sur-Mer, near Nice in southern France. Despite the onset of paralysis in his hands, he never stopped painting large nudes, powerful and magnificent figures rendered in intense, sparkling colors. These large canvases express his ongoing love affair with the female body, as well as the irrepressible vitality of his appreciation for the visible world.

AUGUSTE RODIN
1840–1917
sculptor

At age fourteen Rodin enrolled in the Imperial Drawing School in Paris, where he discovered the importance of natural light in defining volume—a lesson later summed up in his remark that "sculpture is an art of the open air." Aware of the gaps in his artistic education, he often went to the Louvre to draw antique statuary and attended life drawing classes held at the Gobelins tapestry factory. After being refused admission three times to the Academy's School of Fine Arts, in 1864 he began to work in the studio of a famous sculptor, Albert-Ernest Carrier-Belleuse. That same year, his bust entitled *Man with A Broken Nose*, on which Rodin had placed high hopes, was refused by the Salon jury. He continued his apprenticeship by working for Parisian firms specializing

in architectural sculpture. Soon after, he met Rose Beuret, who was to remain his faithful and devoted companion throughout his life, finally becoming his wife shortly before his death.

When the Franco-Prussian War erupted in 1870, Rodin was thirty.

▼ AUGUSTE RODIN. *The Kiss.* 1888–98. Marble, height: 72⅛ inches. Paris, Musée Rodin

Rodin originally conceived this group as part of his monumental Gates of Hell. *The subject, which is mentioned in Dante's great epic poem,* The Divine Comedy, *is the first kiss of Paolo Malatesta and Francesca da Rimini. According to the poem, Francesca was married to Paolo's older brother, and so the lovers were damned. The group was first produced in 1886, first as a small plaster and then as a small bronze. In 1888 the French government commissioned a large marble version. This beautiful image of an embracing couple, whose supple forms seem to melt together, a powerful embodiment of carnal passion, is one of the most poetic evocations of love in the history of art.*

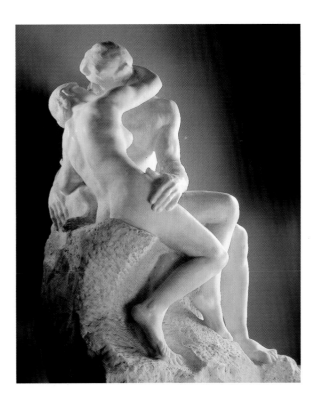

See: Impressionism, pp. 156–157.

Unable to find work in Paris, he moved to Brussels, where Carrier-Belleuse found him employment. There the young sculptor exhibited his work for the first time, and he also discovered the painting of Rubens. Italy now began to attract his interest, so he traveled to Florence, where he was finally able to see the work of Michelangelo at first hand.

After returning to Brussels he worked ardently on a sculpture for the Salon of 1877, *The Age of Bronze*. This figure, a life-sized standing male nude, caused a major furor at the exhibition, for it seemed so lifelike that Rodin was accused—wrongly—of having cast the body of a living model. Still little known, in 1880 he was commissioned to execute a monumental portal for the future Museum of Decorative Arts in Paris, decorated with reliefs inspired by Dante's *Divine Comedy*. The result was the *Gates of Hell,* on which Rodin continued to work until his death but which he left unfinished. He executed several public monuments, including *The Burghers of Calais,* completed in 1895, but only after difficulties with the patrons, for he refused to adapt his vision to suit their wishes. His bronze monument to Balzac also provoked an outcry. Rodin portrayed the great novelist as a massive form with a rough, unfinished appearance, his way of expressing the raw power of genius.

Rodin rejected the smooth modeling taught by the Academy in favor of less finished surfaces. He sought to achieve maximum expressiveness in his renderings of the body, reducing it to essential volumes but enriching it with multiple rough and smooth areas. As Rodin received more and more commissions, he needed many assistants to help him. His strong personality attracted many young sculptors to his studio, including Antoine Bourdelle and Camille Claudel, the sister of the writer Paul Claudel.

The 1890s finally brought the sculptor public honor and financial success. A retrospective exhibition presented at the Universal Exposition of 1900 included 168 of his works in plaster, bronze, and marble. It was an immense success; many foreign museums bought his sculptures and sought to organize exhibitions of his work. On the eve of his death, Rodin donated all of his work to the French state.

▼ HENRI ("LE DOUANIER") ROUSSEAU. *The Snake Charmer.* 1907. Oil on canvas, 66½ x 74⅝ inches. Paris, Musée d'Orsay
This painting of a snake charmer beside an imaginary forest full of snakes—which occupies almost half the canvas—was commissioned by the mother of one of Rousseau's friends, the painter Robert Delaunay. The moon casts a glow on the trees, the marsh water, and on the tall grasses in the foreground. In the meadow next to the wood stands the mysterious form of the snake charmer, a dark, nude woman with long hair, who plays her flute while a great snake glides around her shoulders.

HENRI ("LE DOUANIER") ROUSSEAU
1844–1910
painter

Henri Rousseau was born in Laval, France, in 1844. In 1871 he began working at the Paris customs service (hence his nickname "douanier," customs collector).

At age forty-one he began to paint seriously. Having been authorized to paint copies in the Louvre, he rented a studio and exhibited for the first time in 1886, at the Salon des Indépendants, to which he contributed paintings almost every year until his death. Rousseau retired from his job at age fifty, and thereafter earned a living by teaching music and painting.

In 1905 he began a series of increasingly large canvases representing exotic landscapes. They were much admired by several of his artist and writer friends, including Guillaume Apollinaire and *Picasso,* who organized a famous banquet in Rousseau's honor in his studio at the Bateau-

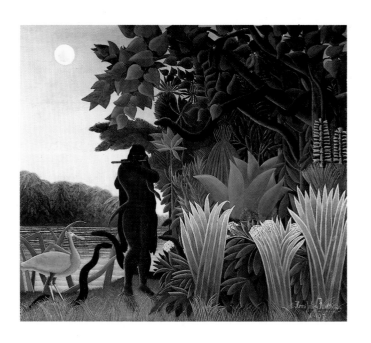

Lavoir. It was a memorable occasion at which Rousseau, seated on a throne, imperturbable and proud, declared to Picasso: "We are the two greatest painters of the era: you in the Egyptian genre, I in the modern genre."

Although dealers began to buy his pictures, his life remained difficult. He lived meagerly and died in a hospital in 1910.

Henri Rousseau painted Paris and its suburbs, bouquets of flowers, portraits of his friends, and forests populated by wild and fantastic beasts. He created a lush imaginary world, telling his friends these images were based on memories of past trips to Mexico. In fact, he had been inspired by advertisements and the botanical garden in Paris.

He always believed he was a great painter despite the mockery of his contemporaries, and time has proved him right. He is sometimes described as a master of naive art, but in the end he remains unique, a remarkable but unclassifiable figure from the earliest period of modern art.

PETER PAUL RUBENS
1577–1640

painter

Rubens was born in Westphalia, where his family, originally from Antwerp, had been obliged to settle due to its Protestant faith. After his father's death in 1589, the young Rubens, his mother, and sisters returned to Flanders. Financial difficulties made it necessary for the boy to abandon his formal schooling and to become a page in the service of countess Marguerite de Ligne Arenberg. At the same time he began his training as a painter, and in 1600 became a member of the Antwerp painters' guild. He then decided, as did many Flemish artists in the early seventeenth century, to travel to Italy to see the masterpieces of the Renaissance and antiquity. On this trip, he visited Venice, Mantua (where he began to work for Duke Vincenzo Gonzaga), Rome, Parma, Bologna, and Florence.

In 1608 news of his mother's serious illness compelled him to return to Antwerp, where the Spanish governor of the Netherlands quickly named him court painter. He married and opened his own workshop, noting that so many young men wanted apprenticeships there that he had to turn away "more than a hundred candidates." As his fame grew, all of Europe seemed to be clamoring for his services. In 1622, the Queen of France, Marie de' Medici, commissioned a cycle of twenty-four paintings recounting her life for her personal residence, the Luxembourg Palace (p. 150), and her son, Louis XIII, ordered twelve designs for a set of tapestries recounting the history of the Roman emperor Constantine. In 1637–38, Philip IV of Spain commissioned 112 oil sketches based on Ovid's *Metamorphoses* for his hunting pavilion near Madrid (the paintings themselves were executed by Rubens's studio).

Multilingual and polished, Rubens was even entrusted with diplomatic missions. In 1610 he helped arrange a peace treaty between England and Spain, and following that, a treaty between the Dutch Republic and the Spanish Netherlands. His first wife died

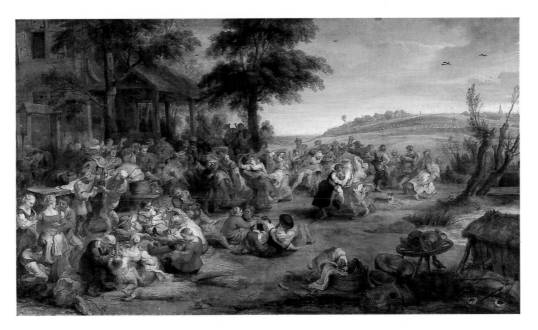

▶ PETER PAUL RUBENS. *The Kermesse,* c. 1635–38. Oil on wood panel, 58⅝ x 102¾ inches. Paris, Musée du Louvre
This painting, also known as The Village Wedding, *depicts a feverish dance of Flemish peasants at a country celebration. In their unconstrained joy, the dancers spiral from the tables at the lower left toward the landscape at the right, whirling toward the distant horizon.*

See: Painting: The Baroque and Seventeenth-Century Classicism, pp. 148–151.

in 1626; in 1630, at 53, he married Hélène Fourment, a young girl only sixteen years of age. He spent his last years painting portraits of his young wife and their children, images of familial happiness that Rubens's matchless brush suffused with extraordinary vibrancy.

Rubens's painting is as rich and jubilant as his life. Combining Flemish and Italian influences, he developed an exuberant style that makes him one of the founding figures of the Baroque. In his famous *Descent from The Cross* in Antwerp Cathedral (1612–14), the formal rhythms are enhanced by color, which, from the white shroud and pale body of Christ to the intensely hued robes, traces an "S" that animates the composition. In addition to the allegories and religious works much in demand in his day, Rubens also painted portraits, hunting scenes, and genre subjects. In all of these, moving flesh seems to shimmer, the result of his radiant colors and lively brushwork, whose triumphant sensuality remains his greatest achievement.

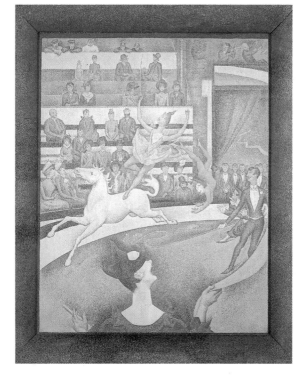

▶ GEORGES SEURAT.
The Circus. 1890–91.
Oil on canvas, 73⅜ x
59½ inches. Paris,
Musée d'Orsay

When Seurat painted the circus, it was a highly fashionable entertainment. In this audacious composition, the figure in the foreground, seen from the back, seems to orchestrate the movements of the dancers and the ringmaster. The picture is made up of tiny dots of only the primary colors, red, blue, and yellow, which the eye blends into secondary hues at a distance.

GEORGES SEURAT
1859–1891
painter

Born into a Parisian middle-class family, at age sixteen Seurat enrolled first in the municipal drawing school, and then entered the Academy's School of Fine Arts, where he studied with a student of *Ingres*. He, too, admired Ingres's work, and he also developed an interest in the work of *Delacroix* and Puvis de Chavannes. In 1880 Seurat left the school and set up a studio with his friend and fellow-painter Edmond-François Aman-Jean. In this period he spent most of his time drawing, and in the 1883 Salon he exhibited a charcoal portrait of his studiomate. Using a sophisticated personal style based on judiciously balanced light and shadow and glowing silhouettes, he managed to achieve an illusion of simplicity.

He completed his training by studying theories of art, notably the *Grammar of the Arts of Drawing* by Charles Blanc. The latter's discussion of "optical mixture," the fusion in the mind's eye of colors that are distinct but adjacent on the canvas, influenced him greatly. Seurat, fascinated by the science of vision, sought to create a technique that would achieve a new degree of harmony between line and color.

After his *Bathers at Asnières* was refused for the Salon of 1884, Seurat decided to exhibit with the Society of Independent Artists, where he met the painter Paul Signac, who became his most faithful friend. Seurat depicted the same subjects as the Impressionists, but his compositions are more studied, his figures more static, and his touch less spontaneous, consisting of carefully applied dots and dashes of color. This new style, soon dubbed Neo-Impressionism (or "divisionism"), reached maturity in *The Grande Jatte* (p. 158). A large, monumentally composed canvas, it depicts some forty figures on a Sunday outing along the Seine, on an island near Paris. Far more imposing than the audacious works by *Renoir* and *Monet* to which the public was becoming accustomed, it caused a sensation when exhibited at the last Impressionist exhibition in 1886.

In 1887 Seurat continued to refine his blend of art and optics in more masterpieces, notably *The Models* and *Le Chahut*. But his career was brutally cut short. He died in 1891 at age thirty-one. His last work, *The Circus*, left incomplete, was exhibited at the Salon des Indépendants. By the time of his death Seurat was the acknowledged leader of the Neo-Impressionists. Faithful to his divisionist theories as well as his memory, his friend Signac succeeded him, organizing the first Neo-Impressionist exhibitions.

GIAMBATTISTA TIEPOLO
1696–1770

painter

Giambattista Tiepolo was born in Venice in 1696. His early canvases exhibit a style of strong colors, emphasized by sharp contrasts of light and dark. Around 1725, however, he began to emerge as a master of large-scale decoration, lightening his palette, and working with a brighter, more luminous range of colors.

At age thirty Tiepolo was invited to Udine to decorate the palace of the archbishop. In its staircase, salons, and gallery he painted large frescoes illustrating scenes from the Bible, that reveal for the first time the full extent of his originality. Dominated by blues, pinks, and yellows, these compositions seem to glow with natural light, as if lit by the sun.

Tiepolo began to receive commissions from abroad as well as from within Italy. In Milan, Bergamo, and of course Venice, he decorated rooms with skillful *trompe l'oeil* ("fool the eye") compositions, featuring marvelously realistic objects that appear to be sitting on shelves, faces that seem to peer from beyond painted doors, and landscapes viewed at a distance through fictive windows. He made a specialty of airy, illusionistic skies that seem to open up the ceiling, but he could also virtually dissolve the walls. In the Palazzo Labia in Venice he represented two opulent scenes from the life of Cleopatra, queen of Egypt, that seem to be taking place right in the great hall of the palace.

In 1750 Tiepolo was invited to Würzburg, Germany, to decorate the palace of the prince-bishop with scenes from the life of Frederick Barbarossa, a medieval German emperor who had been a particular patron of the see. Tiepolo's ability to integrate his compositions within opulent decorative set-tings was put to superb use here. In the monumental staircase of the palace, he represented a radiant Apollo and the Four Continents, splendid allegorical figures that are evoked in animated, brilliantly colored groups that seem to be perched atop a massive interior cornice, leaving the center of the vast ceiling free to become a symphony of light-filled sky, clouds, and airborne divinities.

After returning to Italy in 1753,

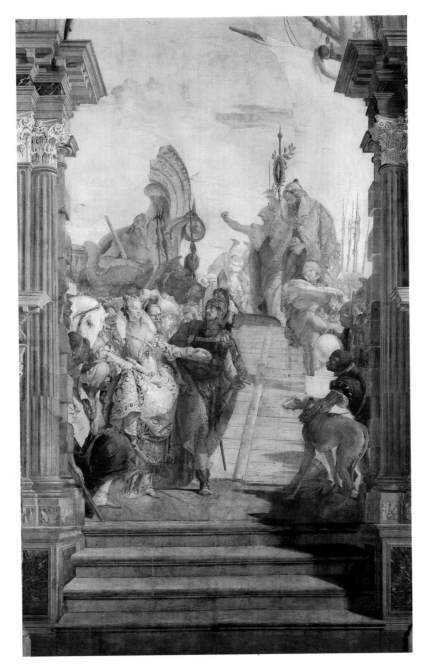

▲ GIAMBATTISTA TIEPOLO.
The Meeting of Antony and Cleopatra.
1747–50. Fresco. Venice, Palazzo Labia
The queen of Egypt, dressed in a richly embroidered gown, has just stepped off the royal barge to greet the Roman general, Marc Anthony. They are shown at the entrance to a splendid eighteenth-century Venetian palace, which is evoked by elaborate trompe-l'oeil architecture.

Tiepolo decorated the walls of the Villa Valmarana, outside Vicenza, with poetic and mythological compositions inspired by Homer, Virgil, and the Italian poets Tasso and Ariosto. The lightness and delicacy of Tiepolo's style here is remarkable, as is the psychological insight that he brought to these sometimes deeply emotional scenes.

In 1762 Tiepolo was invited to Madrid to decorate the new royal palace with frescoes celebrating the triumph of Spain. This was to be the artist's last journey. Tiepolo's Spanish frescoes display a new solemnity; the compositions are still grand, but they are less luminous than his earlier work, and the skies are now heavy with violet-tinted clouds.

A master of illusion, light, movement, and fantasy, witness to the final splendors of Venetian greatness, Tiepolo's decorative paintings embody a rare degree of perfection.

TINTORETTO (JACOPO DI ROBUSTI)
1518–1594

painter

The Venetian painter Jacopo Robusti owes his nickname, Tintoretto ("little dyer"), to his father, who followed that trade. As a young man, the artist was briefly an apprentice in the workshop of *Titian*, but in many respects his style and technique seem to have been self-taught. Like other Venetian artists working after 1530, he was influenced by the Mannerist movement, but he was also affected by developments in contemporary Germany, and by the examples of Byzantine art that he saw about him in his native city. He was also a great admirer of *Michelangelo,* whose work was known in Venice

through engravings and casts.

Endowed with immense stamina and an ability to work with unusual speed, Tintoretto painted large ensembles for the churches and lay religious confraternities of Venice. In 1548 he executed *St. Mark Rescuing a Christian Slave* for one of these confraternities, the Scuola Grande di San Marco. A work of striking originality and emotional power, this was his first masterpiece, and it was much admired by his contemporaries.

Subsequently, other Venetian religious confraternities, whose mission was to care for the poor and the ill, commissioned paintings from him to decorate their buildings. These paintings generally depicted miracles worked by the organizations' patron saints, or scenes from the Bible and the life of Christ. In these commissions Tintoretto gave free rein to his

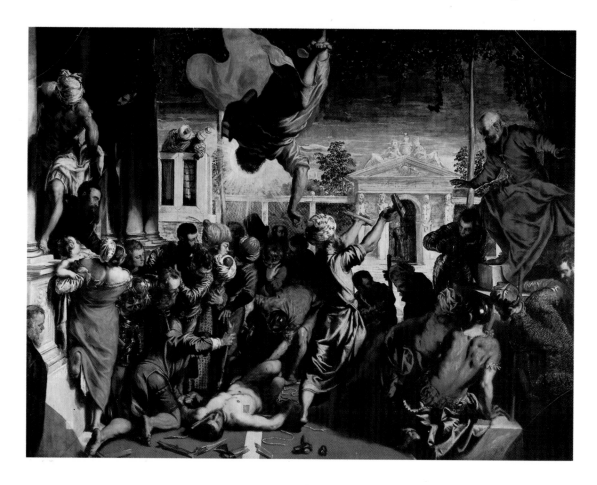

imagination, using vivid, sparkling colors to paint tumultuous compositions into which he incorporated types from contemporary Venetian life.

Between 1562 and 1566 Tintoretto worked on another commission from the Scuola Grande di San Marco. In canvases representing the discovery and transport of the body of St. Mark, he created two vast perspectival renderings, one of a deserted square, the other of a church interior, through which his figures move as if they were on a stage. Here again, the originality of Tintoretto's vision was greatly enhanced by his use of dramatic lighting effects.

In 1564 Tintoretto was commissioned to paint compositions for the Scuola Grande di San Rocco, an extraordinary undertaking that occupied him until 1588. The resulting canvases, painted over a period of more than two decades, are both the fullest expression of his religious fervor and the most complete expression of his art. Covering the walls and ceilings of several large rooms, these works are notable for their grandeur—especially the *Crucifixion*, in which animated crowds caught in vibrant light contrast starkly with the tragic solitude of Christ.

With his rapid brushwork, Tintoretto played with perspectival spaces and created fantastic lighting effects, expressing an intense religious feeling in grand compositions teeming with figures. His work is certainly one of the sources of Italian Baroque painting.

◀ TINTORETTO. *St. Mark Rescuing a Christian Slave.* 1548. Oil on canvas, 163½ x 213¼ inches. Venice, Accademia
Before the eyes of an astonished crowd, St. Mark appears suddenly from heaven to rescue a Christian slave who is about to be punished for having run away from his master to go on a pilgrimage. The powerfully modeled figures, animated facial expressions, and richness of color endow the scene with a feeling of concrete reality that strongly contrasts with the mystery of the miracle.

TITIAN (TIZIANO VECELLIO)
1488/90–1576
painter

Although he was born in the Italian Alps, Titian spent his youth in Venice. After an apprenticeship with *Giovanni Bellini*, he entered the workshop of *Giorgione*, his principal master. At Giorgione's untimely death in 1510, Titian completed his master's unfinished works with such virtuosity that it is now difficult to attribute many paintings of this period to either of the two artists for certain. Titian's genius expressed itself in ample forms, brilliant colors, and radiant light. One of his most important contributions to Renaissance art was his new vision of the female nude. In paintings such as his *Sacred and Profane Love* and his portrait of *Flora*, Titian's goddesses and nymphs exemplify a new ideal of femininity that is both classical and sensual.

After the death of *Giovanni Bellini* in 1516, Titian became, and was to remain, the undisputed master of Vene-

▼ TITIAN. *Venus at Her Toilette.*
c. 1555. Oil on canvas, 48¼ x 41⅛ inches. Washington, National Gallery of Art
Titian kept this painting of Venus admiring herself in a mirror, an embodiment of sixteenth-century Italian ideals of female beauty, in his studio until his death. The artist and his workshop produced many images of the goddess in a variety of poses and settings. This work is a particularly splendid example of Titian's skill at depicting contrasts of texture, from the goddess's soft skin and rich velvet cloak to the bristling fur of its lining, the sparkle of its metallic embroidery, and the brilliance of the goddess's jewelry.

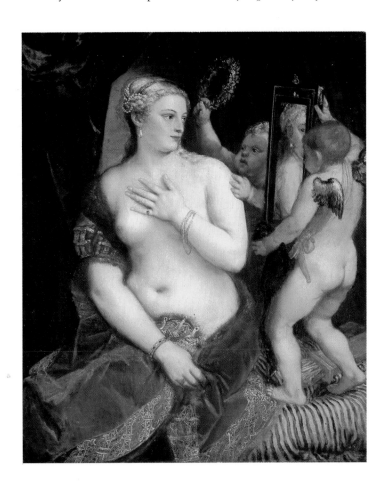

See: The Renaissance, pp. 136–47

tian painting. In 1518 he received his first important commission, an immense altarpiece for the Franciscan (or "Frari") church in Venice of the *Assumption of the Virgin*. Drawing inspiration from both *Raphael* and *Michelangelo*, Titian infused the Virgin's miraculous ascent with an atmosphere of vibrant color. Thereafter he received many religious commissions, for works portraying the Resurrection of Christ, St. Christopher, St. Sebastian, and many Madonnas. His *Virgin with a Rabbit* is a characteristic example of his treatment of that subject, in which figures and landscape seem to merge in the warm afternoon light.

Beginning in 1520, Titian began to work for a number of Italian princes, revealing his exceptional powers as a portraitist. Representing his sitters in soft, diffuse light, he proved adept at evoking the subtleties of human psychology, as in *Man with a Glove* (1523–24), and *La Bella* (1536). On a trip to Bologna in 1530 he met the Holy Roman Emperor Charles V. In subsequent likenesses of the emperor and of other great figures of the day—Isabella d'Este, the duke of Urbino, Francis I of France—Titian was able to reconcile this penetrating vision with the aura of majesty appropriate to court portraiture. Similarly, in his delicately modeled and exquisitely posed *Venus of Urbino* (1538), he fused his sensual treatment of the nude with the worldly elegance of aristocratic art.

During the 1530s Titian was influenced by Mannerist painting. Impressed by its animating tensions, he adopted freer and more vigorous forms and more elaborate compositions to convey the full drama of human existence. This change affected his portraiture, too. His subsequent likenesses of Pope Paul III (1546), Doge Andrea Gritti, and Charles V on horseback (1548) all display a new vigor and authority.

After 1551 Titian never left Venice.

Immensely productive, he and his studio assistants executed numerous commissions for churches, as well as mythological scenes for important patrons. In the mid-1540s, for example, he painted two mythological subjects, *Danäe* and *Venus and Adonis*, for Cardinal Alessandro Farnese. In the following years he and his workshop produced a number of versions of these superb compositions for other clients, as well.

In old age the artist developed an entirely new style featuring agitated figures and strong lighting effects. Works like *The Entombment* and the two versions of *The Crowning with Thorns* evidence a powerful new sense of drama. Painted in summary brushstrokes, the figures in these works are brought forward from the shadowy atmosphere enveloping them into the reddish glow of torches.

Titian now worked his pigments in rapid, thick strokes, sometimes with his fingers instead of brushes. The results are remarkably successful in creating an illusion of life and animation. The most visionary work of the late period is his *Flaying of Marsyas*, in which streams of purple flow from the body of the unfortunate victim. Late in his life Titian began a large *Pietà* to be placed over his own tomb, a work that remained incomplete at his death in 1576, the final statement from an artist whose immense oeuvre is among the greatest achievements of Renaissance art.

HENRI DE TOULOUSE-LAUTREC
1864–1901

painter

Born into an aristocratic family in Albi, France, in 1864, Toulouse-Lautrec was a passionate lover of horses and drawing from his first youth. Disabled early in life due to an accident that broke his legs and halted his growth, he was sickly, alcoholic, and possessed of a bitter sense of humor. After moving to Paris to pursue a career as an artist, he spent much of his time at cabarets, music halls, and the circus. He was the greatest portraitist of his day and a matchless chronicler of contemporary life.

Having obtained permission from his mother to study painting, he arrived in Paris in 1881 and entered the Academy's School of Fine Arts, where he frequented the studios of the academic painters Léon Bonnat and Fernand Cormon. There he made friends with many young painters, notably Émile Bernard, a passionate advocate of *Cézanne* at the time, and later of *Van Gogh*. He was also attracted to realist subject matter, although he loved the Impressionist palette and especially the landscapes of Camille Pissarro. The most decisive influence on his development, however, was the work of *Edgar Degas*. He admired the preeminent role of drawing in Degas's art, its themes of Parisian life and the theater, and, especially, its unorthodox approach to composition, which emphasized asymmetry, eccentric cropping, and audacious effects of foreshortening.

Toulouse-Lautrec spent his evenings in the city's music halls and cabarets. When the popular singer Aristide Bruant opened a new cabaret, the Mirliton, the artist became a regular patron as well as a close friend of Bruant's, who courted notoriety by insulting his audience. The artist also frequented such public dance-halls as the Chat-Noir (Black Cat), the Rat-Mort (Dead Rat), and the Divan Japonais (Japanese Divan). His favorite haunt, however, was the Moulin-Rouge (Red Mill). After the nightclub opened with considerable fanfare in 1889, Toulouse-Lautrec went there almost every night and he painted it repeatedly. In 1890, he produced *Training of the New Girls by Valentin "the Boneless"* (*Moulin-Rouge*), a large canvas in which the restrained

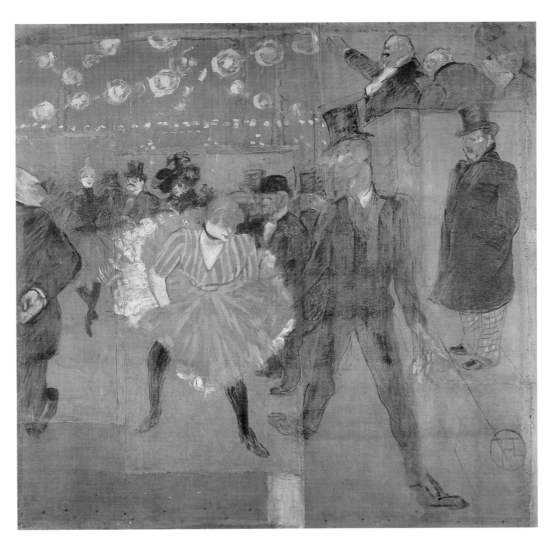

▶ HENRI DE TOULOUSE-LAUTREC. *Dancing at the Moulin-Rouge,* a decoration for the front of the performance booth of La Goulue. 1895. Oil on canvas, 117½ x 124½ inches. Paris, Musée d'Orsay
The famous dancer of the Moulin-Rouge, La Goulue, asked Toulouse-Lautrec to decorate the booth she had just rented at the carnival known as the Foire du Trône *to perform her new* Danse Mauresque *or "Moorish Dance." The artist responded with two works, one of which was this wonderful example of his caricatural verve, showing La Goulue and her partner, Valentin le Désossé.*

silhouette of Valentin, wearing a top hat, contrasts with the unfettered acrobatic movements of his dancing partner. The following year he was commissioned to create a poster for the next season; he produced *At the Moulin-Rouge: La Goulue,* which soon appeared all over Paris. It was a sensation; using a composition of startling originality to convey a simple message with extraordinary graphic clarity, Toulouse-Lautrec had created the first modern advertisement.

Toulouse-Lautrec also turned his attention to licensed brothels, painting portraits of the prostitutes in bed, at their toilette, dressing, and waiting for clients (*In the Salon of the Rue des Moulins*). They were quite at ease with

him, which made it possible for him to produce candid images of them without makeup and in all their bodily fatigue, solitary figures resigned to their sad fate.

A remarkable draftsman, Toulouse-Lautrec had a rare gift for conveying a sitter's character and occupation through posture. With their rapidly executed but expressive lines, his portraits often border on caricature, as with those of his favorite model, the singer Yvette Guilbert, whose pointed nose and expressive, black-gloved hands he rendered with knowing exaggeration. His decorative style, telling use of arabesque, and simple forms as well as his skillful use of unmodulated color and incisive line make him the

first master of the modern advertising poster, as evidenced by his still-famous poster *Aristide Bruant* (1891).

Alcohol abuse destroyed Toulouse-Lautrec completely. After an initial attempt to swear off drinking he reverted to his old habits, which eventually paralyzed him. He was forced to submit himself to the care of his mother in the family château, where he died in 1901.

Toulouse-Lautrec's work was highly influential. His characteristic technique of using paint thinned by turpentine on cardboard was taken up by the Nabis (p. 159), while his incandescent colors and economical virtuoso draftsmanship were much admired by the Fauves and the Expressionists.

See: Impressionism, pp. 156–57; Expressionism, pp. 162–63.

JOSEPH MALLORD WILLIAM TURNER
1775–1851
painter

The son of a barber, Turner lived in London close to the Thames, where he liked to take walks to admire the play of the water and the sails of the ships obscured by the fog. At age fourteen he enrolled as a scholarship student at the Royal Academy school, where he remained until 1793. A very hard worker, he decided to pursue landscape painting. To make a living, he spent his evenings painting watercolors after works by other artists.

He began to travel in England every summer, which provided him with new sources of inspiration. In 1796 he exhibited his first oil painting, *Fishermen at Sea*, at the Royal Academy. Thereafter, the oil medium became his prime means of expression.

In 1799, at age twenty-four, Turner was elected an associate member of the Royal Academy; he was later elected to full membership. He moved into a house on Harley Street, where he built a gallery for the exhibition of his paintings. He gradually renounced the historical and picturesque landscape subjects characteristic of the eighteenth century in favor of contemporary themes (*Shipwreck; The Battle of Trafalgar*).

At age forty-four, in full command of his gifts, he traveled to Italy, a voyage traditionally made by artists at the beginning of their careers. In the course of two months he completed almost 1,500 pencil drawings of Rome and its environs.

Turner's subsequent work displays a new freedom, employing pure color in allusive compositions (*Rain, Steam and Speed; Peace*). Distinct subjects were replaced by light, clouds, rain, and fog. He frequently applied his pigment with a palette knife, and he often left his paint surfaces transparent, in order to evoke atmospheric effects. One critic remarked that his paintings seemed to be made of "tinted steam."

When Turner was more than seventy years old he bought a house in Chelsea. His health began to decline soon after that, and in 1851 he died in his bedroom overlooking the Thames. He left three hundred oil paintings and many watercolors to the British nation, stipulating that they be preserved in a special gallery and that his personal fortune be used to establish an organization devoted to the care of English artists in need. The terms of his bequest were accepted, although the charitable foundation was never established.

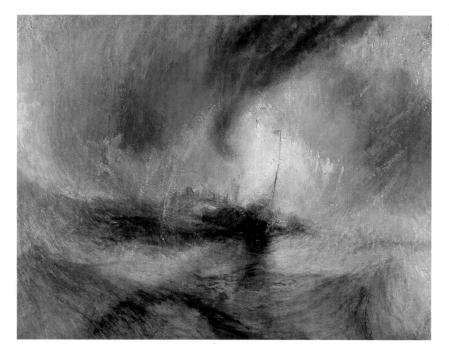

◄ JOSEPH MALLORD WILLIAM TURNER. *Snow Storm—Steam Boat off a Harbor's Mouth.* 1842. Oil on canvas. 36 x 48 inches. London, Tate Gallery

This work was the result of Turner's direct observation of a violent snow storm at sea, which he went to some length to arrange for himself. He persuaded the sailors to tie him to the ship's mast during the storm, so that he could experience its full force. He wrote later: "I was lashed for four hours and did not expect to escape, but I felt bound to record it if I did." In this canvas, the swirling vortex of snow and waves all but obscure the ship, whose mast is barely visible. Although the dense whirlwind of paint conveys well the turbulence of wind and snow, the piece was poorly received by critics, one of whom dismissed it as "soapsuds and milk."

UCCELLO
(PAOLO DI DONO)
1397–1475

painter

Paolo Uccello was born in 1397 near Florence, Italy. After an apprenticeship in the workshop of the Florentine sculptor Ghiberti, he spent five years in Venice, returning to Florence in 1430. Many artists of this period experimented with perspectival constructions of pictorial space, which permitted them to create a convincing illusion of depth. In Uccello's case this interest became almost an obsession; he spent entire days drawing foreshortened figures and devising compositions incorporating elaborate perspective effects.

In 1436 Uccello was commissioned by the city government of Florence to paint a fresco commemorating Sir John Hawkwood, an English soldier of fortune who had commanded the Florentine army (and those of several other cities) during the Italian wars of the fourteenth century. The result was

a monumental illusionistic fresco of a mounted warrior on a wall of the cathedral of Florence. Painted largely in the pigment known as *terra verde* ("green earth"), this striking image, with its powerful, geometric forms, resembles a bronze statue.

Uccello's most famous work, *The Battle of San Romano*, was probably commissioned by Cosimo de' Medici, the energetic ruler of Florence. Composed of three large panels celebrating the Florentine victory over the forces of Siena in 1432, it was painted between 1435 and 1440. The panels are now dispersed among three museums in Florence, Paris, and London. Each depicts a different moment of the battle; all were calculated to create the illusion of depth and the impression of movement.

At age seventy, Uccello traveled to Urbino, where he painted *The Miracle of the Profaned Host*. The predella of an altarpiece that he left incomplete, it is a series of small but lively and unusually poetic scenes that reveal his gift as a visual storyteller. Another painting from the same period shows

his gifts as an animal painter: *The Hunt*, in which a pack of greyhounds and hunters penetrate a dark forest in pursuit of stags.

While Uccello's ties to the Gothic tradition remained strong, his continual experiments with perspective give his work a vitality that continues to delight.

▼ PAOLO UCCELLO. *The Battle of San Romano: The Counter-Attack of Michelotto da Cotignola.* c.1435–40. Tempera on wood panel, 71¾ x 124⅞ inches. Paris, Musée du Louvre

Despite the stiffness of the figures, Uccello cleverly suggested movement in this composition by the arrangement of forms. The upright lances to the right are gradually lowered toward the left of the composition, conveying a sense of a forward charge; similarly, the horses, which are solidly grounded at right, bound energetically forward at left. The brilliant colors of the flags and the elaborate trappings are more suggestive of a joust than a battle, and the warm but somber palette, dominated by reds and blacks, infuses the scene with a surprising elegance.

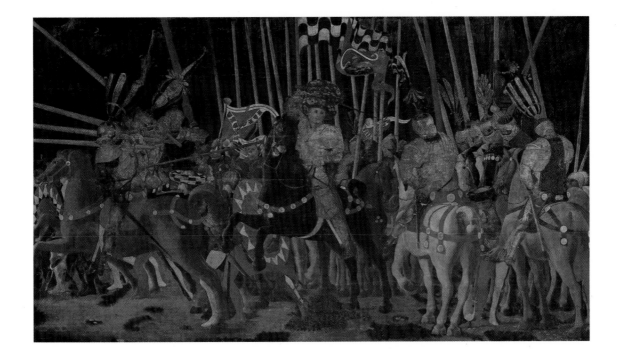

ROGIER VAN DER WEYDEN
1399/1400–1464
painter

There are so few surviving documents recording the work and movements of Rogier van der Weyden that our knowledge of his life is scanty. He was born in Tournai, in 1427 became an apprentice of Robert Campin (see p. 146), and lived in Brussels after 1435. The confident forms of his youthful work reveal the influence of his master, while its elegance, refinement, and meticulous rendering of detail show that he was well aware of the work of *Jan van Eyck*.

Rogier, however, assimilated and transformed the lessons of his predecessors. The composition of his *Deposition*, painted in 1435 for the Archers' guild in Louvain, recalls the vigor of Campin's work, but he replaced the latter's austerity of form with supple, sinuous lines. In his great *Last Judgment*, a polyptych painted sometime before 1446 for the Hôtel-Dieu, or charity hospital, in Beaune, this refinement of form is used to present a vast composition of almost symphonic complexity.

In 1450 Rogier traveled to Italy, but the trip does not seem to have strongly affected his work. He remained very attached to symmetrical compositions infused with rhythmic interest by the subtle play of line and volume. His forms, while often agitated, are monumental, suggestive of sculpture; his palette tends to be clear and bright. Several of his works con-

◀ ROGIER VAN DER WEYDEN. *Last Judgment Altarpiece* (detail of Saint Michael weighing souls). 1443–46. Oil on wood panel. Beaune, France, Hôtel-Dieu

Commissioned by Nicolas Rolin, chancellor of Burgundy, this work originally stood above the altar of the chapel that occupied one end of the long ward of the Hôtel-Dieu, or charity hospital, in Beaune. Its many panels usually stood open, so that dying patients could contemplate the Last Judgment and the Resurrection of the Dead. In this detail, St. Michael weighs the souls of the resurrected dead. If the soul was light, it was free of sin and would rise to heaven. If it was heavy, it was burdened by sin and was therefore condemned to eternal damnation.

▶ JAN VAN EYCK. *Arnolfini Wedding Portrait.* 1434. Oil on wood panel, 33 x 22½ inches. London, National Gallery

Every detail of this bedroom is meticulously rendered. The pair of wooden clogs on the floor at the lower left, the convex mirror, and the small brush hanging to its right all seem so true to life that we feel as if we could touch them. Reflected in the mirror behind the couple, seen between their backs, is a tiny self-portrait of the artist. Inscribed above the mirror is his signature in Latin: Johannes de Eyck fuit hic — "Jan Van Eyck was here" — and the date, 1434.

vey feelings of pain and suffering with an immediacy that is altogether exceptional (*Entombment; St. John Altarpiece; Seven Sacraments Altarpiece*). Toward the end of his life, around 1456, he executed the *Bladelin Altarpiece*, the culmination of his career as a painter. This work exhibits a new luminosity, and it reveals a tendency to downplay drama in favor of serenity.

Rogier's work was highly influential, especially in Flanders, France, and Germany, where many artists emulated his extraordinarily affective style.

Jan Van Eyck
c. 1390/1400–1441

painter

Jan van Eyck was born around the beginning of the fifteenth century in a village in Flanders, a large territory ruled by the dukes of Burgundy. A few documents mention that he had a brother, Hubert van Eyck, also an artist, but these are so few that Hubert's existence has been questioned.

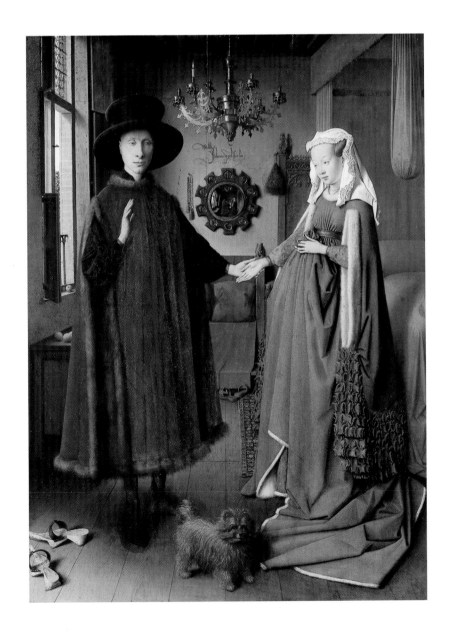

It was long thought Jan had invented oil painting, and while this is not so—oil paint may have existed even as early as the Carolingian period—he certainly perfected its technique, revealing the remarkable expressive potential of this medium in works of great originality.

Jan's work was quite different from contemporary Italian painting, particularly in its meticulous rendering of details. He may have begun his career as a manuscript painter—the famous prayer book known as the Turin-Milan Hours is thought by many to be his oldest surviving work—which might explain his close observation of nature and the goldsmith's precision with which he painted. Certainly he worked with a tiny brush, painting, for example, each hair of an animal's fur or each thread of a piece of embroidery individually.

In 1425, Jan was appointed court painter to the duke of Burgundy, Philip the Good, a post he retained until his death. In addition to the execution of paintings, his responsibilities included secret diplomatic missions. After a trip to Portugal and Spain for the duke's marriage to Isabella of Portugal, he settled in Bruges in 1429.

His first large work was the *Ghent Altarpiece*, which is inscribed on the frame as having been executed both by him and his mysterious brother, Hubert. Hubert may have begun it, but Jan completed it in 1432. This great polyptych is more than eleven and a half feet high; when it stands open, it is more than sixteen feet wide. The imagery of the work is highly complex, incorporating the Annunciation, Adam and Eve, God, the Virgin, and St. John the Baptist, musical angels, four panels of martyrs and other saints, and a large panel of a great crowd of saints adoring the Mystic Lamb, an emblem of Christ's sacrifice for human salvation.

See: The Renaissance, pp. 136–47.

Jan was also an innovator as a portraitist. His *Man in a Red Turban* (1433) is extraordinary in its illusionistic immediacy; every whisker of the beard has been carefully rendered. The so-called *Arnolfini Wedding Portrait* is particularly fascinating and mysterious. It depicts a couple in their bedroom, which is full of objects that suggest meanings relating to marriage, such as the little dog at the bride's feet, a symbol of conjugal fidelity.

Equally illusionistic is the donor figure in *The Madonna of Chancellor Rolin* (c. 1435; see p. 35). The background of this work, commissioned by the principal advisor to the duke of Burgundy for his family chapel in Autun Cathedral, is essentially a meticulous depiction of the city of Liège, although it incorporates a few imaginary features.

With his mastery of the oil technique, Jan changed the way artists painted. His almost miraculous ability to transcribe physical reality and his sensitive handling of light were immensely influential on fifteenth-century European painting.

VINCENT VAN GOGH
1853–1890
painter

Vincent Van Gogh was born in Groot-Zundert, Holland, in 1853, and received an education in keeping with the strict piety of his father, a Calvinist pastor. In 1869 he left school to work for an art dealer, but he was fired after working in the business for seven years. He then spent two years as a lay preacher among the desperately poor miners of the Borinage district of Belgium. At the age of twenty-seven he resolved to become an artist, beginning his new life by drawing unceasingly for two years.

Encouraged by his brother Theo—who was to be a constant source of support, both moral and financial—Vincent began to paint, producing such works as *The Potato Eaters* (1885), a canvas about which he remarked several years later: "I set out to convey the idea that these people who eat their potatoes in the lamplight with their bare hands, worked the earth with these very hands, and that my painting exalts manual labor

and the food that they themselves have so honestly earned."

In 1885 he studied for a while in Antwerp, where he discovered the painting of Rubens, whose use of color he greatly admired. In Antwerp he also bought his first Japanese prints. A solitary man, the lack of available models prompted him to begin painting his own likeness, and thus to begin his long series of self-portraits.

In 1886 he moved to Paris to live with his brother Theo, who was working for the same art dealer who had earlier fired Vincent. There he discovered the Impressionists, and was much attracted to their light palette, free handling, and contemporary subject matter. He also met *Toulouse-Lautrec*, *Gauguin*, Pissarro, and Signac. In *The Italian Woman*, Van Gogh brought Impressionist influence to bear on the lessons he had learned from Japanese prints, combining areas of unmodulated color with readily apparent brushstrokes.

In 1888 Vincent left Paris for Arles, where he hoped to find brighter light and more vivid color. He worked unceasingly, painting images of rural labor (*The Sower*), portraits of local personalities (*The Postman*), sun-

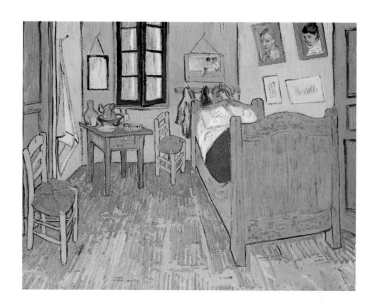

▶ VINCENT VAN GOGH. *The Bedroom of Vincent in Arles.* 1889. Oil on canvas, 22⅜ x 29⅛ inches. Paris, Musée d'Orsay
"It amused me enormously to paint this bare interior," Van Gogh wrote of this painting, of which he was especially fond. It dates from a period of happy productivity when he was awaiting the arrival in Provence of his friend Paul Gauguin. The floor of the room, which slants alarmingly, is the dominant element of the painting, all of whose lines seem to rush toward the rear window, which glows with a strange but impenetrable luminosity.

flowers, and three views of his modest bedroom. His work began to diverge from Impressionism as he adopted distorted spatial compositions and hues of exceptional intensity. A great admirer of Gauguin, he convinced the latter to join him in the south, where they worked together, often using the same models. Marie Gignoux, who posed for *L'Arlesienne*, also appears in Gauguin's *At the Café*. But the two men, who were very different, often fought. Eventually they actually came to blows. After trying to wound Gauguin, Van Gogh, distraught, cut off his own left ear. This is the disturbing episode behind the two versions of his arresting *Self-Portrait with Bandaged Ear* (1889).

Sensing that he was going mad, Van Gogh voluntarily committed himself to an asylum at Saint-Rémy-de-Provence, where he tried to use his painting as a form of therapy. In the resulting landscapes (*Poplars*), portraits, and flower paintings (*Irises*), he applied green, mauve, yellow, and blue pigment in sinuous, discontinuous strokes.

In May 1890, Van Gogh settled in Auvers-sur-Oise in the house of Dr. Gachet, a friend of many artists, including Pissarro and *Cézanne*. There he simplified his compositions to achieve greater expressive focus, as in *The Church in Auvers-sur-Oise*. Tortured by the anguish reflected in his final canvases, in July of that same year he shot himself in the chest and died two days later, on July 29.

Little known during his lifetime, Van Gogh's work greatly influenced both the Fauves and the Expressionists.

DIEGO RODRIGUEZ DE SILVA Y VELÁZQUEZ
1599–1660
painter

Diego Velázquez was born in Seville, in southern Spain. At age twelve he became an apprentice in the studio of the painter Francisco Pacheco, who taught him the basics of technique. Five years later he was admitted into the Seville painters' guild, and the next year, 1618, he married Pacheco's daughter. His early paintings depict scenes of daily life in a somber palette. In 1623 he went to Madrid to paint a portrait of the young King Philip IV,

▼ DIEGO VELÁZQUEZ. *Las Meninas (The Ladies in Waiting)*. 1656. Oil on canvas, 125¼ x 108¾ inches. Madrid, Prado
This enormous canvas, considered Velázquez's masterpiece, is certainly one of the most spatially complex paintings in the history of art. The ladies of the title are gathered around the Infanta Margarita, the king and queen's five-year-old daughter, who has come to visit the painter at work. At the left, Velázquez has shown himself, brush in hand, standing before a huge canvas, whose great size suggests the very painting we are looking at. But the Infanta, who is shown from the front in the painting, is presenting her back to the artist. Another possibility is that the artist is working on a portrait of the king and queen, whose images are reflected in the mirror at the back of the room. But they seem to be standing in the same position as the viewer, who is, of course, not reflected there.

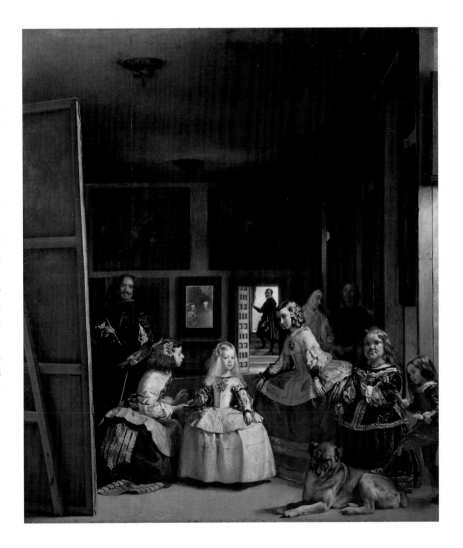

who, delighted, named him painter to the king and accorded him lodgings in a building adjacent to the Alcázar Palace. There followed a long series of portraits in which the artist conveyed, with equal mastery, the majesty of the sovereign, the charm of the young princes, and the alienation—and the humanity—of the dwarves and buffoons attached to the royal children.

In 1629 he received permission to make a trip to Italy, the dream of all artists of his time. He visited Venice and Rome, making copies of the paintings that he saw, especially those of Titian, which made a strong impression on him. After his return to Spain, the portrait gallery gained likenesses of the king and his son, on horseback and in hunting dress. At the same time, Velázquez became passionately involved in the architecture and decoration of the Alcázar Palace.

In 1649 he again visited Italy for two years, this time to buy works of art for the royal collections. In Rome he painted one of his masterpieces, his *Portrait of Pope Innocent X*. After returning to Madrid, he was named Chamberlain of the Palace, a post that carried heavy administrative responsibilities. Thereafter he painted primarily the young princes and princesses of the court, delicate and intimate portraits dominated by pink, gray, and silver. His two final canvases, *Las Meninas* and *The Weavers (The Fable of Arachne)*, are complex meditations on the relationship between illusion and reality. He died in 1660 after having designed decorations for the marriage of the infanta, Maria Theresa, to Louis XIV of France.

Obliged by his position to make kings, princes, and court buffoons his principal subjects, Velázquez became a master of pigment and transparency of touch, allowing the love he felt for those around him to resonate freely through his work.

JOHANNES VERMEER
1632–1675

painter

Johannes Vermeer was born in Delft, Holland, in 1632, the son of an innkeeper and art dealer. We know next to nothing about his formation as a painter, but he was clearly fascinated by illusionism and by the work of Carel Fabritius, one of Rembrandt's most gifted students, who also lived in Delft.

▼ JOHANNES VERMEER. *The Lacemaker.* c. 1670. Oil on canvas, 9⅝ x 8¼ inches. Paris, Musée du Louvre

A young woman is making lace, her eyes focused on her work, her head tilted forward slightly; she seems so absorbed that nothing could distract her. Although the details of the work at first glance seem meticulously delineated, many of them, especially the red and white threads in the left foreground, are painted in a remarkably free and expressive manner. As in all of Vermeer's paintings, the picture is unified by the artist's brilliant handling of light.

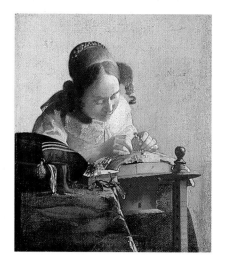

He married at age twenty, and the following year he became a member of the Delft painters' guild, a status that entitled him to sign and sell his paintings. Between 1653 and 1675, the year of his death, he produced only about thirty paintings.

He had ten children, which placed a considerable financial burden on him. In 1672, Holland was invaded by the army of Louis XIV, which precipitated a serious economic crisis. Vermeer sold very few paintings, and his activities as a dealer brought in very little money. He died at age forty-three, exhausted by financial anxieties. After his death, his wife was obliged to cede two of his canvases to creditors to settle outstanding debts.

Apart from a few works probably dating from his youth (*Diana and Her Nymphs*) and the luminous *View of Delft*, which depicts the city and its reflection in a canal, Vermeer painted domestic interiors. He produced only one or two small canvases a year, executing them with exceptional deliberation and attention to detail in a palette often dominated by blues and yellows.

At first glance, little seems to be happening in his pictures. In one, a young woman reads a letter; in others, a woman listens to music or pours milk into a jug; another composition shows a few young people drinking wine. Through the window, light enters and delicately reveals the beauty of the women's faces and the brilliance of their jewelry. It is the women, by turn dreamy or melancholy, fragile or mysterious, who dominate these paintings. The light occasions reflections, reveals effects of transparency, plays over drapery folds, makes glasses and musical instruments sparkle.

As if by magic, time seems to stop in these refined interiors, in which Vermeer's brush celebrates the unobtrusive pleasures of silence.

VERONESE
(PAOLO CALIARI)
1528–1588

painter

Paolo Caliari was called Veronese after the north Italian city of Verona, where he was born. His father, a stonecutter, placed him at a very young age in the workshop of a painter, where he became familiar with the Mannerist style, and on a trip to Mantua, he discovered the illusionistic paintings of *Mantegna*, which exerted a formative influence on his work

Veronese's earliest paintings already exhibited many of the characteristics that marked his mature work; they are large compositions, animated by richly dressed figures, suffused with an air of serenity by the artist's masterful use of color and light. Veronese sought above all to celebrate beauty of a joyous but contemplative kind, which set him apart from his contemporaries, especially *Tintoretto*, whose work is more energetic.

In 1553, Veronese was summoned to Venice to take part in the decoration of a ceiling in the doge's palace. Color now assumed a new importance in his work, taking on a vigor that considerably enriched Venetian painting and won the admiration of even of *Titian*. His talent as a decorative painter is most apparent in his mastery of large perspective constructions, startling foreshortening, and bright, luminous color. In 1555, his decorations for the church of San Sebastiano in Venice—a series of scenes from the life of Queen Esther on the ceiling, the martyrdom of St. Sebastian in the choir, and a *Presentation in the Temple*—revealed the full power of his imagination, enriched with resplendent color.

The frescoes he completed in 1562 at the Villa Barbaro at Maser on the Venetian mainland, a house designed by the architect *Palladio*, are among the major works of Venetian painting. The playful illusionism of these paintings, which include various *trompe-l'oeil* figures peeking from behind fictive doors or peering over mock balconies, establishes a unique atmosphere of refined festivity, making them the perfect foil to Palladio's rather solemn architecture. Similar qualities characterize Veronese's immense *Wedding at Cana*, painted for the refectory of a convent in Venice the following year.

Between 1575 and 1577, Veronese decorated ceilings in the doge's palace in Venice. He was also capable of more intimate productions. In his *Rape of Europa,* for example, figures and landscape are rendered with masterful precision and care and infused with an ineffable tenderness.

Veronese's fantastic, joyful world, forever associated with an imaginary Venice of pageantry and pleasure, greatly influenced later painters, most notably *Rubens* and *Tiepolo*.

▼ VERONESE. *The Wedding at Cana.* 1563. Oil on canvas, 262⅛ x 390 inches. Paris, Musée du Louvre

This immense canvas was commissioned by the monks of the abbey of San Giorgio Maggiore in Venice. It depicts the first of Christ's miracles described in the Bible, the transformation of water into wine at a marriage feast in the Galilean town of Cana. Christ, the Virgin, and the apostles are gathered at the table in the center of the composition. The feast itself is depicted as a sumptuous Renaissance banquet set in a palace, complete with musicians and other entertainers, servants, animals, and dozens of guests in luxurious Venetian dress.

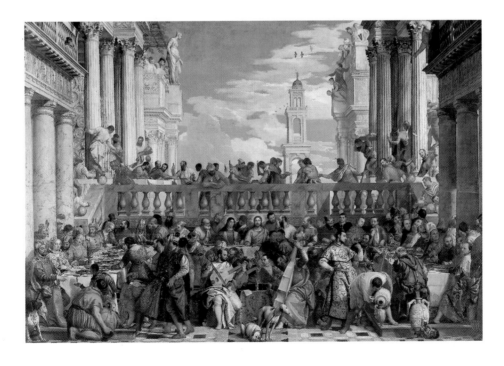

See: The Renaissance, pp. 136–47.

EUGÈNE-EMMANUEL VIOLLET-LE-DUC
1814–1879
architect and theorist

Viollet-le-Duc was born in Paris in 1814, into a family of artists and intellectuals. His father was an architect and would later become overseer of the royal residences; his uncle, Étienne Delécluze, was a well known art critic who had studied painting with *David*. Both regularly entertained important cultural figures of the day, such as the novelist Stendhal, the literary critic Sainte-Beuve, and the writer Mérimée.

Despite his desire to become an architect, Viollet-le-Duc chose not to enroll in the Academy's School of Fine Arts, partly out of a spirit of romantic rebellion and partly because he wanted to learn ancient building techniques. He traveled through France drawing and studying its monuments, which he classified according to style and building type. His career began in earnest when he was commissioned to restore the medieval church of the Magdalene at Vézelay, in Burgundy.

Viollet was subsequently entrusted with the restoration of a number of medieval structures, including the Sainte-Chapelle and the cathedral of Notre-Dame in Paris (1840; 1845), the basilica of Saint-Denis (1851), the ramparts at the southern French town of Carcassonne (1852), and the château of Pierrefonds (1858), among others. His understanding of medieval architecture seems deficient by modern standards, but without his interventions a number of important monuments would not be as well preserved as they are today.

In addition to his restoration work, Viollet-le-Duc designed buildings on his own, most notably the façade of the cathedral in Clermont-Ferrand (p. 33), the new sacristy for Notre-Dame in Paris, and several private churches and châteaus. He was a fervent opponent of

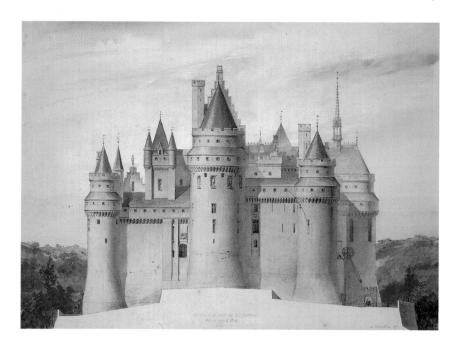

▲ VIOLLET-LE-DUC. Elevation of the Château of Pierrefonds. 1858.
Watercolor, 27½ x 28½ inches. Paris, Centre de Recherche des Monuments Historiques
Viollet-le-Duc believed that restoring a building was not simply a matter of repairing or rebuilding it, but of "realizing a state of completion that may never have existed at a given moment in time." He adhered to this principle in his work at Pierrefonds, and the result, which falls between historical reconstruction and original creation, is one of his best pieces of work.

academic eclecticism, preferring a more functionalist approach that he thought characterized medieval architecture. To explicate his views, he published his *Dictionnaire raisonné de l'architecture du XIe au XVIe siècle*, a dictionary of architecture from the eleventh to the sixteenth centuries (1854–68). This work became indispensable to many architects, and even today it can be useful. In his *Entretiens sur l'architecture* (*Discourses on architecture*; 1863), he writes: "No form that is impossible to explain can be beautiful." It was his view, then, that form must follow function. This functionalist principle, which construes architecture as a logical system of simple rules, was the basis for the early work of *Le Corbusier* and *Frank Lloyd Wright*.

Viollet-le-Duc died in Lausanne, Switzerland, after a sojourn in the Alps, where he had gone to pursue geographical research.

ANDY WARHOL (ANDREW WARHOLA)
1930–1987
painter and filmmaker

Born of Czech immigrant parents, Andy Warhol studied at the Carnegie Institute of Technology in Pittsburgh. At age twenty-one he moved to New York, where he began his career as a fashion illustrator and set about making a name for himself. To a large extent, his notoriety was based on his striking persona. As if to signal his identity as a detached loner, he masked his encroaching baldness with a shaggy, gray-white wig, which became his personal trademark.

His first stencil paintings, inspired by cartoon strips, date from 1959–61 (*Popeye, Superman*); they demon-

strate his attraction to images drawn from everyday life. Soon he was making silk-screen paintings of Campbell's Soup cans and Coca-Cola bottles, which were followed by multiple images of dollar bills and portraits of Marilyn Monroe. The basic principle was simple: on one hand, the artist's selection of these images conferred a certain value on them; on the other, their repetition on single canvases demonstrated their banality. In addition to recycling likenesses of other Hollywood stars (Elizabeth Taylor, Marlon Brando, Elvis Presley), Warhol sometimes broached more serious themes. He was haunted by death, as evidenced by many works featuring electric chairs, automobile accidents, and suicides.

Many of these images were symbols of American postwar consumerism. Warhol's recyclings prompt a reconsideration of the way they function in the world around us.

Warhol also made films, and his efforts in this area are self-consciously experimental. His *Sleep* (1963), for example, is a silent film six hours long that shows nothing but a man sleeping. He also supported a rock band, Velvet Underground, with which he sometimes performed, and in 1969 he launched a monthly, *Interview*, in which he published his observations about the movies. The loft in which he lived and worked, known as the Factory, became an important gathering place for New York's avant-garde.

Warhol became a star who could command higher and higher prices for his portraits, but this did not prevent him from pursuing activities in a subversive spirit. In 1978, he produced his *Oxidation* series, a set of paintings transformed by the artist's and his friends' having urinated on them.

He died suddenly in 1987 from complications resulting from a surgical operation.

◀ ANDY WARHOL. *One Hundred Campbell's Soup Cans.* 1962. Acrylic and liquitex, 72¼ x 52³⁄₁₆ inches. Frankfurt, Museum für Moderne Kunst
By choosing to paint Campbell's Soup cans, Warhol transformed an ordinary object into a work of art, much as Marcel Duchamp had done with his "ready-mades" (see page 166), but he added a new twist by repeating the image a hundred times, compromising its uniqueness and making accumulation central to its character. The result is an archetypal product of Warhol's system of appropriation.

JEAN-ANTOINE WATTEAU
1684–1721

painter

Born in Valenciennes, in northeastern France, Antoine Watteau arrived in Paris at age eighteen. He was hired by an art dealer, for whom he made copies of religious scenes and Dutch paintings all day. After losing patience with this tedious work, he discovered the world of the theater in the workshop of Claude Gillot, a well-known painter of scenes from the Italian comedy. Later he assisted the painter Claude Audran, collaborating on decorations for several elaborate Parisian residences. His wall decorations combined delicate arabesques with charming animals and figures, often *Chinoiseries,* the "Chinese style" decorations fashionable at the time.

Watteau soon benefited from the protection of rich and influential friends, for example, the financier and collector Crozat, at whose home he studied superb Flemish drawings. At Crozat's country retreat, Watteau painted elegant scenes known as *fêtes galantes,* gatherings of well dressed ladies and gentlemen conversing, dancing, and flirting in idyllic landscapes. He generally assembled his groups of figures from the many drawings of friends, musicians, and dancers that he made incessantly, so that the same figures often appear in several paintings. The originality and freshness of his invention, however, makes each of these works uniquely enchanting. Watteau was a passionate lover of music and the theater. He attended performances of the French theater as well as those given by Italian comedians. Many of his friends were actors, and he sometimes painted them onstage. His painting *Pierrot* shows one of the stock characters from the Italian comedy as a lonely figure, isolated in the foreground of the

See: Pop Art, p. 168

canvas. In 1720, shortly before his untimely death from tuberculosis, Watteau began to paint one of his great masterpieces, a large signboard for the shop of his friend the art dealer Edmé-François Gersaint. The result, said to have been painted in only eight days, is known as *Gersaint's Shopsign*. A view of an imaginary art gallery (not Gersaint's) with walls covered with paintings and elegant clients coming and going, it delicately evokes the fragility of life and its pleasures, making it a fitting testament to Watteau's work.

▼ ANTOINE WATTEAU. *Pierrot (Gilles)*. c.1718.
Oil on canvas, 72½ x 58¾ inches. Paris, Musée du Louvre

Much about this painting remains mysterious. At different times it has been known by different titles, and its date is uncertain, as is the identity of the central figure. It probably served originally as a signboard for a café owned by a former actor famous for his portrayal of Pierrot, one of the stock characters of the Italian comedy. Behind the central figure in white, on a lower level and also dressed in Italian comedy costumes, are actors who amuse themselves by pulling a donkey from left to right. Pierrot himself, however, seems to be in another world, a solitary figure on the margins, his melancholy face impassive but deeply moving.

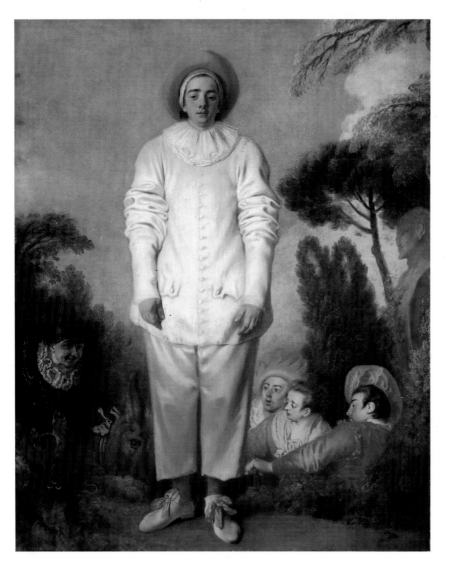

FRANK LLOYD WRIGHT
1867–1959
architect

Born in Richland Center, Wisconsin, in 1867, Frank Lloyd Wright dominated American architecture in the first half of the twentieth century. Immensely inventive, he was also hugely productive, producing more than five hundred buildings, surprisingly, at a time when most Americans preferred a more classical style of architecture. Wright's rejection of this conservative mode surfaced in 1894, when, after spending five years in the firm of Louis Sullivan, the greatest American architect of the day, he turned down an opportunity to study at the Academy's School of Fine Arts in Paris. In 1901 Wright began to design his Prairie Houses, the first buildings to reveal the full extent of his gifts. Featuring ground-hugging horizontal rooflines, they harmonize perfectly with the open spaces of the American midwest.

Between 1916 and 1922, Wright worked in Japan on the Imperial Hotel in Tokyo. Conscious of the threat of earthquakes, Wright designed it to withstand such shocks, and indeed, it was one of the few structures to survive the terrible earthquake of 1923. Back in the United States, Wright made extensive use of the "textile blocks" that he had first employed in Japan: concrete blocks bearing relief designs.

In the 1930s, Wright was widely regarded as a former innovator whose important work was behind him, but in a series of magisterial designs he demonstrated that he was not the romantic spirit still clinging to the nineteenth century that his younger colleagues thought him to be. The cantilevered concrete balconies and terraces of Fallingwater, built over a waterfall in rural Pennsylvania (1936; p. 75), are so sensitively organized

▲ FRANK LLOYD WRIGHT. Robie House.
1908. Chicago, Illinois

This is one of the finest of Wright's so-called Prairie Houses, whose designs exerted enormous influence on American domestic architecture. Within, the rooms flow freely into one another; without, the low, overhanging roofs make them seem to hug the ground. The adjacent terraces and windows blur the boundary between inside and outside.

that they seem part of the natural environment. Later, he built Price Tower, an eighteen-story building in Bartlesville, Oklahoma (1955), and the Guggenheim Museum in New York City (1946–59), conceived as a reinforced concrete spiral resembling a snail shell. At the same time he worked on his Usonian House project, a development consisting of fifteen elegant but simple one-floor designs that would be affordable by families of modest means. Wright died in 1959 at Taliesin West, a communal complex consisting of a school, a studio, and a residence for himself that he built in the Arizona desert beginning in 1938.

FRANCISCO DE ZURBARÁN
1598–1664
painter

After serving an apprenticeship with a minor painter in Seville, Francisco de Zurbarán opened his own workshop at age twenty in the province of Estremadura. In 1629, he completed a notable series of paintings for the Franciscan college of San Bonaventura. The solid, rather static forms of these paintings convey a sense of timelessness, which reinforces the religious fervor with which they are suffused. That same year the city government of Seville invited the artist to move his workshop there; he accepted, and was rewarded with a number of important commissions from the city's religious communities.

See: Houses in Nature, pp. 74–75

In 1634, on the recommendation of *Velázquez,* whom he had met in Seville, Zurbarán was invited to Madrid to help decorate the new royal palace known as the Buen Retiro. He obliged with battle scenes and a series of paintings depicting *The Labors of Hercules.* This sojourn proved very important for Zurbarán, for it allowed him to study the Italian paintings in the royal collections. As a result, he lightened his palette and began to model with a softer light.

In 1637 the monks of the Carthusian monastery in Jerez commissioned a set of large altarpieces from Zurbarán, including an *Annunciation* and an *Adoration of the Shepherds.* Between 1638 and 1645 he painted an imposing series of figures from the Hieronymite order for the sacristy of the church in Guadalupe; this is the only cycle by the artist still in its original site. In Seville, he led a life devoted exclusively to the production of religious paintings for abbeys and private clients. Many of his works depict scenes from the life of the Virgin, a subject especially beloved by the Spanish.

Beginning in 1650 many religious communities began to face serious financial difficulties, with the result that there were fewer large commissions from them, and competition for the few remaining was intense. Zurbarán, however, had by this time developed a clientele in South America. Patrons in Lima, Peru, ordered a series of thirty-eight paintings from him, including a series of figures of saints.

During the 1650s, the wars waged by Philip IV resulted in widespread misery in Spain, which was intensified by the plague, which decimated Andalusia and claimed Zurbarán's eldest son Juan, a fine still-life painter. In 1658 the artist settled definitively in Madrid, where he continued to paint sacred works, now on a smaller scale and with a lighter, suppler touch. He died in Madrid in 1664.

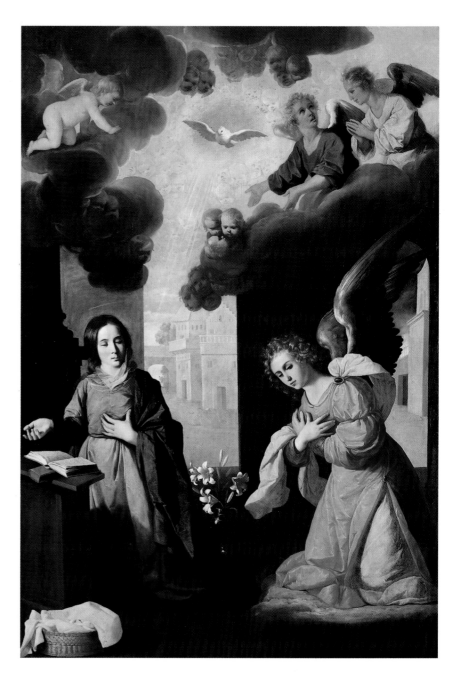

▲ Francisco de Zurbarán. *The Annunciation.* c. 1638–40.
Oil on canvas, 105¼ x 72⅞ inches. Grenoble, France, Musée
The Annunciation — the moment when the Archangel Gabriel announced to the Virgin Mary that she would miraculously give birth to a child who would be a king of Israel — was a favorite subject of painters of the Renaissance and Baroque periods. Zurbarán's portrayal of the scene is both grand and serious; the forms are imposing and symmetrically arranged. The setting, with its distant towers, emphasizes the monumentality of the composition, while the bright light falling on the Virgin highlights her central importance to the theme. Everything about her — her calm demeanor, her gracefully posed hands, her erect posture — suggests an ideal of simple dignity.